THE HIDDEN
DURER

PHAIDON

OXFORD

THE HIDDEN DÜRER

PETER STRIEDER

Frontispiece illustration:
ADAM
Detail
Oil on panel (pine); $82 \times 31\frac{7}{8}$ in.
(209×81 cm)
1507. Bears Dürer's monogram AD
Madrid; Prado
See page 109

THE
HIDDEN
DÜRER

BY PETER STRIEDER

EDITORS: MARIELLA DE BATTISTI, MARISA MELIS
EDITORIAL COLLABORATION: FABRIZIO D'AMICO
PAOLA LOVATO
GRAPHIC DESIGN: ENRICO SEGRÈ
TRANSLATED FROM THE GERMAN BY VIVIENNE MENKES

First U.K. edition by arrangement with Bay Books, Sydney, Australia.
Published 1978 by Phaidon Press Ltd., Littlegate House, St Ebbe's Street, Oxford.
Copyright © 1976 by Arnoldo Mondadori Editore S.p.A., Milan
English translation copyright © 1978 by Arnoldo Mondadori Editore S.p.A., Milan
All rights reserved
including the right of reproduction in whole or in part in any form

ISBN: 07148 1863 1

Printed in Italy by Officine Grafiche di
Arnoldo Mondadori Editore, Verona

Filmset by Keyspools Ltd, Golborne, Lancashire

Contents

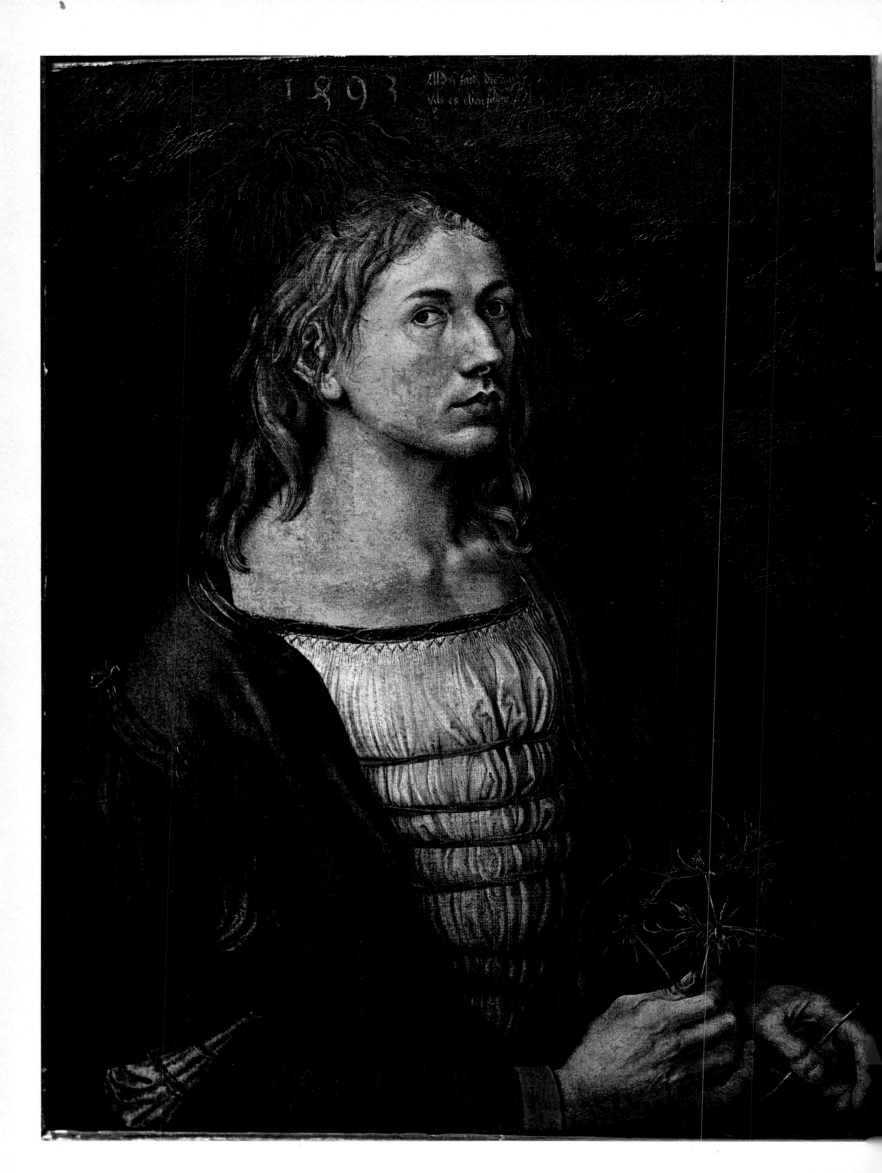

Albertus Durerus Noricus

Life and Personality

The name of Albrecht Dürer stands for a period of exceptional development in German art. His work and personality exerted a particularly strong influence on the work produced by other artists of the time, yet the impact of his ideas, which were put into practice with the greatest manual dexterity and the highest spirit of craftsmanship, reached beyond German art and culture. We are told by a contemporary of Dürer, the humanist and theologian Cochläus, that merchants from all over Europe used to buy his engravings. Admiring the delicacy with which they were executed and the perfect use of perspective, the foreign merchants wanted to show them to artists in their own countries. His art, which was derived from a completely new way of feeling and thinking, became increasingly independent of artistic and social traditions.

At the age of thirteen or fourteen Dürer drew a self-portrait from a mirror image in order to explore his own appearance (p. 8). This drawing is one of the earliest independent self-portraits in Western art, as it dates from the period before he cut short his original apprenticeship with his father, who was a goldsmith, to spend three years as an apprentice to the painter Michael Wolgemut. The self-portrait may have been inspired by one done by his father, which shows the elder Dürer with a piece of his own work—a statuette of a knight on horseback holding a banner on the end of a lance (Vienna, Albertina). Both self-portraits are executed in silverpoint, a technique that involves preparing the paper by coating it with opaque white and that allows little opportunity for corrections. The early self-portrait is clearly the work of a budding genius. Our amazement at his sure touch and his ability to express himself in line is followed by a feeling of puzzlement at the earnest way in which this attractive child explored and portrayed his own features in an attempt to achieve self-awareness.

Dürer kept the drawing as proof of his own development as an artist. Later, he was to write a detailed note in the top right-hand margin, confirming that it was drawn in 1484 and stressing that he had drawn it himself, looking at his reflection in a mirror. In what appears to be an unnecessary postscript he adds that this was when he was a child—it seems he was still proud of what he had achieved at such an early age.

The outer form—a half-length portrait in three-quarters profile—shows that he was already familiar with the formula normally adopted for commissioned portraits in Wolgemut's workshop. Longing to be a painter instead of a goldsmith like his father, the boy obviously had taken a good look around his future teacher's workshop, which was only a few yards from his parents' house.

His determination to put across the important aspects of his own personality—most unusual for the period—is matched by the written descriptions he made of episodes from his family's history and from his own experiences. His father, who was also called Albrecht, had done the same, for the younger Albrecht used his father's notes when he compiled a family chronicle, which has survived in a seventeenth-century copy. The chronicle

SELF-PORTRAIT WITH
ERYNGIUM FLOWER
Oil on canvas (transferred from
vellum); $22\frac{1}{4} \times 17\frac{1}{2}$ in. (56.5×44.5 cm)
At the top of the painting appears the date (1493) and the following inscription: "My sach die gat/ Als es oben schtat" ("My affairs shall go as ordained on high")
Paris, Louvre
In 1840 this painting was in the collection of Dr. Habel of Baden, near Vienna. It was subsequently in the Felix Collection in Leipzig and in the Goldschmidt and de Villeroy Collections in Paris.

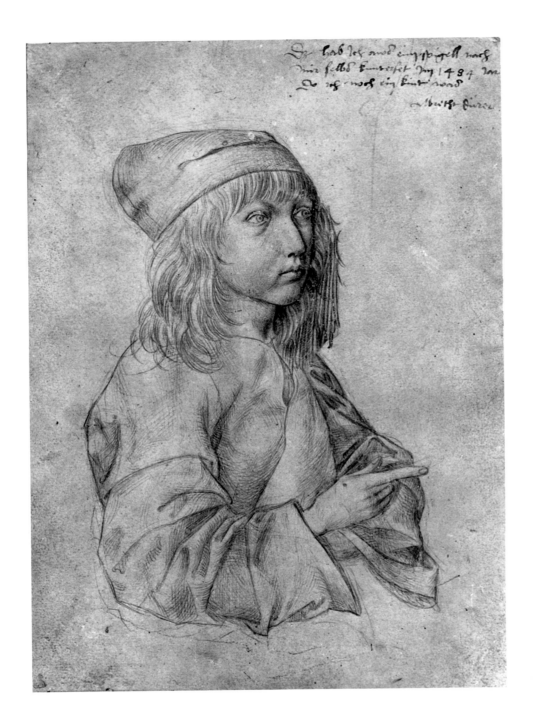

SELF-PORTRAIT AT THE AGE OF
THIRTEEN OR FOURTEEN
Silverpoint; $10\frac{7}{8} \times 7\frac{3}{4}$ in.
$(27.5 \times 19.6$ cm$)$
1484
Vienna, Graphische Sammlung,
Albertina.

gives a detailed account of Albrecht's own birth and those of his seventeen brothers and sisters, leaving it to his father to add at the end of this long list that apart from the artist only his younger brothers Endres and Hans ("the third of that name") were still alive. Death was as common as birth in the Dürer household. As all three surviving brothers died childless, the generation that had concentrated all its potential in a single member was the last of the line, and the family died out.

The exact date of young Albrecht's birth, May 21, 1471, is noted in his father's papers: "Item. 1471 years after the birth of Christ, in the sixth hour on St. Prudentia's day on a Tuesday in Rogation Week, my wife Barbara bore my other son, to whom Anthonj Koburger [Anton Koberger] stood as godfather, calling him Albrecht after me." The second surviving son, Endres, was born in 1484 and trained as a goldsmith. His pleasant, ordinary-looking face has come down to us in various portrait studies by Dürer. Then in 1490, shortly before his father's death, came the youngest son, Hans. He was to become a problem and worry to Albrecht and was subsequently to be a minor painter at the court of the Polish king Sigismund I in Cracow.

The family records delve into genealogy, offering proofs of ancestry as though they were of the aristocracy. Dürer's male ancestors were, in fact, all goldsmiths. His father and his paternal grandfather, Anton Dürer, came

from a Hungarian village called Ajtós, which was razed by the Turks in 1566 and never rebuilt. The family name came from this village, as the Hungarian word *ajtó* means "door," which is *Tür* in modern German and could have been *Tür* or *Dür* in fifteenth-century German. An open door is featured on the family's coat of arms, which Dürer's father already may have used, as it appears together with that of his wife on the back of a portrait painted by his son in 1490.

Anton Dürer served his apprenticeship in nearby Gyula, the capital of the county of Békés, but his son Albrecht moved to Germany. The brief notes in the chronicle suggest that he first stayed in some unspecified town, but this was probably after he had finished his apprenticeship, which he ought to have completed with his father. Dürer's father continued his training by visiting "the great masters" in the Low Countries. Finally, he settled permanently in Nuremberg on June 25, 1455, which was St. Eligius's Day (St. Eligius, or Eloi, is the patron saint of goldsmiths).

Albrecht senior became assistant to a goldsmith called Hieronymus Holper and probably lived with the Holpers as well. In 1467 he became a full-fledged member of the family by marrying Holper's fifteen-year-old daughter Barbara. His marriage enabled him to acquire the freedom of the city of Nuremberg and the status of master craftsman—indeed, this was the only way a penniless foreign craftsman could acquire such status. In 1475 he

TERENCE WRITING HIS PLAYS
Drawing on wood block;
$3\frac{5}{8} \times 5\frac{3}{4} \times \frac{15}{16}$ in. ($9.3 \times 14.7 \times 2.4$ cm)
Basel, Öffentliche Kunstsammlung, Kupferstichkabinett
The design has been drawn on the block but has not yet been engraved. It was intended to appear as the frontispiece to an edition of Terence's plays, but the project was abandoned. Although the work was never finished, 126 blocks with drawings on them and 6 engraved blocks have survived, also 6 woodcuts from blocks that have not come down to us.

paid 200 guilders for a house on the corner of present-day Schmiedgasse and Burgstrasse. His son Albrecht was born in this house, which is no longer standing, and lived and worked there until 1509, when he bought an imposing house near the Tiergärtnertor, which was part of the estate of the astronomer Bernhard Walther. Even today "Dürer's house," standing as it does directly beneath the impressive city walls, conveys something of the influence that the building and its site must have exercised over the head of the household in his role as artist.

Dürer described his father as "a pure and artistic man." He painted two portraits of him that reveal something of his character, his purity, and his religious nature. The earliest portrait (p. 11) was painted in 1490 and depicts him without any of the tools or symbols of his trade, wearing a simple fur-lined cloak and a fur cap. Albrecht senior is quietly holding a rosary and looking solemnly and devoutly up to heaven. Seven years later his son did another portrait of him, drawing on the experience he had acquired during his years of travel as a journeyman and during his first visit to Italy (p. 33). This second portrait used to hang in the town hall in Nuremberg, but in the difficult times caused by the Thirty Years' War the town council decided to make a present of it to Charles I of England, and it was handed over to the

Earl of Arundel in 1636. Either the original portrait or a close copy now hangs in the National Gallery in London. Experts have cast doubt on the authenticity of the London portrait, and it is now generally thought of as a copy of a painting that has been lost. Yet it seems likely that the face, at any rate, is Dürer's work, though the body and background are clearly by another hand. Unlike the earlier portrait, this is a full half-length, and Dürer's treatment of the figure is freer, more assured and spontaneous. His father's face has aged and shows traces of cares and worries. He gazes past us, no doubt looking at his son as he worked on the painting.

The only portrait we have of Dürer's mother is a charcoal drawing executed in 1514, two months before her death (p. 135). It is a moving, even shocking image of a woman who had once been described by her future husband, who was of course twenty-five years older, as "a pretty, upright maid." That was in 1467, and a hard life, during which she had given birth to eighteen children, had worn her out. Two years after her husband's death she was destitute, and her son had to take her to live with him. Every stroke of his soft pencil carefully traces her face, sparing nothing and making no attempt to soften the ugliness, yet the portrait conveys the son's great love and respect for his mother.

This is one of Dürer's most important drawings, as it had a strong influence on the style of his later portrait studies. He recorded the feelings evoked by his parents' deaths in a special "commemorative book," only one page of which has survived. As he watched his mother dying he showed the same acute powers of observation that we can see in all his paintings and graphic work. Relating his experiences in words that reflect deep feelings, he finally reaches a point where he can say no more: "It gave me such pain that I can't express it." Dürer's account of his parents' deaths clearly was intended for a wider readership, for friends who read of his father's death were asked to pray for his soul, and the description of his mother's death begins with the words: "Now you shall know. . . ."

Dürer never quite lost the conviction that he must examine his own situation by doing portraits of himself. Three more self-portraits have survived from his journeyman's period, which extended from Easter of 1490 to Whitsuntide of 1494. Two are drawings (now in Erlangen and New York), but the third, dated 1493, is painted on vellum (p. 6). An old inventory tells us that the collection of Willibald Imhoff in Nuremberg included two portraits painted on vellum attributed to Dürer, allegedly of his teacher in Strasbourg and his wife. The use of vellum, unusual for larger portraits, suggests that the self-portrait of 1493 was painted in the workshop in Strasbourg. It dates from the latter part of his journeyman's period, before his marriage, and still shows the influence of the formula normally used in Nuremberg for portraits. As in the drawings, he sat in front of a mirror and worked directly onto the vellum without making a preliminary sketch. Originally the left hand holding the paintbrush (really the right hand, of course, as this is a mirror image) was missing, but it was added later.

It would be wrong to see this portrait as a "wooing picture" painted because Dürer wanted to show his fiancée in Nuremberg that he was a handsome, fashionably dressed young man with long blond hair and a tasseled red cap perched at a jaunty angle over one ear. He makes it quite clear in his family chronicle that their betrothal followed the usual pattern of the period: "[And when I had come back home] Hanns Frey negotiated with my father and gave me his daughter called Miss Agnes, and also gave me 200 guilders."

The eryngium flower in the young man's hand is a symbol of male fidelity—Goethe, who had seen a copy of the painting in Helmstedt, referred to this—but it does not necessarily support a romantic interpretation of the portrait. The eryngium has a variety of symbolic meanings and also points to a religious significance. This appears even more clearly in the inscription at the top of the portrait, which takes the form of a rhyming couplet. It reads: "My sach die gat/Als es oben schtat," which means roughly: "My affairs shall go/As ordained on high." This formula of submission to God's will links Dürer's self-portrait to paintings of devout donors on medieval altars. Individual portraits developed, among other ways, from these altar paintings. The first examples of the genre were always inspired by an urge to

PORTRAIT OF DÜRER'S FATHER
Oil on panel; 18¾ × 15⅝ in.
(47.5 × 39.5 cm)
In the top left-hand corner appear Dürer's monogram and the date (1490), but they are not in Dürer's hand. The coats of arms of the Dürer and Holper families and the original date appear on the reverse
Florence, Uffizi
Provenance: collections of Endres Dürer (?), Willibald Imhoff, and Emperor Rudolf II. In 1675 the work was included in the estate of Cardinal Leopoldo de'Medici.

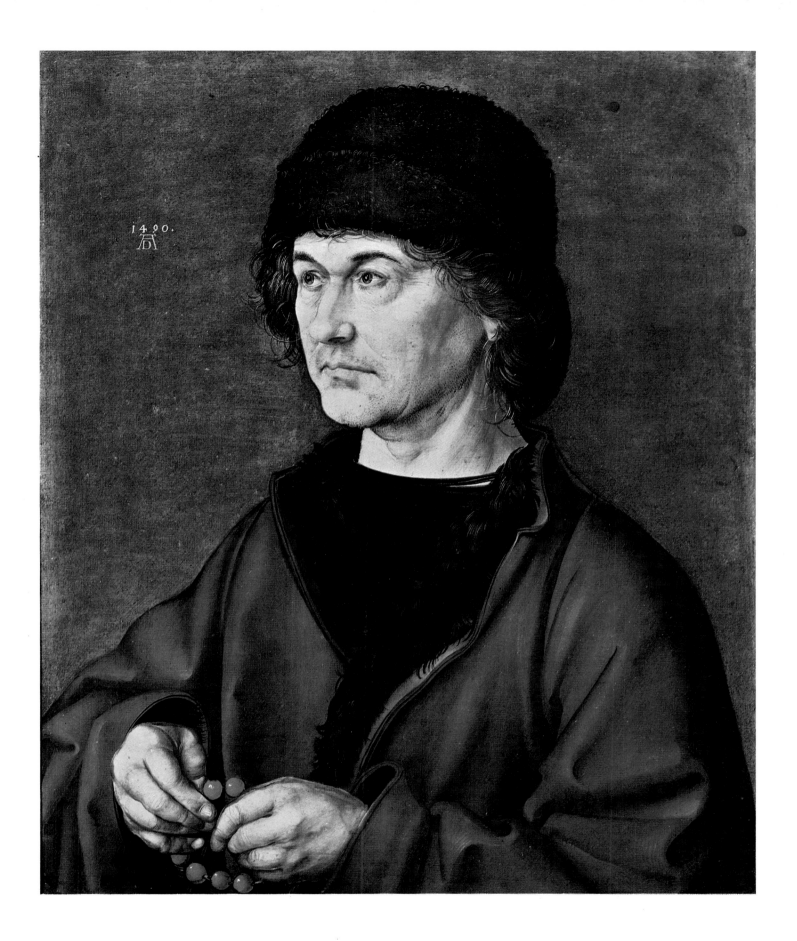

call on God to intercede on behalf of the living and the dead.

Albrecht Dürer senior must have seen his son's marriage to the daughter of a respected master craftsman as confirming his own status in the town, which he had earned by his abilities. After all, Hans Frey had been awarded various honorary municipal offices; he was a well-known harpist as well as being a smith working in brass and bronze, and he had invented and made a wind-driven table fountain. His interest in automatons of this type may have brought him closer to Dürer senior, and Dürer junior's designs for table fountains to be made in precious metal and displayed at banquets were presumably inspired by his father-in-law's work. Having been an apprentice

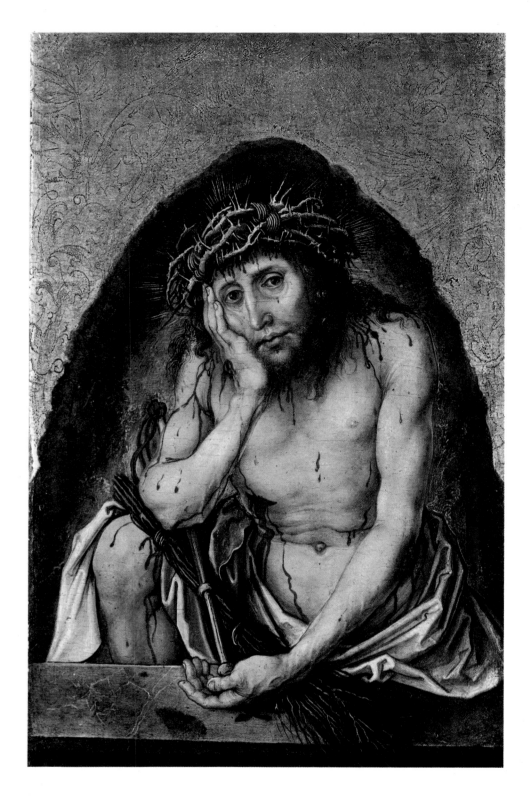

CHRIST WITH THE SYMBOLS OF
HIS PASSION (ECCE HOMO)
Oil on panel (pine); $11\frac{3}{4} \times 7\frac{1}{2}$ in.
(30×19 cm)
Probably painted in Strasbourg about
1493
Karlsruhe, Staatliche Kunsthalle
From the collection of the heirs of the
painter P. Röth, Aschaffenburg.

DER RITTER VOM TURN
Woodcut; $4\frac{1}{4} \times 4\frac{1}{8}$ in. (10.9×10.6 cm)
This was one of the 45 woodcuts
illustrating the German edition of the
moral tales written by a Frenchman
named Geoffrey de La Tour-Landry for
his two daughters in 1371–1372. The
German edition, translated by
Marquart vom Steyn, was published in
Basel in 1493.

goldsmith at one time, he was familiar with the properties of various
materials, which also may have influenced and encouraged him in this field.

Dürer's marriage does not seem to have been happy, though Willibald
Pirckheimer's libelous comments—he believed that his friend's early death
was caused by his wife's failure to understand him—should not be taken at
face value. The difference between their intellectual levels must have been
too great. Agnes Frey had thought wrongly that she had followed the usual
trend of girls in her social class by marrying a craftsman who would work
hard at his trade to give his family security and improve his status among his
peers. Dürer, too, wanted to do this—and did. He must have worked
enormously hard and with unparalleled craftsmanship, and he also must
have had a very good head for business. But he wanted more than that. He
wanted to find out all he could about everything connected with his art—
how it originated and the conditions under which it had developed, how to
collect knowledge and pass it on to others.

The year they were married Dürer did a pencil sketch of his wife, who was
still a child. Apparently she did not notice what he was doing as she sat at a

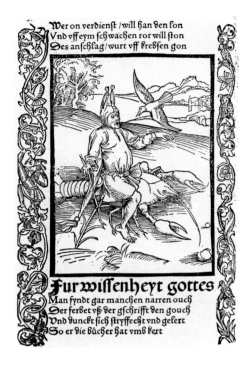

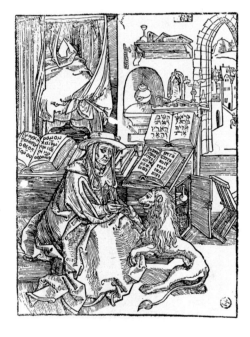

MADMAN RIDING A LOBSTER
Woodcut
One of the woodcuts engraved by
Dürer to illustrate the satirical poem
Das Narrenschiff (*Stultifera navis* or
Ship of Fools) by Sebastian Brant,
published in Basel in 1494 by Johann
Bergmann.

ST. JEROME IN HIS STUDY
Woodcut; 7½ × 5¼ in. (19.2 × 13.4 cm)
Woodcut for the frontispiece of an
edition of St. Jerome's letters pub-
lished in Basel on August 8, 1492, by
Nikolaus Kessler. Dürer probably de-
signed it in early 1492 very shortly
after his arrival in Basel, where he
stayed until 1493.

table in front of him, her chin resting on her hand, for the drawing has a
spontaneous feel about it. Later portraits show that Agnes became a rather
dry-seeming woman and subsequently a plump, matronly figure. She never
had any children. When Agnes was forty-five years of age, her husband
chose her as a model for a painting of St. Anne with two other figures
(pp. 142–43). The study is carefully drawn, with gray brush strokes on dark
gray paper. A kerchief conceals part of her face, leaving only the eyes, nose,
and mouth visible, and her head is tilted toward her left shoulder. Although
this appears to be a gesture of resignation, it was probably planned as part of
the overall composition. Dürer has captured her thoughtful expression as
she looks toward him, but otherwise the personal element has been toned
down in favor of a more general statement about the woman revered as a
saint because she was the mother of the Virgin Mary.

On two different occasions Dürer left his wife behind in Nuremberg for
more than a year while he studied and worked in Venice. The first time he set
off was in October, 1494, only a few months after their wedding, and the
second time late in the summer of 1505. Plague was rife at the time, so he
could scarcely have believed that it was a good moment to travel, yet
concern for his wife's health and safety did not hold him back.

Three years after his first visit to Italy, at a time when he was working on
the drawings and prints that would one day bring him fame and when he
would soon be traveling beyond Germany again, he took stock of himself
once more in a self-portrait (p. 38). This one is slightly smaller than the
previous self-portrait and is carefully painted on wood. It is inscribed with
the date and Dürer's age and is signed with his full name, plus the famous
monogram based on the letters "A" and "D," which he used from 1496 on. It
is a half-length portrait depicted in three-quarters profile. The painter is
standing in front of a window, which provides a source of light in the dark
interior. He is leaning back against a pillar that supports an intersected arch.
The carefully shaded white and gray of his doublet and cap are interrupted
and highlighted by the use of dark stripes, and the black and white cord
holding the light brown cloak over his left shoulder stands out sharply
against his partially exposed chest. The restrained coloring of his clothing
allows the flesh tones and the golden tinge in his long, well-groomed hair to
stand out. The brightness in his neck and face is repeated in the mountain
landscape that can be seen through the window. The miniaturelike delicacy
of this landscape shows us how much he had learned during his stay in Italy.
The same link between portrait and landscape can be seen in both Dutch and
Italian art before his day, but the idea of looking at landscape as a single unit
built up from shapes and light was new.

In this painting Dürer showed what he could achieve as a painter. The
fashionable clothes he wears are more than an indication of good taste or a
touch of vanity and self-love. They reflect his conviction that the artist has a
special part to play in society, and an important one at that. Just about the
time when Dürer executed this self-portrait people in Nuremberg were
beginning to indicate their place in the social hierarchy through the clothes
they wore. In the fourteenth and fifteenth centuries clothing regulations
were still in force. Designed to put a stop to excessive luxury, they laid down
the same rules for all the inhabitants in any one town. But at the end of the
fifteenth century a new regulation was introduced, this time to differentiate
among the social classes. Clothing thus became an official indicator of a
person's social position.

The third and last self-portrait rejects the formula of the three-quarters
profile (p. 52). Instead, Dürer painted himself in a frontal pose, with his
right hand—really his left hand in the reversed mirror image—held in front
of his chest. He is gently fingering the soft fur trimming on his robe, which
gave its name to the portrait (*Self-Portrait in a Fur-Collared Robe*). Whereas
the self-portrait with the landscape background expressed Dürer's new
awareness of his social status, this one conveys his awareness of his artistic
mission more clearly than any other painting before or since. He is less
concerned with himself as a person than with himself as an artist, and less
with the artist than with the origin and exalted mission of art itself.

This self-portrait was painted in 1500, as we can see from the figures above
the large monogram on the left-hand side. This year does not represent an

arbitrary choice of date for painting a new self-portrait. In a period when traditional values were beginning to show signs of breaking down and religious and social upheavals were in the offing, people were looking forward with considerable excitement to the turn of the century, to the moment when they would embark on the second half of the millennium. Pope Alexander VI had proclaimed 1500 a holy year, and a large number of pilgrims had responded to his appeal to obtain a "jubilee" indulgence by taking an interest in their eternal salvation.

Dürer gives further information about himself and about the portrait in an inscription on the right-hand side of the painting. This one is in Latin, the language of the Church and of the humanists. It reads: "Albertus Durerus Noricus/ipsum me propriis sic effin/gebam coloribus aetatis/anno XXVIII." ("I, Albrecht Dürer from Noricum, painted myself with ever-lasting colors in my twenty-eighth year.") So he had painted his own portrait in everlasting colors, wanting to hand down an undying image to posterity. In his family chronicle he notes gratefully that his father, recognizing his ability, sent him to school, and, once he had "learned to read and write," took him on as an apprentice. As a result the young Albrecht did not have to take any further part in the Latin lessons that normally followed the basic grounding. He did learn Latin later, however, acquiring as much of the language as he needed to understand and interpret the sources on which his study of the theory of art was based. He could rely on help in this area from his learned friend Willibald Pirckheimer, who probably devised the inscription on the self-portrait, using the adjective *proprius* for "everlasting" or "immortal"—it is in fact rarely used in this sense.

The strictly frontal pose and the symmetrical composition recur in images of Christ, particularly in the form of the *vera icon*, or "true image," based on the impression on the handkerchief that St. Veronica is said to have handed to Christ when he was on his way to Golgotha. The connection between these pictorial formulas was noted at an early date, as was the fact that the strict

 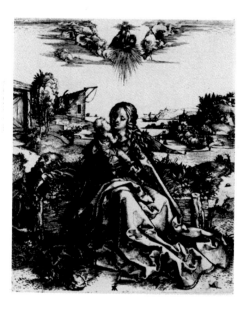

Left
THE HOLY FAMILY
Pen-and-ink drawing; $11\frac{1}{2} \times 8\frac{1}{2}$ in.
(29×21.4 cm)
Probably 1492–1493
Berlin, Staatliche Museen Preussischer Kulturbesitz, Kupferstichkabinett.
Formerly in the Esdaile, Galichon, and Rodriguez Collections.

Right
THE HOLY FAMILY
Engraving; $9\frac{1}{4} \times 7\frac{1}{2}$ in. (23.6×18.7 cm)
Probably 1495
Monogram appears at bottom edge in the center. The work also is known as *The Virgin with the Dragonfly*.

symmetry of the face was based on a construction made up of a circle and a triangle—a formula used down to the Byzantine period for images of the Redeemer. In this self-portrait Dürer appeals to Christ, just as he appeals to God in the introduction to a textbook he planned to write on painting, formulating his belief in the hierarchy of art and its divine origin. Art comes from God, he says. God created all forms of art and "the attainment of true, artistic, and lovely execution in painting is hard to come unto. . . . Whosoever, therefore, falleth short cannot attain a right understanding for it cometh alone by inspiration from above."*

*Quotations from Dürer's writings are taken from *The Literary Remains of Albrecht Dürer*, ed. and trans. W. M. Conway (Cambridge: 1889).

The self-portrait executed in 1500 was the last Dürer ever painted. In it he had expressed what he wanted people to know about himself and his attitude toward art, and, as we have seen, it was intended as an "everlasting" statement. For some time—we don't know exactly when the painting was removed, but it was probably soon after his death—this portrait hung with other works by Dürer in the Upper Regimental Room of the town hall in Nuremberg, which was used as a picture gallery. The Dutch painter Carel van Mander saw it there when he visited Nuremberg in 1577. After building alterations at the town hall, the painting was hung in the small assembly room known as the "Beautiful Hall," and in 1805 it went to the royal collections in Munich.

Two pen-and-ink self-portraits that tell us a great deal about Dürer's personality clearly were not intended for public showing. One is a large nude in Weimar; the other, which used to be in Bremen, is a drawing identifying Dürer with the "Man of Sorrows." (It has been missing since the end of World War II, along with other important drawings and prints by Dürer from the same collection.) On the other hand, a small pen-and-ink drawing lightly washed with watercolor has survived. It is an occasional piece and shows Dürer, clad in a loincloth, pointing to his side, apparently to call attention to the area of his spleen (p. 148). An inscription above the drawing explains its purpose: "Where the yellow spot is and I am pointing with my finger, that's where it hurts." We probably cannot assume that the drawing was made solely for a consultation with a foreign doctor. Contemporary doctrine on the "humours" taught that the spleen was the seat of melancholy, so in pinpointing that organ as the source of his pain he also may have been describing his mental state. A statuette of Venus carved by a Nuremberg artist around 1520–1530 shows that such symbolic allusions to one's mental state were not particularly unusual. This small bronze figure from a fountain is of the "Venus pudica" type—the goddess is covering her breasts and pubic

BACCHANALIA WITH SILENUS
Pen-and-ink drawing in light and dark brown; $11\frac{3}{4} \times 17\frac{1}{4}$ in. (29.8 × 43.5 cm)
At the top appears the artist's monogram with the date (1494) to the left of it
Vienna, Graphische Sammlung, Albertina.

region with her hands and stands on a sphere inscribed with the words, "VBI MANVS IBI DOLOR" ("Where my hand is, there is the pain").

Dürer's personality is further revealed in ten letters that he wrote to Pirckheimer during his second visit to Venice, from autumn of 1505 to January or February of 1507, and in the diary he kept of a trip to the Low Countries from July 12, 1520, to the second half of the following July. The Pirckheimer correspondence describes incidents that occurred in Venice and the successes he enjoyed there. He also talks about errands he was doing for his friend, which took up a great deal of his time, and sometimes about his family—instructions to his wife and his mother about selling his drawings and engravings and anxious comments about his younger brother Hans, whom he wanted to see apprenticed to his own former teacher, Michael Wolgemut.

Incidentally, Dürer must have been a conspicuous figure in Venice, both in his appearance and behavior. In the frescoes painted by Venetian painters to decorate the Scuola del Carmine in Padua, we can see an unmistakable portrait head of Dürer, with shoulder-length hair and fixed gaze, among the nonportrait faces of Mary's suitors in the scene showing the miracle of the staff.

We gather from the letters to Pirckheimer that during the summer of 1506 he was planning to travel farther south to Rome in the suite of Emperor Maximilian I, who was organizing a procession for the imperial coronation. This suggests that his main aim in traveling to Rome would have been to see the grandiose spectacle of the coronation; when Maximilian's procession fell

VIEW OF INNSBRUCK
Watercolor; 5 × 7½ in. (12.7 × 18.7 cm)
1495
Vienna, Graphische Sammlung, Albertina
This watercolor was painted during Dürer's first visit to Italy.

16

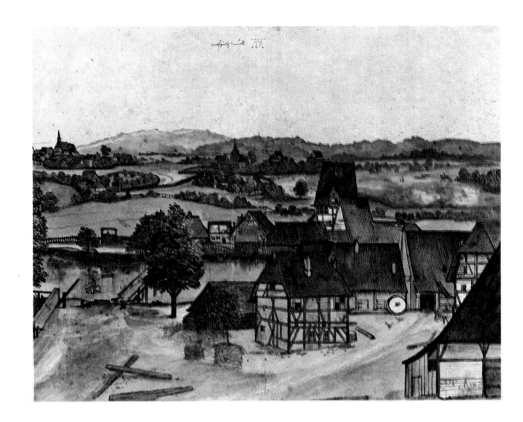

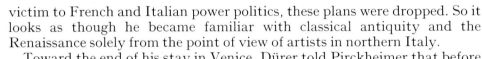

WIRE-DRAWING MILL
Watercolor and gouache on vellum;
$11\frac{1}{4} \times 16\frac{3}{4}$ in. (28.6 × 42.6 cm)
Probably 1494
Berlin, Staatliche Museen Preussischer Kulturbesitz, Kupferstichkabinett
Autograph inscription "Trot-zichmüll" at the top. The monogram was added at a later date.

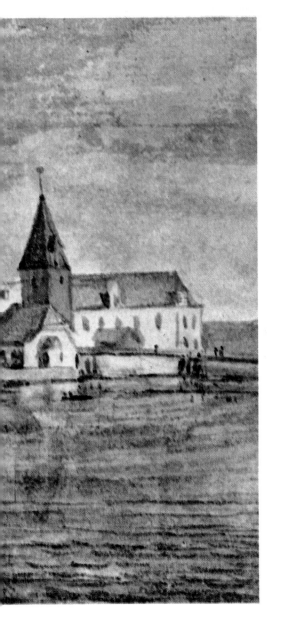

victim to French and Italian power politics, these plans were dropped. So it looks as though he became familiar with classical antiquity and the Renaissance solely from the point of view of artists in northern Italy.

Toward the end of his stay in Venice, Dürer told Pirckheimer that before traveling back to Nuremberg he was going to visit Bologna for some important training in the arts of perspective, probably by the mathematician Luca Pacioli. Much secrecy surrounded contemporary teaching on perspective, and Dürer also hoped to learn from Pacioli about Piero della Francesca's theories in this field. In 1507 he bought a copy of a Latin edition of the works of the ancient Greek mathematician Euclid, published in Venice. His reason for buying it was clearly connected with his perspective studies. The book itself, together with the record of the sale, has survived (Wolfenbüttel).

In his biography of Anton Kress, Christoph Scheurl confirms that Dürer went to Bologna.(Kress, the provost of the St. Lorenz church in Nuremberg, was a friend of Dürer.) A second hypothesis was that once he had reached Bologna, Dürer decided to ride on to Rome, at least for a short while. We know the date of his return to Germany, and he certainly could have fitted in about a fortnight in Rome. But this theory was exploded by the discovery of a copy of Dürer's painting of the twelve-year old Christ among the doctors (p. 102). The written text on the original, which consists of a monogram, the words "opus quinque dierum" and the date 1506, is supplemented on the copy by the words "F[ecit] Romae." When the original painting was cleaned, traces of the supplementary text were found on the same spot.

The supposition that Dürer would have painted this work, which he described as "opus quinque dierum" (a work which took five days to complete), in Rome is also strongly contradicted by the fact that the artist would have had to bring his painstakingly accurate preparatory drawings with him to Rome, as well as by a remark of Dürer himself in a letter from Venice to his friend Pirckheimer, which establishes a connection with the "opus quinque mensium" (a work which took five months to complete), i.e. the altar painting for the Saint Bartholomew church in Venice, and suggests that both pictures, however contrasting in concept and execution, were executed in Venice.

When Dürer had worked out plans for the Bologna trip and had arranged to return to Nuremberg in early 1507, he exclaimed sadly: "Oh, how I shall long for the sun in the cold. Here I am a gentleman, but at home I am a

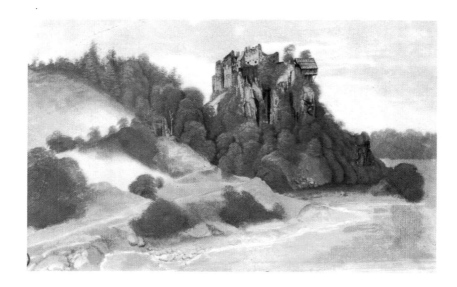

parasite etc." He uses a metaphor also used by the Nuremberg poet and dramatist Hans Sachs to convey the frosty mood that came over him when he thought of the discrepancy between his status in Venice and his status in Nuremberg. He believed that people in Nuremberg thought of him as a parasite, and the final "etc." conceals other equally negative possibilities. The status of an artist in the service of the pope or one of the major secular rulers of Italian city-states was clearly different from that of an artist working in a German town. Yet Dürer had turned down the doge's offer to enter the service of the Venetian city-state, along with private commissions totalling 2,000 ducats. Clearly he did not underestimate the freedom he enjoyed in his native town, for there he was his own master and even the financial success of his work could not be denied him.

Financial security was again the motivation behind his last long journey abroad. In 1515 Maximilian I had promised him a yearly annuity of 200 guilders from the tax that the town of Nuremberg was committed to hand over. This was in return for a large number of drawings and engravings glorifying the emperor and his family. When Dürer's imperial patron died in Upper Austria on January 12, 1519, the cautious city fathers suspended his annuity until it was ratified by the new emperor, Maximilian's grandson Charles V. Dürer decided to settle the matter in a personal interview. He set off on July 12, 1520, with his wife and a maid.

He stayed in Antwerp, Brussels, and Mechlin, taking part in the imperial coronation in Aachen —to make up, as it were, for the one he had missed in Rome. Then on November 12, when he was in Cologne, his annuity was

confirmed in writing. His journey had therefore served its purpose, but he decided to return to Antwerp and stayed there, with interruptions, until July 2, 1521.

The whole journey was an impressive experience for him, both as a person and as an artist. A seventeenth-century copy of the diary he kept during the trip gives full details about his itineraries, about the people he met, and about the masterpieces of Dutch and Flemish painting he saw. The diary includes the names of Jan van Eyck, Rogier van der Weyden, and Hugo van der Goes and gives a detailed account of the tokens of esteem given to him by the painters in Antwerp and Bruges. He made detailed notes of his expenses and of receipts from the sale of his drawings and engravings and from *honoraria* for portraits. He drew many portraits, most of them probably very large ones.

The governor of the Low Countries, Margaret of Austria, Maximilian's daughter, received him, though she would not accept the portrait of her father that he offered her. In his diary he noted this refusal as a piece of business that had slipped through his fingers.

Dürer kept two sketchbooks for himself, filling them with impressions of people and landscapes that he jotted down quickly but carefully, and with a sure touch. At first the diary of his journey was nothing more than a detailed record of incomings and outgoings noted down by a man living in a foreign country who had to budget diligently to make sure that there would be enough money for himself, his wife, and the maid. As a result the occasional personal comments stand out even more sharply — his delight at the tributes he received, and his absolute amazement when he saw the Mexican works of art that Charles V had brought back from his Spanish dominions. At one point the entries become a powerfully written personal confession. He thought that Martin Luther had been taken prisoner after the Diet of Worms, perhaps even murdered, and he breaks out into a dirge that takes the form of a prayer to God and Christ. At the end he appeals to Erasmus of Rotterdam to ride out as a "Knight of Christ" to "defend the truth and earn ... a martyr's crown." This outburst is so uncharacteristic of the diary, and indeed of all Dürer's writings, that some experts used to think that it was a later addition. But this is clearly not the case.

Dürer's Writings on Art

From a time not later than his return home from his second trip to Italy,

COURTYARD OF THE HOFBURG IN INNSBRUCK (also known as CITY SQUARE)
Watercolor; $13\frac{1}{4} \times 10\frac{1}{2}$ in.
(33.5×26.7 cm)
1495
Vienna, Graphische Sammlung, Albertina.

VIEW OF ARCO
Watercolor and gouache; $8\frac{3}{4} \times 8\frac{3}{4}$ in.
(22.1×22.1 cm)
1495
Paris, Louvre
At the top appears the autograph inscription "fenedier klawsen" ("Venetian ravines"). This is one of a group of landscapes painted during the return journey from Italy.

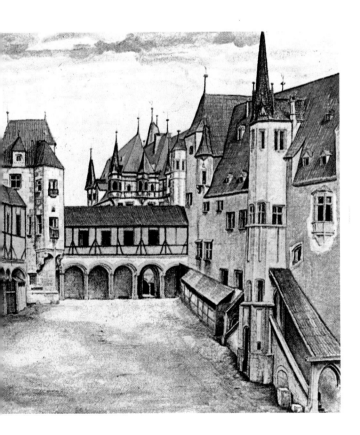

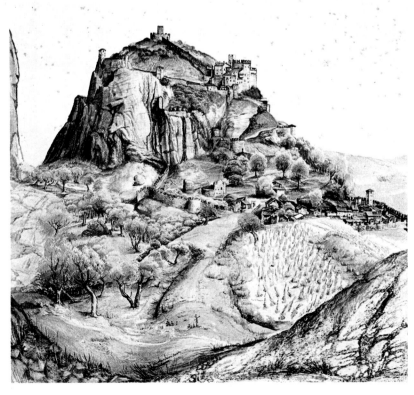

toward the end of the winter of 1506–1507, Dürer was busy working on a project for a long textbook on painting, based on earlier studies. In the first drafts for an introduction and table of contents, which have survived, he gives his views on the divine origin of art, the tasks it must set itself, and its importance for mankind. His comments serve to defend art and the urge to find out about its laws, along with any other form of thirst for knowledge, against potential criticism. Reproaches of this kind clearly were voiced even before the Reformation and the new critical approach to representational religious art that came with it.

To begin with, only the treatise on the proportions of the human figure was completed. By 1523 it was ready in manuscript form as "four books on human proportion." But for some reason it did not go to press until 1528, the year Dürer died, so he never saw the finished product. The book is divided into four sections. It deals with the questions of how to construct human figures (p. 158); the proportions of the human figure, based on the measurements of eight men and ten women; and how to modify the structure of the figures without changing their proportions. Another section is concerned with kinetics (the theory of motion) and includes drawings of the parts of the body circumscribed by cubes. In texts that he later rejected, in which he dedicated the work to Willibald Pirckheimer, he writes about its early history, saying that it was derived from the studies on proportion made by the ancient Roman writer Marcus Vitruvius Pollio in the first century A.D. and from those by the Renaissance architect, theoretician, and humanist Leone Battista Alberti.

Dürer had been obsessed with the problem of proportion ever since the traveling Venetian artist Jacopo de' Barbari had shown him drawings of a man and a woman carefully drawn in proportion. That was in Nuremberg around 1500. As de' Barbari could not or would not reveal the secret of constructing the human figure, Dürer turned, as he put it, to "Fitruvium, who writes a little about human limbs." As far as possible he wanted to publish what he had found out for the sake of younger artists. He did not presume to instruct major painters—in fact, he wanted to be instructed by them. In a version that was not revised until 1528, just before the treatise went to press, Dürer reiterates his concern that knowledge about art should live on. The treatises on art written by the major artists of the ancient world had been lost, and none of the famous Italian painters had handed down his knowledge. As iconoclasts now wanted to suppress this type of knowledge, Dürer felt that all artists should note down the results of their research

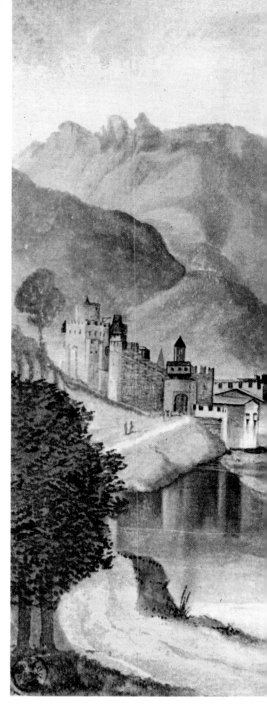

VIEW OF TRENT
Watercolor and gouache; $9\frac{1}{2} \times 14$ in.
$(23.8 \times 35.6$ cm$)$
Probably painted in 1495 on the return journey from Italy
Also disappeared from the Kunsthalle in Bremen.

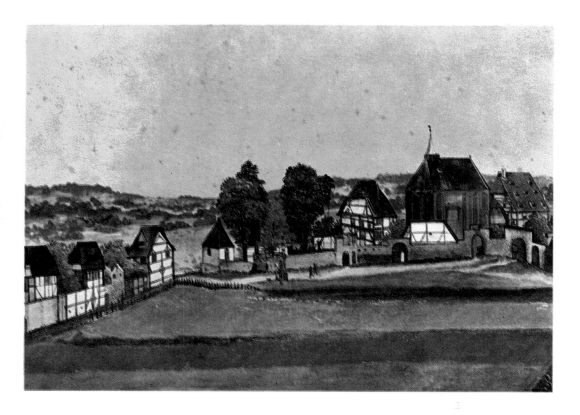

CEMETERY OF ST. JOHN'S CHURCH, NUREMBERG
Watercolor and gouache; $11\frac{1}{2} \times 16\frac{3}{4}$ in.
$(29 \times 42.3$ cm$)$
This is one of the works by Dürer that disappeared from the Kunsthalle in Bremen.

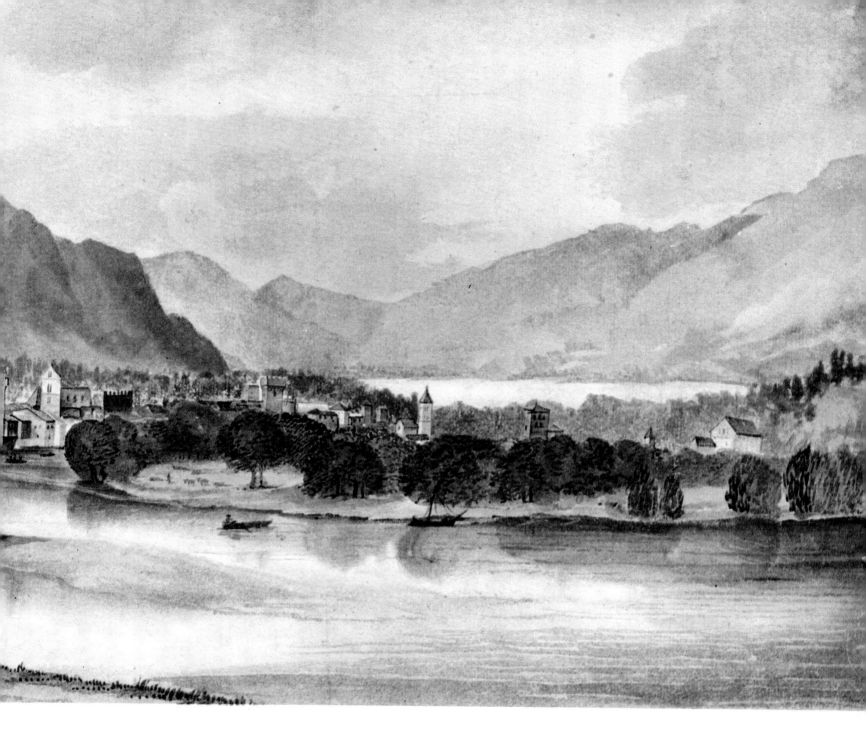

because art, used correctly, does not involve idolatry. As early as 1525 Dürer already had criticized those who promulgated the view that painting was idolatrous. An example of this was the draft of the dedication to Pirckheimer for his treatise on geometry (*Underweysung der messung . . .*)—he could be certain that Pirckheimer agreed with him on this point.

In actions such as these we cannot miss Dürer's concern not only that his own lifework should survive but that art in general should live on, since he could not envisage art as a purely secular matter. For the sake of his own spiritual and material existence he was forced to speak out against thought processes and conclusions that were threatening to gain ground within the Reform movement, conclusions that emanated from people whom he knew personally, some of them even close friends.

Contemporary Views on Dürer
Long before Johann Neudörffer wrote his comprehensive account of Dürer, the painter was the subject of a number of printed assessments by contemporaries, and his sudden death occasioned detailed obituaries. These accounts are unanimous in stressing the importance of his work and its influence in Germany and beyond. As usual with the humanists, he was compared with the most outstanding painters of classical antiquity, particularly with the most popular among them, Apelles—at this date a large number of stories were circulating about Apelles's artistic skill. But the comparison with the famous artists of ancient Greece and the ensuing

21

comments about the lifelike quality of Dürer's style are mere stereotypes that tell us nothing about what his contemporaries really found fascinating in his work.

Erasmus is the exception here. Dürer had done a drawing of the great scholar in Brussels, and in 1528 Erasmus published a dialogue about the correct pronunciation of Latin and Greek in which he referred to Dürer. Admittedly he does follow his contemporaries in taking Apelles as his starting point. He stresses the special importance of Dürer's graphic work and compares him to Apelles, saying that the ancient Greek painter had needed to use color to portray what Dürer could express in a series of black lines—shadows, light, brightness, height, and depth. The last sentence shows that Erasmus' remarks were partly based on Pliny's "Naturalis Historia," but it is quite obvious that Erasmus had made a close study of Dürer's engravings.

We also have some contemporary accounts of Dürer's appearance and character. Dr. Lorenz Behaim, a canon and lawyer from Bamberg who originally came from Nuremberg, commented on a horoscope he cast of Dürer when the artist returned from his second trip to Venice in 1507. This was at a time when the natural sciences were just beginning to be consolidated, and astronomy was still closely linked with astrology. The fact that the two men knew one another personally makes the picture of Dürer's character that Behaim read in the position of the stars more valuable, as does the delight he felt when he saw that the conclusions he had drawn from Dürer's horoscope matched his own experience of the painter.

The picture Behaim sketches of Dürer's life includes artistic genius, an

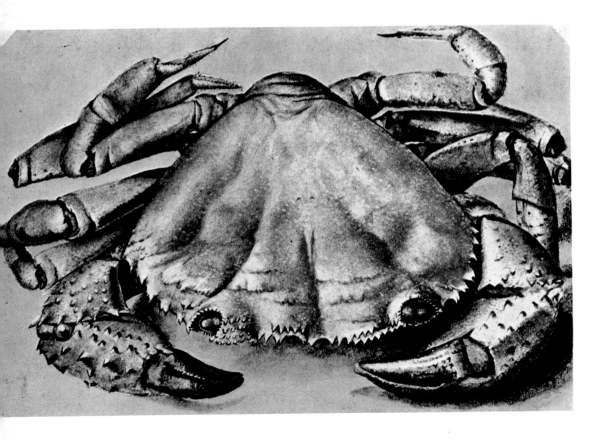

SEA CRAB
Watercolor; $10\frac{3}{8} \times 14$ in.
(26.3 × 35.5 cm)
1495
Rotterdam, Boymans-van-Beuningen Museum
Formerly in the Gawet, v. Festetits, Böhm, de Behague, and Van Beuningen Collections.

elegant appearance, success with women, and financial success, as well as a passion for weapons and traveling. He predicts that Dürer will be married only once—this was more or less exceptional in those days, when the mortality rate for women was very high—and says that though he will never be penniless, he will never have any money to spare. On this last point the stars, or their interpreter, erred—Dürer died a rich man, leaving the considerable fortune of about 7000 guilders in gold and material assets. We

know this from the division of his estate between his wife and his surviving brothers, Hans and Endres.

The assessments made of Dürer's work and personality immediately after his death express the conviction that his fame would not die with him. Eobanus Hesse, who had been a professor of rhetoric and poetry in Nuremberg since 1526, expressed this view in a roundabout way in a dirge he wrote for Dürer. Modeled on the dirges written in classical antiquity, it addresses Dürer as the glory of sixteenth-century painting. Anyone who studies the image of the dead man will say that his fame will last forever. A man who leaves behind him evidence of his genius will never die, and posterity will sing his praises.

The elegy with which Pirckheimer bids farewell to his friend sounds a personal note even though it is written in classical Latin. He changed some Greek stanzas only slightly, finding consolation in the fact that his friend was not dead but slept beneath the flower-decked grave mound as a good man in Christ.

Life in Nuremberg

Production and Trade

Albrecht Dürer's genius cannot be explained in terms of the artistic tradition of Nuremberg. He was too independent of local ways of looking at things and local workshop practice, though these did influence him to a certain extent. On the other hand, the intellectual and material ambience prevailing in the town and the large number of different factors that produced it did have a decisive effect on the development of his character and his artistic aspirations.

In his description of Germany, Enea Silvio Piccolomini, a highly cultured scholar and diplomat (later to be Pope Pius II) who was familiar with the situation in the country, refers to Nuremberg as the center of the empire. His book was printed in Leipzig in 1496. In it he held up to the Germans a mirror of their culture, their material well-being, and their intellectual gifts. The book made a considerable contribution to the emergence of a sense of patriotism in Germany. Nuremberg's central position, he claimed, favored trade links that reached out to all points of the compass, and it also made the town a point of intersection for the lines of a new international understanding—lines being drawn through Germany by the leading intellects of the day. Nuremberg was still a town in which public affairs were governed by a practical entrepreneurial and commercial spirit, and it had no university. An attempt to found a university, launched with the spiritual guidance of the theologian Philip Melanchthon near the end of Dürer's life, was not successful in the long term. But the town's tradesmen were open-minded and enlightened and were wise in the ways of the world because of the international trading relations they enjoyed.

As a result of their favorable material circumstances, men of Dürer's generation were able to acquire a wide-ranging education abroad, particularly in the Italian towns that led the field in commercial practice and financial transactions. Thus the young sons of tradesmen were the first to come into contact with the erudition of the Italian humanists, which was based on a new appreciation of the literary works of classical antiquity. Members of the town's leading families who chose to make a career in theology or law attended Italian universities. Even Willibald Pirckheimer's grandfather, who had initially been in trade, had decided after his wife's premature death to complete his classical and legal studies in Perugia, Bologna, and Padua. He was subsequently to serve his native city as a town councilor and diplomat. When Dürer made his two trips to Venice to acquire

the sort of experience he felt he must have, but which no one in Germany could provide for him, he merely was following the pattern of the Nuremberg merchants' sons.

In the mid-fifteenth century Nuremberg had a population of over 20,000, and its commercial strength was growing thanks to a combination of production and foreign trade, with an emphasis on metal production and metalworking. Iron ore was mined close by in the Swabian Alb and also in Upper Franconia and the Fichtelgebirge. A new method for smelting copper, invented in Nuremberg, led municipal entrepreneurs to become involved in extracting nonferrous metals as well, so that by the early sixteenth century men from Nuremberg controlled the mining industry in the whole of Saxony and Bohemia. Mining shares were held not only by the leading merchant families but also by craftsmen who had come up in the world. If you were going to climb the social scale, you had to own at least a share of the means of production besides being involved in trade. We know that Dürer's father, who was a goldsmith, owned a share in a gold mine in Goldkronach—the owners of the land, the margraves of Ansbach-Kulmbach, had disposed of the license to prospect. But he never managed to enter the affluent class as we can see from the fact that only two years after his death his widow was completely penniless. His son's capital increased mainly as a result of selling his own drawings and engravings. In 1524 Dürer was able to invest 1,000 guilders in the town, at a yearly interest of 50 guilders, as "eternity money."

The metals were worked in foundries on the banks of the River Pegnitz close to Nuremberg, many of them upstream from it. The wire-drawing mills were also driven by the river—their technical equipment had been invented locally. Dürer sketched the buildings of a plant of this type in 1494, after he had returned from the traveling he did as a journeyman. The mills were near the Hallerwiesen, west of the town as it was in those days. The watercolor bears the inscription "trotzich müll" (p. 17). Along with a watercolor of St. John's church (p. 20), this is "the first independent colored landscape in pictorial art that faithfully reproduces a specific locality" (Winkler). But we should not assume that it was the topographical site alone that led Dürer to draw this particular scene since the specific function of the mills must have played at least some part in his choice. The metalworking trade in Nuremberg enjoyed a high reputation, especially the work of the armorers. Dürer's horoscope described him as having a passion for weapons, and this observation is confirmed by his drawing of three views of a tournament helmet (Paris, Louvre). In this drawing Dürer did more than record the cubic shape accurately and draw the helmets exactly in perspective: his use of color shows that the shimmer of the polished metal also fired his imagination.

At this period the traditional craft of figured metal casting had reached such a high level of technical skill in the Vischer family's foundry that the Nuremberg founders were superior to their counterparts anywhere else in Germany. The metal walls of the figures they cast by the lost wax method were so thin that they were not very heavy, and by saving on metal costs could be kept down. The town council tried to safeguard their own interests by forcing the founders to stay in the town and also did their best to prevent the export of the clay that was found in the Nuremberg area, which had a high lead content and was used for making crucibles for smelting the metal. Thus they also protected the founders from an unpleasant level of competition within Nuremberg itself.

For instance, when the sculptor Veit Stoss wanted to personally cast the molds he had prepared for figures for Maximilian I's tomb, the emperor's delegate had to apply tremendous pressure to persuade the town to negotiate with the bronze and brass smiths' leaders and make an exception by allowing the molds to be cast. They made it clear that this was a once-only concession. Incidentally, Dürer too contributed to the tomb, which had been planned by Maximilian and was begun in his lifetime. It was displayed in the court chapel in Innsbruck until it eventually was completed long after the emperor's death. Larger-than-life bronze figures of the dead emperor's ancestors were to follow his body in a splendid funeral procession while busts of the emperors of ancient Rome reminded onlookers of the dead man's predecessors on the imperial throne. The historian Stabius had traced

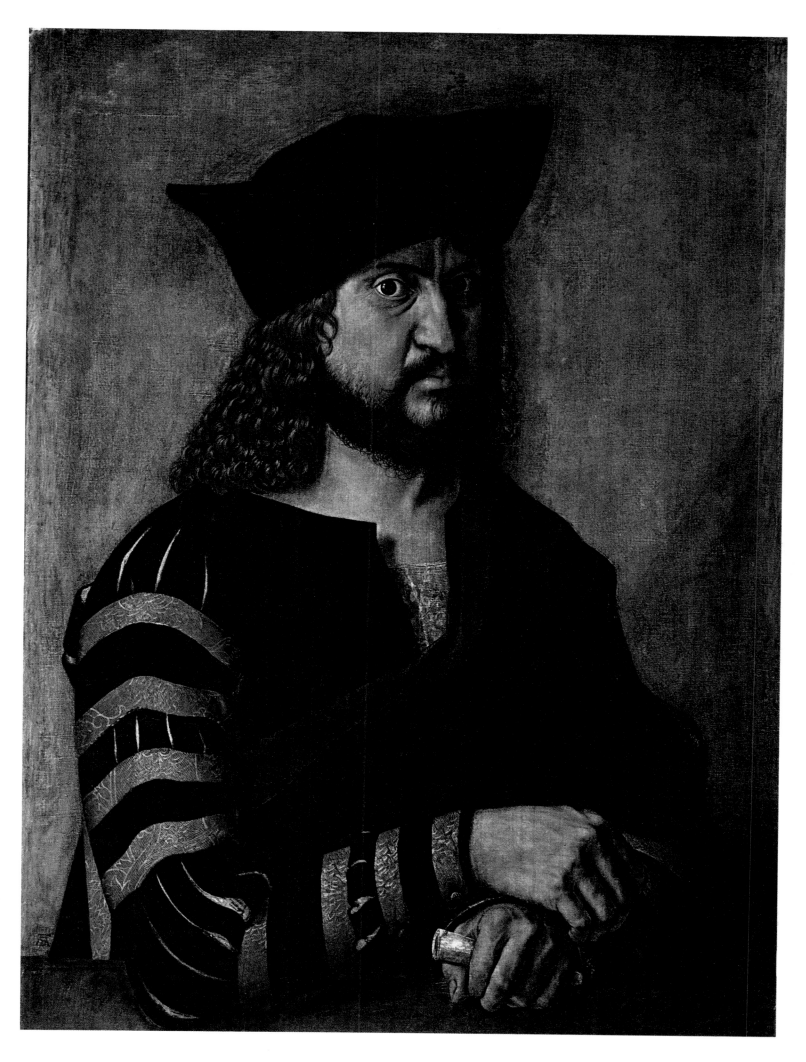

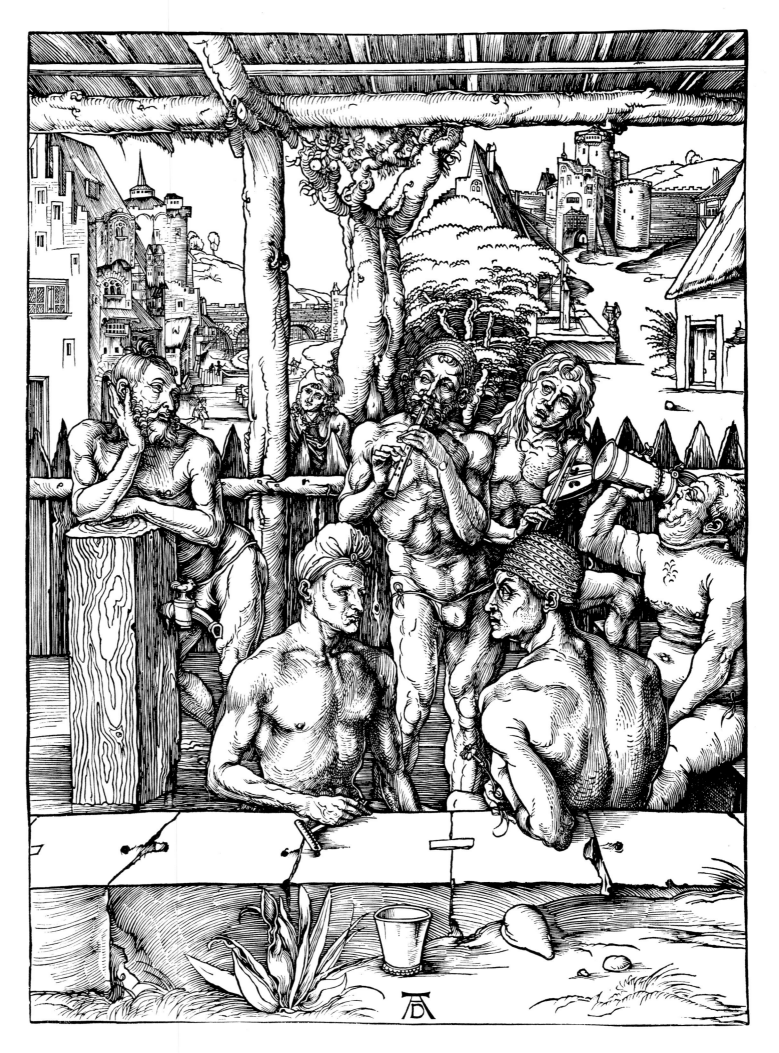

Maximilian's ancestry back to remote antiquity, and Dürer was commissioned to supply sketches for King Arthur and the Ostrogoth King Theodoric, known as "Dietrich of Berne" in heroic legend. Both figures bore the trademark of Peter Vischer's foundry, and the technique used for casting them was quite different from that employed in Maximilian's foundry in Mühlau, near Innsbruck.

The master metalworkers of Nuremberg remained preeminent in Germany down to the mid-sixteenth century. Their products were exported all over the world and made the town famous. They made religious articles, adornments for men and women, elaborate goblets for special occasions, and centerpieces for the table. The homes of the rich merchants of Nuremberg were treasure-houses full of objects made of silver and occasionally of pure gold.

If a goldsmith did not want to design his own pieces, special pattern sheets were available. Martin Schongauer, who was the son of a goldsmith, reproduced large numbers of these patterns in the form of copperplate engravings. It was only natural that Dürer too should provide designs for goldsmiths—he had personal connections with the trade, having learned a great deal about the potential inherent in gold and the techniques used for working it when he was apprenticed to his father. Sketches for goblets on a page of what is known as his "Dresden sketchbook" show that he liked using lifelike tree motifs such as trunks, roots, and branches for the stem, and fruit motifs—apples and pears—for the bowl (p. 88). Some very accurately drawn designs for figural table centerpieces and for elaborate table fountains have survived. Of the objects that have come down to us, the design for a goblet in the form of an apple supported on the branch of a tree can be attributed to Dürer with a degree of certainty because it is closely related to a design in the Dresden sketchbook. But it seems highly unlikely that he made articles in gold and silver himself, though in 1675 the painter and art historian Joachim von Sandrart did attribute to him a goblet, or beaker, with engraved scenes that show Christ falling seven times on the way to Golgotha. But the goldsmiths belonging to the guild undoubtedly would have stopped him from doing that kind of work, just as the founders turned against Stoss.

Mathematics and Astronomy

Some of the most outstanding articles produced by the metalworkers of Nuremberg were precision instruments for measuring the earth and the heavens. This aspect of the trade, along with efficient printing works and a wealthy and interested middle class, attracted famous astronomers, mathematicians, and geographers to the town. Chief among them was Johannes Müller from Königsberg, known as "Regiomontanus," who worked in Nuremberg from 1471 to 1476 and set up an observatory with the help of his patron and pupil Bernhard Walther. His almanacs and tables of the daily phases of the moon and planets from 1474 to 1505, along with his improved quadrant for measuring the distances between the stars, enabled sailors to chart their position on the high seas and thus made possible the first voyages of discovery. A three-dimensional image of the earth in the form of a globe was made in Nuremberg in 1492—for the first time since classical antiquity—on the basis of data provided by Martin Behaim. It was made for the town council at the instigation of three members who were interested in geography.

Dürer had many close friends among the geographers and mathematicians and knew of their problems. His treatise on geometry contains the first detailed essay in German on the construction of sundials, as well as instructions about how to represent geometric figures. His workshop also produced woodcuts of maps and star charts by Johannes Stabius, along with Stabius's calculations of the position of the sun in the form of horoscopes. On June 14, 1509, Dürer bought the house near the Tiergärtnertor where Regiomontanus and Walther had worked (Walther had died in 1504). Dürer lived there for the rest of his life. In 1523 he bought ten books from Regiomontanus and Walther's library, which was supervised by Pirckheimer and stored in the house.

THE MEN'S BATHHOUSE
Woodcut; 15½ × 11⅛ in.
(39.2 × 28.2 cm)
Probably 1496
Dürer's monogram can be seen at the bottom edge in the center. Dürer made a series of preparatory studies for this woodcut, which he engraved on his return from Italy. He did a woodcut of *The Women's Bathhouse* in the same year as a companion piece to this one; a study could be seen in the Kunsthalle in Bremen until 1945.

Printing

The experience gained in the metalworking trade probably also helped to bring about the rapid flowering of a completely new craft in Nuremberg — printing with movable type, which consisted of characters cast in metal. Thanks to the work of Johann Gutenberg around the middle of the fifteenth century, toward the end of the century Nuremberg was playing a leading role in the printing trade, particularly in the field of illustrated books.

The first book printed with movable type and illustrated with woodcuts came out of Albrecht Pfister's Bamberg workshop in 1461. Bamberg, the seat of the bishop who was responsible for the free imperial city, was famous for its constant interchange of artistic ideas. Before this, in the first half of the fifteenth century, there had been what are known as "block books," in which the drawings and the text are cut out of the block together. Like letterpress printing, the woodcut technique is also a relief process. The wood engraver cuts away at the surface of the wooden block, leaving only the portions that are to touch the paper when the impression is made. He removes the rest of the wood with a knife, a scorper, and a flat iron. When the ink has been applied, the block and the paper are pressed lightly together. Once the teething troubles are ironed out, the text and the pictures can be reproduced in a single operation. This was clearly only the beginning of what would one day be a flourishing trade. In Nuremberg a man called Johann Sensenschmidt took charge of the whole process, producing a two-volume collection of saints' lives in 1475.

We know less about the men who prepared the woodcuts than we do about the printers, who had to be wealthy entrepreneurs or at any rate had to have such men to back their bigger projects. Several different operations were involved. The first step was for the draftsman to do a rough sketch that established the subject of the woodcut and the overall composition. The composition was then transferred to the block, in some cases from a specially prepared fair copy of the drawing, and engraved, with the engraved lines following the design exactly. Once it had been printed, the woodcut could be colored. The figures initially had very few carved details inside the basic outline so that color could be added easily.

In the production of early fifteenth-century broadsheets, in which the process developed, the same craftsman might be responsible for the various operations involved. But very soon the process was divided into separate specializations, with one man designing the composition, another cutting it into the block, and a third man coloring it. A decisive moment in the history of the woodcut came when painters began to appreciate its potential and started designing woodcuts themselves. Wood engraving thus became a graphic technique in its own right, and the later addition of color was no longer necessary, as the black-and-white effect was seen to be enough.

In Nuremberg the breakthrough occurred in Michael Wolgemut's workshop, with the young Dürer looking on. In fact, it is thought that Wolgemut's young apprentice actually worked on the woodcuts by himself. Two works in particular can be seen as forming the basis for Dürer's own work in this field. The first was a collection of sermons by the Franciscan friar Stephan Fridolin. The *Schatzbehalter*, as it was called, was published in 1491 with whole-page illustrations by Wolgemut and his stepson Wilhelm Pleydenwurff. The second was a "world chronicle" by Hartmann Schedel, a doctor employed by the city of Nuremberg. The Latin edition of this book, known in English as *The Nuremberg Chronicle*, was published on July 12, 1493, and the German edition on December 23 of the same year, but it was actually begun in 1487–1488. It contained a total of 1,809 woodcuts printed from 645 different blocks, which were repeated at intervals. Both of these books were produced by Anton Koberger, Dürer's godfather.

The designs produced by Wolgemut transformed the woodcut. Instead of reproducing an outline that was intended to be colored in later, they created real pictures composed according to the laws of panel painting, and instead of color they used hatching to create a graduated series of blacks and whites. The fair copy of the drawing for the title page of *The Nuremberg Chronicle* has survived complete in all details (London, British Museum) and gives a clear idea of what Wolgemut demanded of his engravers. This very precise and subtle use of the technique could be achieved only with close

THE PRODIGAL SON
Engraving; $9\frac{3}{4} \times 7\frac{1}{2}$ in. (24.8 × 19 cm)
Probably 1496
Dürer's monogram can be seen at the bottom edge in the center. There is a preparatory drawing in the British Museum (W 145).

collaboration between draftsman and engraver, and the work must have been executed in Wolgemut's workshop.

As the woodcut is a mirror image of the picture cut into the block, the fact that the design for the title page and a few other preliminary drawings (Nuremberg, Municipal Library) that have recently come to light, done only in outline, face the same way as the printed illustrations in the book suggests that the draftsman turned them around when he transferred them to the block. This complicated process, which must have involved dividing the work up between several different specialists, is seen more clearly in the extremely detailed projects commissioned by Maximilian I to glorify himself and his imperial line. The first of these dates from 1512. Let's look first at the 192 different large woodcuts for the "gate of honor"—a triumphal arch with images representing the emperor's predecessors, ancestors, and deeds (p. 136). If we examine the coats of arms, study the overall style, and peruse the relevant documents, we find that the process was as follows: first the historiographer Stabius drew up a program for the series, then the Innsbruck court painter Jörg Kölderer prepared a preliminary sketch; Dürer used both of these as a basis for his designs. At least three details have survived (London, Dresden), and they give us an idea of how this stage of the work proceeded. Dürer transferred only a fairly small number of his designs onto the blocks himself—just the decorative motifs that pervade the illustration, plus a few individual figures and historical scenes. His work was used as a model by his pupils and collaborators Wolf Traut and Hans Springinklee, who did the remainder of the illustrations. Hieronymus Andreae and his assistants were responsible for cutting the blocks once the designs had been transferred onto them. The woodcuts must have been printed in Dürer's workshop, or at any rate the samples supplied to the emperor were.

The work was divided into so many different jobs that the outlines for two corner towers to go at the side, which were probably added to the scheme later to represent the emperor's private life, were supplied by Albrecht Altdorfer, a painter working in Regensburg. The date given on them, 1515, probably refers to the year when the sketches were finished. As Maximilian wanted some alterations made, the cutting of the blocks and the actual printing dragged on into 1517–1518.

The Economic and Political Situation of Nuremberg in and around 1500
It goes without saying that the large number of artists and craftsmen who must have contributed to the rich pictorial decoration of *The Nuremberg Chronicle* could be found only in a city where they were sure of finding enough work to make a living. In the second half of the fifteenth century Nuremberg benefited from the boom enjoyed by towns throughout Germany, and indeed was a particularly flourishing town. At the beginning of the sixteenth century it expanded its territory considerably at the expense of the Upper Palatinate by taking part in the war against Rupert of the Palatinate for the Landshut succession. The people of Nuremberg fought on the winning side, which was led by Duke Albrecht IV of Bavaria and Munich and the Emperor Maximilian, and were rewarded with six cities and several market towns, plus a large number of smaller settlements. In 50 years the number of inhabitants living inside the city walls almost doubled, rising to 40,000.

The last of the important large-scale architectural commissions to be completed were the church of St. Lorenz and the Augustinian monastery church. The choir of St. Lorenz was started in 1439 and completed in 1477, turning the original High Gothic nave into a hall church. The Augustinian church followed between 1479 and 1485. It stood until 1816, when it was demolished.

The townspeople were well off and, thanks to their religion, fond of giving to charity. Because of these two factors the churches had beautifully made windows and large numbers of altars and commemorative images. Among the contributors were the emperor and some of the princes, who erected memorials to themselves by donating windows for the town's churches. Michael Wolgemut's workshop supplied designs for stained-glass windows, as did Dürer and his pupils Hans Baldung-Grien and Hans von Kulmbach.

THE DRESDEN ALTARPIECE

VIRGIN ADORING THE INFANT JESUS
Tempera on canvas; 41½ × 37½ in. (105.5 × 95 cm)
1496–1497
Dresden, Staatliche Kunstsammlungen, Gemäldegalerie
This is the center panel of what has become known as *The Dresden Altarpiece*. It probably was not painted by Dürer himself although the side panels (right) are definitely his work.

ST. ANTHONY and ST. SEBASTIAN
Tempera on canvas; each painting 45 × 17¾ in. (114 × 45 cm)
About 1497–1498
Dresden, Staatliche Kunstsammlungen, Gemäldegalerie
These are the side panels of *The Dresden Altarpiece*.

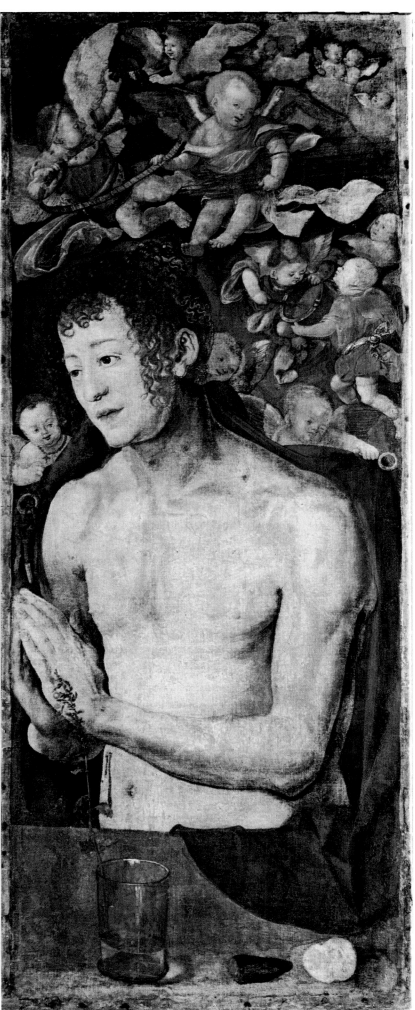

The extensive network of trade links built up by the merchants and families of Nuremberg enabled the painters and sculptors working in the town to produce large-scale altarpieces for churches in other towns too, some of them a considerable distance away. For instance, Hans Pleydenwurff painted the side panels for the high altar in St. Elizabeth's Church in Breslau and was actually present when they were installed. Then in 1479 Wolgemut, who inherited both his wife and his workshop, supplied an altarpiece for St. Mary's Church in Zwickau. It had four movable side panels and two fixed ones. Out of his fee of 1,400 guilders he had to pay the journeyman who did parts of the painting, plus a carpenter for making the shrine, a sculptor for carving the figures that appeared in the shrine and in the buttressed wall above it, another man for painting them, and lastly a gilder for gilding parts of the shrine and the frame. Anyone who owned a painting workshop in the late Middle Ages had to be an entrepreneur capable of coordinating large numbers of different craftsmen.

Export was an essential lifeline for the metalworkers and goldsmiths, and the same was true of the men who produced the popular copper basins with figured decorations. The aristocracy's wealth benefited the surrounding areas as well as themselves, because they invested large sums in building churches, monasteries, and manor houses. Once again the artists living in the town benefited from these commissions.

Yet the fact that fortune smiled upon the artists and craftsmen of Nuremberg should not blind us to the inability of a relatively large percentage of wage earners to make even the bare minimum needed for supporting their families. If they fell ill or suffered some other misfortune, they would have to apply for public or private charity. A decree issued by the town council in 1522 tells us that a middle-class citizen, specifically referred to as "Albrecht Dürer's relative," was not spared this fate. He was banished from Nuremberg because he had been begging, though he was allowed to return on condition that he would beg only with permission, which meant wearing a special badge. In times of crisis up to a third of the inhabitants might have to rely on public relief. Fortunately, Nuremberg had a well-organized system of caring for the poor. Without this system it undoubtedly would have suffered from social disturbances during the period of political and religious unrest that occurred at the beginning of the sixteenth century.

After all, craftsmen were excluded almost completely from taking part in running the town. In 1348 a revolt led by members of the metalworking trade had resulted in a government recruited mainly from craftsmen. The revolt was closely bound up with the quarrels between the newly elected king, Charles IV, and Ludwig of Brandenburg, the son of Charles's predecessor, Emperor Ludwig of Bavaria. In 1349, when Charles had managed to consolidate his power—the old town council had acknowledged him—the families who had been banished returned and took over the town council as before. From then on a few families, all belonging to the town's top economic stratum, maintained strict control over the municipal government. In 1520 forty-two flourishing families who were eligible for the town council banded together to form an upper class. The only people to be taken in later were the Schlüsselfelder family, who were well known because in 1442 they had donated a larger-than-life figure of St. Christopher to be set up outside St. Sebaldus's Church and also because they had a silver table centerpiece in the form of a ship. (It has been suggested that this was made by Dürer's father.)

Ranking immediately below this upper class came another three to four hundred families who were considered to be "honorable." Many of them were in fact related by marriage to the upper-class families. They were officially appointed to the Great Council and acted as witnesses during lawsuits and as public notaries. Intellectual or artistic achievements, as well as wealth, could provide an entree into this class. Dürer himself was appointed to the Great Council and in 1518 attended the Imperial Diet in Augsburg with the Nuremberg representatives. He did a drawing of Maximilian I on this occasion. Then in 1519 he went to Switzerland with his friend Willibald Pirckheimer, who was traveling to Zurich with Martin Tucher on behalf of the council. Dürer had clearly managed to obtain a

ST. JOHN CHRYSOSTOM AS A PENITENT
Engraving; $7\frac{1}{8} \times 4\frac{5}{8}$ in. (18.1 × 11.7 cm)
About 1497
Dürer's monogram appears at the bottom edge in the center. According to one legend, St. John Chrysostom allowed himself to move only on his knees as punishment for having seduced a young princess who had taken refuge in his cave.

special status for himself in the town, as we can see from the decision reached by the town council over an offense he had committed against the building regulations. He did have to pay the fine, but he got the money back again in the form of a donation!

The Emperor and the Free Imperial City

Nuremberg's central position inevitably entered into the emperor's political calculations, and at the same time the members of the town council were particularly anxious to maintain a good relationship with the emperor of the day since they always felt threatened by their powerful royal neighbors, the

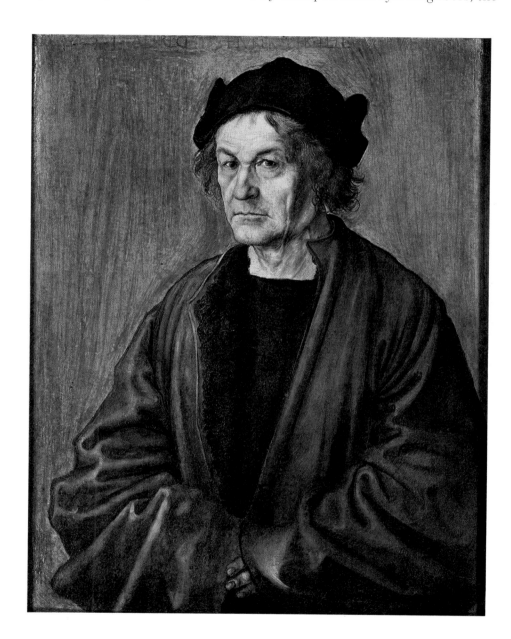

PORTRAIT OF DÜRER'S FATHER
Oil on panel; $20\frac{1}{4} \times 15\frac{3}{4}$ in.
$(51 \times 39.7$ cm)
Inscribed at the top with the date (1497) and the words: "ALBRECHT. THVRER. DER. ELTER. VND. ALT. 70 IOR." ("Albrecht Dürer, Senior, at the age of 70")
London, National Gallery
The painting probably was presented to Charles I of England by the city of Nuremberg in 1636. In 1650 it was sold along with the rest of the royal collection. In 1900 it was in the collection of Lady Louisa Ashburton. It subsequently came into the possession of the Marchioness of Northampton and was acquired from her by the National Gallery in 1904. There is some doubt about the painting's authenticity, and it may be that only the face and hands are by Dürer. At any rate, this is the best of the extant copies.

margraves of Ansbach and the Wittelsbachers. They were rewarded for their loyalty in 1424 when King Sigismund entrusted the town with looking after the imperial treasures. A whole series of relics went with the insignia, including the most highly venerated item in the collection—a holy lance that had a nail from Christ's cross inserted into its tip.

In the year when the jewels and relics were handed over to Nuremberg Bishop Friedrich of Bamberg had given permission for the relics to go on public display on the day of the Festival of the Holy Lance, which was celebrated on the Friday after the eight-day Easter period. He also had agreed that a celebratory mass should be sung and public sermons should be

preached. The shrine was displayed in the marketplace, and a special platform was built in front of a house that had belonged to the Schopper and Behaim families and later to Hans Fütterer. This platform was known as the "sanctuary seat" and could be reached from the house via the "Insignia Room." The day before the treasures were to be put on display they were taken from the Church of the Hospice of the Holy Spirit, where they were normally kept, and placed in this room. Dürer had been commissioned by the town council to paint two larger-than-life portraits of Charlemagne and Sigismund (pp. 126 and 127) for this room. In 1513 he was paid eighty-five guilders for the work.

Inscriptions on the back of the paintings and on the front of the magnificent frames, which were painted in lapis lazuli, gave details of Charlemagne's crown and imperial robes, which were on display, and of the way the treasure had been transported from Bohemia to Nuremberg. The portraits are painted on both sides, which suggests that they were intended to be reversible. They were to be hung on the wall, with the emperors' portraits facing the small number of spectators who would be entitled to enter the chamber and see them on the day when the treasures were put on display.

Dürer viewed as historical objects the crown, the sword, and the coronation robes modeled on priest's vestments, which were part of the treasure. He therefore depicted them faithfully, making preliminary studies for the Charlemagne portrait by copying the originals in the Hospice of the Holy Spirit. When he came to paint the Emperor Sigismund, he could refer to a relief portrait that he probably possessed in the form of a medallion or a

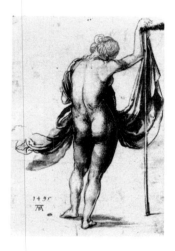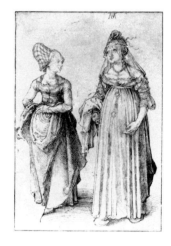

FEMALE NUDE
Pen-and-ink drawing; $10\frac{3}{4} \times 5\frac{3}{4}$ in.
(27.2×14.7 cm)
The date (1493) appears in the top left-hand corner
Bayonne, Musée Léon Bonnat
This is Dürer's first drawing of a nude and probably depicts a bath attendant.

NUDE SEEN FROM THE BACK
Drawing; $12\frac{3}{4} \times 8\frac{1}{4}$ in. (32×21 cm)
1495
Paris, Louvre.

VENETIAN WOMAN AND NUREMBERG WOMAN
Pen-and-ink drawing; $9\frac{3}{4} \times 6\frac{1}{4}$ in.
(24.7×16 cm)
About 1495
Frankfurt, Städelsches Kunstinstitut
The monogram appears at the top but is not in Dürer's hand. Some preparatory costume studies for this drawing, drawn in Venice and Nuremberg, are still extant.

woodcut. It gave him an idea of the emperor's features—a large nose, a divided full beard, and an elaborate moustache. For his portrait of Charlemagne he was influenced by the traditional image of God the Father and by the features of the historian Johannes Stabius, who had already served as a model for a woodcut of St. Koloman. He created an ideal portrait that colored people's idea of what the great emperor looked like right down to the nineteenth century.

With the coming of the Reformation, the ceremony of displaying the relics came to an end. They were shown for the last time in 1525, and the paintings were moved to the town hall. But this did not mean that no one was interested in the two emperors or in Dürer's work anymore. As late as 1532 the painter Jörg Pencz was given permission to copy his teacher's painting for a Saxon prince.

Of all the rulers who were in power during Dürer's lifetime Maximilian I came to Nuremberg more often than any of the others and spent more time there. In 1491, for instance, he spent five entire months in the town, representing his father, Frederick III, at the Imperial Diet. Then in spring 1512, after he had become emperor, he was there for more than two months. This visit was a particularly important one as far as Dürer's career was

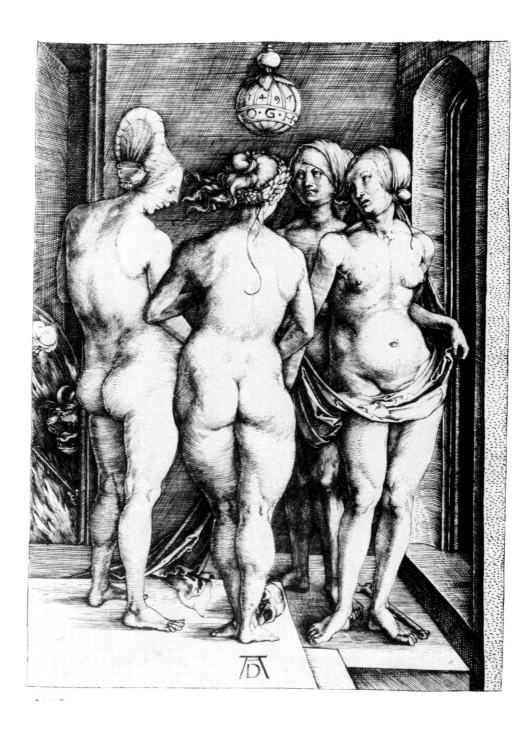

THE FOUR WITCHES (DISCORD)
Engraving; $7\frac{1}{2} \times 5\frac{1}{8}$ in. (19×13.1 cm)
The monogram appears at the bottom
edge in the center while the date (1497)
is engraved on the gourd at the top
together with the letters "O.G.H."

concerned. Presumably the two men already knew one another, and from
then on Dürer took over the supervision of all the emperor's most important
commissions, the sort of work he counted on to ensure that he would be
remembered by posterity.

The emperor fully appreciated the potential of the new reproduction
techniques of book printing and wood engraving, since they made wide
distribution possible, and he therefore chose them as a medium for his
various projects. Dürer was probably brought to Maximilian's notice by his
literary advisers Provost Melchior Pfinzing, Johannes Stabius, and
Willibald Pirckheimer and possibly also by the Augsburg antiquarian
Konrad Peutinger. When Maximilian died, his successor, Charles V, showed
little interest in the works his grandfather had planned, and many of them
were left unfinished.

The largest scheme involved a series of woodcuts of a procession modeled
on the triumphs organized by victorious Roman generals. The crier Praeco
rides on a griffin at the head of the procession, trumpeting forth the
emperor's fame and glory to the four corners of the earth. Then the royal
household and all the princes of Germany come riding past. The emperor's
warlike deeds are presented in images and groups of figures in a series of

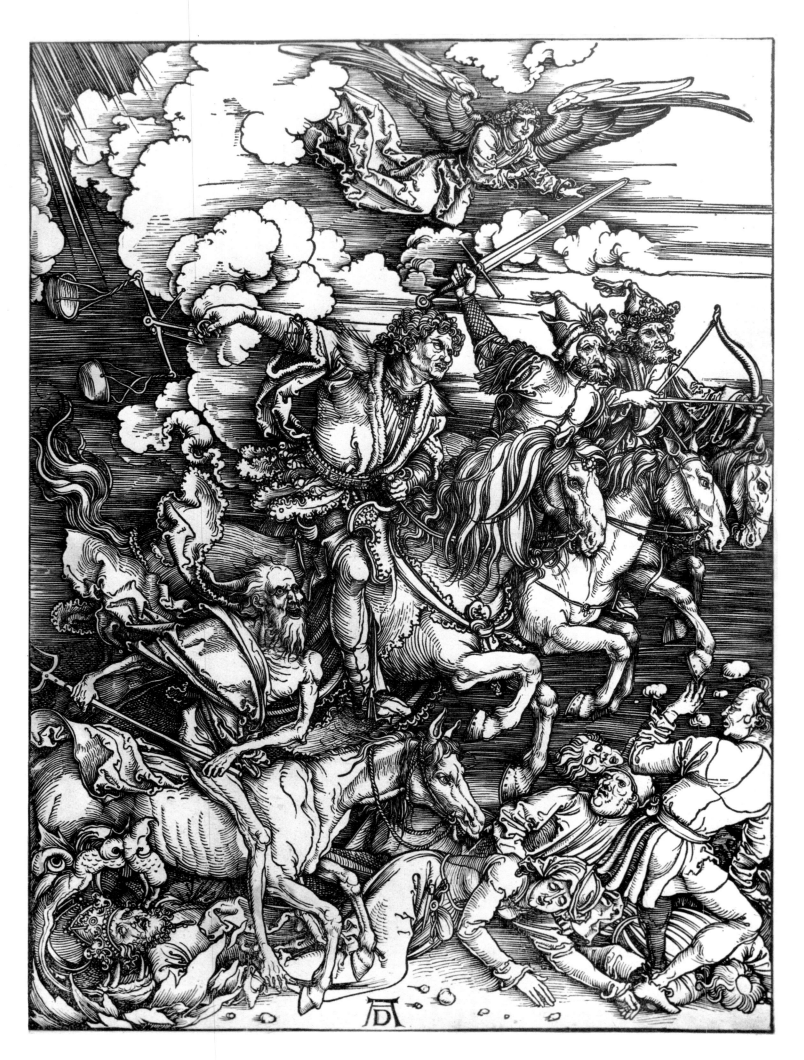

THE FOUR HORSEMEN OF THE APOCALYPSE

Woodcut; 15½ × 11 in. (39.4 × 28.1 cm)
1498
The monogram appears at the bottom edge in the center. This is one of 16 woodcuts, including a frontispiece, designed by Dürer for the *Apocalypsis cum figuris* (*The Revelation of St. John*), which appeared in 1498 together with the text in German and Latin. A second edition was published in 1511, in Latin this time and with a new frontispiece, for which Dürer designed an extra woodcut.

THE BATTLE OF THE ANGELS

Woodcut; 15½ × 11⅛ in.
(39.4 × 28.3 cm)
The monogram appears at the bottom edge in the center. This is the ninth woodcut in the 1498 "Apocalypse" series.

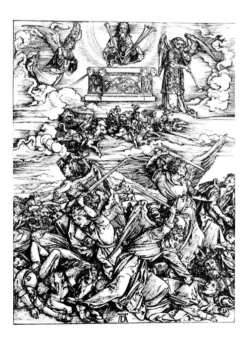

carriages, and we are reminded of who his ancestors were by the bronze figures on his tomb. The army's baggage train brings up the rear. The first printing was in 1528, before all the blocks were cut. It was commissioned by Archduke Ferdinand and consists of 138 single sheets, which stretch to a length of 177 feet (54 meters) if you lay them out side by side. The Augsburg artist Hans Burgkmair did most of the preliminary drawings, using designs by court painter Kölderer. The battles and wars and the ancestors portrayed as tomb figures are the work of Dürer's pupil Springinklee. Dürer himself only drew one chariot. It symbolizes the event that had a decisive effect on Maximilian's life and politics—his wedding to the daughter of Charles le Téméraire, heiress to the Burgundian empire. Marie de Bourgogne and her bridegroom stand beneath a canopy in an open carriage drawn by four horses. The horses are being driven by the figure of Victory, and the bridal couple are holding a coat of arms with the fleur-de-lis of France combined with the lion of Flanders.

The highlight of the procession, the victor's own carriage, was supposed to be by Dürer, but it is not there. All he had ready to send the emperor in 1518 was a colored sketch. Pirckheimer emphasizes that this was drawn by Dürer personally (pp. 150–151). Working at his own expense, independently of the commissioned project, Dürer published eight woodcuts of carriages and other horse-drawn vehicles in 1522. On the whole, he kept to the earlier design for these. The detailed explanatory text, printed by letterpress, was written by Pirckheimer, as was the prospectus, which is full of humanistic speculations. The emperor is seated in an open carriage drawn by twelve horses. He is protected by his virtues, and the horses are identified with other virtues of his. The original design included the whole imperial family— Marie de Bourgogne; Maximilian's daughter Margaret, the governor of the Netherlands; his son Philip and daughter-in-law Joan of Castile; his grandsons Charles and Ferdinand; and his granddaughters. But they do not appear in the woodcut. The emperor is seated alone, in regal solitude, in a magnificent carriage, which is full of allegorical allusions.

In the works designed for wide circulation, including the triumphal arch that we already have discussed, Maximilian used the pictorial arts, the "press" of the day, to spread and uphold his own fame and that of his imperial house. When he commissioned pictorial decorations for a prayer book intended for his personal use, he went back to the illustrations found in the margins of illuminated manuscripts, which were still being produced in the sixteenth century as expensive items for princes of the Church and other rich patrons. The prayers, hymns, and psalms specially compiled for the emperor were printed in Augsburg in 1513. Johann Schönsperger printed them in black letter, or Gothic, type in black and red on parchment. (The emperor's secretary, Vinzenz Rockner, is thought to have designed this type.) Probably only ten copies were planned, of which five have survived. The books were intended to be given as gifts to selected members of the chivalrous Order of St. George, which had been founded by Frederick III in 1469. Maximilian gave the order particular encouragement as an alliance aiming to drive out the Turks.

A whole series of artists were entrusted with the task of decorating the emperor's own copy with marginal illustrations. Among those who contributed, apart from Dürer himself and his former pupil Hans Baldung-Grien, who was now working in Freiburg, were Burgkmair and Jörg Breu from Augsburg and Albrecht Altdorfer from Regensburg. Peutinger acted as an intermediary in Augsburg, both among the various artists and between them and the emperor. The unity of the whole series is maintained in spite of the differences in style because the basic principles underlying the decoration are the same. This suggests that Dürer supplied the other artists with samples.

The prayer book never was completed. Work on it was stopped in 1515, probably because of difficulties that had arisen over incorporating saints from the House of Hapsburg into the calendar. The portions with marginal drawings by Dürer and Cranach are in the Bavarian National Library in Munich while the other sections went to the Municipal Library in Besançon, France. They were bequeathed to the Besançon library by Cardinal Granvella, minister to Charles V and Philip II of Spain.

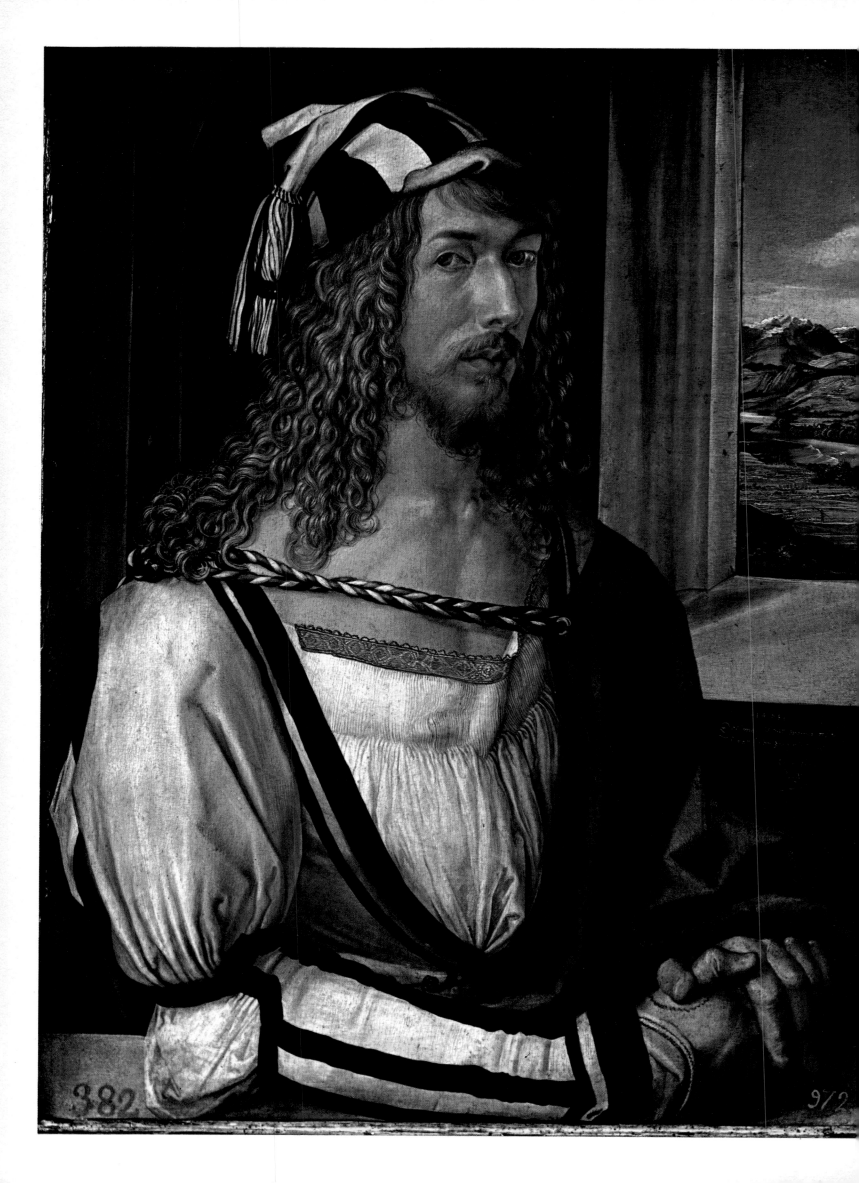

Dürer's skill as a draftsman and his imaginative powers are clearly evident in the red, green, and purple pen-and-ink drawings. They are not hampered by the dry and scholarly program or by the way that the forms are inevitably blurred by the process of redrawing and cutting. In fact, Maximilian's commission led to some of the most beautiful and sumptuous examples of book illustration ever produced. The printed text, which is moved slightly inward and upward on the page, is surrounded by margins of unequal width. These margins are full of drawings in which figures and decorative motifs are closely related. The overall theme consists of vividly swirling interlaced motifs, or *entrelacs*, full of plants and animals and grotesques, which form a transition to pure arabesques. The figural images, suggested by the relevant text, are a combination of Christian elements with secular medieval themes and elements from classical antiquity. When the Romantic Movement of the nineteenth century brought about a strong revival of appreciation for Dürer's art, the marginal drawings were published for the first time in the form of lithographs by Nepomuk Strixner. The title chosen for this publication, *A. Dürers Christlich-Mythologische Handzeichnung* ("Albrecht Dürer's Christian and Mythological Drawings"), shows that the archetypal character of the variations on Jewish and Christian prayers had already been clearly understood.

In 1518 the emperor and his artist came together once again. During the Imperial Diet in Augsburg, Dürer did a half-length drawing of Maximilian "high up on the Palatinate in his little chamber on the Monday after St. John the Baptist's Day." That was how he described this important event, with his usual attention to detail, in a five-line inscription in the top right-hand corner of the portrait (Vienna). Obviously Dürer did not have much time to do the drawing, as only the head, with a flat beret perched on top of it, is executed in detail. Yet even here he needed only a few strokes to make the emperor look regal and dignified though he did not include any outer symbols of Maximilian's high rank. At the same time he caught something of the weary resignation that affects the emperor's gaze and part of his mouth. His court robes and the chain of the Order of the Golden Fleece are only lightly sketched in.

We do not know whether Dürer was commissioned to execute this portrait or whether the emperor graciously agreed to sit for him. At any rate, neither of the two painted portraits based on the drawing, which depict the emperor half-length and include his hands, was painted until after his death. A study of a pair of hands holding an opened pomegranate, Maximilian's personal symbol, bears the date 1519 (Vienna). Both portraits stress the emperor's role as a ruler rather than the personal and human aspect, as in the drawing. The sitter's bearing, the expression on his face, and the clothes he is wearing all contribute to this impression as do the carefully drawn wide chain with the Golden Fleece hanging from it and a large shield next to the emperor's head with armorial bearings depicting the imperial crown and the double-headed eagle. The first version (Nuremberg) is painted in tempera on thin canvas (p. 147). What appears today to be the final version, painted in oil on panel, is now in Vienna, though there is no evidence of its having been there before 1783. The various external devices are no longer included — the chain has completely disappeared and the coat of arms is considerably smaller and has been moved up into the top left-hand corner, in alignment to the inscription, which is written in carefully formed roman capitals and gives details of the sitter's rank and dates. The emperor himself now dominates the picture, with the pomegranate held loosely in his left hand replacing the orb. He is wearing a sumptuous fur cloak open at the front. The expression on his face is also very different from that in the portrait drawing — he looks older, lonelier, and more reserved.

In a woodcut portrait based on the drawing, Dürer clearly has taken into account Maximilian's popularity, which was a particularly topical subject following his death. It is, incidentally, the first portrait print he ever executed. A second block was used to add a gold overlay to parts of the figure, and four copies that have survived also have coloring added, the idea being to make the woodcut look like a painting. For the large number of plain black-and-white prints that have survived as well, the engraver copied a block on which Dürer had sketched his design.

SELF-PORTRAIT (WITH LANDSCAPE)

Oil on panel; $20\frac{1}{2} \times 16\frac{1}{4}$ in. (52×41 cm)
The date (1498) appears on the right, below the windowsill, together with the inscription "Das malt ich nach meiner gestalt/ Ich war sex und zwenzig jor alt/ Albrecht Dürer" ("I painted this after my own appearance at the age of twenty-six, Albrecht Dürer"), followed by Dürer's monogram
Madrid, Prado
In 1636 the painting was presented to Thomas Howard, Earl of Arundel, by the city of Nuremberg as a gift for Charles I. In 1650 it was sold at the auction sale of the royal collection to Philip IV of Spain, and in 1827 it was acquired by the Prado.

THE SEA MONSTER
Engraving; 10 × 7½ in. (25.3 × 19.1 cm)
1497–1498
The monogram appears at the bottom edge in the center. This print depicts a sea monster abducting a girl while her father and friends rush about distractedly, but in vain, on the opposite bank. The scene probably was inspired by classical mythology although it does not refer to a specific incident.

THE VIRGIN IN HALF-LENGTH (THE HALLER MADONNA)
Oil on panel; 20½ × 16⅞ in. (52 × 43 cm)
1496–1497 (?)
Washington, National Gallery of Art, Samuel H. Kress Collection (1099). Formerly in the collections of Phillis Loder, Thyssen and Samuel Kress, who gave it to the gallery in 1952
The coat of arms of the Haller von Hallerstein family, who commissioned the painting, appear in the bottom left-hand corner; the armorial bearings in the bottom right-hand corner have not been identified. The reverse of the panel depicts *Lot and his Daughters Fleeing from Sodom and Gomorrah* (see overleaf).

Influences

Michael Wolgemut and the Nuremberg School of Painters
When Dürer decided to become a painter and entered Michael Wolgemut's workshop, he came face to face with a closely knit tradition of painting that already had lasted more than a hundred years. Over the years certain factors had united the various workshops in the town and set them apart from other painting schools. One of these continuing factors was an emphasis on line rather than color, a strong tradition that also involved outside influences. A second factor was that commissions for panel paintings always fell within a fairly narrow field. Painters were often asked to do side panels for polyptychs, which were groupings of panels fastened together with hinges (since the mid-fifteenth century the center panel generally had been reserved as a shrine for sculptures).

The memorial paintings that were donated to the churches of Nuremberg in memory of members of the better-off families, and even of craftsmen's families, were also a traditional source of commissions as late as the sixteenth century. An image taken from the life of Christ that related to death or resurrection and eternal life would generally be combined with portraits of the dead man or woman and of the family donating the painting. Closely related to this type of "donor painting" was the independent portrait, which made its first appearance in Germany in the second half of the fifteenth century. Judging by the examples that have survived, the people of Nuremberg eagerly seized this new opportunity for handing down their own image to posterity—much more eagerly, in fact, than the people of any other town where German art and culture prevailed. Thus they created a new sphere of activity for the town's painters, a sphere that was to be important for the future.

As a pupil of Michael Wolgemut, Dürer came across special stylistic features peculiar to Wolgemut's workshop that inevitably influenced his own style. Once he had become independent he picked out what he wanted from the wide range of traditional assignments and changed the emphasis to fit his own views of what an artist should do. Right from the start the working methods used in his own workshop were different from those he had become familiar with in Wolgemut's. The main difference was that he did not produce any of the big polyptychs that involved both painters and sculptors. It was definitely no accident that he left this type of work to his pupils, starting with Hans Schäufelein and then, when Schäufelein had left to settle in Augsburg, Hans von Kulmbach. Instead of the big altars, Dürer's workshop specialized in collaborating on woodcut decorations for several of the books that appeared in the first ten years of the sixteenth century and then, in the period between 1510 and 1520, on work for Maximilian I, which again involved producing woodcuts.

Despite his divergence from Wolgemut's practices, Dürer still felt that the workshop was necessary to artists as a way of organizing their activity. Although he came up with new ideas about the value of artistic achievement, he was convinced of the supremacy of the workshop over the work of any one of its members. When Hans Baldung-Grien designed some woodcuts in 1505, Dürer added his own monogram as a sort of workshop "stamp," and he was still selling them in the Low Countries in 1520.

The documents that have survived give us some idea of the division of labor that was an essential part of running a workshop. For instance, when a Frankfurt merchant named Jakob Heller commissioned an altar, Dürer arranged for the panels to be primed by someone else, painted the whole of the center panel himself, and divided up the side panels among his assistants. (The center panel was once in the Residenz in Munich but was destroyed by fire in 1729; the side panels are in the Historisches Museum in Frankfurt.)

If we turn to the memorial paintings that were so important in Nuremberg, we find that Dürer contributed to one that a goldsmith named Albrecht Glimm commissioned to honor his wife Margarethe, who died in 1500 (pp. 55–59). The theme, no doubt chosen by Glimm, was a moving dirge for the Redeemer. The scene takes place just after the Deposition from the Cross, with the Cross itself towering up against a landscape with mountains,

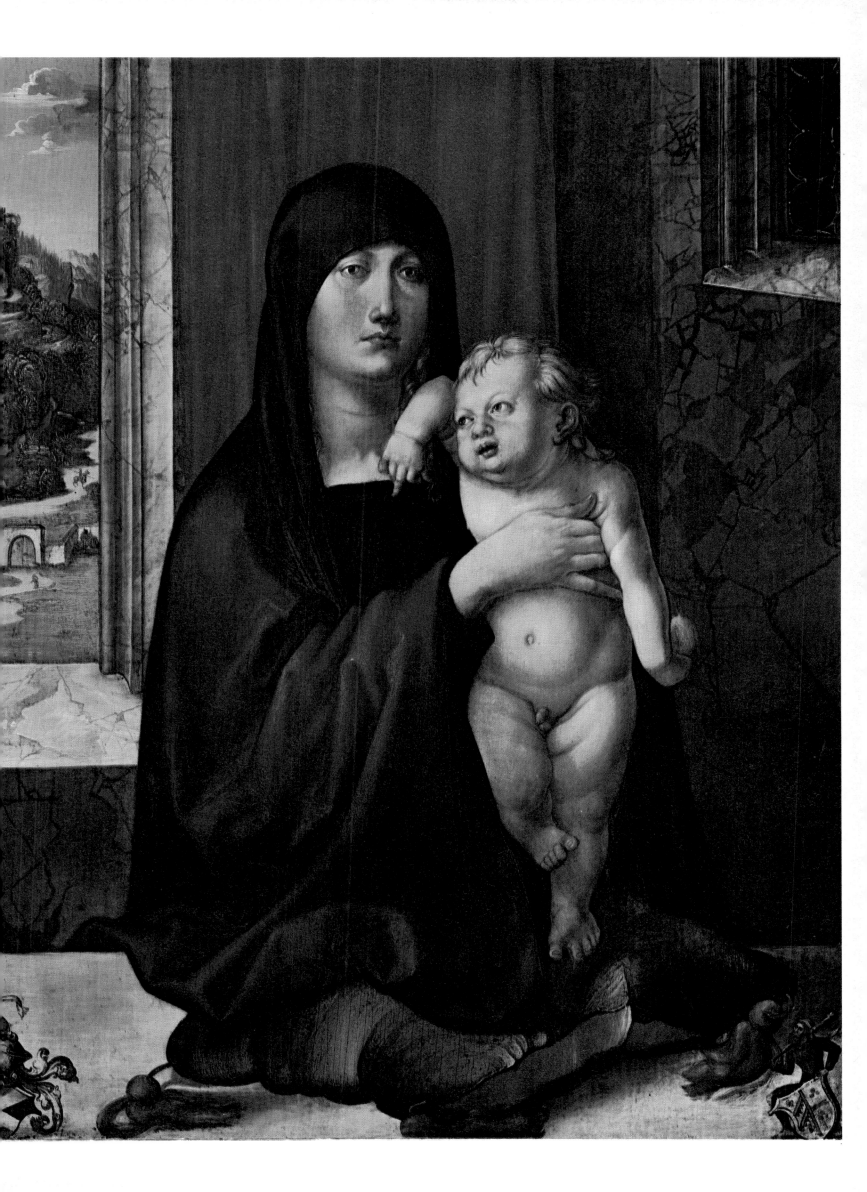

a castle, and the sea. Nicodemus and Joseph of Arimathea are holding the outstretched winding-sheet, which forms a gentle curve as it cradles the dead Christ. The austere and youthful figure of St. John towers over the unbroken circle of people silhouetted against the background, who are grouped around the Virgin Mary. The workshop supplied an almost identical copy as a memorial to Karl Holzschuher, who died in 1480 (Nuremberg).

The experience of portrait painting that Dürer acquired in Wolgemut's workshop was an important factor in his development. Even as a young man he was attracted by the idea of grasping the essential elements of a person and conveying the way they are manifested in his or her appearance and

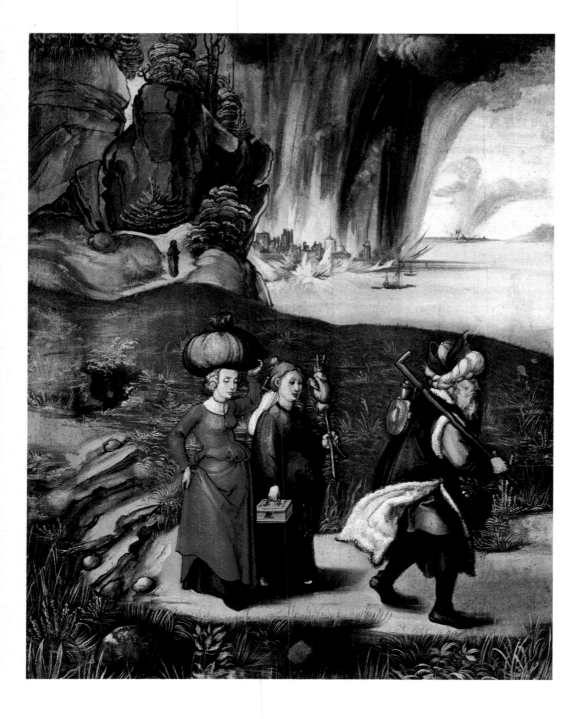

LOT AND HIS DAUGHTERS FLEEING FROM SODOM AND GOMORRAH
Oil on panel; $20\frac{1}{2} \times 16\frac{7}{8}$ in. (52×43 cm)
About 1498
Washington, National Gallery of Art, Samuel H. Kress Collection
This is the reverse of the *Virgin in Half-length* (p. 41). See details, opposite and overleaf.

behavior. As we have seen, he started by depicting himself. His early work is closely related to Wolgemut's style of portrait painting, for Wolgemut had taught him how to depict the human face. One of the earliest of Dürer's paintings to have survived is his portrait of his father (p. 11), which bears the date 1490. This means that it was painted after the end of his apprenticeship in the winter of 1489, before he set out on his travels as a journeyman at

Easter time in 1490. The portrait follows the formula of a half-length figure in three-quarters profile, with the hands visible, and the graphic treatment of the facial features sets it squarely in the Nuremberg tradition of portrait painting. However, the striking individuality of his father's expression, which seems to be constantly changing and alive, brings a completely new element to German portraiture.

Martin Schongauer and the Master of the Housebook
It seems certain that Dürer came across copperplate engravings in Nuremberg, either in Wolgemut's workshop or perhaps during his

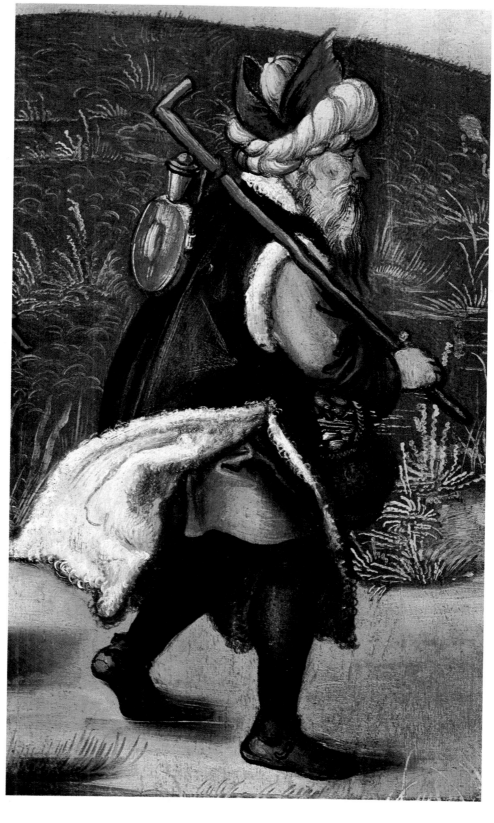

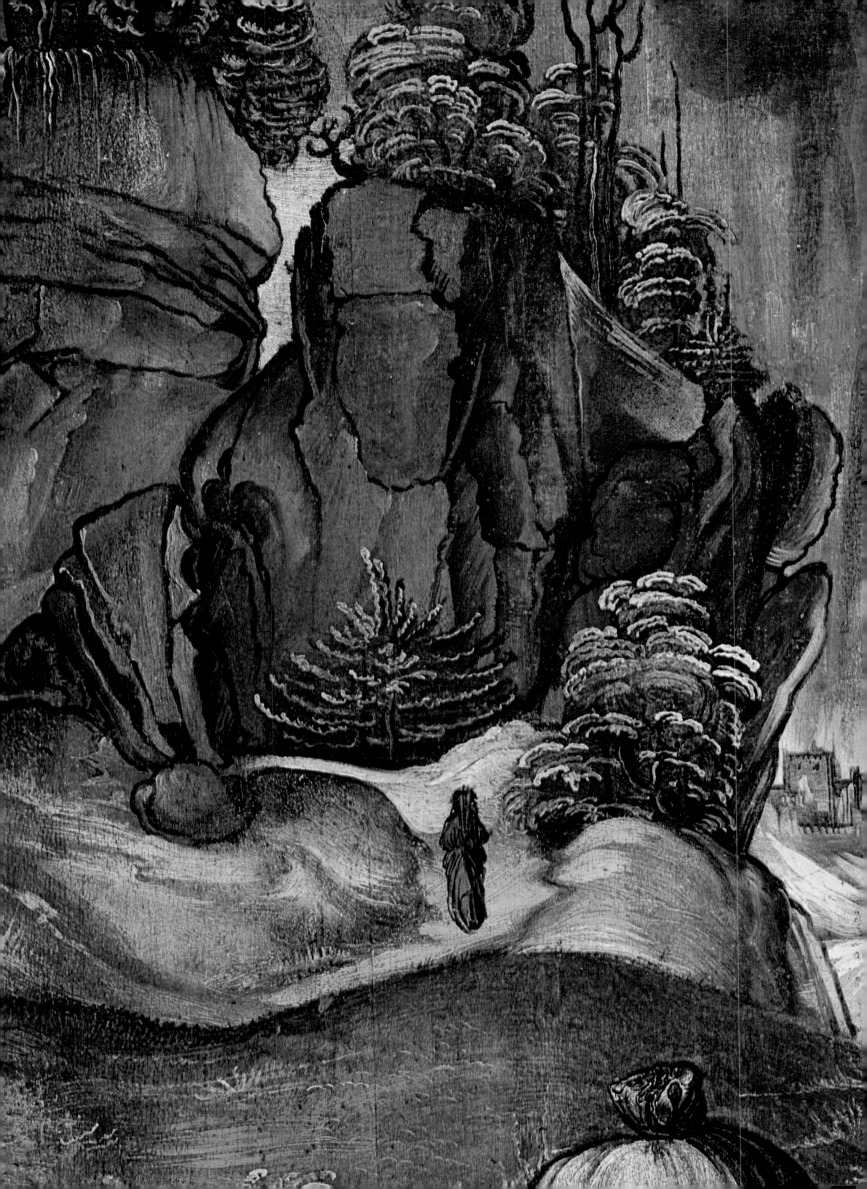

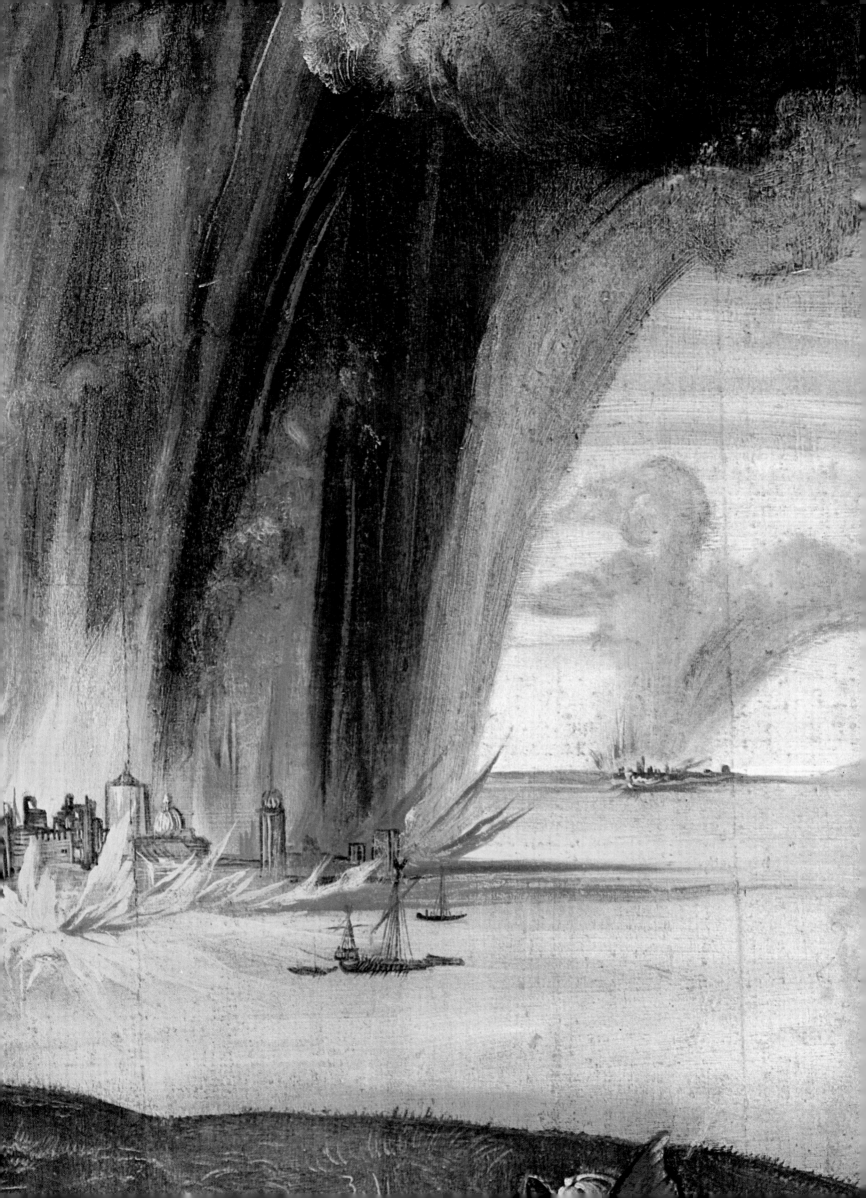

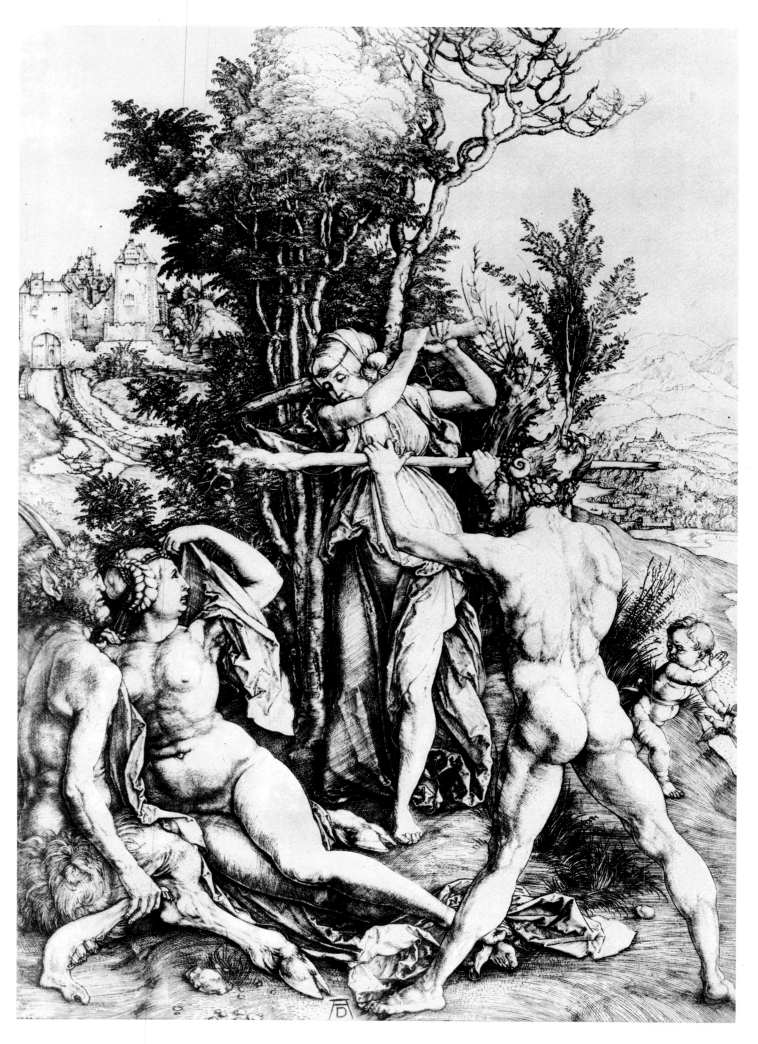

46

apprenticeship to his father, though the technique was not practiced in the town. Copperplate engraving differs from making woodcuts in that it is an intaglio process in which the lines that are to appear on the paper are cut out of the plate with a graver or burin. The ink is wiped off the smooth surface of the plate but remains in the engraved furrows, so that when the paper is pressed into the furrows during the printing process it absorbs the color. As the paper and the plate have to be pressed very firmly together, the relatively soft copper eventually becomes twisted. This means that only a limited number of copies can be reproduced. The 500 copies Dürer produced of his portrait of Cardinal Albrecht of Brandenburg must have been the

HERCULES (JEALOUSY)
Engraving; $12\frac{3}{4} \times 8\frac{3}{4}$ in. (32.3×22.3 cm)
1498–1499
This engraving depicts Hercules at the Crossroads between *Virtus* and *Voluptas*.

SOLDIER ON HORSEBACK
Detail
Drawing with watercolor; $16\frac{1}{4} \times 12\frac{3}{4}$ in. (41×32.4 cm)
The date appears at bottom center (1498) with the monogram beneath it.
Vienna, Graphische Sammlung, Albertina
The following inscription, in Dürer's hand, appears at the top of the sheet (not reproduced here): "Dz ist dy rustung zw der czeit/ Im tewtzschland gewest" ("This is the armor worn in Germany now").

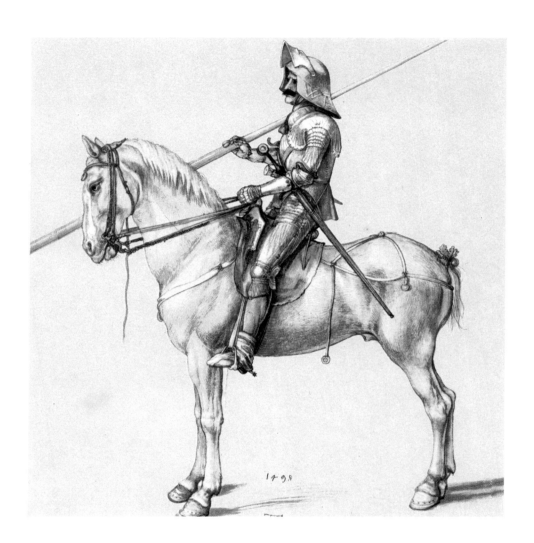

maximum number that could be reproduced successfully by this technique.

An artist working in copperplate engraving did everything himself, from the preliminary drawing to the actual printing. He could vary the results by the way he inked the surface of the plate. Engraving was not used in the early stages of book illustration because of the technical difficulties that arose from combining relief and intaglio work. But it was used from the outset for producing reproductions of masterpieces on single sheets, both paintings and pieces of sculpture, and artists often used engravings as models. Developed from the engraved work done by goldsmiths, the technique served a further purpose in providing artists with a wealth of new motifs that could be adapted to their own work.

Around the time when Dürer was born, Martin Schongauer, who was a native of Augsburg but worked in Colmar, had developed the technique of copperplate engraving to such a high level of perfection that he could render even the most elaborate designs in a lifelike manner. He would put single prints together to form a series of plates, which suggests that his engravings had become collectors' items. His prints must have been featured in the

pattern books of almost all the painting workshops in the whole of the German-speaking world. An amazingly high percentage of paintings and reliefs are based on particularly popular, and modern-looking, engravings of his.

The wealth of pictorial imagery in the Low Countries, to which Schongauer was greatly indebted, also helped to enrich his style. The paintings produced by Wolgemut and his collaborators were clearly influenced by Schongauer's engravings, and traces of their influence also can be seen in the line technique used in the drawings that Dürer executed when he was apprenticed to Wolgemut. For contouring figures and objects he used short lines and little hooks in the lighted areas and cross-hatching in the shaded areas. The cross-hatching was sometimes so thick that the shaded areas deepened to solid black.

It seems that Dürer must have come across a work done by the painter and engraver known as the "Master of the Housebook" during his years of travel as a journeyman or even earlier. *The Medieval Housebook*, as it is called in English, is part of the collection of Prince Waldburg-Wolfegg at Wolfegg. It contains drawings depicting everyday life and craft techniques in the late Middle Ages. Opinions are divided on the artist's identity, but he probably was active between 1460 and 1480 in the central Rhine area. As well as the drawings in the *Housebook* and a few paintings, a series of drypoint etchings of religious and secular subjects are recognizably his. The technique he used involved scratching the copper plate lightly with a pointed instrument resembling a needle. This technique is faster than using a graver, and the result has a freer and more spontaneous look. The furrows are very shallow, and only a very limited number of prints can be made since the plate is soon twisted out of shape during the printing process. This means that few copies of the Master of the Housebook's work have survived—indeed only a single copy in some cases.

Drypoint etching can be seen as the precursor of another graphic technique in which the lines are etched with acid instead of being scratched into the plate with a graver or needle. The metal is covered with a protective layer that is impervious to acid, and the technique involves drawing on the coated plate with a needle wherever a black line is desired, removing either part or all of the protective coating on that spot. The plate is then put in an acid bath, which eats away the exposed areas thus allowing the ink to settle there. The first experiments with this etching technique were made by Dürer toward the end of his life, using an iron plate.

Dürer clearly was familiar with the Master of the Housebook's work. Some of his drawings use similar subject matter, and the delicate use of line in these drawings is not as strongly influenced as usual by the precision that he learned from Schongauer's engravings. His first drawings of the Holy Family set against a landscape, which he produced during his traveling period, are clearly influenced both by Schongauer's work and by a drypoint etching by the Master of the Housebook, though Dürer's own contribution—the clear-cut depiction of both figures and landscape—should not be overlooked. A large drawing (now in Berlin) that is more like a painting in its completeness depicts the Virgin Mary sitting on a bench made of planks and pieces of turf (p. 14). Between the fingers of her right hand, which is still pure Gothic in its pointed shape, she holds the stem of a carnation—one of the symbols frequently used to refer to the Mother of God. The baby Jesus is sitting in her lap and turning away from her toward

PORTRAIT OF OSWOLT KREL
Oil on panel (lime); $19\frac{1}{2} \times 15\frac{1}{2}$ in.
(49.6 × 39 cm)
Inscribed at the top with the sitter's name and the date (1499)
Munich, Alte Pinakothek (WAF 230)

In 1812 this portrait was acquired for the Oettingen-Wallerstein Collection from the art dealer Hertel of Liesheim. In 1828 it entered the collection of Ludwig I of Bavaria
Left: Detail of the landscape.

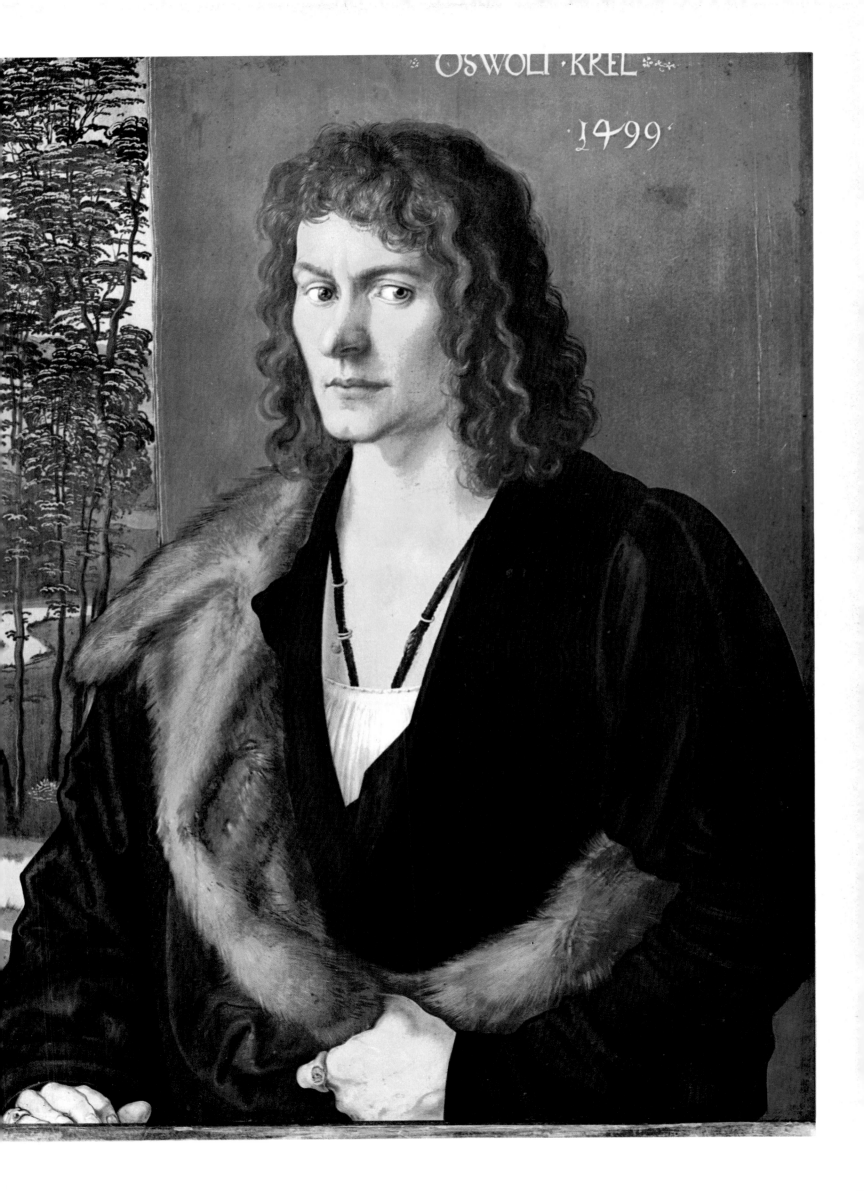

the balding Joseph, who has managed to find a discreet spot on the ground to the side of the grassy bench and behind it, so that he is partly hidden. His head is propped up on his right hand and he is fast asleep. Behind the group of figures and framing them is a parklike landscape with a river depicted in pleasing perspective.

Dürer's drawing of the Holy Family at rest is an early version of a theme taken up a few years later by Lucas Cranach and then by Hans Baldung-Grien—the Holy Family resting during the Flight to Egypt. This theme was to become very popular. The Virgin's appearance and bearing are clearly based on Schongauer's work, as is the rich treatment of the folds in her voluminous cloak. The inner contouring of the drapery is achieved by the careful use of a few lines, plus a large number of short hooks and cross-hatchings. This drawing is so complete that it can stand by itself as an independent work of art. In its subject matter, particularly in the position of Joseph on the ground near the bench, it is related to a drypoint etching by the Master of the Housebook that dates from about 1490, a little before Dürer's drawing.

When Dürer started to make use of the knowledge and experience he had acquired on his first trip to Italy, the first subject he chose was the Madonna on the grassy bench, which had also appealed to Schongauer. His engraving of the Madonna with a dragonfly is based on the earlier drawing of his own (p. 14). When the engraved plate is printed it is reversed, and Dürer has taken this into account in the position of Jesus—the Virgin is now holding Him up with her left hand and drawing Him toward her with her right hand. This makes the sleeping figure of Joseph seem even more isolated, as if he were excluded from the close relationship between mother and child. His arm now lies limply beside his head on the bench.

As Dürer took the drawing as his starting point, the changes in the Virgin's bearing and in the treatment of her robe are particularly obvious. He has in fact invented a new type of woman, different from the adolescent figure who appears in Schongauer's work. The contours of her body are visible beneath her robes, the folds of which support the top half of her body, which is held erect, and form a series of unbroken lines that shine brightly where the light catches them. The forms are smaller, the idea being to make the whole scene clearer. This also applies to the folds in the robes and to the landscape, which is seen through completely new eyes. At the same time, the material details are stronger and more clear-cut. The wooden planks and stakes that make up the bench are depicted in detail, and all the recognizable plants are so accurately depicted that they must have been based on studies from nature. Similarly, the little segment of the world that we see has not been chosen at random but is highly symbolic. As is usual with engravings, Dürer added his monogram when he had finished, using a small "d" and a capital "A" in this instance. In size the engraving equals the largest of Schongauer's—it measures nine by seven and one-eighth inches (twenty-three by eighteen centimeters).

The influence of Schongauer's engravings on the young Dürer's style was obvious even to his contemporaries. In his manual of German history, which was written in 1502 and printed in Strasbourg in 1503, Jakob Wimpfeling refers to Dürer as a "German" who was a pupil of Martin Schongauer. Both of these statements were amended in a paragraph added by Christoph Scheurl to his biography of Anton Kress, which appeared in 1515. He stresses that his remarks are based on information supplied by Dürer himself. He says that Dürer's father, also named Albrecht, "was born in a village called Cüla, not far from Wardein in Hungary," and wanted to send his son to Martin Schongauer when he was only thirteen. But Schongauer died around this time, so young Albrecht was bound to a three-year apprenticeship with a neighbor, Michael Wolgemut. Eventually, after traveling all over Germany, Dürer arrived in Colmar in 1492 and had been kindly received by Martin's brothers Kaspar and Paul, who were both goldsmiths, and Ludwig, who was a painter. He later met the fourth brother, who was also a goldsmith, in Basel. Dürer definitely had not been a pupil of Martin Schongauer and had never even met him, though he would very much have liked to.

Yet even this piece of information, though supplied by Dürer himself,

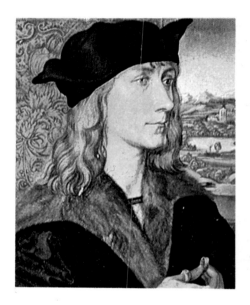

PORTRAIT OF HANS TUCHER
Oil on panel; 11 × 9½ in. (28 × 24 cm)
The inscription "Hans Tucher. 42iering. 1499" ("Hans Tucher at the age of 42. 1499") can be seen in the top left-hand corner
Formerly in the Schlossmuseum in Weimar but stolen in 1945 and now definitely thought to be in New York
The Tucher family's coat of arms has been painted on the reverse. This is one of four portraits of the Tucher family painted by Dürer. The others were of Hans' brother Nicholas, Nicholas' wife, Elspeth, and Hans' wife, Felicitas. The portrait of Nicholas is now lost.

PORTRAIT OF ELSPETH TUCHER
Oil on panel (lime); 11½ × 9¼ in. (29 × 23.3 cm)
Inscribed along the top of the curtain with the words: "ELSPET. NICLAS. TVCHERIN. 26 ALT/1499" ("Elspeth, wife of Nicholas Tucher, aged 26/1499")
Kassel, Staatliche Kunstsammlungen.

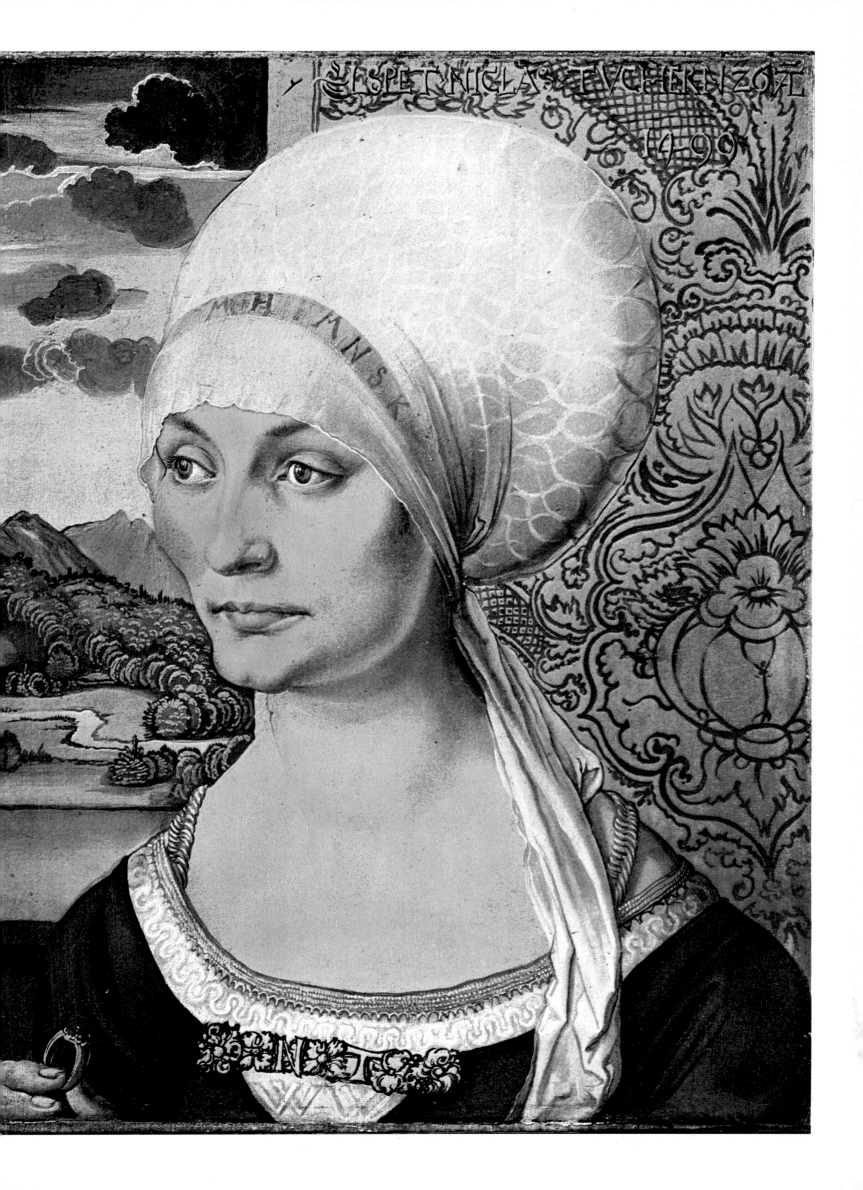

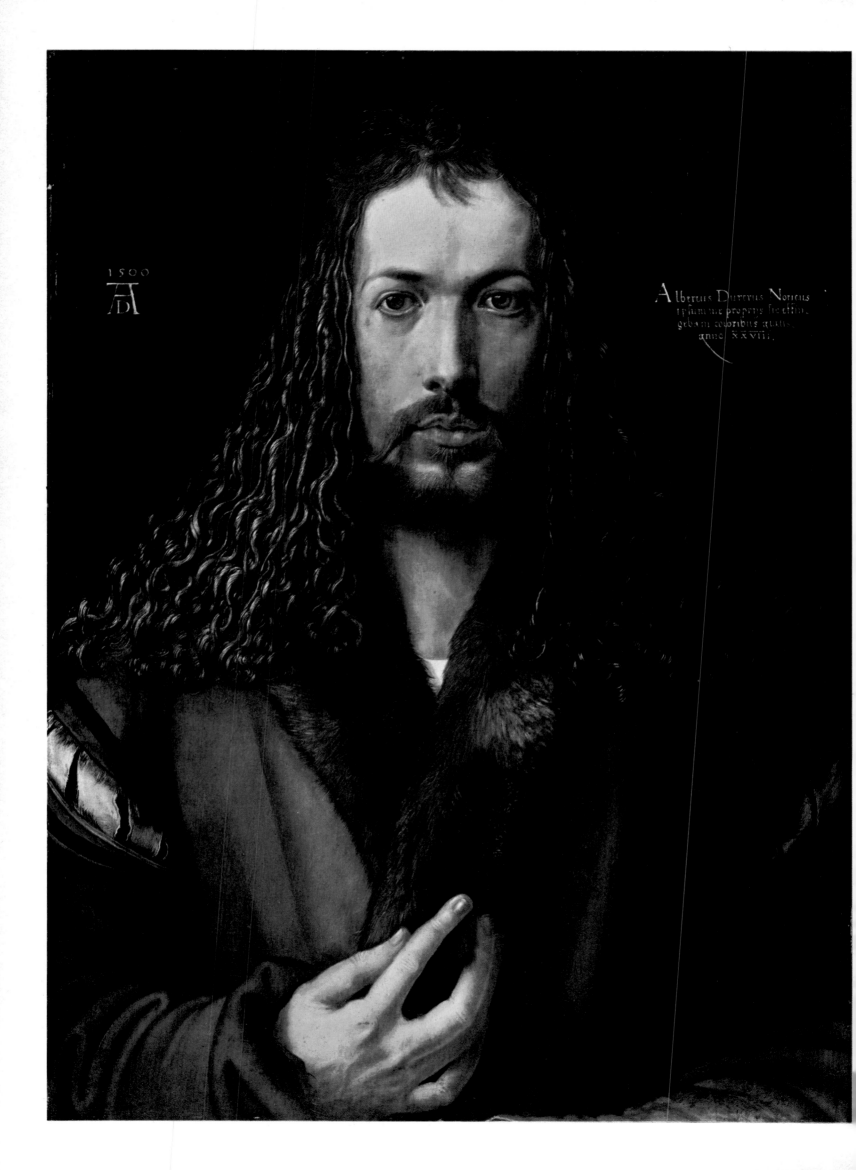

SELF-PORTRAIT IN A FUR-COLLARED ROBE
Oil on panel (lime); $26\frac{1}{2} \times 19\frac{1}{4}$ in. (67 × 49 cm)
The monogram and the date (1500) appear near the top of the painting on the left-hand side, with the following inscription on the right: "Albertus Durerus Noricus/ ipsum me propriis sic effin/ gebam coloribus aetatis/ anno XXVIII" ("I, Albrecht Dürer from Noricum, painted myself with everlasting colors in my twenty-eighth year") Munich, Alte Pinakothek.

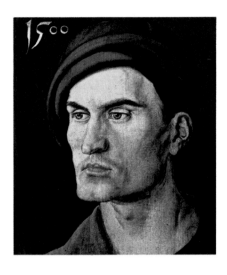

PORTRAIT OF A YOUNG MAN
(Hans Dürer ?)
Oil on panel (lime); $11 \times 8\frac{1}{4}$ in. (27.2 × 21.6)
Dated 1500 in the top left-hand corner Munich, Alte Pinakothek
The first mention of the portrait is in the catalog of the Paulus Praun Collection in Nuremberg (1616). In 1809 it was acquired by Crown Prince Ludwig of Bavaria via a Nuremberg dealer named Frauenholz. The sitter so far has not been identified with any degree of certainty.

needs to be interpreted correctly. It would have been extremely unusual for an apprentice not to be bound to his father's workshop or to one very close at hand for his initial training in his chosen craft. If Dürer's father really did correspond with Schongauer, as Scheurl tells us, he probably was applying for his son to be taken on when he had completed his apprenticeship and journeyman's period, just as, a little over ten years later, Hans Baldung-Grien had left his home in Strasbourg once he had completed his training and made his way to Nuremberg to work with Dürer. Schongauer did not die in 1484 but on February 2, 1491, when he was working on the frescoes of the Last Judgment in Breisach Cathedral. This also suggests that the plan was for Dürer to go to see Schongauer when he was a journeyman, not at the age of thirteen, and that he did not hear of his sudden death until he arrived in Colmar.

Scheurl tells us hardly anything about Dürer's travels, which started at Easter, 1490 — probably Dürer urged him only to correct the story about his allegedly having been a pupil of Schongauer. According to Scheurl, Dürer traveled all over Germany as a journeyman painter instead of going straight to Colmar from Nuremberg, so he clearly was not short of time. Although it would have been unusual for him to set off for southwestern Germany — indeed, the only apparent reason for doing so would have been to visit Schongauer — many artists had had contact with art in the Netherlands since the second half of the fifteenth century, and important Dutch and Flemish paintings could be studied in Cologne.

This brings us to the vexing question of whether Dürer too followed this trend, traveling to the Lower Rhine area and to the Low Countries even before his later visit in 1520–1521. Not doing so would have been strange, but on the other hand it is also strange that in the diary he kept during the 1520–1521 visit he never once mentions an earlier stay in the Low Countries, and when he notes that he has seen paintings by the great fifteenth-century Netherlandish painters, it reads as if he were seeing them for the first time.

Carl van Mander noted in 1604 that Dürer stayed in Haarlem, and Joachim von Sandrart says that he spent four years in the Low Countries when he had completed his apprenticeship. But both these references were written too late and are not sufficiently specific to provide incontrovertible evidence. Dürer could have seen paintings by Dutch and Flemish artists, either in the original or in copies, without leaving Nuremberg and could have become familiar with the art of Rogier van der Weyden as reflected in Schongauer's engravings and in paintings by Hans Pleydenwurff in Nuremberg or by Herlin in Rothenburg and Nördlingen. The same could not be said of the work of painters living in the northern part of the Low Countries, such as Geertgen tot Sint Jans, Master of the Virgo inter Virgines, and Hieronymus Bosch. These artists do not seem to have had a direct influence on fifteenth-century German art, yet experts recently have seen parallels between their work and Dürer's. This view presupposes that he had a more detailed knowledge of painting in the region that is now Holland and gives greater weight to van Mander's account.

Basel and Strasbourg
Scheurl's reference to Dürer having traveled from Colmar to Basel is confirmed by the fact that he did some paintings there. Basel remained part of the German empire until 1499. It was a publishing center and housed a whole series of efficient publishing and printing firms. The ideas and thinking of the humanists were encouraged and spread by scholars and writers such as Sebastian Brant and by three highly educated printers and publishers — Johann Bergmann von Olpe, Johann Amerbach, and Nikolaus Kessler. The books and other publications published in Basel at the end of the fifteenth century and the beginning of the sixteenth cover an extraordinarily wide field, including both theological and secular subjects.

The General Council helped considerably to bring about this upsurge of intellectual activity. They held meetings in Basel from 1431 to 1437, and then, after a split, some members continued to meet there until 1448, which meant that ecclesiastical dignitaries from both west and east used to come together in the town. The painter Konrad Witz from Rottweil also was working in Basel at this time; he used the latest findings of artists in the Low

Countries and Burgundy to create his own personal style and was turning out some very fine and highly individual paintings. His special status was well known and was probably what prevented at least sections of his altars from being destroyed during the serious iconoclastic riots that broke out in 1529.

As virtually all the religious art in Basel was destroyed during these riots, we cannot obtain a clear picture of the standards reached by the city's painting workshops in the second half of the fifteenth century. There do not appear to have been any really outstanding painters, which means that as well as earning his living a young painter could put his own ideas into practice and could give a new impetus to local talents. Dürer managed to do this in the field of book illustration. The technique of making woodcuts had reached such a high level of artistic and technical excellence in Michael Wolgemut's workshop that Dürer's work clearly surpassed that of the local craftsmen. It is also possible that a number of doors were opened for him by recommendations from his godfather, the printer and publisher Anton Koberger, who appears to have been in contact with Amerbach in later years.

Any attempt to trace the works that Dürer produced in Basel, none of which is signed or documented in any way, must start with the wood block depicting St. Jerome, which came into the collection of Basilius Amerbach and is still in Basel today (p. 13). On the back it bears the inscription: "Albrecht Dürer von nörmergk" ("Albrecht Dürer of Nuremberg") in Dürer's own hand. There has been a great deal of discussion about whether this signature refers only to the drawing or whether Dürer cut the block as well to show the wood engravers of Basel how to do it and to demonstrate the technical potential of the medium. This question has never been solved satisfactorily, but it should be pointed out that when the Emperor Maximilian's big commissions were being carried out, the blocks were signed by the men who cut them, no doubt to facilitate the calculation of their pay.

Dürer must have executed this portrait of the scholarly translator of the Scriptures—who was, as it were, the patron saint of humanists—soon after his arrival in Basel in the spring of 1492 since it was used as the title page for an edition of St. Jerome's letters edited by Kessler and published on August 8. In his drawing Dürer has managed to give a clear three-dimensional image of the saint's bedroom-*cum*-study, which is linked to rows of houses in a town by means of an open door. St. Jerome is sitting on a low bench and has interrupted his work to remove a thorn from the paw of his legendary lion. A sense of space and depth is created by the very solid figure of the saint and by the furniture and other articles in the room. Dürer has used hatching to indicate light and shade, varying the thickness to give an impression of the surface texture of each object. In clarifying every line in this way Dürer goes beyond the woodcuts produced in Wolgemut's workshop and makes high demands on the engraver, who had to transfer the original design faithfully to the block.

This contribution to Kessler's edition of St. Jerome's letters was clearly seen both by Dürer and by the Basel publishers as a trial piece. Commissions to illustrate three other publishing projects followed. One of these, Brant's *Ship of Fools (Stultifera Navis)*, was one of the most successful books produced in this period, and it owed a considerable part of its popularity to Dürer's powerful illustrations (p. 13). It was published in 1494, and pirated editions with copies of the woodcuts were being sold in Nuremberg and Reutlingen that very year.

Brant, who lived in Basel until 1499 and then moved to Strasbourg, had chosen as his target the corrupt nature of men and women, which leads them to commit all sorts of foolish actions. His views are expressed in simple, straightforward verses, and each of the short chapters is illustrated with pictorial decoration, the interlaced designs in the margins forming a well-balanced whole with the typeface and the illustrations in the text. Once again the layout of the pages in the printed book is modeled on that of illuminated manuscripts. Dürer has taken Brant's vivid style and transposed it literally into his woodcuts. In a series of grotesque actions and situations the numerous actors show that they deserve the dunce's or jester's

LAMENTATION OVER CHRIST
Oil on panel (pine); $59\frac{1}{2} \times 47\frac{5}{8}$ in. $(151 \times 121$ cm)
1500
Munich, Alte Pinakothek
Presented to the Predigerkirche in Nuremberg; between 1598 and 1607 it was acquired by Duke Maximilian. The painting was commissioned by the goldsmith Albrecht Glimm, who can be seen in the bottom left-hand corner with two of his sons. Glimm's first wife, Margareth Holtzmann, can be seen on the other side of the painting with one of their daughters as well as the family's coat of arms. Dürer intended the city in the distance to represent Jerusalem
Overleaf: Two details.

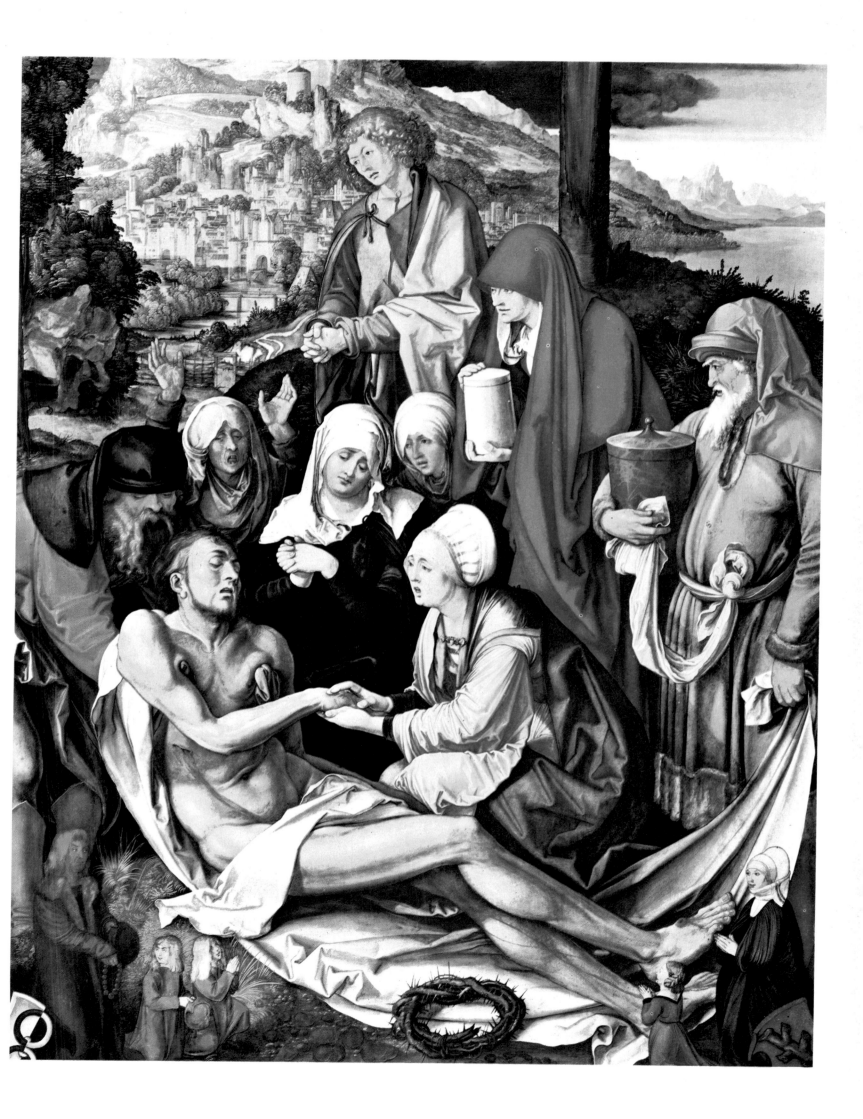

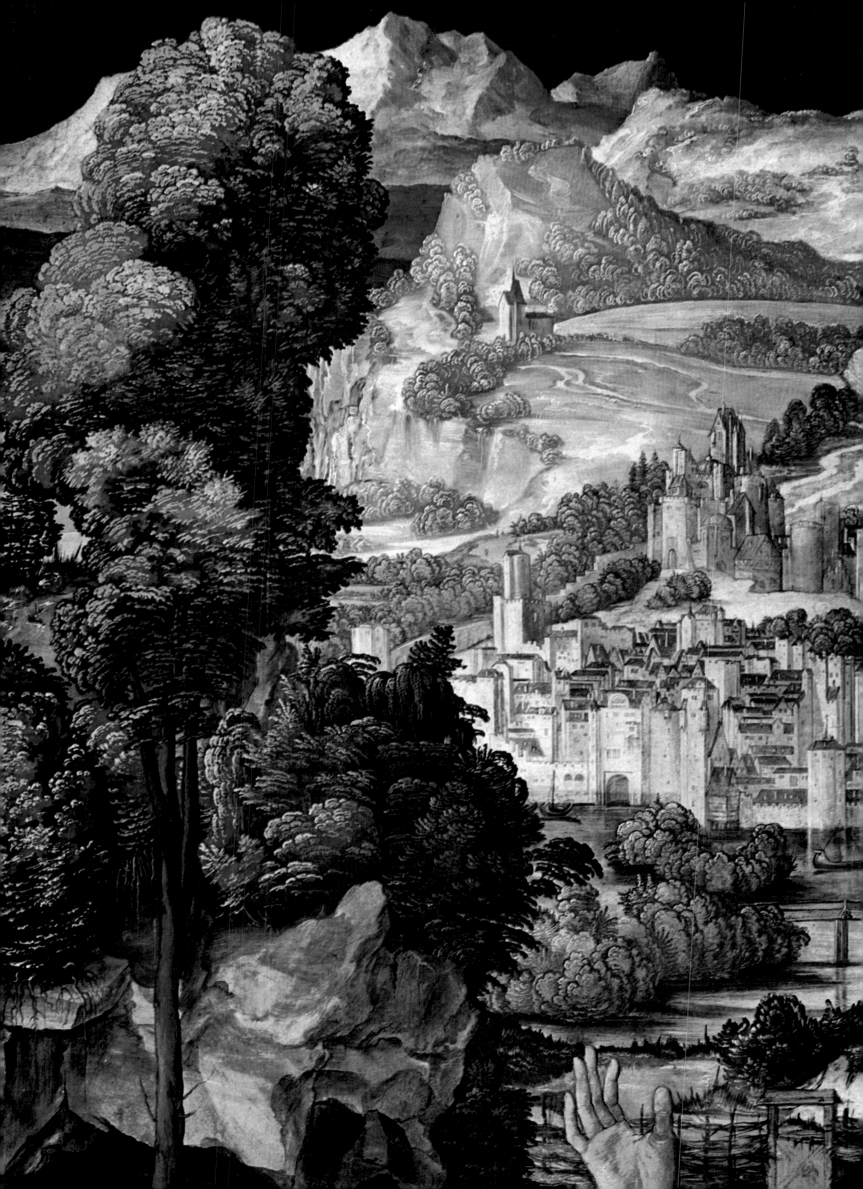

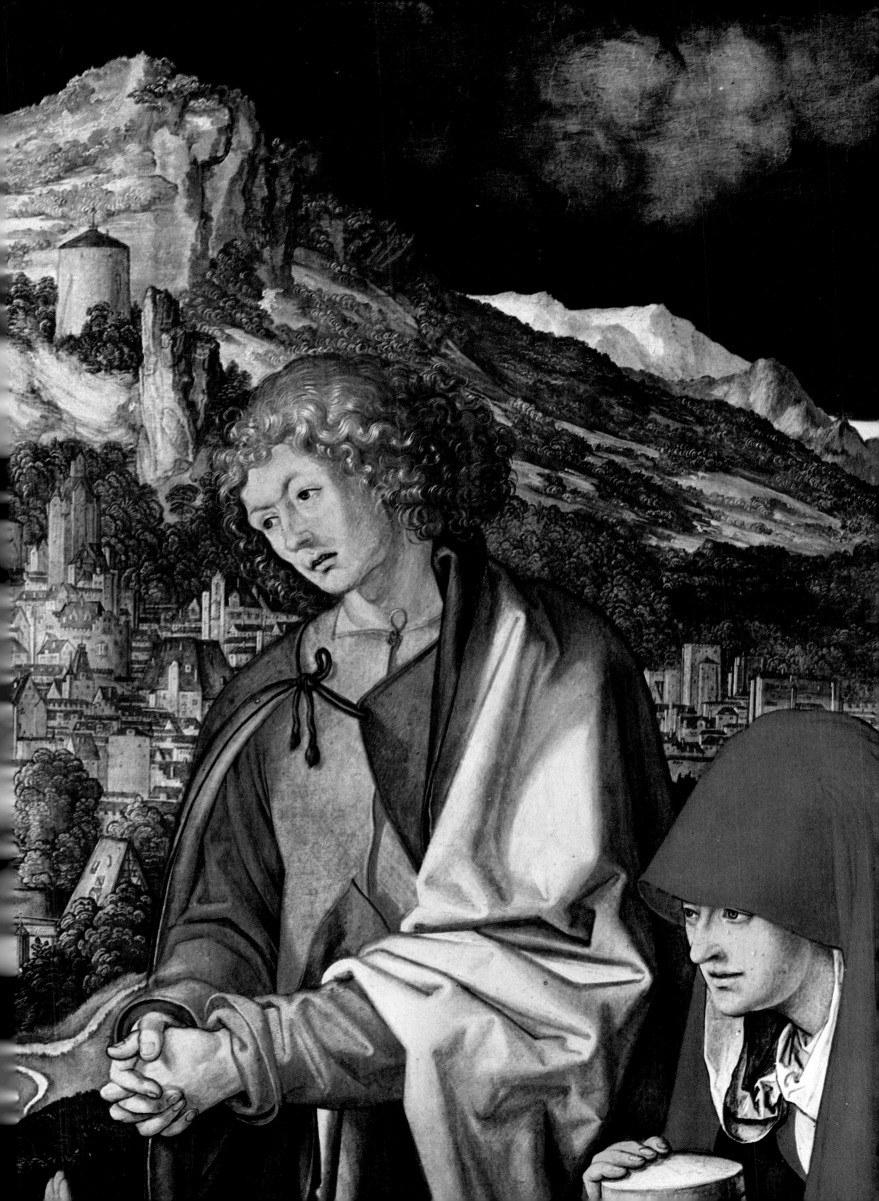

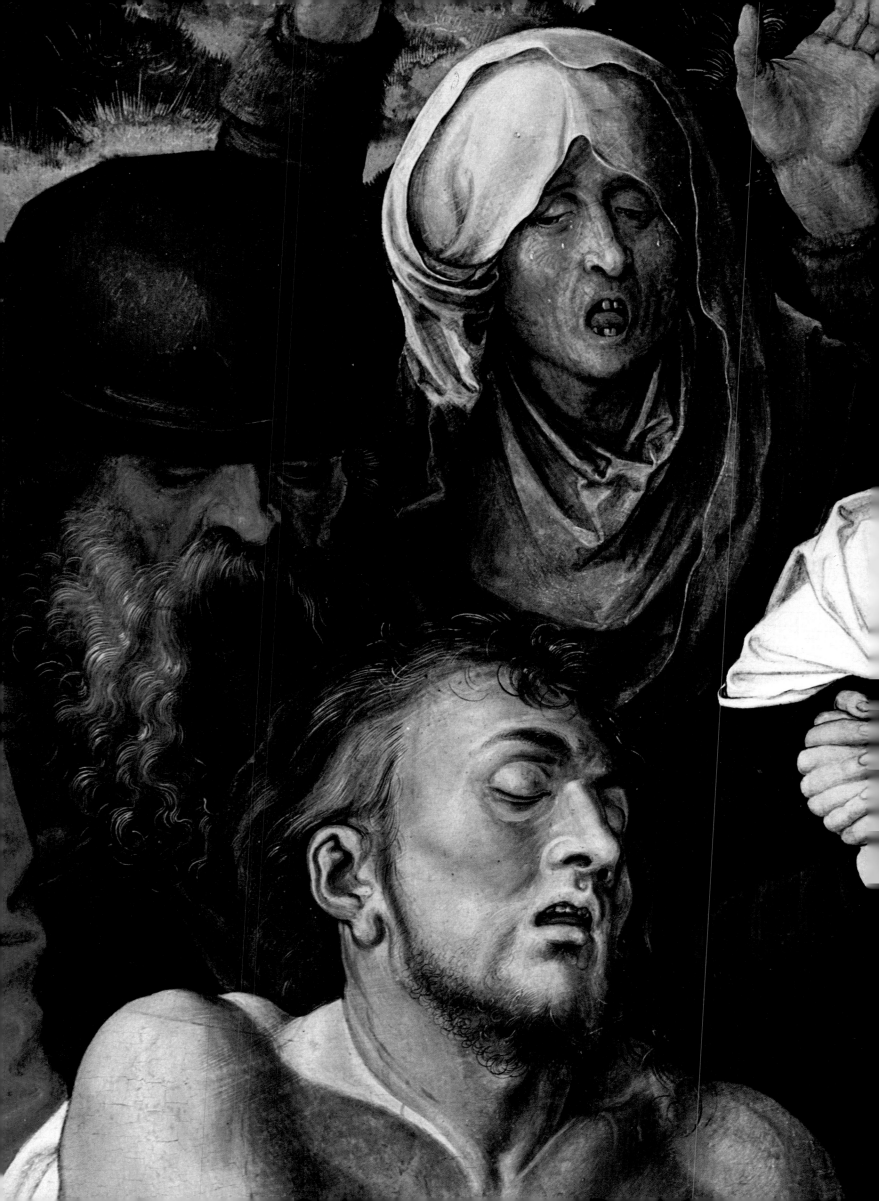

cap they wear, with its donkey's ears and little bells. The images are simpler than those in the St. Jerome woodcuts, and the messages they are intended to convey can be understood at a glance, yet the surface textures of the objects depicted are still clearly visible.

Dürer did not design all 116 illustrations for the Brant book, and the same pictorial motifs are sometimes treated very differently, which suggests that he collaborated with a local artist and used other assistants for the later parts of the book, which were completed by publisher Johann Bergmann von Olpe after Dürer moved from Basel to Strasbourg.

Before working on *Ship of Fools*, Dürer had supplied forty-seven woodcuts for another didactic book, *Der Ritter vom Turn* ("The Knight of the Tower"), produced by the same publisher. In spite of their moralizing tone some of the stories in this book are extremely powerful. They are translations of "examples" that Geoffrey, Chevalier de La Tour-Landry, a nobleman living in what is now the Maine-et-Loire *département* of France, devised and wrote down as a warning to his daughters (p. 12). The characters are depicted in a landscape or interior that serves as a stage on which they act out the behavior and gestures described at important moments in the story. The figures are throbbing with life, their individual appearance and demeanor drawn with a few terse strokes that are perfectly attuned to the medium and to the task at hand.

Another project, on which Dürer's collaboration must have been very welcome, was never published. The plan was to produce a new edition of comedies by the ancient Roman poet Terence (195–159 B.C.), edited by Brant. Terence's plays were performed in schools throughout the Middle Ages, but new interest in them was now being shown by the humanists as examples of the theater in classical antiquity. A total of 126 wooden blocks with illustrations drawn on them have survived, plus another 6 that already have been engraved and 6 prints from blocks that have disappeared.

Dürer probably approached the text through an early illustrated manuscript of the plays that Brant used when he was working on the dialogue. The illustration of the author, crowned with a laurel wreath and sitting in the countryside writing his verses (p. 9), is more obviously based on a classical model than the illustrations to the individual plays, which depict the characters and their surroundings in a thoroughly contemporary vein. It generally is assumed that the publisher, Johann Amerbach, canceled the work in Basel when a modern edition of Terence appeared in Lyons in August, 1493. The Lyons edition contained illustrations based on performances of the comedies on the ancient Roman stage and therefore gave a clearer picture of the fruits of the humanists' researches than Dürer's technique of transposing the comedies into contemporary reality.

The inventory of the collection built up by Willibald Imhoff, an upper-class citizen of Nuremberg, lists portraits of his Strasbourg master and his wife as Dürer's work. This is the only reference to Dürer having worked in Strasbourg as a young man. The only woodcut for a Strasbourg publisher that can be traced to Dürer is the title page for the fourth part of the *Complete Works* of the French theologian Jean Gerson (1363–1429), whose mystical theology proved extraordinarily influential when it was taken up again at the end of the fifteenth century and the beginning of the sixteenth. The last part of the Strasbourg edition was not published until 1502, but the woodcut undoubtedly was engraved in 1494 at the same time as those for the previous volumes. It depicts Gerson as a pilgrim, striding through the countryside with a dog at his side, but it has been ruined by the engraver, whose technique obviously did not match the demands made on him by the artist. Yet the arrangement of the whole composition and of all the individual motifs, which are designed to attract attention to the dominating figure of Gerson, gives an idea of the amazing progress that Dürer had made in mastering composition and in constructing the human figure. This woodcut is actually closer to the *Apocalypse* prints of 1498, which laid the foundations of Dürer's international reputation, than to the St. Jerome woodcut of 1492.

There is much less evidence of Dürer having produced any paintings during this period. Apart from the self-portrait of 1493 (p. 6), which probably was painted in Strasbourg, the only work that can be attributed to

ST. EUSTACE
Engraving; $14\frac{1}{8} \times 10\frac{1}{4}$ in. (35.7×26 cm)
About 1500–1502
The artist's monogram can be seen at the bottom edge in the center.

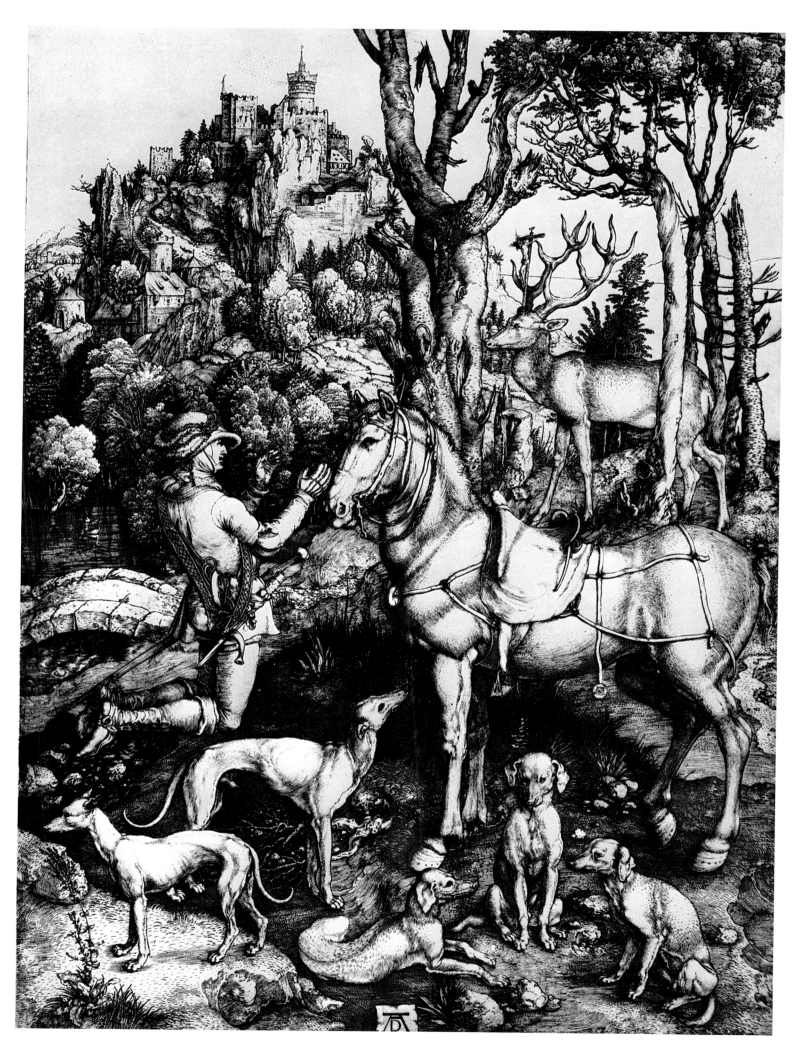

61

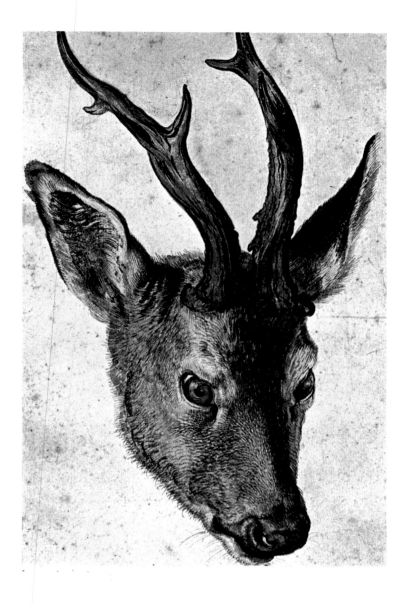

him with any certainty is a small panel depicting Christ as the "Man of Sorrows" (p. 12). Some fragments of an altarpiece dedicated to St. Dominic (Darmstadt, Munich) resemble his work, and he might have collaborated on some of the panels. The altarpiece was painted for a Dominican monastery, possibly the one in Colmar.

Italy

In May of 1494 Dürer returned to Nuremberg, having been tried and tested as a journeyman, and married Agnes Frey. Then in October he set off again on a trip to Venice. Quite apart from the fact that it was odd to leave his nineteen-year-old wife after such a short time rather than proceeding to build up a workshop and take on commissions, there was no precedent for painters to travel south. It is unclear what actually led him to take this unusual step or who told him that in Italy he would be able to acquire the knowledge he would need to progress along his chosen path: that the old guild rules alone no longer would be enough; that theoretical knowledge was an essential prerequisite for perfecting art; and that Italian artists could draw on Greco-Roman sources for this type of knowledge.

The humanists generally were interested first and foremost in the literary content of a work of art, not in its form. The "archhumanist" Konrad Celtis, who was crowned as a poet by the Emperor Frederick III, had mapped out a plan for Wolgemut to paint a room belonging to Sebald Schreyer of Nuremberg with scenes from classical antiquity. But even medieval artists harked back to classical themes and incorporated them in their own style. What excited the artists of northern Italy—and this was what Dürer could learn in Venice—was the idea of trying to depict classical literary subjects by means of classical methods.

Copperplate engraving had brought Dürer close to the classical style of the northern Italians, particularly Andrea Mantegna, as well as to Schongauer's late Gothic art. Although their work was not as common in the workshops as engravings produced by German artists, individual plates depicting subjects taken from classical antiquity may have reached Nuremberg via humanists such as Willibald Pirckheimer, and Dürer may have seen them there.

A Dürer drawing dated 1494 is copied from an engraving by Mantegna depicting a group of bacchanals surrounding the naked figure of Silenus

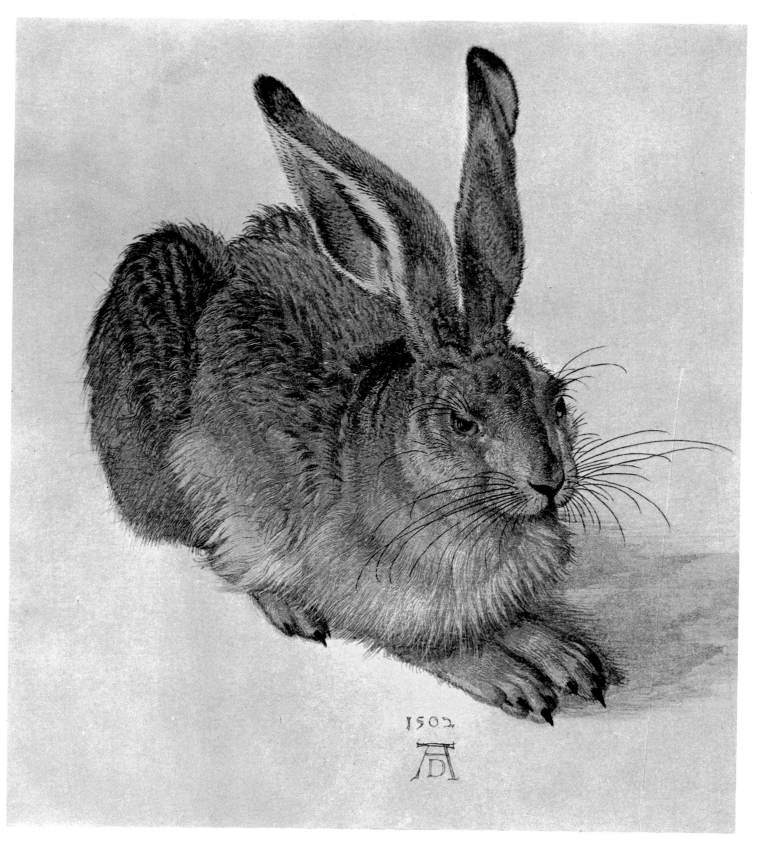

1502

borne by cloven-hoofed satyrs (p. 15). But the date does not tell us whether Dürer made the copy while he was still in Nuremberg or after he had reached Venice. The outlines of the figures have been traced directly from the original, but the drawing inside these outlines diverges from the Italian engraver's use of parallel hatching. It is based instead on Schongauer's cross-hatching, which gives the figures greater volume, but it rejects his method of combining figures to create a three-dimensional effect. Instead it creates space by isolating the figures. In Dürer's work all the concrete elements—skin, fur, and clothing—have a more substantial feeling of texture, and even the vine tendrils in the background are not mere ornament but are transformed into botanical reality.

Although the immediate signposts that guided Dürer along the road from Nuremberg to Venice are still obscure, based on mere suppositions and possibilities, there is nothing shadowy about the commercial and political links between the two cities. Before the discovery of the sea route to India, Venice, the powerful queen of the Adriatic, was the door for all Oriental commodities, including the spices produced in the Far East. The town was a meeting place for people, ideas, and goods, and her most important church, St. Mark's, bears monumental witness even today to the strong influence of the Eastern Church that radiated from Constantinople. The political successors of the Byzantines, the Turks, had drawn threateningly near, and some of them were actually in the town, providing artists with welcome models in their foreign-looking dress.

Free exchange of commodities with Venice, untroubled by alliances based on power politics, was vitally important to the trading towns of southern Germany, and Nuremberg firms dominated the Fondaco dei Tedeschi, the large building near the Rialto where the German trading community lived and stored their goods. As early as the beginning of the fourteenth century they had donated an altar honoring their local patron saint, St. Sebaldus, to the German church, San Bartolomeo, and had founded a brotherhood that was attached to it. Contact between the two towns was maintained by a regular courier service.

This means that once he had decided to go south, Dürer was urged to go to Venice since he would be able to meet important Italian artists there, especially Giovanni Bellini, as well as major scholarly publishers such as Aldus Manutius. And his fellow countrymen in Venice would be able to help him in an emergency and also could help to finance his visit by commissioning him to do work for them. A large number of young men from Nuremberg had been students at the famous university in nearby Padua—Willibald Pirckheimer among them from 1488 to 1491.

For his autumn journey, which he made either on foot or on horseback, Dürer did not follow the courier, who traveled briskly, but stopped to sketch and paint watercolors whenever he saw a spot that he felt was worth a topographical sketch. These sketches of landscapes, town views, and buildings enable us to chart his outward and homeward routes through the Tyrol fairly accurately on both sides of the Alps. He started off by traveling to Innsbruck, probably following the standard route via Augsburg-Mittenwald. Three watercolors of Innsbruck have survived—a panoramic view of the town over the River Inn (pp. 16-17) and two sketches of the castle courtyard, which has since disappeared (p. 19). This suggests that he stayed there for some time. When he was in the Brenner Pass he painted a watercolor of the gallows just outside Waidbruck, but the view with mountain passes later used for his engraving *Das Grosse Glück* ("The Great Fortune") probably dates from the return journey—the original sketch is now lost. The floods near Trento mentioned in a chronicle of the town of Bozen dated 1494 probably encouraged him to follow the mountain route from there through the Cembra Valley, where he painted a watercolor of Segonzano Castle, which he labeled "Welsch pirg" ("Italian castle"). On his return journey in May, 1495, he stopped at Trento (pp. 20–21) and Arco (p. 19).

It would be interesting to know what induced Dürer to paint these watercolors since apart from the two views seen from the castle in Innsbruck most of them show mountain landscapes with views of towns or individual buildings. Landscapes he had painted previously lacked such additions,

IRIS (GLADIOLUS)
Watercolor; $30\frac{1}{2} \times 12\frac{3}{8}$ in.
(77.5×31.3 cm)
The monogram and date (1508) are fakes
Bremen, Kunsthalle.

COLUMBINE (AQUILEGIA VULGARIS)
Watercolor and gouache; $14 \times 11\frac{3}{8}$ in.
(35.5×28.8 cm)
The date (1526) in the bottom right-hand corner is a fake
Vienna, Graphische Sammlung, Albertina.

with the exception of two views of the area just outside Nuremberg—the wire-drawing mill near the Hallerwiesen and St. John's cemetery (pp. 17, 20). These two watercolors suggest that when he set off, he already had decided to paint some of the more striking locales on the journey—this may in fact, have been one of the reasons for his sudden departure.

It has been pointed out that Dürer's views of Nuremberg are contemporary with town views in *The Nuremberg Chronicle* and with the first treatise on the origin, topographical situation, customs, and institutions of Nuremberg, written in Latin by Konrad Celtis and handed over to the town council in 1495. *Norimberga*, as it was called, appeared in print in 1502 in a collected volume of the author's writings with a frontispiece designed by Dürer. At the same time, the humanist also was planning, with the help of letters from people abroad, a *Germania Illustrata*. This was to be an informative description of the whole of Germany modeled on Flavio Biondo's *Italia Illustrata*. Dürer's topographical paintings may have been connected in some way with this project, which never came to fruition, though that still would not explain the artistic phenomenon of the watercolors and the way Dürer used light and color to create space in the landscapes.

Dürer began learning about the structure of the human body and the functions of its movements, based on his own observations, when he was still a journeyman. His study of a female bath attendant (Bayonne, dated 1493) is the earliest drawing of a nude from life by a German artist (p. 34). The fact that it has survived shows that Dürer attached importance to it as a landmark in his development as an artist and deliberately kept it safe. He used thin lines and thick hatching to draw the outline and contours of his model, who is standing in a frontal pose with her knees together. This pose presents relatively minor problems for the artist in depicting the interplay of the limbs.

As far as we can judge from the works that have survived, Dürer did not continue with this type of drawing at the time, probably because it was not easy to find a model. His newly acquired knowledge of the art of classical antiquity must have underlined the problems he perceived in relating bodies and movements to real life rather than to some intellectual preconception. He found that a study of the nude figure was necessary before attempting to portray it clothed and that themes taken from classical antiquity offered opportunities to depict the nude body.

When Dürer was in Venice, instead of picking his subject matter more or less at random, as was probably the case with the drawing of the bath attendant, he deliberately concentrated on studies of the nude and of figures in special costumes and took advantage of the opportunities for study that were available to local artists. Apparently Dürer did not view these studies solely as exercises in observation and perception—he always had in mind the idea of using them one day as the basis for a full-scale picture. Yet we must not forget that a high proportion of his studies of individual poses have disappeared, though he did refer to them for the early engravings on classical themes, mostly with nude figures, that he worked on as soon as he returned home.

Soon after his first visit to Italy, Dürer began to study the theory of movement, clearly inspired by what he had seen there. He planned to produce a thick textbook on the subject eventually, but only a few individual extracts were ever completed and published. After his second visit to Venice he stopped doing studies of nudes from life and concentrated instead on trying to construct the human figure in proportion. We also should bear in mind that the later nudes were not studies from life but exercises drawn from memory and based on his knowledge of the human form.

A brush drawing on blue Venetian paper of a female nude seen from behind dates from the time when he was deeply interested in the nude (p. 34). The model is leaning on a pole; a cloth hangs down from it and is laid across her left shoulder, covering her breasts and pubic region and ending in a fluttering point. These details add a narrative note to the drawing, though they tell us nothing precise, and make it something more than a working study. The displacement of the pelvis and the curving line of the spine are

BUNCH OF VIOLETS
Detail
Watercolor and gouache on vellum;
$4\frac{5}{8} \times 4\frac{1}{8}$ in. (11.7 × 10.4 cm)
This work is not dated or signed, and some critics believe that it is not by Dürer
Vienna, Graphische Sammlung, Albertina.

emphasized by the *contrapposto* pose. The figure was intended to be "the naked image [Bild] of a Wallachian woman." (By *Bild* Dürer meant both the painted and the sculpted nude.) It was no accident that this drawing found its way into a sketchbook containing a large number of drawings of the Vischer family's foundry in Nuremberg, for Dürer's choice of pose and his decision to emphasize the three-dimensional quality of the forms may well have been influenced by Italian sculptures, probably small bronzes.

On one occasion Dürer grouped together studies of male nudes seen from various angles for a scene derived from the late Middle Ages, when bathing was a popular pastime (p. 26). There was nothing unusual about bathhouses in paintings and drawings of the period, and since this scene was reproduced as a woodcut, we can assume that a fairly wide sale was expected. The men are wearing skimpy bathing costumes and have gathered in an open summerhouse, not in the bathhouse itself, which was used by both sexes. They probably have just emerged from a Turkish bath and are drinking and listening to music, while part of the bathing hut can be seen in the top right-hand corner. The wide tap is decorated with an image of a rooster. (This is a play on words, as *Hahn* in German means both a stopcock, or spigot, and a rooster, or cock.) The water is available to the bathers for washing and cooling purposes, but it isn't needed at the moment.

In Dürer's day virtually all bathing establishments were owned by the upper classes and provided a source of revenue for them, as they rented them to barber surgeons, a social class which was discriminated against. The

SMALL PIECE OF TURF
Watercolor and gouache on vellum;
$4\frac{5}{8} \times 6$ in. (11.7×15 cm)
1502–1503 (?)
Vienna, Graphische Sammlung,
Albertina
Most experts think this is not Dürer's
work.

LARGE PIECE OF TURF
Watercolor and gouache; $16\frac{1}{4} \times 12\frac{3}{8}$ in.
(41×31.5 cm)
Dated 1503 in the bottom right-hand
corner
Vienna, Graphische Sammlung,
Albertina.

natural springs were owned by the town authorities, but the poorer classes were entitled to use them free of charge. During the sixteenth century syphilis reached the town and spread so rapidly that this type of communal cleanliness and hygiene soon died out.

In this woodcut Dürer wasn't content with merely portraying a *genre* scene or depicting the naked bodies of men of different builds and ages in a variety of poses. The scene is in fact an interpretation of the five senses (in the activities of the figures) and the four humours (in their physiques and behavior); indeed the two spheres overlap. Thus the two men by the stone rampart in the foreground, seen from the waist up and holding a scraper and a flower, represent the senses of touch and smell; the fat man sitting down and clearly able to hold his liquor represents taste; and the man standing

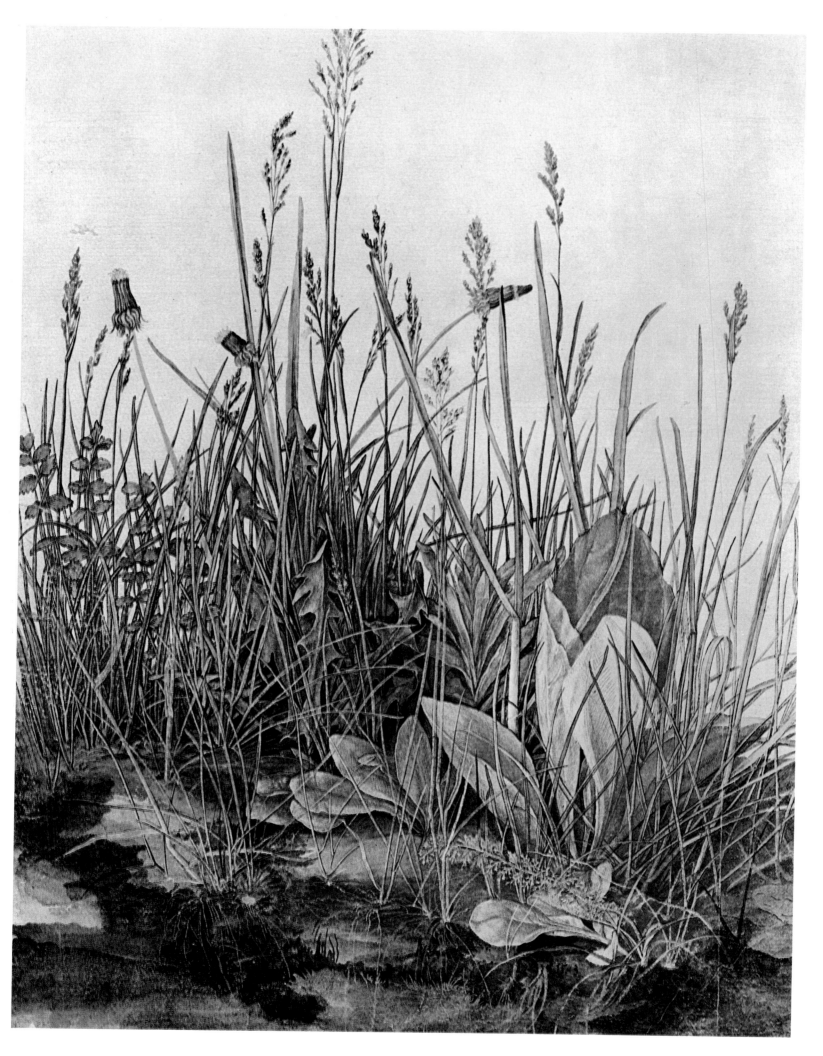

near the stopcock, who has Dürer's features, represents both hearing and melancholy as he puts his hand to his ear and listens to the musicians.

In studying the clothed figure Dürer discovered a basic difference between German and Venetian garments that was not due solely to fashion, and he made this difference clear in a deliberate comparison (p. 34). The Nuremberg lady is dressed in late Gothic style, with a tall headdress, stiff folds in her skirt, which is gathered in front, and pointed shoes, which are emphasized by the model's stance. The Venetian lady's dress, on the other hand, is governed by ideas concerning a balance between weight and support. A high-set bodice, with its horizontal lines repeated in abbreviated form in the half-length sleeves, is supported by a skirt whose cut and overall structure, which consists of parallel cylindrical folds, immediately makes one think of the surface of a fluted column. Wide shoes, little of which can be seen, provide a

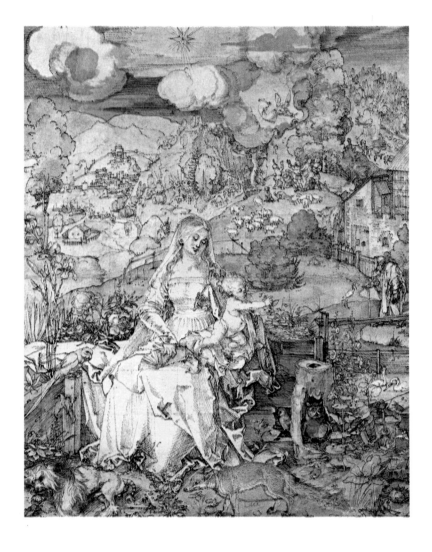

VIRGIN WITH A MULTITUDE OF ANIMALS
Pen-and-ink and watercolor;
$12\frac{5}{8} \times 9\frac{5}{8}$ in. (32.1 × 24.3 cm)
About 1503
Vienna, Graphische Sammlung, Albertina.

firm base for the whole structure. For the Venetian lady Dürer used a costume study depicting a model wearing a similar costume and seen both half sideways and from behind, though the latter view includes only the most important lines (Vienna).

Dürer seems to have been encouraged to draw directly from life by the costume studies that were part of the Italian tradition. If this interpretation is correct, it puts him in a position midway between the medieval workshop, which used traditional patterns, and the modern idea of studying nature in all of its various manifestations. The costume figure, in fact, had a considerable influence on his style. Dürer clearly was interested in the historical and ethnological aspects of costume as well as its purely artistic qualities. For instance, even on his first visit to Venice he drew men in Oriental costume, probably copied from paintings. Later he executed a series of paintings of the local dress worn in Nuremberg, and when he was in

AMOROUS PEASANTS
Pen-and-ink and watercolor; $8 \times 5\frac{5}{8}$ in.
(20.4×14.2 cm)
1502–1503
Milan, Biblioteca Ambrosiana
Sketch for a table centerpiece.

the Low Countries, he recorded peasants and soldiers and Livonian women in highly unusual costumes.

Quite apart from his studies of nude and clothed figures, Dürer's eagerness to learn also led him to acquire detailed knowledge about perspective based on scientific theories. In the first half of the fifteenth century Florentine artists and theoreticians led the way in applying and describing the laws of central perspective. The knowledge they had acquired was known to northern Italian artists such as Andrea Mantegna, Gentile and Giovanni Bellini, and Vittore Carpaccio, and Dürer was introduced to it in Venice. Toward the end of his second visit to Venice he noted in writing that he wanted to travel to Bologna "for the sake of art in secret perspective," and the paintings and drawings he produced in Venice in 1495 and subsequently in Nuremberg clearly were preceded by concentrated attempts to penetrate

these secrets. His study of a crab (*Eriphia spinifrons*, p. 22) reveals a knowledge and use of the technique of viewing objects from a low angle in close-up, and this presupposes not only familiarity with works in which the subject was "alienated" in a similar way by means of perspective but that he had worked on this type of study himself. The unexpected view of the crab gives it something of a primeval, threatening quality.

The paintings and prints he produced after returning from his first visit to Venice show even more clearly what he had learned both about constructing the human figure and the treatment of perspective. They show that he was a painter, as he himself put it, "full of images." The products of his exceptionally fertile imagination are conjured up in forms that derive expressive power from natural laws. He revealed his belief in the importance of nature when he said: "For art truly does lie hidden in nature. Anyone who can draw it out has captured it."

Ten letters written from Venice to Willibald Pirckheimer in Nuremberg between January 6 and October 13, 1506, have survived. They offer insights into Dürer's frame of mind and the successes he achieved during his second visit to Venice, plus a glimpse of his relationship to art and to the artists working in the shadow of San Marco. Once again, we do not know whether he had a specific reason for this second journey to the south. It might have been that discussions already were under way for the splendid commission he was offered by the German merchants once he had reached Venice. Or perhaps he simply felt a need to get away for a while from the daily round in Nuremberg, from life at home with his wife and mother, and to relive his earlier experiences, regaining the feeling that he was a person of consequence. He could live off the proceeds of the sale of a series of small altarpieces, which he took with him from Nuremberg. This also might explain why a *Madonna* of his came to be in Italy in the strict Capuchin convent of Bagnacavallo near Bologna. It was discovered there after World War II and is now in a private collection in Italy (p. 24).

The figure of Mary, visible to her knees, is seated in front of an archway, holding the naked Christ child on her lap. The mother and child are looking at one another, giving the impression that there is a close spiritual relationship between them—an impression that is emphasized by the way the child is reaching for his mother's hand. The way the Virgin is linked to the architectural elements, which offer a glimpse into the depths of the background, is fairly common in German art and probably originated in the Low Countries. For the figure of the baby Jesus, Dürer used a copy he made in 1495 of a drawing by the Florentine artist Lorenzo di Credi, showing Jesus lying down (Paris). We can see the influence of a pictorial type created by Giovanni Bellini, which recurs in many paintings and depicts the Madonna half-length, or visible down to her knees, generally behind a rampart or balustrade. In fact, this influence appears less in the way the Virgin's face is portrayed than in the way Dürer has adopted the Italo–Byzantine manner of covering her head with a white veil that descends over her forehead, with a cloak laid above it and wrapped around at the front.

Earlier writers on Dürer erred in contending that he did not paint this picture, which is still linked to the late Gothic tradition in Germany, both in its overall structure and in individual details, until his second visit to Venice. On the other hand, the fact that the painting turned up in the convent in Bagnacavallo, which was founded in 1774, doesn't necessarily prove that it was painted in Italy. If it was, it must have been painted in 1495–1496, and we know of no other paintings by Dürer that date from that period. The well-balanced combination of German and Italian stylistic elements, between motherliness and dignity; the clear modeling and composition of the bodies, assimilating his Italian experiences; and the extraordinarily careful execution all make it seem more likely that Dürer did not paint it until he had returned home. Once back in Nuremberg he made full and systematic use of his Italian experiences in his engravings and woodcuts.

A portrait drawing of a woman inscribed with the words "una vilana windisch" ("an ugly Windish [Slovene] woman") alongside the monogram and the date (1505) has led some experts to assume that Dürer came across the woman in one of the Slovenian-speaking areas of Carinthia or Friuli. This

PORTRAIT OF A YOUNG MAN IN A CAP
Chalk drawing, highlighted with white, on paper prepared with a brown wash; $11\frac{3}{4} \times 8\frac{1}{2}$ in. (29.8 × 21.5 cm)
Bears Dürer's monogram and the date (1503)
Vienna, Kupferstichkabinett, Akademie der Bildenden Künste
Formerly in the Mariette, Lagoy, and Jäger Collections
Inscribed at the top with the words: "Also pin Ich gechtalt in achtzehn Jor alt" ("I was depicted thus at the age of eighteen").

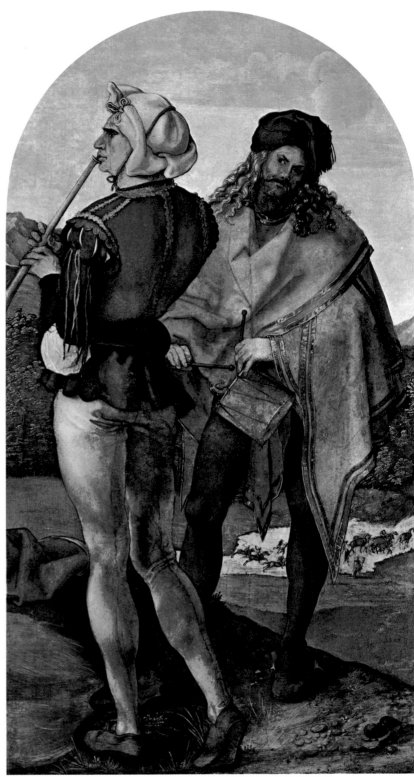

JOB AND HIS WIFE
Oil on panel (lime) ; $37\frac{3}{4} \times 20\frac{1}{8}$ in.
(96×51 cm)
About 1504
Frankfurt, Städelsches Kunstinstitut
Overleaf: Detail.

TWO MUSICIANS
Tempera on panel (lime) ; $37 \times 20\frac{1}{8}$ in.
(94×51 cm)
About 1504
Cologne, Wallraf-Richartz-Museum
This painting is a pendant to the one of
Job and his wife. The two paintings
were probably the side panels of a
triptych, *The Jabach Altarpiece.*

would imply that he didn't go over the Brenner Pass on his second journey to
Italy. Another portrait of a woman, in charcoal this time (p. 90), bears the
same date and probably was drawn at the same time. The unusual flat
headdress embroidered with various motifs and the particularly detailed
modeling of the features might indicate that the model was another Windish
peasant. Like the Slavonic inhabitants of Carinthia and Friuli, the people
living on the Dalmatian coast opposite Venice were known as "Winds," or at
any rate that is how they are labeled on a map by Martin Waldseemüller that
was published only a few years later in 1511. So it is possible that Dürer saw
the aristocratic-looking *eschiavonesca* in Venice and persuaded her to sit for
him. The portrait is carefully drawn and complete in all details, showing no
sign of having been hastily jotted down during a journey.

By this time the Venetian painters were beginning to take notice of the
newcomer, but Dürer's arrival seems to have caused some unpleasantness.
The Venetians criticized his paintings and seem to have regretted the

absence of any classical feeling in them. Just less than a year later, on September 8, 1506, when Dürer was sure that his painting for San Bartolomeo was a success, he wrote to Pirckheimer to say that he had managed to silence all of the artists who were willing to recognize him as an engraver but not as a painter: "I have stopped the mouths of all the painters who used to say that I was good at engraving, but, as to painting, I did not know how to handle my colors. Now everyone says that better coloring they have never seen." But suspicion and tension were still rife, and Dürer even thought that someone might try to kill him.

Only two artists are mentioned by name in his letters. Giovanni Bellini, now an old man and above petty quarreling, visited Dürer in his workshop, praised him highly, and said that he would like to own something by him. Dürer returned the compliment by describing Bellini as the finest painter of all, in spite of his age. On the other hand, he had nothing but scorn and criticism for the Venetian painter Jacopo de' Barbari, who was highly praised by his patron, Anton Kolb, a Nuremberg merchant living in Venice. De' Barbari had tried his luck in Germany and between 1500 and 1503 actually had worked in Nuremberg, where he had come into close contact with Dürer. But he lost a great deal of his attraction for Dürer when he had to stand comparison with Venetian painters. In judging him Dürer lets slip a comment about the high level of painting in the city. He writes to Willibald Pirckheimer that there were a large number of painters in Venice better than "Master Jakob," and Dürer's colleagues there are quoted as saying mockingly: "If he was any good he would have stayed here."

An interesting sidelight is Dürer's change of heart concerning a view he had held on his first visit to Venice eleven years earlier. We do not know precisely what is in question, but he writes to Pirckheimer, who took an opposite view, "And that which so well pleased me eleven years ago pleases me no longer; if I had not seen it for myself I should not have believed anyone who told me." Dürer thus shows himself capable of taking a fresh, impartial look at Venetian art and of revising earlier impressions and opinions.

Although Dürer preferred the elderly Giovanni Bellini to younger artists, and in particular compares his own great altarpiece for San Bartolomeo with Bellini's work, he was prepared to consider new elements expressed in the art of the younger generation, which included Giorgione and Titian. Of all the work Dürer produced in Venice the portraits especially, in their restrained and graduated coloring and individualized features, reveal the impression that Giorgione's work had made on him.

In 1505 Dürer executed another portrait of a woman (p. 91) that is unfinished but has a particularly strong modern appeal because of the immediacy Dürer achieved in it. The change that Dürer underwent in Venice, which was to bring out all of his potential, already can be seen in this painting. Bright colors, verging on brownish red, are set against a black background—a bright red dress, reddish-blonde hair beneath a Venetian cap worked in gold, and lightly sun-tanned skin. The fairly large nose, the sensual mouth with full lips, and the energetic chin are depicted clearly.

Of two portraits of young men the one now in Genoa seems to show Giorgione's influence most clearly, though it is not in a very good state of preservation and has been restored several times. The outstanding feature of all the portraits Dürer painted in Venice in 1506 and 1507 is the special harmonious quality he manages to give to his sitters. When looking at them one feels no need to protect one's own personality against the tension and willpower that emanate from them. Instead, the viewer willingly lets himself be caught up in a moment of reflective tranquillity. Some tensions and pressures must have relaxed in Dürer; he seems to have developed a feeling for the perfect balance that pervaded the world that Giorgione had built around him.

There is no doubt that the Venetian portrait was followed immediately by another female portrait, now in Berlin (p. 101), which Dürer did not date. The detail selected shows a bare head and shoulders portrait, and the figure, turning slightly to her right, seems very close to the spectator. We cannot now be sure whether or not the softly blurred shapes are largely the result of the painting's condition—the top layer of color either has disappeared or

PAUMGARTNER ALTARPIECE
THE NATIVITY
Oil on panel (lime); $61 \times 49\frac{5}{8}$ in.
(155×126 cm)
About 1502
Munich, Alte Pinakothek
Acquired by Maximilian I in 1613 from the Katharinenkirche in Nuremberg
This is the center panel of a triptych known as the *Paumgartner Altarpiece* because it was commissioned for St. Katherine's church by the children of Martin Paumgartner in memory of their father, who died in 1478. The donors' family can be seen at the bottom of the painting – Martin Paumgartner and his sons Lucas and Stephan on the left, along with the second husband of Martin's widow, Hans Schönbach (the figure with the white beard). On the right are the donors' mother, Barbara (née Volckamer), and her daughters Maria and Barbara
Overleaf: Detail.

been damaged. But on the whole this impression, which is characteristic of the whole painting, seems to be caused by the play of light and shade on the skin and the lack of contrast in the coloring, which uses a variety of brown tones in the figure and places them against a blue background, which becomes darker at the bottom. The initials embroidered on the border around the neckline are those of Dürer's wife, Agnes, though the sitter is undoubtedly a southerner.

Dürer's Venetian masterpiece, which is imbued with the essence of all that he learned from Italian Renaissance art, is the altarpiece that used to be in the right-hand chapel in the chancel of San Bartolomeo (pp. 92–96). In 1606 Joachim von Sandrart tells us that it was bought by Rudolf II and carefully packed in wool and rugs, then wrapped in a waterproof cloth and carried by four men, on poles, to the emperor's residence in Prague. (An "Annunciation" by Hans Rottenhammer from Munich can now be seen on the spot where Dürer's painting previously hung.) With this work Dürer announced himself as a master painter to the Venetian artists and in so doing invited comparison between his artistry and theirs.

Two details from *The Nativity* (*Paumgartner Altarpiece*)
Left: The infant Jesus with cherubs
Right: Barbara Volckamer and her daughters.

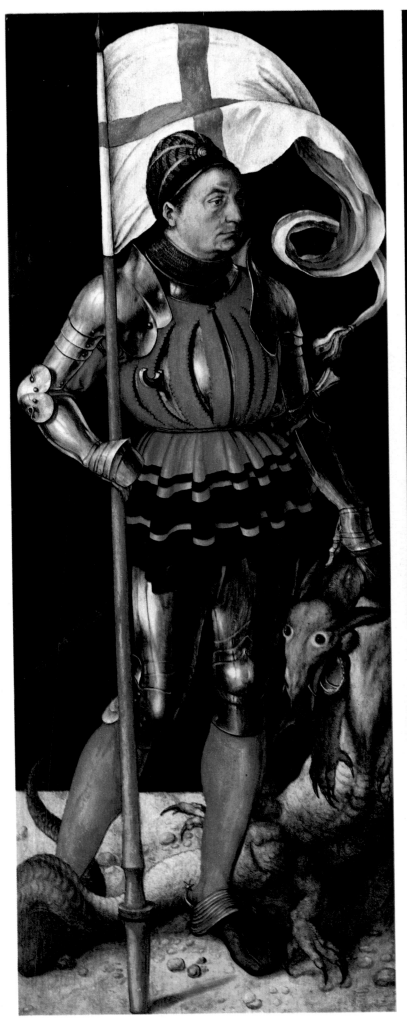 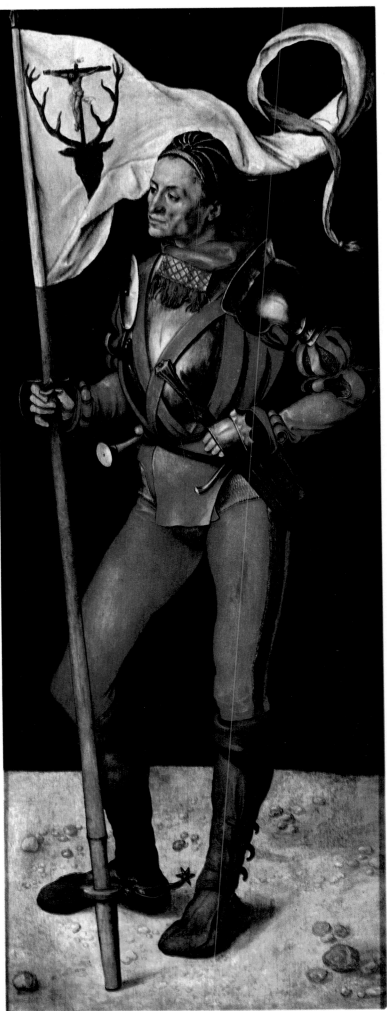

We know a good deal about Dürer's preparation for this painting, about the progress of the work, and about the sensation it caused once it was completed thanks to his letters to Pirckheimer, which mention it several times, and also to the twenty-two carefully drawn detail studies executed with a brush on blue Venetian paper. One of them has not survived, but we have a copy of it. The Venetian painters had taught Dürer the technique of making detailed preparations for altarpieces by doing a large number of individual studies, and each of his sheets of studies is an important work of art in itself.

We know rather less about the people who commissioned the altarpiece and about the worshippers who are depicted in it. On January 6, 1506, in the first of the letters to Pirckheimer that has survived, he mentions casually that he has a commission to paint an altarpiece for the German colony and has received 110 guilders for it, against which he has to offset expenses of less than 5 guilders. He is trying to prove to Pirckheimer, to whom he apparently owed a large sum, that he is solvent. He says that he already has started on the priming coat because the painting must be placed on the altar a month after Easter.

Although Dürer refers to "the Germans" as having ordered the painting, we cannot assume that the entire German colony in Venice, both merchants and craftsmen, had commissioned and paid for it. The subject matter, which no doubt was chosen by the clients, includes Mary, Jesus, and St. Dominic distributing rose garlands to a crowd of people led by the pope and the emperor. As this was not a traditional theme either in Germany or Italy, Dürer took as his starting point for the *Feast of the Rose Garlands*, as it is called, an unpretentious woodcut printed alongside a text about the rosary by Jakob Spengler. Right down to the nineteenth century St. Dominic was believed to have introduced the cult of the rosary and the brotherhoods founded to foster it, the Friars Preachers. A very wide variety of brotherhoods were active within the Roman Catholic Church, and many of them brought together people in the same trade. Their members met for divine service and were pledged to offer prayers or other spiritual exercises for the salvation of their brothers. The first Brotherhood of the Rosary was founded in Cologne in 1475 by Jakob Spengler.

Although there is no record of any association of this kind within the German community in Venice, the painting and Dürer's brief comment, in which he does not refer to any specific individual or family as the donor, point to the existence of such an association among members of the German colony under the sign of the rosary, rather like the brotherhoods. The painting might have been made possible by a fund set up by the merchants from Nuremberg who were involved in trade with Venice. The first surviving record of this fund or foundation refers to the year 1434. The aim behind it was to pay a salary to a permanent chaplain for an altar in San Bartolomeo dedicated to the patron saint of Nuremberg, St. Sebald, or St. Sinibaldo as the Italians called him, and to celebrate the saint's feast day on August 19 in suitable fashion from both the spiritual and the secular points of view. At first the accounts for the money collected in Nuremberg and in Venice were kept by the Paumgärtners in Nuremberg; from 1491 to 1515 the trading firm of Konrad Imhoff and Sons was in charge of the fund. The Fuggers in Augsburg were involved in a similar undertaking for an association that was connected with Dürer's *Feast of the Rose Garlands*, which might explain why in 1606 their firm obtained permission to sell it.

The format of the painting, a wide rectangle with no movable side panels, conforms to Italian practice. The imposing way in which the central group of figures is linked together to form a rectangle, with a square within it, formed by the lines connecting the four heads, is also typically Italian. The composition is dominated by the figure of the Virgin Mary on a raised throne in the center. The canopy and the crown, which is a masterpiece of the goldsmith's art in the late Gothic period, emphasize her rank as the Queen of Heaven, while the representatives of Christendom kneel before her. The angel who appears among them, striking his lute in rapturous delight, represents a friendly gesture of reverence to Giovanni Bellini and his altarpiece in the church of the Frari. On either side of this main group, and set back slightly, are the rest of the representatives of humanity. They are

PAUMGARTNER ALTARPIECE
ST. GEORGE and ST. EUSTACE
Oil on panel (lime); each panel
61¾ × 24 in. (157 × 61 cm)
About 1502
Munich, Alte Pinakothek
Like the center panel (p. 75), these side panels were acquired by Maximilian I from the Katharinenkirche in Nuremberg in 1613
The two saints are portraits of Stephan and Lucas Paumgartner, forming the inside of the side panels of the Paumgartner triptych. The outside of the panels originally was painted with an *Annunciation*, but only the figure of the Virgin is still extant. The figure of the angel has disappeared from the right-hand panel
Overleaf: St. Eustace, detail.

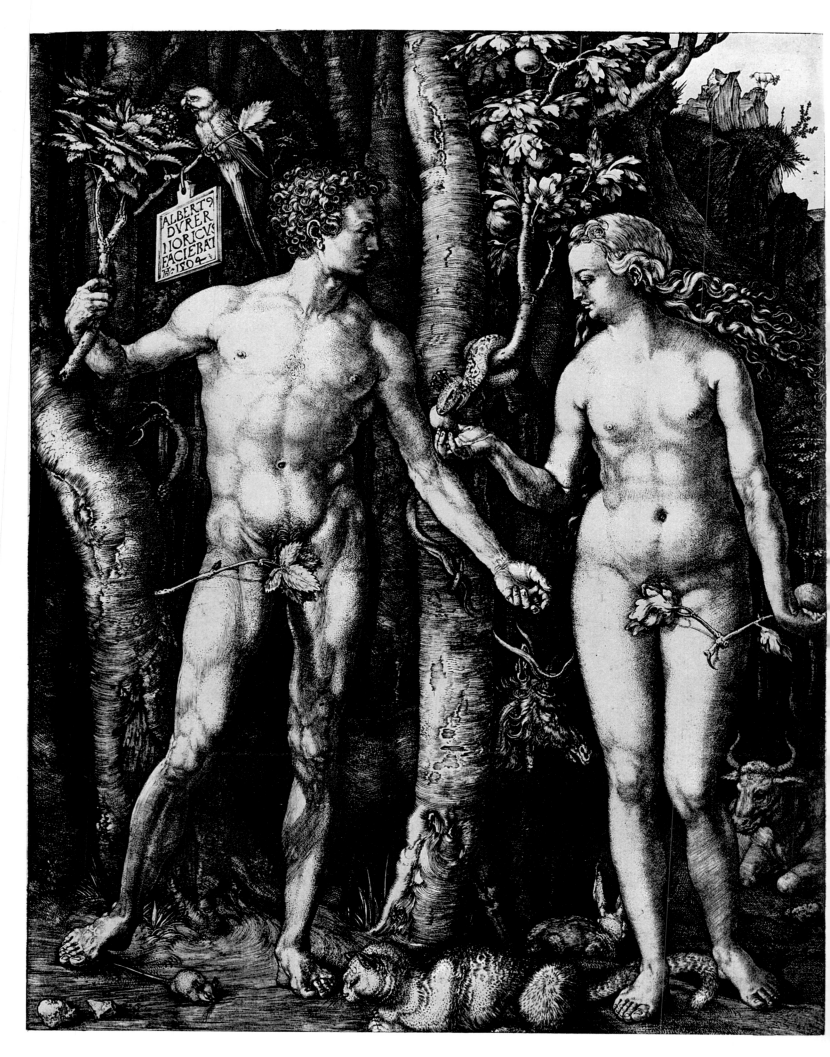

kneeling in rows, and each face is an individual portrait. The figures frequently overlap, which makes the number of worshippers seem greater than it really is if you look more closely. On either side of the enthroned figure of Mary fairly narrow glimpses of an alpine landscape with a southern feeling about it can be seen.

After it had been removed from Venice, the painting suffered considerably. Today it is a ruin, albeit one that is carefully looked after. It has been put together from a mosaic of original and restored fragments, so that although its famous brilliance has survived in small areas, the overall impression it was intended to create has suffered badly. For instance, a wide strip in the middle, including the Madonna, had lost virtually all its original color and had to be restored.

Dürer was particularly proud of his handling of color in this altarpiece, and indeed he managed to impress the Venetians in an area in which they rightly thought of themselves as experts. The jewel-like impression created by the coloring results from his choice of values and the painstaking way in which he applied the paint. The colors are blue and various shades of red in the figures, plus gold on the pope's pluvial and on the angel's garment. The worshippers in dark clothing in the background act as a foil to the very brilliant coloring in the foreground. The dominating color is the blue of the Virgin's robe in the center of the picture. It recurs a few shades lighter in the sky, with the green of the canopy and the trees standing out against it like a trellis. The fact that the human figures are portrayed as individuals helps to make the scene come alive.

The only identifiable figure is the emperor, who is portrayed as Maximilian I. For this portrait Dürer used a study by a Milan artist, probably Ambrogio de Predis (Berlin), as he had no studies of his own to fall back on at that time. De Predis was one of the circle of painters around Leonardo da Vinci and was attached to the retinue of Bianca Maria Sforza, the daughter of the Duke of Milan, who became Maximilian's second wife in 1494. That was how de Predis came into contact with the emperor, and he also worked for him in Innsbruck. It is a profile portrait—a format virtually unknown in Germany but very popular with Italian artists—and that made it easier for Dürer to transfer it to his own painting.

The identity of the other portraits is a matter of guesswork, some of it less than convincing, and the poor state of preservation of a few of the heads makes identification even more difficult—the entire front of the pope's face has been restored, for instance. Also, attempts at identification do not explain why these particular people were chosen or clarify the question of who donated the altarpiece.

Standing apart from the main action, looking straight out from the background, Dürer portrayed himself with another man, who is watching the garlands being handed out. Dürer is holding a piece of paper, and our eyes are drawn toward it to read the Latin inscription: "Exegit quinquemestri spatio Albertus Durer Germanus M.D.VI." ("Albrecht Dürer, a German, completed it in the space of five months. 1506."). Dürer confirmed the inscription and the self-portrait in his letters to Pirckheimer, in which he refers to the painting again and again. He may have stood in just that position watching the doge and patriarch of Venice as they examined his painting. The reference to a working time of five months, which covers only the time spent actually painting it, not the preparation of the first sketches, is intended to emphasize yet again how much trouble he had taken with this altarpiece. In his letters he frequently complains about the time the commission was taking, leaving him with no profit at all because of the expense involved in staying in a foreign town. He had started on the painting later than planned because he was suffering from a skin disease, and he came nowhere near meeting the original deadline of a month after Easter. He did not write home to Nuremberg to announce that the painting was ready until September.

Dürer varied his method of stating his origin. On his Basel woodcut he writes "von Nörmergk." Later this became "Noricus" or "Norenbergensis" when he wanted to describe himself as a citizen of his native town. On two paintings executed in Venice he refers to himself as "Germanus," and on three pictures painted immediately after his stay in Venice he uses

ADAM AND EVE
Engraving; $9\frac{7}{8} \times 7\frac{3}{4}$ in. $(25.2 \times 19.5 \text{ cm})$
The slate on the left bears the inscription: "ALBERTVS DVRER NORICVS FACIEBAT 1504" and the artist's monogram
There are preparatory drawings for the two figures and for the animals in the Pierpont Morgan Library in New York, the Biblioteca Ambrosiana in Milan, and the British Museum.

"Alemanus," which probably should be translated as "South German." The proud use of "Germanus" hints at the sort of patriotic fervor that was encouraged by the humanists and fostered by the idealized picture of the Teutonic people that emerges from Tacitus's work, which was published in Venice in 1470.

Many attempts have been made to identify the man standing with Dürer in the *Feast of the Rose Garlands*, but the mystery never has been solved. If the figures in the foreground really do include portraits of the people who commissioned the painting, it seems likely that the man in the background, like Dürer himself, was not one of them but perhaps influenced the commission or the way in which it was executed.

The reference to the length of time needed to complete the painting links it to another, *Christ among the Doctors* (pp. 102–105), which bears an inscription stating that it was completed in five *days*. Dürer already had depicted the twelve-year-old Christ in the Temple in Jerusalem, arguing with the doctors who were well-versed in interpreting Scriptures. His first attempt was a woodcut in a series on the life of the Virgin. On that occasion he had set the scene in a wide room with pillars and had depicted the room in accurate perspective; by their diminishing size the figures would lead the eye toward the young Christ, who is sitting at a lecturer's desk in the farthest corner of the room. In the new version he abandoned that setting altogether and gave no indication of where the incident was taking place. The only pictorial space is created by the figures, who are thrust into the foreground, and the close grouping around the young Christ. The bottom edge of the painting sharply crops in half two of the doctors and the books they are holding while the heads of the other four touch the top edge of the picture. In the middle of the group, running the whole length of the picture, stands the figure of Jesus with long curly hair and a sad and pensive expression, counting his arguments out on his fingers. The representatives of sheer erudition, sure of themselves, refusing to listen to reason, are interrupting him, trying to break the thread of his argument, gesticulating with their hands, and quoting from the open volumes of Scripture. Only one of the faces, in the top right-hand corner, looks thoughtful, displaying some of the amazement at the Child's wisdom that, according to the evangelist, seized his interlocutors. The twisted features, distorted to the point of caricature, the importunate hands thrusting forward, and the heavy, leather-bound books create an oppressive effect.

Contrary to more recent views, a brief remark by Dürer in a letter written on September 23, 1506, was rightly believed to refer to this painting. It also confirms that it was painted in Venice. Dürer writes to his friend that besides the *Feast of the Rose Garlands* he has finished another painting, "the like of which I have never done before." A piece of paper hanging from the book held by the doctor on the left—he is holding it firmly shut, with his hands folded over it, as the indisputable source of all knowledge—bears the date 1506, Dürer's monogram, and the comment that it represented five days' work ("opus quinque dierum"). The link between this inscription and the reference to the *Feast of the Rose Garlands* having taken five months cannot be a coincidence. *Christ among the Doctors* probably resulted from Dürer's need to do a painting that appealed to his imagination after the rigorous precision required for the larger painting, the "very careful nicety," as he called it in a letter to the Frankfurt merchant Jakob Heller.

Dürer's treatment of the same theme in his life of the Virgin dates from much earlier, which explains why he remarked that he hadn't ever done anything like it. Pictures on the same theme painted at roughly the same time by artists such as Giovanni Bellini and Cima da Conegliano, whose work impressed Dürer, have survived or are known through descriptions of them. They all treat the theme as a half-length composition, which perhaps is based on the painting commissioned from Leonardo da Vinci by Isabella d'Este in 1504.

The crucial factor in Dürer's version is the way the distorted features, which are represented in German art as the expression of moral depravity, have been "psychologized" by Dürer's decision to adapt Leonardo's studies of facial forms and features. Recent research in Italy again has pointed to the German elements in Venetian art, and an awareness in Italy of Dürer's

ADORATION OF THE MAGI
Oil on panel; 39½ × 43¾ in.
(100 × 114 cm)
Bears Dürer's monogram and date (1504)

Florence, Uffizi
Commissioned for the Schlosskirche in
Wittenberg by Frederick the Wise,
Elector of Saxony.

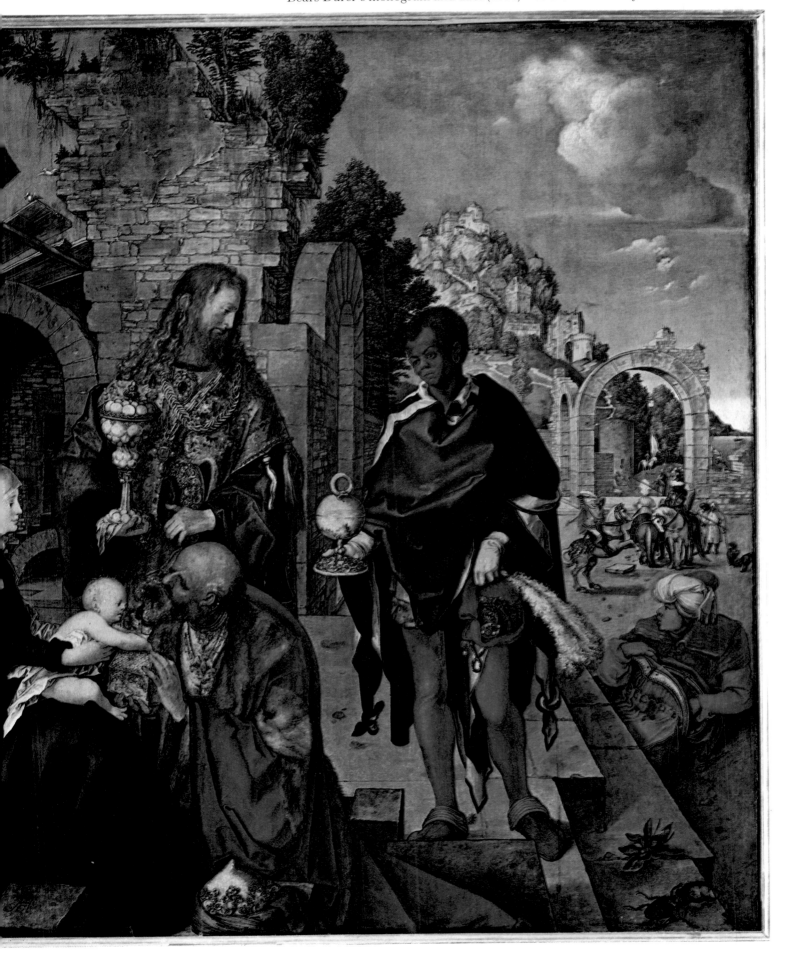

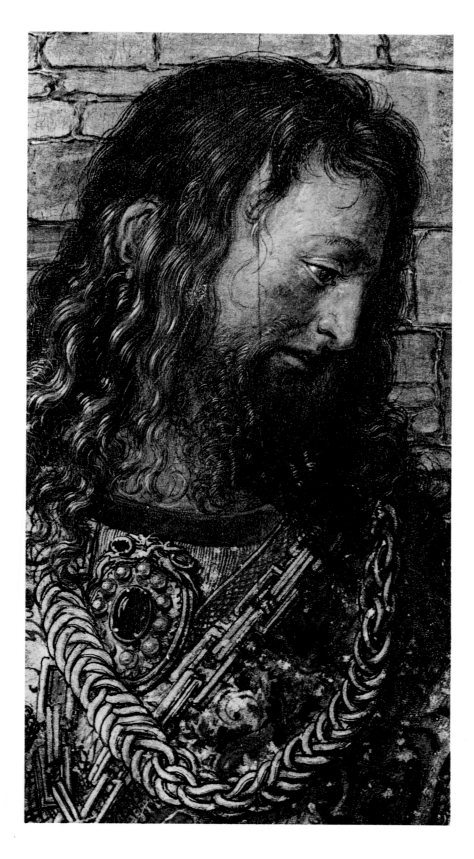

ADORATION OF THE MAGI
Two details
Left: One of the kings
Opposite: Archway with group of soldiers.

DESIGNS FOR GOBLETS
Drawing; $9\frac{7}{8} \times 11$ in. $(20 \times 28\,\text{cm})$
1507–1519
Dresden, Sächsische Landesbibliothek
In the bottom right-hand corner appears the following inscription in Dürer's hand: "morgen willich Ir mer machen" ("I shall do some more tomorrow"). This is a sketch from what is known as the *Dresden Sketchbook*.

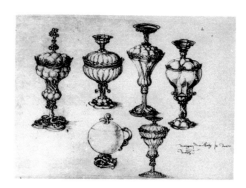

paintings should be seen as decisive proof of such elements. Of course it was the younger generation of painters, men such as Giorgione, Titian, and Lorenzo Lotto, who adapted the "German element" into their own style, not older painters such as Giovanni Bellini.

The Low Countries
Dürer's last long journey was to the Low Countries, where he spent a year at the age of fifty. Even at that age he was open to new people and new forms of art and was capable of using his experiences in his work. The reason for the journey was to persuade the new emperor, Charles V, to ratify the pension

granted to Dürer by his predecessor, Maximilian I. As usual Dürer was worried about his financial situation, and early in 1520 he had written to Georg Spalatin that the town council wanted to stop paying him the annual sum of 100 guilders, granted by the Emperor Maximilian for his great efforts, trouble, and work. "So I am to be deprived of it in my old age and to see the long time, trouble, and labor all lost, which I spent for his Imperial Majesty. As I am losing my sight and freedom of hand my affairs do not look well." It may be that this complaint reached the ears of Charles V via Spalatin's employer, the Elector Frederick of Saxony. At any rate, the emperor ratified his pension in Brussels at the end of August, 1520, and freed the aldermen of Nuremberg from the anxiety of having to compensate for the money they paid out, perhaps from the municipal treasury.

Dürer clearly set off with the intention of spending a fairly long time in the Low Countries, not simply for business reasons since he took his wife and a maid with him, plus a large number of engravings by himself and other artists, which he intended either to give as presents, exchange for other things, or sell. He also kept a diary of his journey, the idea being to keep a careful eye on his accounts—after all, he had to provide for three people in a manner appropriate to their station in life. But the diary also contains longer entries that tell us about his visits to other artists' workshops and what he thought of the masterpieces of earlier Dutch and Flemish painting that he saw.

His experiences in the Low Countries encouraged Dürer to take up his brush and palette once again. In the years before his journey he had neglected painting in favor of drawing, engraving, and theoretical studies. His paintings were all portraits, and the preliminary studies he made for larger paintings on religious themes never bore fruit. Perhaps the reason was that changes in religious beliefs had cast doubt on the justification for painted or engraved images.

If we study the surviving sketches, we can reconstruct three projects that were started when Dürer was still very much under the influence of his experiences in the Low Countries. For instance, a series of sketches dated 1520 and 1521 clearly were intended for a new series of engravings of scenes from Christ's passion, starting with the prayer on the Mount of Olives (Basel, R. von Hirsch Collection; Frankfurt). Then come two different versions of Christ bearing the Cross, which were influenced by Dutch and Flemish models in that they portray the scene as an historical incident with a large number of figures (Florence). The series ends with three sketches of Christ's body being borne to the grave (Florence, Uffizi; Nuremberg (p. 154); Frankfurt). This theme was unknown in German art. German artists had depicted the lamentation at the foot of the Cross or the actual burial while Dutch and Flemish painters had portrayed Christ's friends in funeral processions and had shown them carrying the Savior's body to His grave in a pall.

It is not clear whether a vertical image of the crucifixion was intended as the central image in the sequence, changing the standard format, or was to be issued as a separate engraving. A few proofs of this plate, with not all of the lines included, depict the powerful body of Christ beside the Cross, which is seen frontally, towering over the onlookers. At first only the standing figures of Christ's friends and the Virgin Mary were drawn in, and a blank space was left for the mounted soldiers grouped around their captain.

When he was in the Low Countries or, which seems more likely, shortly after his return home, Dürer was once again busy working on another large altarpiece. Both in its format and in the details of its composition it takes up ideas already expressed in the *Feast of the Rose Garlands*. It contains a mixture of Italian and Dutch and Flemish elements, joining Dürer to a whole string of Dutch and Flemish painters who continued their training in Italy. One of them, the young painter Jan Scorel, had visited Dürer in Nuremberg about 1520, before he continued on to Italy. Dürer met another of them, Bernaert van Orley, in Brussels and did a charcoal drawing of him. Van Orley became court painter to the Stadholder of the Netherlands, the Archduchess Margaret, in 1518 after he had returned from his visit to Italy.

The subject of the new altarpiece was a representative group of saints around the figure of the Virgin in Majesty. Dürer made a number of detail

studies for the figures and parts of their clothing, and he also produced a few variants on the final composition (Paris), including one with the colors he planned to use written in (Bayonne, Musée Bonat). The studies are drawn in chalk on a green or dark purple ground, with certain areas highlighted in white. They are works of art in themselves, and in each case Dürer added his monogram and the date.

The studies for St. Barbara (Paris) and St. Apollonia (p. 153) assisting the Virgin exhibit such a thorough blending of individual characterization with prototypes of a girl growing to maturity that the question of whether Dürer used a model or created ideal figures from his imagination has never been solved. Although the personalities of the women are neutralized by their lowered eyelids, which hide their expression, the faces look so like portraits that they must have been drawn from life. Light shining from behind and beside the half-length figure of St. Apollonia makes parts of the left side of her body and face stand out so brightly that the contours have disappeared, whereas the contours of the areas that are not caught by the light are built up with dark lines of shadow. It seems that Dürer was studying the effect of light—he was far ahead of his time in doing so—by placing his model in front of a window with bright sunlight streaming in. There is no reference to anyone commissioning the altarpiece in the *Diary of Dürer's Journey to the Low Countries* or in any of his letters. If it was intended for one of the churches in Nuremberg, he was too late; the religious requirements for a painting devoted to the Virgin and the saints were now a matter of dispute.

During his visit to the Low Countries Dürer was kept particularly busy drawing portraits—virtually every entry in his diary refers to the completion of one or another. In fact his stay in the Low Countries and the various side journeys he undertook while there were financed by the payments he received for his portraits as well as by receipts from the sale of his prints.

Dürer preferred to use charcoal for the drawings as it is a particularly suitable medium for reproducing forms contoured by light. He did few portraits with a brush since it would require turning to friends and colleagues living in the Low Countries to help with preparatory work on the panel. He does mention a painted portrait of King Christian of Denmark in his diary, and two others also have survived. For the portrait drawings he generally chose a stark, half-length pose ending at the chest and leaving out the arms except for the shoulders. The sitters are placed so far forward that they fill virtually the whole picture area. The fashionable large cap worn by the men is scarcely visible, as it is cut off by the edges of the sheet. Seen so close up, the sitters exude an impression of self-assured masculinity, which is very much in keeping with the outlook of Renaissance man. The painted portraits show more of the sitters, and their hands are visible. Stylistically, Dürer was following the great Dutch and Flemish portrait painters such as Jan Gossart (Mabuse), whose *Deposition from the Cross* he saw in Middelburg (it was destroyed by fire in 1568), and Quentin Massys, whom he visited in Antwerp. But elements of the type of portraiture popular in Nuremberg in earlier times also remain.

The diary entry for March 16, 1521, mentions an oil portrait of a man called Bernhard von Resten, who showed his gratitude by giving Dürer eight guilders and making a present of one crown to the painter's wife, Agnes, and one guilder, worth twenty-four *stuber*, to Susanna, the maid. This is probably the portrait now in Dresden, as the sitter is holding a letter addressed with the words "Dem pernh . . . zw" ("To Bernh . . . at"), though the rest of the address, giving the surname and the place, is hidden by the fingers (p. 163). Attempts at identifying Bernhard von Resten have come to nothing, though a young Danish merchant named Bernhard von Reesen did die of the plague in 1521 at the age of thirty, and records show that Reesen's trading firm had connections with Antwerp a few years later. In those days people were very cavalier about spelling proper names, and, besides, a mistake may have crept in when the diary was copied—the original has disappeared.

As with the drawings, the half-length figure takes up virtually the whole panel in this painting, and the sloping shoulders are pressed against the frame. The oblique angle of the right arm is repeated in the cap, which spans

PORTRAIT OF A PEASANT WOMAN
Charcoal drawing. The background was colored at a later date with green watercolors, except for the inset panel with the date and the monogram; $13\frac{3}{4} \times 10\frac{1}{2}$ in. (35×26.6 cm)
Bears the monogram and the date (1505)
Rotterdam, Boymans van Beuningen Museum
Formerly in the Campe, Vieweg, Eissler, Koenigs, and Van Beuningen collections.

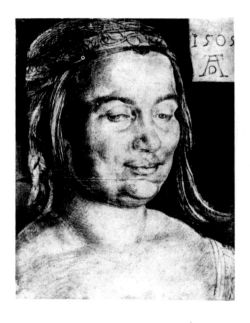

PORTRAIT OF A YOUNG VENETIAN WOMAN
Oil on panel (elm); $12\frac{3}{4} \times 9\frac{3}{4}$ in. (32.5×24.5 cm)
Bears Dürer's monogram and the date (1505)
Vienna, Kunsthistorisches Museum
Was in the Schwartz Collection in Danzig at the end of the eighteenth century, then went to a private collection in Lithuania. Was acquired by the Kunsthistorisches Museum in 1923. The portrait is unfinished; it was one of the first works produced by Dürer during his second visit to Venice.

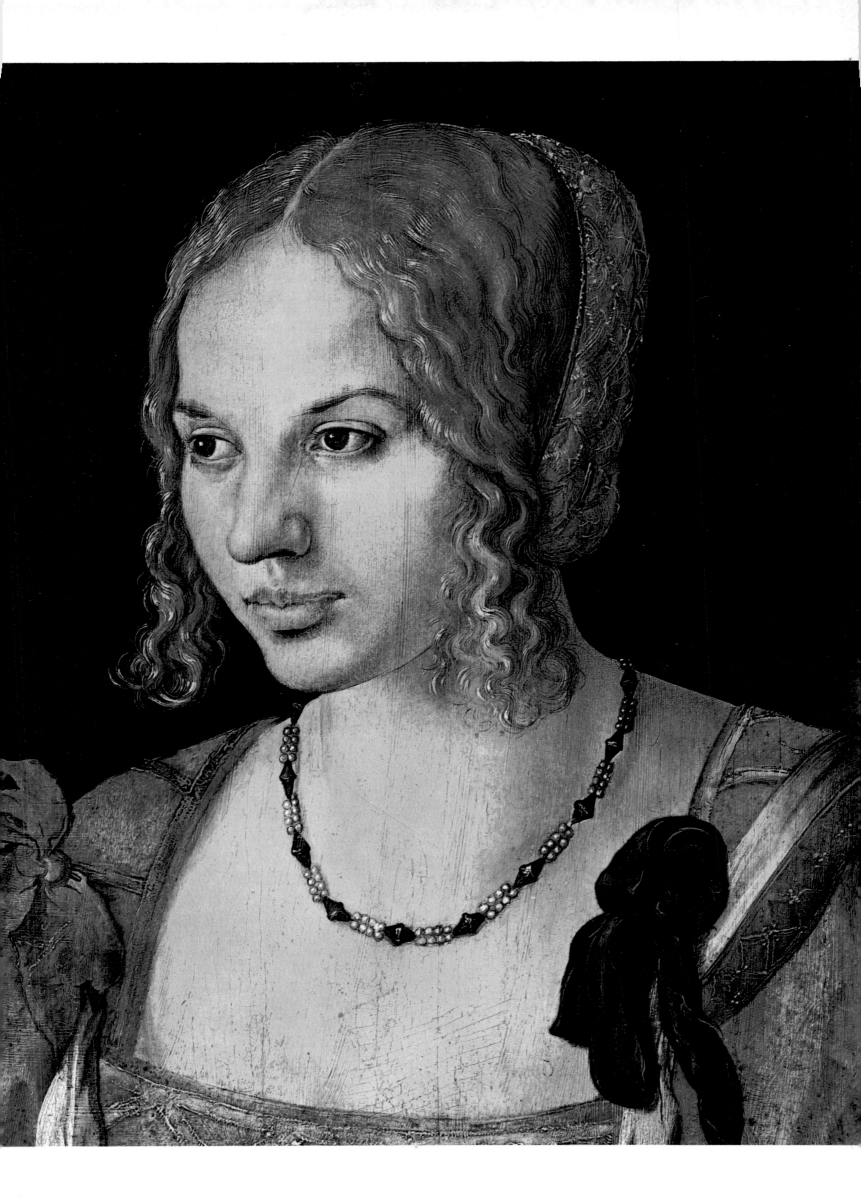

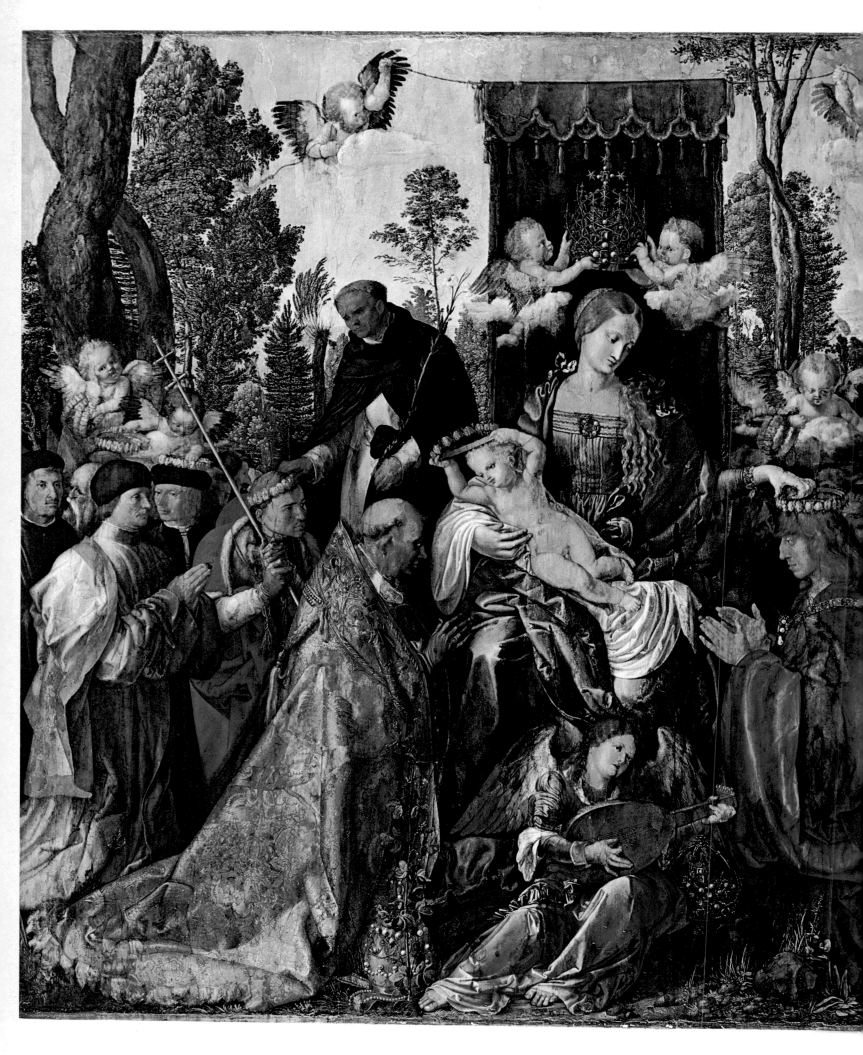

the width of the picture and disappears behind the frame, which forms part of the composition. The right hand, with only part of the fingers visible, lies along the lower edge of the portrait while the thumb and two fingers of the left hand, which is holding the letter, are visible. The sitter's clothing is in the subdued colors fashionable at the time, the only touch of brightness occurring in the white shirt emerging from the dark, fur-trimmed cloak. The only area of color is the subdued brownish red of the background. The face is turned very slightly to the sitter's right and stands out from the shadowy area of the left cheek and the black of the cap and cloak in a patch of brightness, reflecting the white of the neckline. The prominent cheekbones, a determined chin, a broad nose, and the slightly pouting lower lip give character to the face, which is still youthful. The eyes are fixed on some point in the distance and hint at the strain of sitting for one's portrait. The painting is in a good state of preservation —even the top layer of paint —and we thus can see what a marvelous painter Dürer was when he stayed in environments that excited his painter's vision. A veil of soft colored light seems to blend together the shapes and colors of the painting to form a single unit.

The Dresden portrait is closely related to another one of a mature-looking, energetic man who has not yet been identified, though many people have tried to do so (p. 162). The small figures of the date, which are barely visible against the ground, have contributed to this uncertainty. The date used to be read as 1521, and as the portrait seemed related to the ones Dürer executed during his visit to the Low Countries, it was thought likely that the sitter was a prominent figure in Antwerp. But recently experts who have examined the painting believe the date to be 1524, which indicates that the portrait must have been done in Nuremberg. Certain aspects of the style also suggest that it is a late work. The figure has rather more breathing space, the cap isn't cut off by the edge of the picture, and the ground is visible on the left in a gap between the frame and the sitter's upper arm. The left hand holds a rolled up document of some sort. Fashion, too, had to be adapted to fit the composition —the collar of the fur cloak is thrust so far back that instead of a square neckline we have a sharp V-neckline. The play of light and shade on the face creates a self-assured, determined expression. Even the coloring has become harder and is now dominated by the dark green ground. Until some indisputable evidence emerges to identify the sitter, it seems worth considering the idea that the commanding bearing and the strength and energy in the facial expression point to the possibility that the painting is an idealized portrait of Willibald Pirckheimer.

The only painting on a religious theme that Dürer painted in the Low Countries also is based on a portrait drawing. He was always interested in the unusual, and when he was in Antwerp he did a portrait of a man of ninety-three, who, to his amazement, was "still healthy and with all his faculties," as he noted at the top of the sheet. The old man's head, with its long beard and heavily lined face, is drawn with a brush on grayish-mauve paper. Dürer used this very careful and sympathetic portrait in a painting of St. Jerome (pp. 155–157). Whereas his earlier paintings of the saint depicted

THE FEAST OF THE ROSE GARLANDS (THE BROTHERHOOD OF THE ROSARY)
Oil on panel (poplar); $63\frac{3}{4} \times 76\frac{1}{2}$ in. (162×194.5 cm)
Signed and dated on the scroll held up by Dürer, who is portrayed on the right-hand side, leaning against a tree. The inscription reads: "Exegit quinque/mestri spatio Albertus/Dürer Germanus/MDV[I]" ("Albert Dürer from Germany executed this in five months/1506"). The monogram also appears
Prague, Národni Galerie
This painting was in the church of San Bartolomeo in Venice until the beginning of the sixteenth century, then in Strahow Monastery in Czechoslovakia. In 1933 it entered the National Gallery in Prague

The figures on either side of the Virgin represent Pope Julius II (?) and Emperor Maximilian I, with the clergy grouped behind the pope and lay dignitaries behind the emperor. Dürer painted this panel in Venice. It was commissioned from him by members of the German colony there for the church of San Bartolomeo near the Fondaco dei Tedeschi.

Overleaf: Detail.

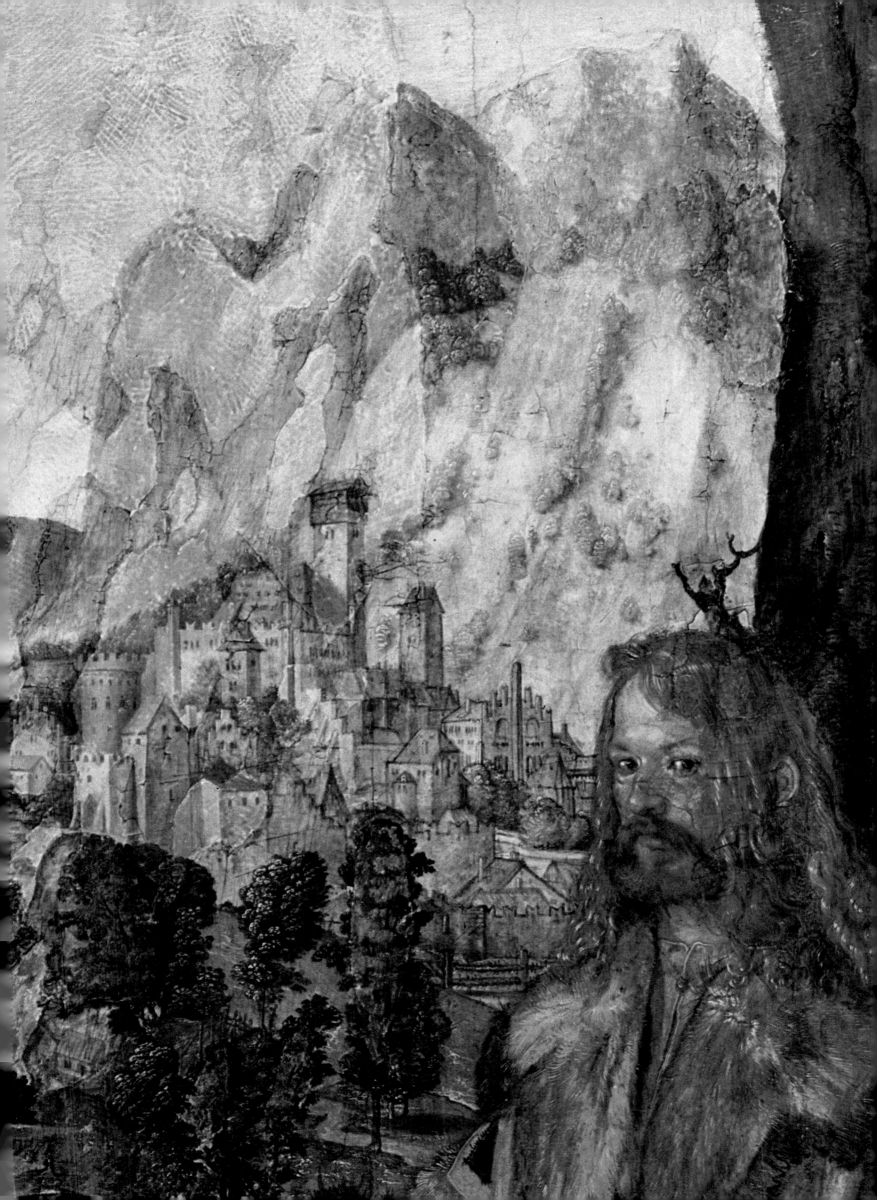

THE FEAST OF THE ROSE
GARLANDS
Detail: Angel making music.

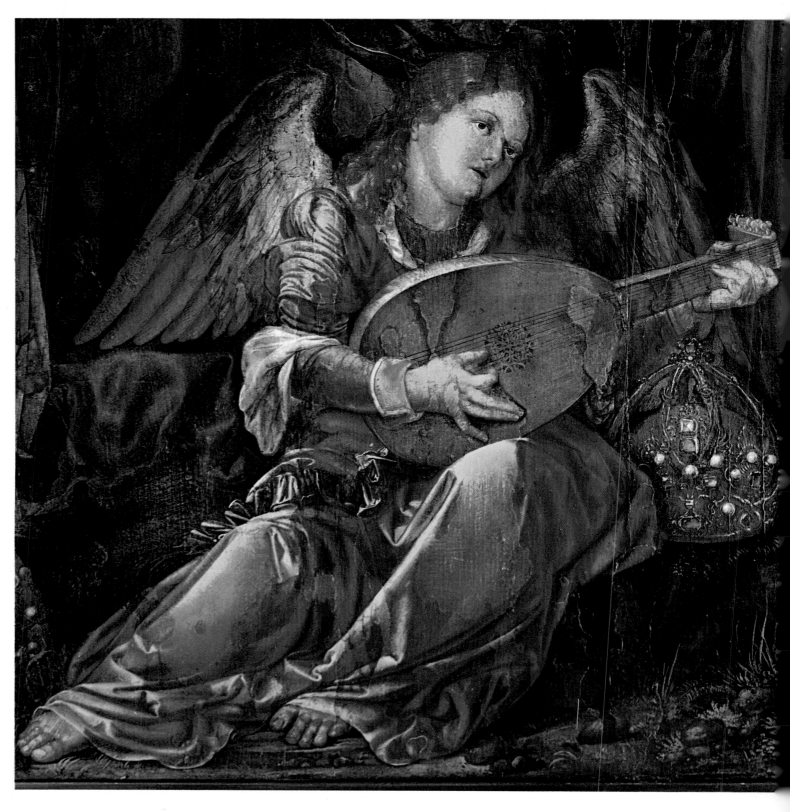

him either as a solitary anchorite flogging himself before a crucifix or as a scholar quietly and contentedly going about his work, this new version juxtaposes the books with a skull. The index finger of the saint's left hand is pointing at the skull, which has slipped in between the open books on the writing desk and the quill pen standing in the ink well. The elderly philosopher with the homely features of the old man from Antwerp has offered his last piece of wisdom in recognizing the transitory nature of all earthly things, which even Christ on the Cross could not escape—indeed our gaze is directed toward the crucifix on one of the pillars.

Dürer notes in his diary that he gave the portrait as a gift to one of his patrons in Antwerp, a rich Portuguese merchant named Rodrigo Fernandez d'Almada, and that in giving it away he was not afraid to point to the futility of all the goods of this world. Although the painting went into a private collection, it must have been widely known, for it was repeated in a large number of variants, chiefly by Dutch and Flemish artists. Its theme was clearly seen as topical since it expressed the antithesis of the *joie de vivre* preached by the humanists.

Dürer's Works

Themes and Techniques

Dürer's work fully uses all of the techniques available to the artist in his day. He took advantage of all the methods of artistic expression, furthering their development by his own important contributions. He was the first artist to produce both woodcuts and copperplate engravings—his predecessors always had attempted only one or the other of these graphic techniques, never both. And he was the first artist to adopt the technique of etching metal, which had been used by the armorers to embellish their products once they had been tempered, with decorative motifs or figures. In so doing he developed several styles that were peculiar to etching. Then, too, the importance of his drawings and sketches is quite unique—almost a thousand of them have survived. Even though they were intended as preparatory drawings for other works, virtually all of them are works of art in their own right, and many of them are signed and dated.

For his drawings Dürer employed a very wide variety of materials and types of papers, thus expanding artistic expression in this medium. For instance, he used charcoal, crayons, chalks, metalpoints, quills made from reeds, brushes, watercolors, and India ink and worked not only on white paper but on various blue Venetian papers, some of which he prepared himself, coloring only one side in various shades. Then for silverpoint work the paper had to be prepared with a special ground. We can differentiate between separate periods when one technique or another seemed best suited to expressing what was most important to him at that particular stage of his career.

Dürer was so skilful at drawing with a brush that all sorts of anecdotes made the rounds, comparing him to the ancient Greek painter Apelles, who was capable of splitting even the finest line drawn by one of his rivals.

For his paintings Dürer used oil and tempera on primed panels made of the local lime wood, of poplar wood during his visit to Italy, and of oak when he was in the Low Countries. But he also used size paints on thin canvas. Unfortunately, many of the paintings involving the latter technique were ruined by the later addition of varnishes containing fat. As a result, only one painting can still give a satisfactory idea of the effect originally created by this technique: an altarpiece in Dresden depicting the Virgin flanked by St. Anthony the Hermit and St. Sebastian (p. 31). This painting was restored after the war, with very successful results.

Different media were used for different subject matter. Christian themes, for instance, were treated both in paintings and in prints. Dürer did think out these themes afresh in each work, but he did not really broaden the choice of subjects. The technique of painting was reserved chiefly for themes relating to the Virgin, whereas Christ's passion was covered in three series of engravings and one series of drawings known as "The Green Passion." He also produced individual engravings of the saints as they were known to the devout in the late Middle Ages—helpmates in times of trouble on earth. People no longer wanted to see images of them, with their promise of protection and solace, only in the form of paintings or sculptures in their local church. They wanted the saints in their homes as well in order to see them every day. And the time had come when printed images—woodcuts certainly—could be issued in very large numbers, providing the printing process was handled properly. Thus ordinary people could have their own private pictures, whereas previously they had belonged only to the Church or various secular or ecclesiastical communities as common property. Furthermore, each individual could use his pictures the way he chose: as a worshipper, an art collector, or a connoisseur.

Of all the non-religious themes Dürer used, the most important was the portrait. He was, in fact, the first German artist in whose *oeuvre* portraits were as important as the traditional religious subject matter—important, that is, both from the point of view of quantity and of the significance he attached to his work in this area. Only a few of his portrait drawings were preparatory sketches intended from the outset to be transferred to a different medium. Many of them were planned as works of art in themselves, and this applies not only to the ones he drew in the special circumstances of his journey to the Low Countries but also to others drawn before and after that visit. In the last ten years of his career Dürer discovered that printing techniques could be used for portraits too. In this he was following in the footsteps of Lucas Cranach the Elder.

Besides plumbing the depths of individuals by means of portraits, Dürer also set out to discover nature. His sketches of entire landscapes and landscape details probably were all intended for his own collection. They included studies of the vast slopes of the stone quarries in the vicinity of Nuremberg, a drawing of a small piece of grass with plants growing from it (known as *The Small Piece of Turf*), and sketches of animals, either alive or pierced with a huntsman's arrow. Most of these sketches were executed in opaque colors or watercolors and could, if occasion arose, be used for a larger work. Yet even when left unfinished, as many of the landscape studies were, they were works of art in themselves, and there was no need to polish them.

The dominant subject matter for Dürer's non-religious scenes was classical mythology. Virtually all of these works took the form of engravings or woodcuts, and they represent an important aspect of his work after he had returned home from his first visit to Venice.

The wide variety of techniques available to Dürer also was used to depict contemporary themes. Virtually all of the themes —especially contemporary mores, including both good and bad customs—that seemed of significance to the generation of "minor masters" who were born at the turn of the century already had been used by Dürer, though they were never a major factor in his work.

He began to show an interest in peasants and village life at an early stage of his career. For instance, in his illustrations for one of Terence's comedies, *Heauton Timorumenos* ("The Self-Tormentor"), the great landowners referred to in the text have become humble peasants. This was the first time a well-rounded picture of village life, with its inhabitants and tools and other equipment, had been portrayed, and although Dürer's prejudices about the peasant class do creep in, his pictures have an authentic ring. Even Dürer didn't quite manage to shake off the stereotyped image of rowdy peasants, always kicking over the traces and ignorant of city refinements based on education and a sense of order.

One theme that could be treated in many different ways was the relationship between peasant men and their womenfolk. Man and wife are seen walking side by side, the man shouting and waving his arms, the woman looking timidly down at the ground; or the couple is dancing wildly with

THE MADONNA WITH THE SISKIN
Oil on panel (poplar); $35\frac{7}{8} \times 30$ in. $(91 \times 76$ cm)
A paper on the little table bears the following inscription in Dürer's hand: "Albertus durer germanus/ faciebat post Virginis/ partum 1506" ("Painted by Albrecht Dürer from Germany in the year of Our Lord 1506") followed by the monogram
Berlin, Staatliche Museen Preussischer Kulturbesitz, Gemäldegalerie.

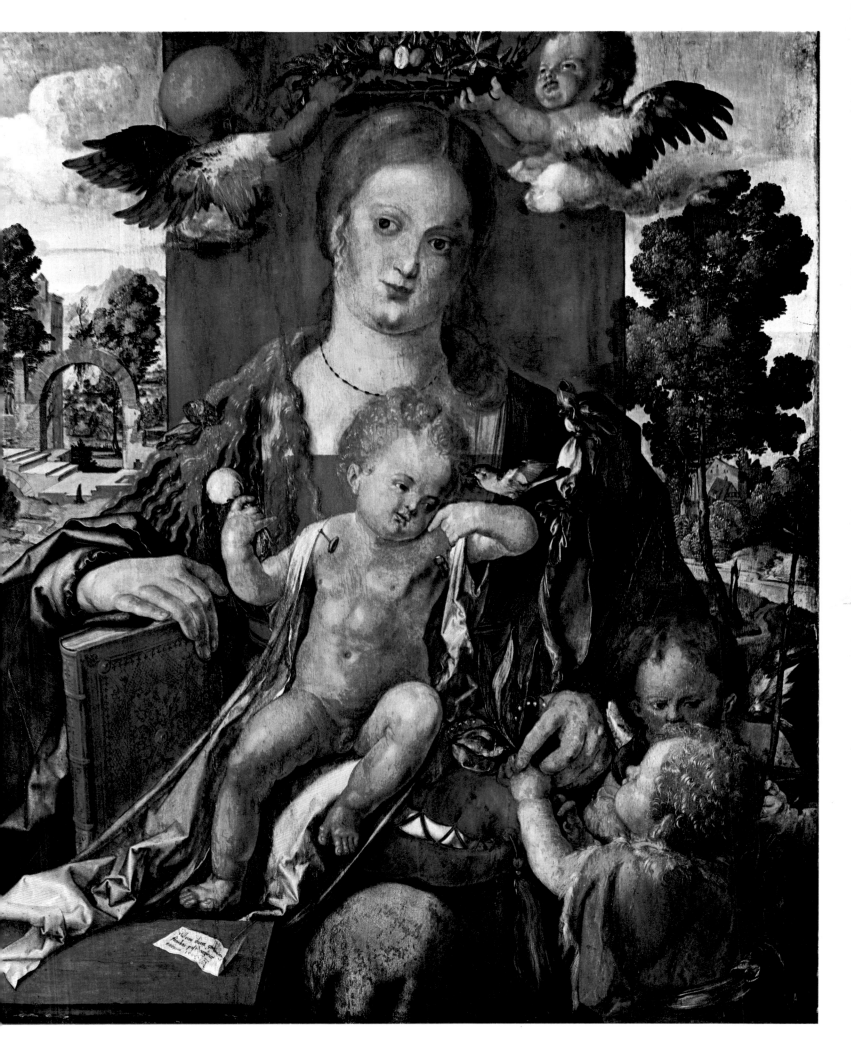

THE MADONNA WITH THE
SISKIN
Detail of the landscape with the ruined
archway.

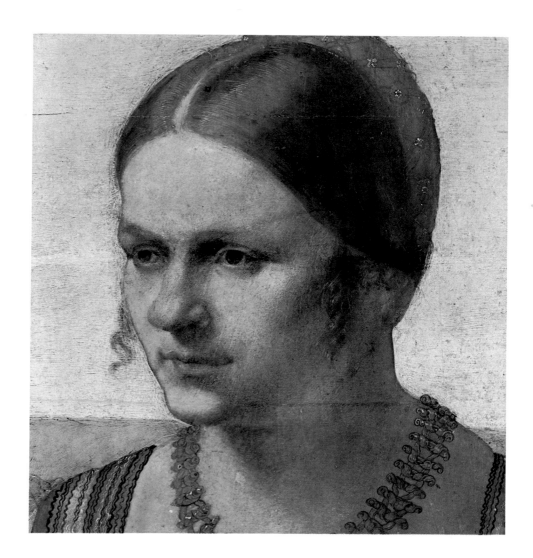

PORTRAIT OF A VENETIAN
WOMAN (Detail)
Oil on panel (poplar); $11\frac{1}{4} \times 8\frac{1}{2}$ in.
$(28.5 \times 21.5$ cm)
1506
Berlin, Staatliche Museen
Preussischer Kulturbesitz,
Gemäldegalerie.

much stamping of feet—some of Dürer's engravings depict just such scenes
(p. 132); or the man and woman are indulging in coarse displays of lust
(p. 69). But whatever they are doing, they always are judged from the
standpoint of the city dweller, with good-natured ridicule. Although Dürer
emphasizes the hard life led by the peasantry and shows them looking
disheveled, often with ragged clothing, he looks with sympathetic eyes at
the individuality of these thick-set figures with their huge hands and angular
faces. No outrages were committed in the Nuremberg area during the
Peasants' War of 1525, and no hideous punishments were meted out. In his
Treatise on Geometry Dürer designed a symbol for the victory over the
"rebellious peasants," along with schemes for erecting various monuments.
In one drawing the shaft of the pillar is made of the standard attributes of
the peasantry. On top is a peasant, subdued now and sitting pensively with
his head propped up on his hand although he has been stabbed in the back
with a sword. Or again, the peasant is seated on a plough that is turned
upside down on top of a market cage containing a hen and a pig. Dürer
clearly felt sympathy for the defeated peasants, and his humane attitude
also can be seen in other scenes of peasant life.

In depicting the peasant's surroundings, with farmyard and village seen
as a haphazard cluster of individual buildings, Dürer used the image of the
Prodigal Son, who must be content with looking after the pigs once his
birthright was lost (p. 29). The scene is no longer the meadow referred to in
the Bible but a farm with a dungheap. The pigs' food has been flung into a
hollowed-out tree trunk, and the suckling pigs are guzzling theirs from a
small trough. The herdsman kneels among the pigs with his clothing tucked
up, his hands clasped, and a long club-like stick over his arm. His face bears a
slight resemblance to Dürer's own features. In his thoughts he is already
back with his father—he has decided to seek him out and beg forgiveness—

and he has sunk to his knees surrounded by pigs. Dürer has depicted the farm buildings in such minute detail, showing exactly what they are made of and what sort of state they are in, that some people have attempted to identify the spot as a farm called Himpfelshof to the west of the Spittlertor in Nuremberg. What we do know is that for this engraving, which dates from 1496–1497, Dürer took as his starting point the overall views of village life that he had used already in the illustrations for Terence's plays. Furthermore, he had visited the local farms when he was making landscape studies in the area round Nuremberg.

The Influence of Classical Art
The individual prints that Dürer produced after his return from Italy in 1496 and over the next few years included a series of woodcuts and engravings concerned with themes taken from classical antiquity and from the Old and New Testaments. The gods and heroes of ancient Rome and Greece, when history and mythology were closely intertwined, had not sunk entirely into oblivion in the Middle Ages, and many traces of them may be found in medieval art. The humanists' rediscovery of classical authors and their searching examination of their work resulted in the emergence of a wealth of new pictorial themes that must have been familiar to a wide circle

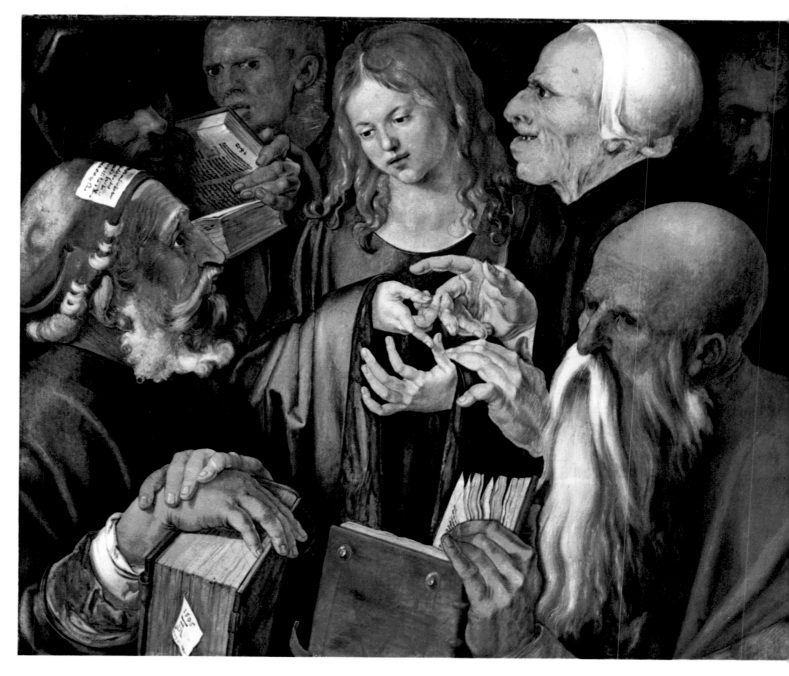

CHRIST AMONG THE DOCTORS
Oil on panel (poplar); $26\frac{5}{8} \times 31\frac{5}{8}$ in.
$(67.5 \times 80.4$ cm$)$
A piece of paper sticking out of one of
the books bears Dürer's monogram and
the date (1506), plus the inscription:
"opus quinque dierum" ("the work of
five days")
Lugano-Castagnola, Thyssen-
Bornemisza Collection
Painted in Venice – in five days accord-
ing to the inscription – during Dürer's
second visit to Italy. Formerly in the
Palazzo Barberini in Rome.

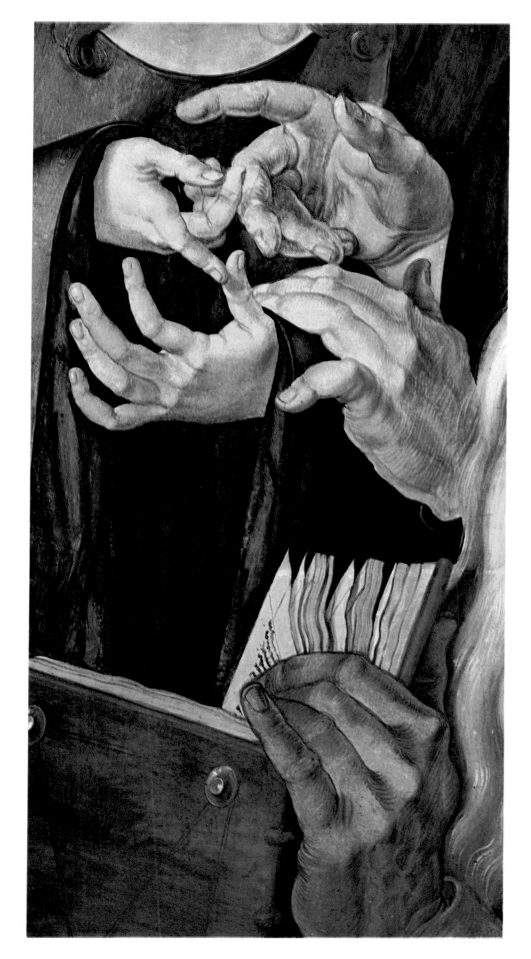

CHRIST AMONG THE DOCTORS
Detail
Overleaf: Two heads.

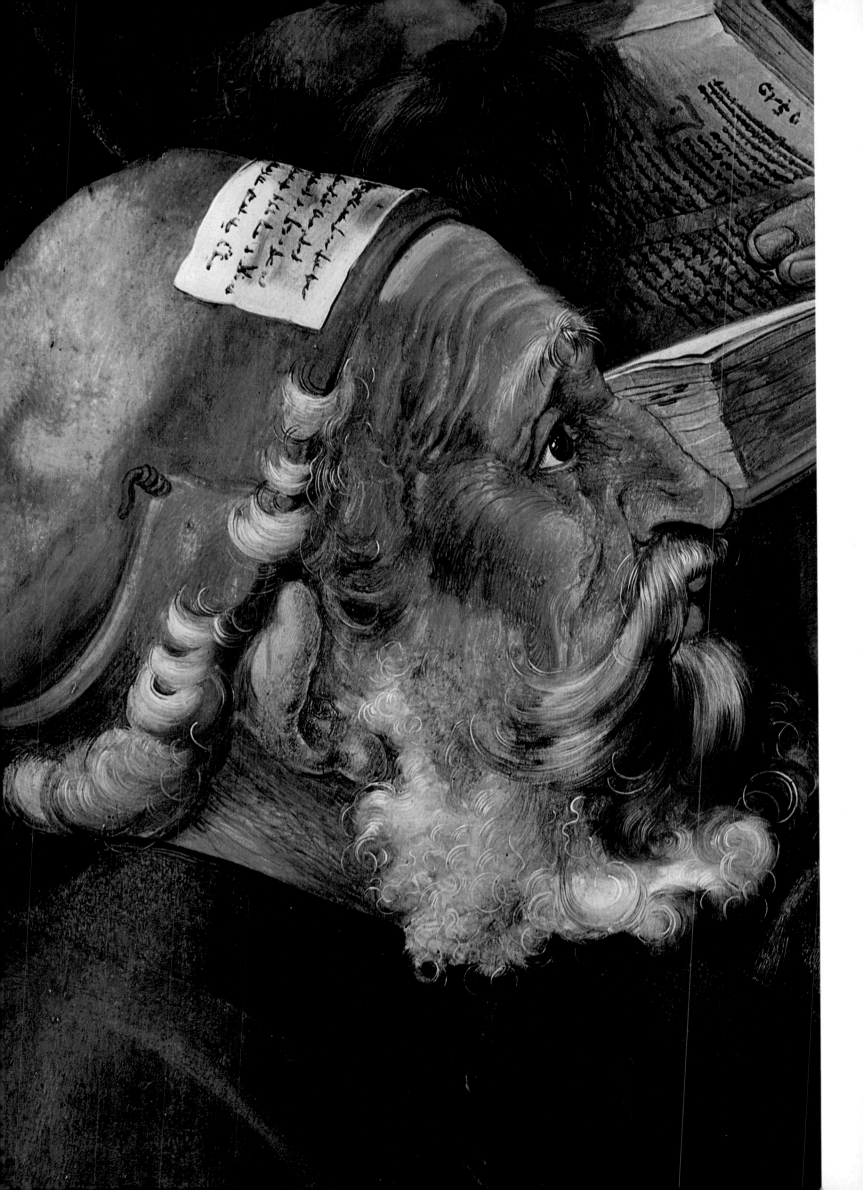

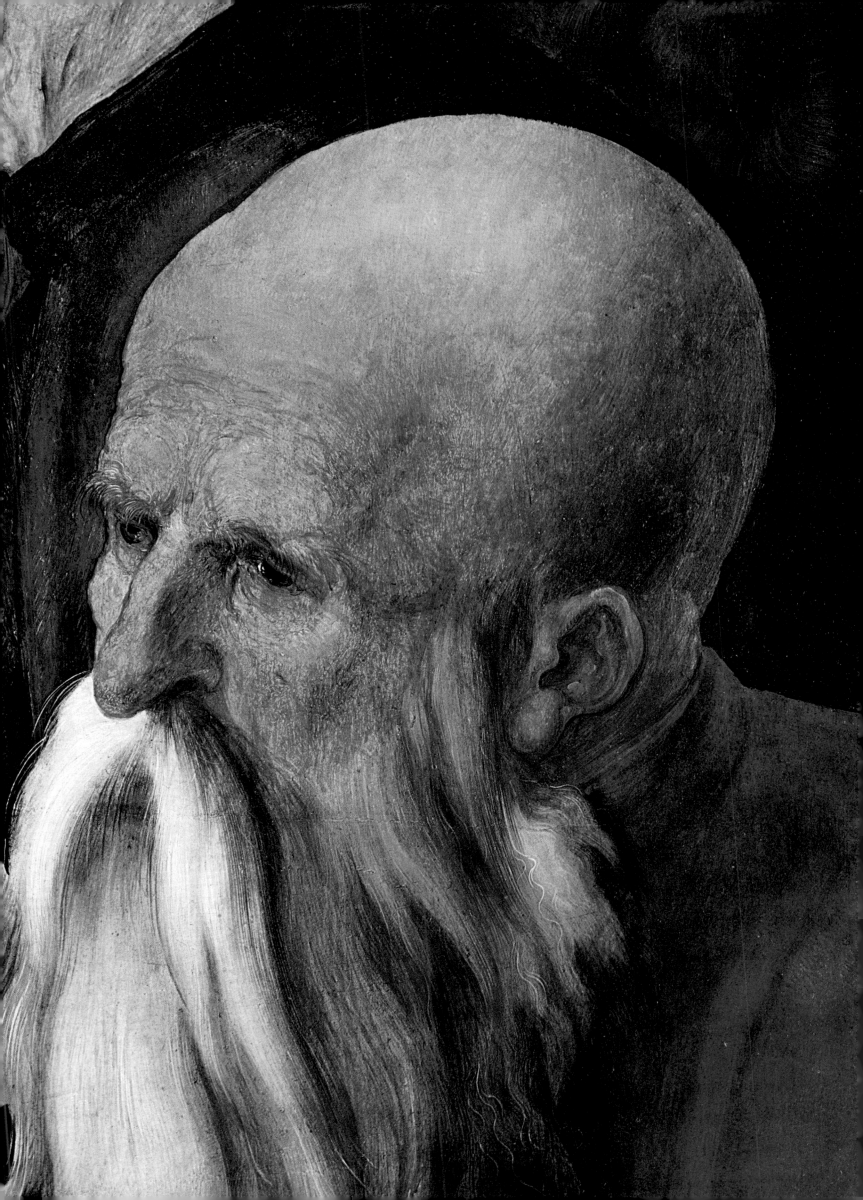

of interested people. Yet the material selected was only rarely the same as the figures and incidents that have become familiar to us through nineteenth-century collections of the legends. Thus it often was difficult to interpret the incidents depicted by Dürer, and although recent research has managed to identify some of them, a large number of doubts and ambiguities remain.

The Renaissance humanists were interested primarily in the literary aspect even when they studied the art that had survived to their day, the most important examples being sarcophagi and tombs. There was no interest in harking back to the pictorial traditions of classical antiquity, and indeed this would have been difficult since the vases and frescoes bearing illustrations of Greek mythology dating from the archaic and classical periods had not yet been excavated. Instead, fifteenth- and sixteenth-century painters were influenced by the techniques used by the sculptors of classical antiquity. Some classical groupings and single figures that had survived clearly had a direct influence. One particularly important example is a statue of Apollo in the courtyard of the belvedere in the Vatican, known simply as the *Apollo Belvedere*. It is a Roman copy of a Greek statue dating from the end of the fourth century B.C.

Dürer, too, had seen drawings of this statue. In his eyes classical themes were inextricably bound up with the study of the human figure, particularly the nude. One engraving, known as *The Four Witches*, was used initially to depict three different views of a female nude (p. 35), for which Dürer probably referred back to studies he had made in Venice, using the same model in several different poses. The nudes are seen in an empty room, with an object that looks like a lamp hanging from the ceiling. It bears the date 1497 and the initials "O.G.H." The engraving is dominated by the three figures, but there is also a fourth nude who is half hidden by the main group and standing so much in shadow that only parts of her body and limbs can be picked out. A rectangular opening in the left-hand wall has flames licking halfway up it, with the head of a demon visible among the flames.

In this engraving the fires of hell and the devil are juxtaposed with a blatant display of feminine charms. The pose of the three women is clearly based on the myth of the Judgment of Paris—the shepherd forced to decide which of three goddesses, Juno, Minerva, or Venus, is the most beautiful. His decision—in favor of Venus—led by roundabout means to the outbreak of the Trojan War. Dürer identified his three women as the goddesses who took part in this momentous contest by giving them various attributes. Juno, Jupiter's wife, wears a coif, which is the symbol of a married woman; Minerva, the goddess of the arts, is adorned with the poet's laurel wreath; while Venus's only attribute is the total nudity with which she turns to face the spectator, who must play the part of Paris. She is wearing a sort of kerchief hanging down from her head and trailing over her left shoulder, but it conceals little.

The most recent interpretations of this engraving, which we have followed here, suggest that the fourth woman is the Goddess of Discord, who gave rise to the dispute when she threw a golden apple bearing the words "For the Fairest" among the gods attending the wedding of Thetis and Peleus. The infernal region with the sea of flames is therefore seen as Hades, which devours the victims of discord, namely, the heroes who die in battle. When Homer has Odysseus descend into the underworld he meets them there, leading a joyless existence. If this interpretation is correct, it shows—and this also may be seen in other mythological scenes depicted by Dürer—that the artist took a careful look at classical mythology and its interpretations before he depicted incidents from it; Dürer did not simply repeat what he had read. When Lucas Cranach the Elder depicted the Judgment of Paris in a 1508 woodcut and later in numerous paintings of the same subject, he did not try to analyze the classical myth but rather took as his starting point a medieval novel about Troy, Guido da Columna's *Historia destructionis Troiae*. The tale has been transposed into the setting of a German landscape and becomes the subject of a dream experienced by a traveling knight. Cranach the Elder also embellished the unfamiliar and shocking nudity of female bodies with moral statements, thus completely transforming his classical subject matter.

HEAD OF A NEGRO
Charcoal drawing; $12\frac{5}{8} \times 8\frac{5}{8}$ in.
$(32 \times 21.8 \, \text{cm})$
The date (1508) and the artist's monogram are inscribed along the top edge but may not be in Dürer's hand
Vienna, Graphische Sammlung, Albertina.

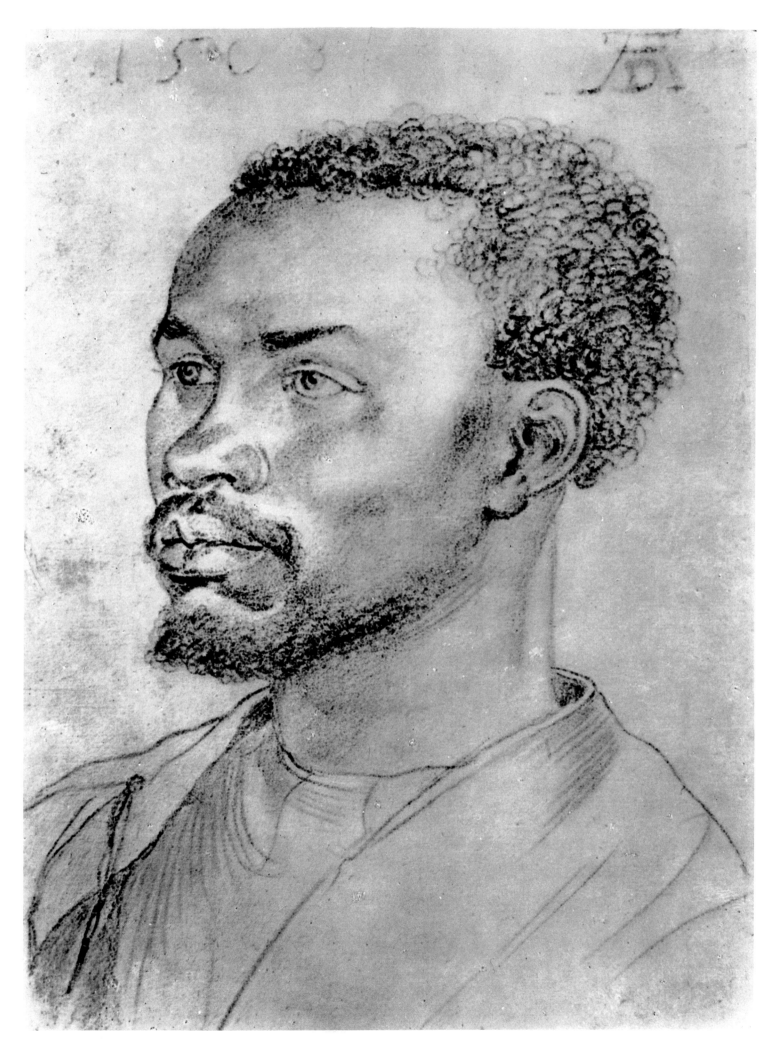

107

Dürer also combines figures from classical mythology with present local surroundings. In one engraving, which he refers to as *The Sea Monster* in a diary entry detailing the sale in the Low Countries of a large number of engravings (p. 40), a creature who is half man and half fish abducts a young woman as she is swimming with her friends, who are wailing and crying as they try to reach the shore. The father, dressed in Turkish clothes, is rushing toward the sea, waving his arms in the air. A mountain forms the backdrop to this scene. Between its precipitous slopes and the sea stretches a walled castle with a great hall and a large number of other buildings, while another fortress is perched on the mountain top. Both the mountain and the castle are quite alien to the Greek setting of the story, and elk antlers sprout from the water god's head instead of the lobster claws of classical legend.

Dürer's disparate couple is based on ancient Greek and Roman tombs and mosaics, depicting sea nymphs and all sorts of male sea creatures making merry. The erotic element in the meeting can be explained by the inclusion of Venus. Dürer must have come across creatures that were a cross between men and fish and bearing beautiful women on their backs in an engraving by Mantegna, of which he made a copy. But this clearly was not his only source since Dürer's hybrid creatures are not the same. The engraving's traditional title refers only to the fish-man, which suggests that it was not based on any particular classical myth of a woman being abducted or of tritons and nereids making merry. In drawing the woman with the semi-upright top half of her body resting on her seducer's shoulder, Dürer chose the reclining position that already had preoccupied painters of the *quattrocento* and was to become popular in the next century as a nude pose.

Another mythological scene also makes it clear that Dürer's aim was not so much to transform literary material into pictorial images as to investigate and record various positions of the human body and their effect on the interplay of the limbs. He turned to myths whenever he felt that they were convenient vehicles for interpreting the figures and groups he wanted to portray. In so doing he first studied the myths carefully and then modified them. Thus he never created a series of illustrations on related mythological themes as he did for his religious subject matter.

We can perceive the originality of Dürer's interpretation of classical myths if we study an engraving entitled *Jealousy*, which is in fact based on a more recent interpretation of the well-known story of Hercules at the Crossroads, i.e., the parting of the ways between good and evil (p. 46). The myth, by providing a theme, enables him to group nude and clothed figures in a variety of poses. The right-hand side of the engraving consists of a powerful rear view of the hero in an attacking posture. Dürer did not use any life studies for this figure, or at any rate that was not all he used. The engraving most likely was based on a small bronze made by someone in the circle around the Florentine goldsmith, painter, and sculptor Antonio del Pollaiuolo. Beside Hercules appears the full-length figure of a woman who is swinging her arms back to strike a blow with a strong branch, which she is gripping firmly with both hands. She is wearing a belted, sleeveless garment that reaches to the ground, the sort of thing worn by ancient Greek or Roman figures and also seen in fifteenth-century Italian paintings. The contours of her body are revealed by the way the drapery falls, but the ornamental folds seen in Gothic art, which seem to have a life of their own, have more or less disappeared except for a small area where the drapery is gathered up on the ground. The garment is slit at one side to reveal her left leg, which is slightly in front of the right leg. As she prepares herself for the blow, her whole body is twisted around. Her intended victim is a naked nymph who has found a comfortable spot in a thicket and is lying there with a satyr. Frightened by this surprise attack, the nymph has raised her arm in self-defense. On the right-hand side we see a naked cupid running away with a bird in his hand.

Various ways of depicting figures have been brought together here to create a whole scene. Standing and reclining figures, seen from in front and from behind, nude figures and clothed figures, all act out the drama in the shelter of a tree, which serves as a backdrop. A mountain and river landscape can be seen in the distance. *Voluptas*, standing for unbridled sexual passion whose sole aim is fulfillment, is being attacked by *Virtus*, in whom virtue is

ADAM
Oil on panel (pine); $82 \times 31\frac{7}{8}$ in.
$(209 \times 81$ cm$)$
1507
Madrid, Prado
The monogram can be seen in the bottom right-hand corner. Presented by Queen Christina of Sweden to Philip IV, together with the companion painting of Eve. Both paintings were in the Academy from 1777 to 1827, when they went to the Prado.

EVE
Oil on panel (pine); $82 \times 32\frac{3}{4}$ in.
$(209 \times 83$ cm$)$
The little panel hanging from the apple branch bears the inscription: "Albertus dürer alemanus/ faciebat post virginis/ partum 1507" ("Painted by Albrecht Dürer of Germany in the year of Our Lord 1507") and the monogram
Madrid, Prado
Overleaf: Detail.

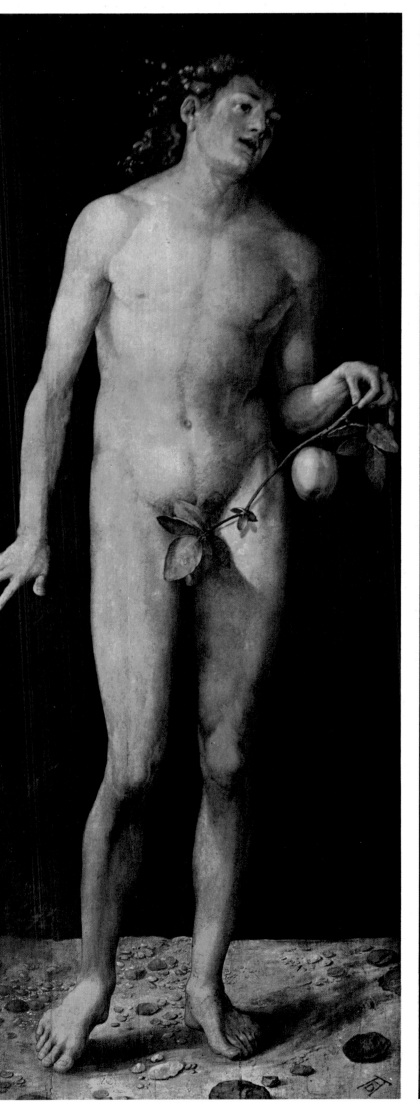
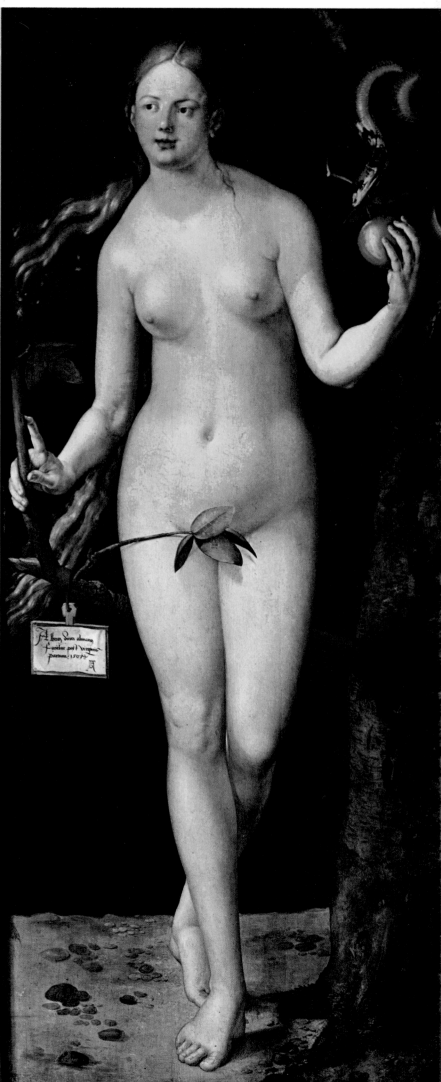

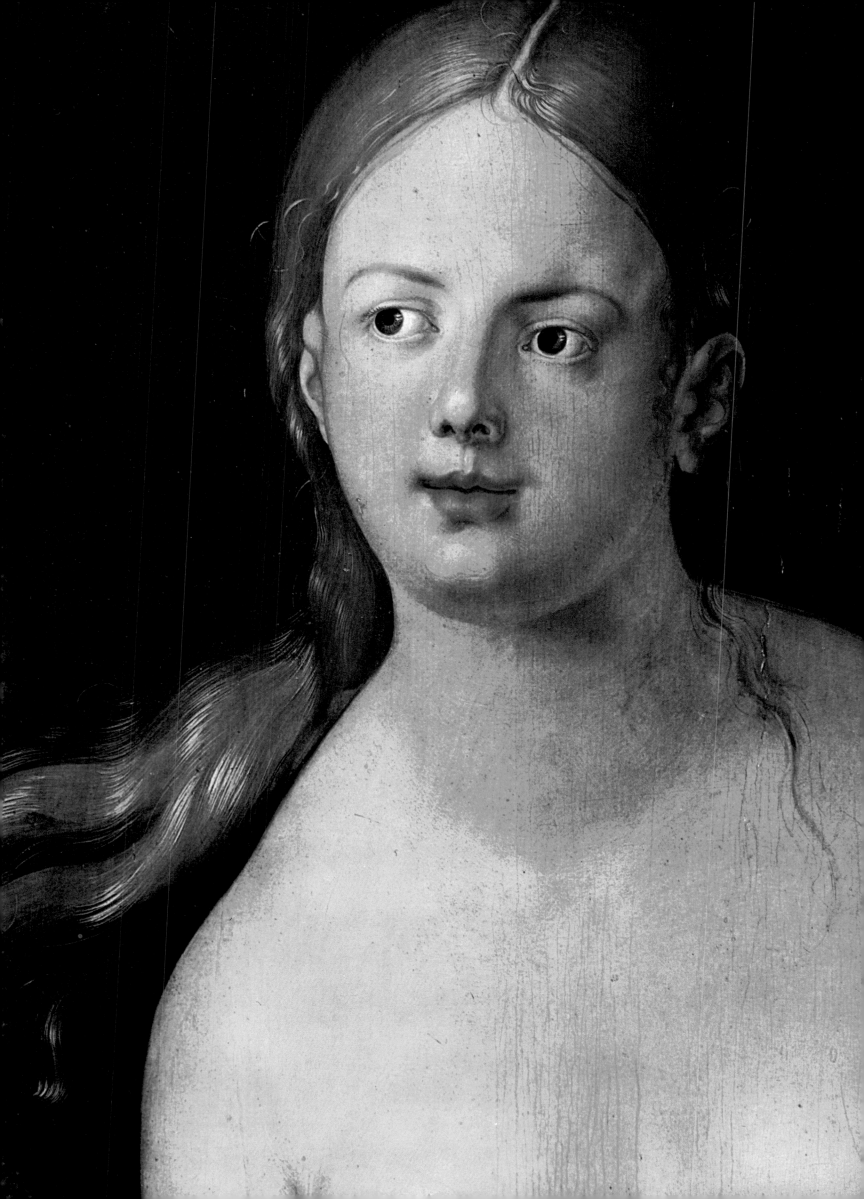

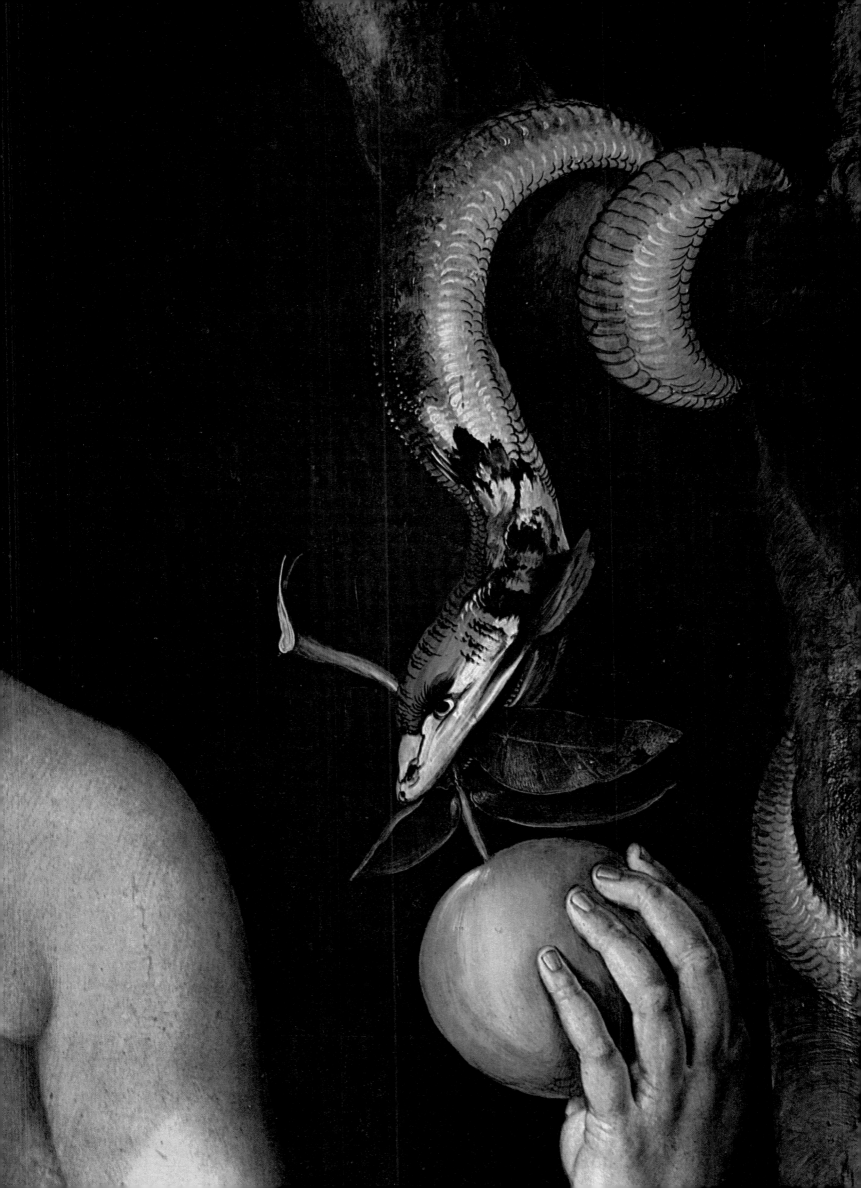

THE MARTYRDOM OF THE TEN THOUSAND

Oil on panel transferred to canvas;
$39 \times 34\frac{1}{4}$ in. (99×87 cm)
Signed and dated (1508)
Vienna, Kunsthistorisches Museum,
Gemäldegalerie

Painted on commission from Frederick the Wise but subsequently came into the collection of Cardinal Granvella. Emperor Rudolf II acquired it in Besançon in 1600 from the cardinal's nephew, the Count of Cantecroy. The Albertina in Vienna has a preparatory drawing of c. 1507, and an engraving of 1498 depicts the same subject.

The incident that provided the inspiration for Dürer's painting is the martyrdom of ten thousand Christians on the orders of the emperors Hadrian and Antoninus. Dürer portrayed himself in the center of the composition. He is standing with a friend (see detail on right) and holding a little banner bearing his monogram and the inscription: "Iste faciebat ano domini 1508/Albertus Dürer alemanus" ("Albrecht Dürer from Germany painted this in the year of Our Lord 1508")
Right and Overleaf: Details.

equated with action. The engraving differs from the traditional myth in that the two reclining figures are not turning eloquently toward the hero, trying to win him over to their outlook on life. Virtue has not come down from her fortress to dispose of her enemy with words but instead relies on a surprise attack. Dürer has appealed to Hercules to put an end to the unequal struggle by acting as arbitrator. The way in which the hero is brandishing his club — which is in fact a tree trunk torn from the ground — holding it horizontally above his head with both hands, suggests that he is not going to intervene on one side or the other. He is in fact using the primitive weapon rather as a herald uses his staff in a tournament to separate the jousters so that the verdict may be pronounced and the winner proclaimed.

We might describe a female nude that Dürer drew for one of his etchings almost twenty years later, in 1516, as a reclining figure in motion. In this work Dürer transformed the clear light emanating from the classical myths into the shadowy twilight of the rampant German and Celtic popular legend (p. 137). Against a background of clouds gathering for a storm and taking a

spherical shape, a bearded man with hair licking around his head like flames abducts a naked woman on a frantically galloping unicorn. The woman is putting up a fierce struggle—drawing her legs up, waving her arms in the air, and screaming for help. But she is unable to free herself because the man is holding her tightly around the waist. Dürer clearly had no literary source for this scene, which can be interpreted in many ways. In the background is an image of the "Wild Huntsman," a mythological creature who symbolizes lawlessness. He is drawing near, spreading fear and destruction in his path. One recent interpretation suggests that the fact that the woman is naked indicates that she is a witch and is being forcibly dragged into the kingdom of the "Wild Huntsman."

In this engraving Dürer has moved away from classical antiquity in technique as well as in subject matter. In fact, the content and the technique have affected each other. Compared to the unequivocal line used in engravings, the technique of etching, which Dürer experimented with between 1512 and 1516, allows the artist to use line expressively and to differentiate strongly between light and dark areas. It is, therefore, well suited to the theme, which undoubtedly influenced its choice.

After his second Italian journey, nude studies from life no longer were as important for Dürer. Even the bodies in the *Abduction of Proserpine* probably were not based on life studies but rather created from memory, with Dürer drawing on his knowledge of form. The steed is a cross between a horse and a goat with one short, downward curving horn growing out of its forehead. As with so many of the fantastic creatures he drew, Dürer has managed here, too, to convince even the educated spectator that a fabulous creature of this kind might indeed exist. He achieves this verisimilitude by his accurate observation and reproduction of natural shapes and forms. The creatures conjured up from his imagination are not basically different from the ghostly figures depicted in medieval images of hell and temptation or

Left
THE FLIGHT INTO EGYPT
Woodcut; $11\frac{3}{4} \times 7\frac{7}{8}$ in. (29.8×20.1 cm)
Published before 1511, without text
The monogram appears in the bottom left-hand corner
This is one of 20 woodcuts (No. 14 to be precise) that make up the cycle known as *The Life of the Virgin*, executed between 1501–5 and 1510. Dürer made a large number of preparatory drawings for this cycle. The whole series was published in book form in 1511, accompanied by a Latin text.

Right
THE ARREST OF CHRIST
Woodcut; $15\frac{5}{8} \times 11$ in. (39.7×27.9 cm)
The monogram appears in the bottom left-hand corner, and the date (1510) at the top
Like the next two illustrations, this woodcut is part of a cycle of twelve woodcuts depicting incidents from Christ's life and passion. The first seven blocks of this cycle, known as *The Great Passion*, were made between 1496 and 1499; the remainder were added in 1510–1511.

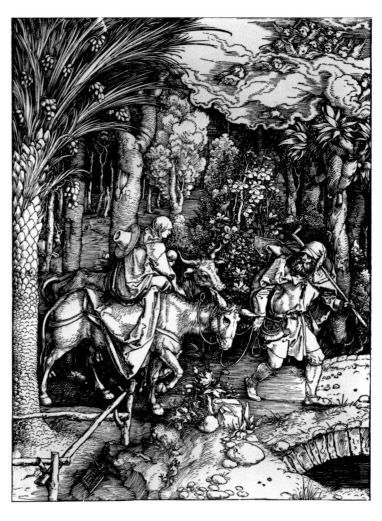

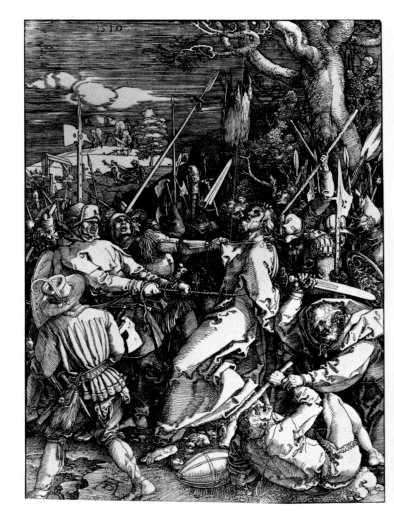

indeed from the apparitions and phantoms created by his contemporaries Matthias Grünewald and Hieronymus Bosch.

Classical subject matter plays only a minor part in Dürer's paintings. One canvas, dated 1500, does depict Hercules fighting the Stymphalian birds (Nuremberg, Germanisches Nationalmuseum). This may have been commissioned by Frederick the Wise, for when his castle at Wittenberg was decorated, the paintings included a series of scenes taken from classical mythology, among them the *Labors of Hercules*.

The second painting on a classical theme is dated 1518 and depicts Lucretia committing suicide after being raped by Sextus Tarquinius (p. 146). This subject is one of those exceptional, exemplary deeds performed by the men and women of ancient Rome that were still widely known in the Middle Ages and often used as a subject for paintings. Renaissance painters normally depicted Lucretia in the nude, the idea being, as with other subjects, to neutralize the sensuality of the bare flesh by the moral tone of the subject matter. (A later painter made the garment draped over the lower half of her body wider and concealed the entire image behind a Lucretia painted by Lucas Cranach (Munich), to which clothing was added later.)

The life-size figure of Lucretia is Dürer's only painted female nude apart from his *Eve* in Madrid. Preparatory drawings dated 1508 (Vienna) show that he originally intended to paint her immediately after depicting Adam and Eve, but for some unknown reason he did not do so until 1518. The happy mood in which he painted the Madrid pictures, while still stimulated by his experiences in Venice, was now over. Whereas in some indefinable way his early prints and drawings came close to the spirit of classical Greece, little of this mood is felt in the nude figure of Lucretia, who in her composition and coloring appears oddly embarrassed in the homely bedroom with its accoutrements.

Left
CHRIST BEARING THE CROSS
Woodcut; $15\frac{1}{8} \times 11\frac{1}{8}$ in.
(38.4×28.3 cm)
The monogram appears at the bottom edge in the center
This is the seventh woodcut in the cycle known as *The Great Passion*.

Right
CHRIST IN LIMBO
Woodcut; $15\frac{5}{8} \times 11\frac{1}{4}$ in.
(39.6×28.4 cm)
Bears the monogram and the date (1510)
This is the ninth woodcut in the cycle known as *The Great Passion*.

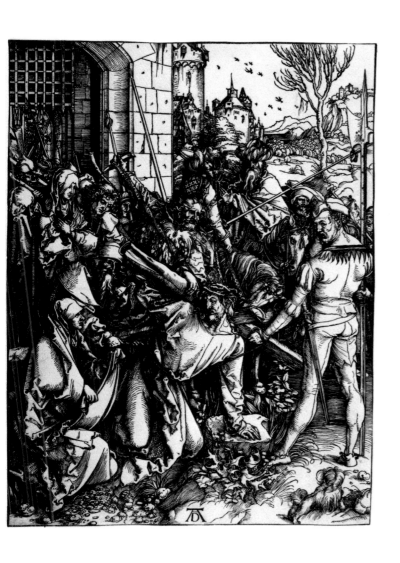

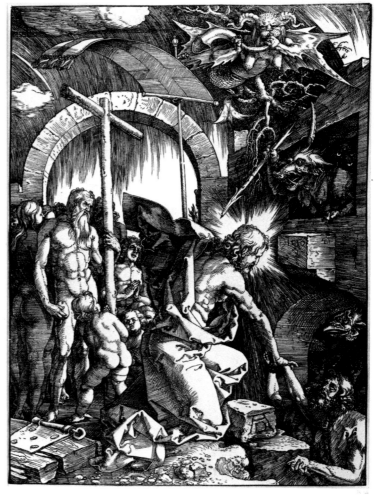

Constructional Figures

As Dürer's interest in studying and portraying the naked human body in motion diminished, he turned less and less often to mythological and related themes. Instead, he concentrated on constructing the human figure in proportion and, probably under the influence of Leonardo, on the structure of horses. The tradition in which Dürer had been trained occasionally did require constructing a work of art in proportion. The building workshops, which were inevitably concerned with geometric designs, were the first to point to ratios between lines. From this there developed a system whereby objects, too, were built up on the basis of correctly proportioned geometric figures. In a book called *Geometria Deutsch*, published in 1498 in Nuremberg, Matthias Roriczer, an architect, showed how a jousting helmet could be constructed by means of a square and a grid, using a system of coordinates labeled with letters of the alphabet. It is odd, to say the least, that at roughly the same time Dürer did a large and very painstaking wash drawing showing three views of a jousting helmet (Paris, Louvre); we cannot now tell whether he used geometric lines to get the proportions right. On the other hand, it can be shown in fact that the head and shoulders of the 1500 self-portrait (p. 52) are built up from a square, a triangle, and a circle—all contributing greatly to its hieratic quality.

Dürer must have become familiar with the basic principles of working with a pair of compasses and a ruler when he was an apprentice in his father's goldsmith shop, and he based his first anatomical studies of male and female bodies on geometric figures. In doing so he also aimed to work out the contours, not just the dimensions, of the body mathematically. Yet he had no native German tradition to fall back on when, as a means of constructing the ideal body, he experimented with calculating anatomical dimensions on the basis of proportion.

The instruction Dürer received from the Venetian painter Jacopo de' Barbari didn't tell him what he needed to know, so he turned to Vitruvius's *Architectura*, which in fact is concerned solely with the male figure. Vitruvius started with the overall stature and worked out the measurements of the various parts of the body as fractions of the whole figure. To begin with, Dürer, too, followed this method. Then in the second book of his *Treatise on Proportion* he moved on to a different procedure based on Leon Battista Alberti's *De Statua*. This book wasn't published until 1568, so Dürer must have had a copy of the manuscript. There may have been one in Bernhard Walther's library—as we have seen, he was a pupil of Regiomontanus—or Dürer might have seen one during his 1506 visit to Venice. Alberti worked out proportional numbers, or coefficients, by dividing the height of the body into equal lengths. The actual size of these segments depended on the height of the body, but their number remained constant. Dürer refined these subdivisions and invented names and symbols for the individual portions. Thus a person's height is divided into *Messtäbe* ("measures"); the *Messtab* is itself divided into ten *tzall* (*Zahlen*, "numbers"); the *tzall* is divided into ten *Teile* ("parts"); and the *Teil* into three *Trümlein* ("particles"). As the overall stature has been subdivided into separate units, these can be used to calculate the size of the limbs.

A special measuring instrument was prepared for each calculation, of which Dürer made a large number. The results of his experiments with constructing the human figure on a geometric basis went directly into his paintings and drawings, whereas his later attempts to fathom the mystery of ideal beauty by taking large numbers of measurements and noting down the results in a series of tables were reflected in the woodcuts in his *Treatise on Proportion*, which depict series of figures in outline with the measurements indicated.

Adam and Eve (p. 84) must have seemed particularly suitable subjects for depicting the ideal body since the beauty bestowed on them by the God of Creation, which was in tune with the laws of nature, had not yet been diminished by sin. Since time immemorial they always had been depicted naked, so no mythological or moral embellishment was needed to justify their nudity. Dürer's engraving of Adam and Eve is the result of his attempts to construct male and female figures in proportion by means of geometry, and it includes a little panel inscribed with the words

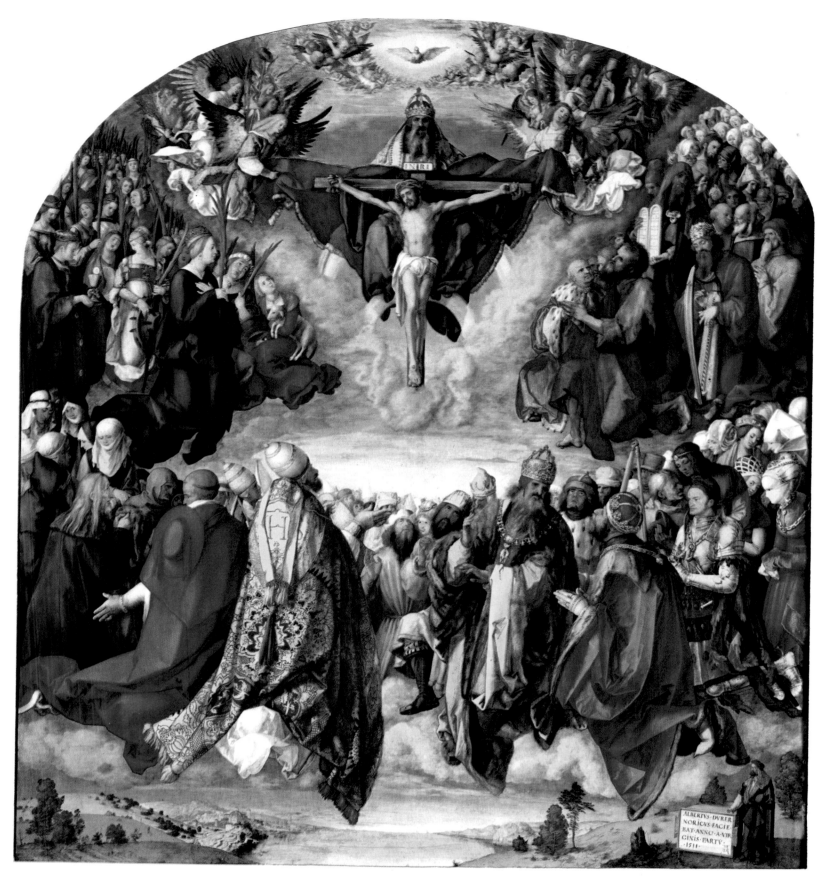

ADORATION OF THE TRINITY
Oil on panel (poplar); $53\frac{1}{4} \times 44\frac{1}{4}$ in.
$(135 \times 123.4$ cm)
The little panel in the bottom right-hand corner is inscribed as follows:
"ALBERTVS. DVRER/NORICVS. FACIE/
BAT. ANNO. A. VIR/GINIS. PARTV./1511"
("Painted by Albrecht Dürer from Noricum in the year of Our Lord 1511")
Vienna, Kunsthistorisches Museum, Gemäldegalerie

Painted for the Zwölfbrüderhaus (a home for single people in need) in Nuremberg. It was acquired by Rudolf II in 1585 and was in the Belvedere in Vienna in 1780.
The painting was commissioned from Dürer by Matthias Landauer for the All Saints' Chapel attached to the Zwölfbrüderhaus. At the top of the painting, at the feet of the Holy Trinity, Dürer has depicted the Holy

Martyrs being led by the Virgin Mary and Old Testament figures led by John the Baptist. Beneath them is a throng of human figures, with the representatives of the clergy on the left, including the donor, and the laity on the right.

"ALBERT(VS) DVRER NORICVS FACIEBAT 1504" and the well-known monogram. Normally, he put inscription panels only on his paintings, which shows how much importance he attached to this engraving.

Preparatory studies for the engraving give a clear idea of how the figures and their relationship to one another developed, though the order in which the sketches were made can only be inferred. The figure of Adam was based on nudes constructed in proportion and modeled on copies of the *Apollo Belvedere*. As for Eve, it has been assumed that Dürer was familiar with a classical Venus in the same style as the Medici Venus, but references to it are rather vague. Traces of the figures' origins—studies in proportion based on classical models—may be seen in the engraving, and this explains why it has a cool, classical feel about it.

The trees and animals in the engraving were not selected at random but used to explain the consequences of the Fall for the whole of mankind. Thus Adam is holding the tree of life, which is depicted as a mountain ash. A parrot is perched on the tree, a bird sometimes depicted with the Virgin Mary, the second Eve, as a symbol of the birth of Christ to a virgin. Death comes by way of the woman, from a fig tree, which is probably an allusion to the incident when Christ put a curse on the fig tree (Mark 11:13–14, 20). According to the Schoolmen the humours were connected with the Fall since it fragmented man's character, which once had been whole and perfect. Dürer probably took up this idea, using the elk to stand for the melancholy

temperament, or humour, the hare for the sanguine, the cat for the choleric, and the ox for the phlegmatic.

When Dürer came home from Venice for the second time and once again had become a painter in the full sense of the word, he returned to Adam and Eve as the subject for a vertical rectangular painting (pp. 109–111). It is signed in lower case letters on a little panel hanging from a branch on the tree of life. The inscription reads "Albertus Dürer alemanus faciebat post virginis partum 1507," and the monogram appears in the bottom right-hand corner. We can see at a glance that Dürer took the earlier engraving as his starting point but made a large number of important changes both in form and content. The two figures appear on separately-framed panels, suggesting that they did not contribute equally to man's expulsion from paradise. Each is a figure in his or her own right. They are of course linked, but you have to know the Bible story to understand the link between them. Whereas the engraving depicts the Fall, the painting is of Adam and Eve.

ADORATION OF THE TRINITY

Right: Detail showing one of the figures in the group representing the laity. He is Wilhelm Heller, the donor's son-in-law. An image of the Virgin Mary and the Heller family's coat of arms is hanging from his chain
Left: Detail of the landscape.

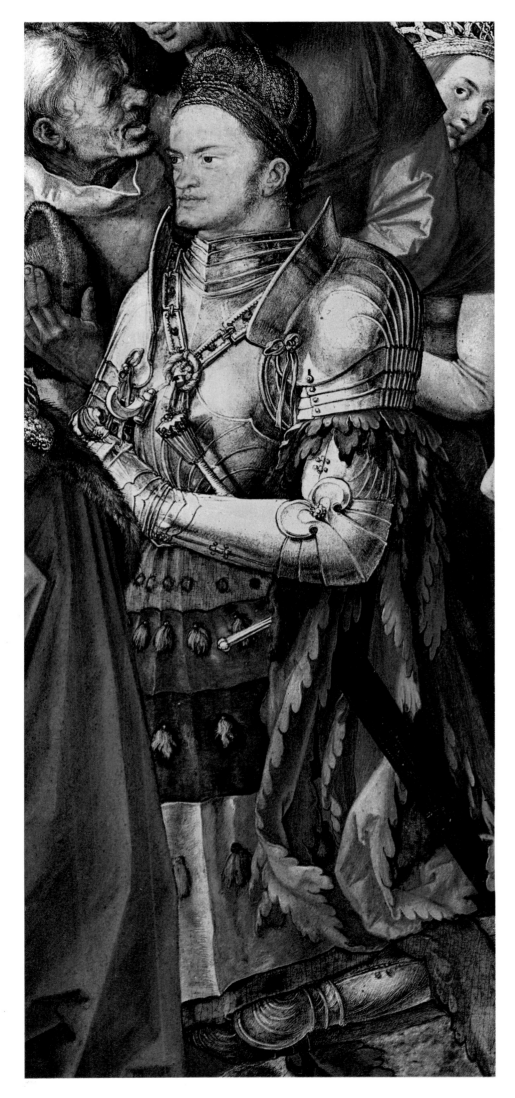

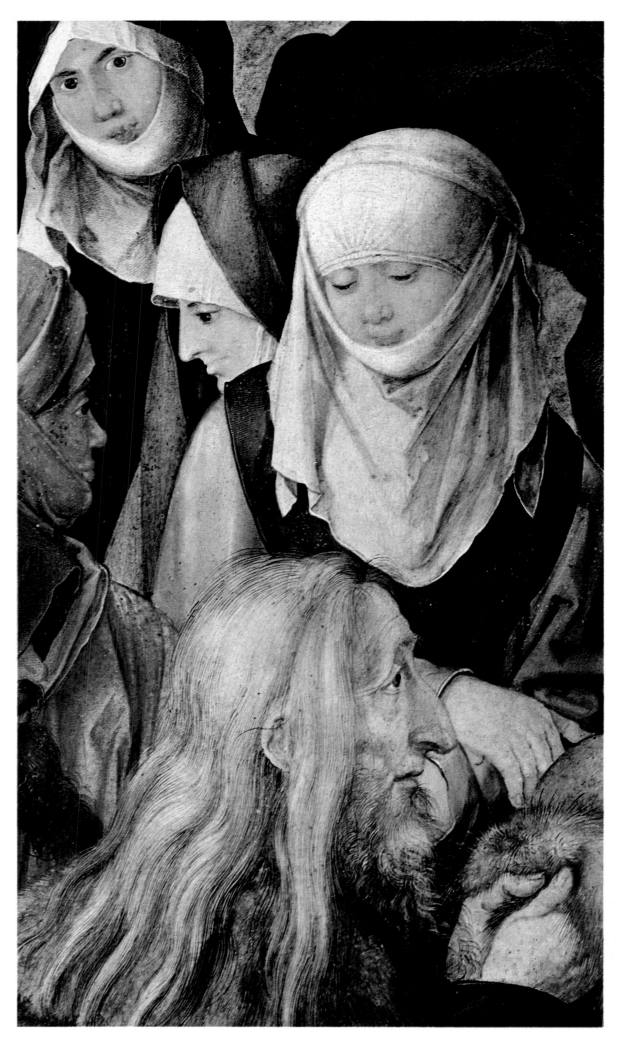

ADORATION OF THE TRINITY
This page and opposite: Three details.
The old man with the long beard is the
man who commissioned the painting,
the canon Matthias Landauer.

Incidentally, the two figures in the engraving were planned individually, but during the last stage of his preparatory drawings, Dürer united the two studies to form a single sheet (New York, Morgan Library).

Dürer had only to study the porches or doorways of medieval cathedrals to find inspiration for his life-size figures of our "first parents." Although the figures sometimes were designed as separate pieces of sculpture and placed side by side, they often must have appeared as a single group in scenes depicting Christ's passion and salvation. We know that Dürer spent some time in Bamberg in 1514, but this does not mean that he hadn't seen the figures of Adam and Eve on the east doorway of the cathedral many years earlier and never forgotten them. Jan van Eyck already had used painted sculptures of Adam and Eve on individual panels of a reversible altarpiece that he had devised.

Although Dürer's idea of depicting the two figures separately was entirely his own, many artists were to copy it subsequently. It might be easier to understand why he separated them if we knew who commissioned the paintings or who first owned them. It is highly unlikely that these two nudes—the first life-size nudes in the history of German painting—had a religious function. The mystery surrounding these paintings, which incidentally are now in Madrid, is increased by two copies (Florence; Mainz) that were made while Dürer still was alive. Carl van Mander saw the original in 1602 in Prague, and the copy now in Mainz hung in the town hall in Nuremberg until 1801. A text published in 1516 by the Bohemian humanist Jan Dubravius, later to become Bishop of Olmütz, tells us that Bishop Johann Thurzo of Breslau bought a painting by Dürer on the same subject for 120 guilders. Although it still isn't clear whether this refers to the pair of panel paintings, the fairly high price would have been paid only for a large painting. The reference to a prelate such as Thurzo, who was also a passionate collector, suggests that the *Adam* and *Eve* must have been painted for someone in the circle of enlightened connoisseurs who were in the market for large paintings on this or similar themes.

Dürer confessed that he did not know what beauty was: "It befits a painter who is capable of creating a picture to paint it as beautifully as he can. But what beauty is, that I do not know." Apparently he did not think of the figures of Adam and Eve in the engraving as representing perfect beauty, and indeed he made important changes to the dimensions and proportions of the nude figures in the painting. Eve's stance, with its swaying motion, harks back to Gothic art, and the position of the legs, one behind the other, plus the change in the ratio of the head to the overall height of the figure

from 1:7.4 in the engraving to 1:8.2 in the painting make the body seem slimmer and taller. She seems to be scarcely touching the ground. When he came to Adam, Dürer adhered more closely to the classical *contrapposto* pose, with the figure leaning slightly to one side. The fact that Adam's legs are closer together makes him, too, seem lighter. These changes go hand in hand with the soft coloring, which molds the contours by means of light and shade but softens the stark contrast between light and dark, between illuminated areas and shadowy zones, which gives a feeling of restlessness to the engraving.

These two paintings always have been considered among Dürer's best work. The bodies are bathed in light as they stand out against the dark background. The male body is painted in warm shades (which seem darker today because the varnish has gone brown) in contrast to the figure of Eve, whose reddish skin tone is highlighted with white gleams in the silvery light. Dürer is interested only in the figures, and accessories are reduced to the bare minimum. To the right of Eve, who is holding an apple in her left hand, appears the reddish-brown tree of death, from which the serpent, with its brightly colored head, is hanging. Behind her is a branch with a young shoot bearing dark green and light green leaves. Adam holds a twig with another apple growing from it. There is no attempt here to explain the incident by adding symbols as in the engraving.

Besides studying the proportions of the human figure, Dürer also experimented with constructing horses. In the same year that his *Treatise on Proportion* appeared—it was not published until six months after his death—one of his pupils, Sebald Behaim, produced a study called "On the

Left:
Preparatory Studies for THE KNIGHT, DEATH AND THE DEVIL
Pen-and-ink sketches drawn on both sides of a single sheet; $9\frac{3}{4} \times 7\frac{1}{4}$ in. (24.6 × 18.5 cm)
Probably 1513
Milan, Biblioteca Ambrosiana.

Right:
THE KNIGHT, DEATH AND THE DEVIL
Engraving; $9\frac{5}{8} \times 7\frac{1}{2}$ in. (24.4 × 18.9 cm)
The monogram, the date (1513), and the letter "S" (Salus ?) can be seen in the bottom left-hand corner.

Proportion of the Horse." He was suspected unfairly of having stolen one of Dürer's manuscripts—the town council refused to allow him to publish it "until the proper work as prepared by Dürer before his death is completed and printed and published"—but Behaim probably was simply inspired by Dürer's engravings to tackle the problems of drawing horses in proportion.

Once again, Dürer's interest in this subject had been aroused in Italy, and we can be reasonably certain that he knew about the studies of horses made by da Vinci when Leonardo was commissioned to design a monument to Francesco Sforza, which depicted the duke on horseback. Dürer's first attempts to construct horses' bodies from squares and segments of a circle date from the turn of the century, only a little later than his similar experiments with people and objects. The results are to be seen in a series of engravings, which culminates in *The Knight, Death and the Devil* and the preparatory studies for it (pp. 124–125).

The first in this series is the largest engraving Dürer ever produced.

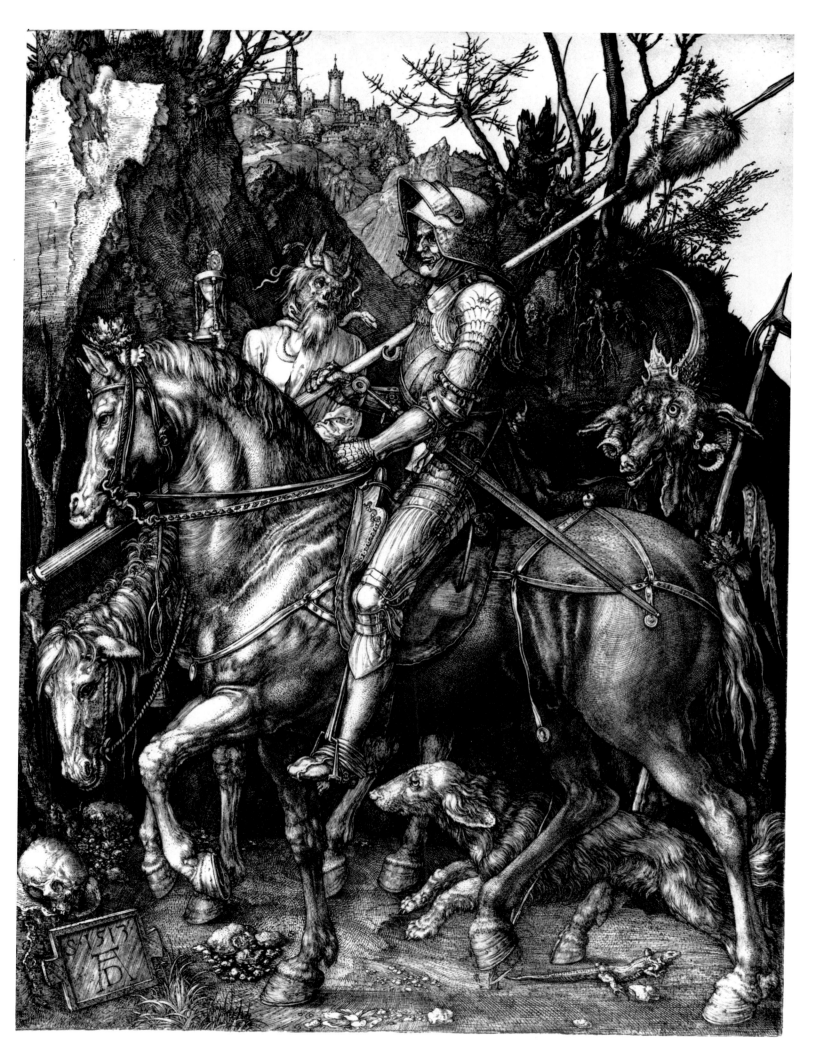

THE EMPEROR CHARLEMAGNE
(Detail)
Oil on panel (lime); with frame
84½ × 45¼ in. (214.6 × 115 cm); without
frame 73⅝ × 34½ in. (187.7 × 87.5 cm)
1513
Nuremberg, Germanisches
Nationalmuseum (on loan from the
city of Nuremberg)
On either side of the face there is the
following inscription: "Karolus
magnus/imp[er]avit Annis. 14." The
arms of Germany and France can be
seen at the top.

THE EMPEROR SIGISMUND
Oil on panel (lime); without frame
73¾ × 34½ in. (187.7 × 87.5 cm); with
frame 84½ × 45 in. (214.6 × 115 cm)
1513
Nuremberg, Germanisches
Nationalmuseum (on loan from the
city of Nuremberg)
On either side of the emperor's head
there is the following inscription:
"Sigismund[us] imp[er]avit/Annis.
28." The arms of the Empire, of
Bohemia, Hungary, and Luxembourg
can be seen at the top. Like the
painting opposite, this portrait was
commissioned from Dürer by the city
of Nuremberg, probably in 1512.

It depicts the legend of St. Eustace, which tells how the crucified Christ appeared to him when he was out hunting (p. 61). The wealth of detail in the landscape anticipates the style of the Danube School of artists. It also anticipates the work of seventeenth- and nineteenth-century landscape painters, particularly in the depiction of the pond with a bridge and swans. While the huntsman sinks to his knees at the sight of the crucifix between the stag's antlers, his horse stands stock still like a statue, with its right hind leg slightly raised. The horse is tied to a branch by a short rein or thong, which can be seen only upon very close examination. As a result, and in its motionless posture, it seems likely that a horse drawn from life was used for the engraving. This possibility is further suggested by the difference in scale between the horse and the saint, who seems much farther away from us. The fact that he is kneeling on a little mound of earth does not satisfactorily explain the discrepancy. The hounds are merely five different views of the same dog. Dürer's first study of a dog from nature corresponds to the dog immediately to the left of the horse (Windsor Castle). The St. Eustace engraving was followed by two more, executed in 1505, in which two views of a horse have become the main subject, while its rider, standing behind it and mostly hidden, plays only a secondary role.

In 1513 Dürer completed his horse studies with an engraving called *The Knight, Death and the Devil*, though he himself called it simply "The Knight." The first preparatory study for this is a watercolor of a mounted lancer. This is a carefully drawn fair copy, and there is no trace of the lines he used to construct the horse (p. 47). The same animal already had been the model for the horse in the St. Eustace engraving. The inscription at the top of the drawing, which reads: "D[a]z ist dy rustung zw der czeit Im Tewtzschland gewest" ("This is the armor that was used in Germany at the time"), indicates that it belongs to a series, including paintings executed in 1501 of women in the local costume of Nuremberg, which realize the objectives of Dürer's costume studies. Tradition has it that the knight is Philipp Link, master of the horse to the Paumgartner family, though this cannot be verified. At any rate, he undoubtedly must have been one of the Nuremberg horsemen.

A man on horseback is one of the major themes running through the whole history of Western art. Ancient Roman statues provided the inspiration for Italian Renaissance painters to revive the theme, and in the 1480s Leonardo started work on his monument showing Francesco Sforza on horseback. Dürer could have seen Donatello's *Gattamelata* in front of the Santo in Padua on his first visit to Italy, and he even may have been present when Verrocchio's *Colleoni* was unveiled in Venice on March 21, 1495.

German artists, too, took up the "man on horseback" theme. In 1501 the Nuremberg artist Sixt Syri carved a wooden statue of Bartolomeo Colleoni on horseback for the Colleoni tomb in Bergamo. Then in 1509 a rough-hewn block of stone was set up in front of the church of St. Ulrich and Afra in Augsburg so that Gregor Erhard could carve a statue of Maximilian I on horseback (the designs were by Hans Burgkmair). Dürer's *Knight* should be seen in this context. The preparatory drawing showing the horse and rider has survived (p. 124). The auxiliary lines are still visible, and they show that Dürer built up the horse's body from squares based on the length of the head, according to a system devised by Leonardo.

A number of mysteries and problems surround this engraving, which is one of a group of three generally referred to as Dürer's "master engravings" (*Meisterstiche*). (The other two are *Melencolia I* and *St. Jerome in his Study*.) We cannot even be sure whether death and the devil are the knight's enemies or whether they should be interpreted as his attributes, in which case he should be seen as a robber knight. The engraving has even been interpreted as a covert tribute to Savonarola, who was burned at the stake in Florence in 1498. This reading is based on the presence of the letter "S" in front of the date (1513) and on the dog and salamander, which are seen as hieroglyphs for *Horus Apollo*, a work translated by Willibald Pirckheimer and used in this context to represent a sacred writer, visionary, or any person burned to death. There is no disputing the fact that the significance of the knight's figure is enhanced, compared to the lancer in the drawing, by the carefully proportioned stance of the horse and by the surroundings. The artistic,

127

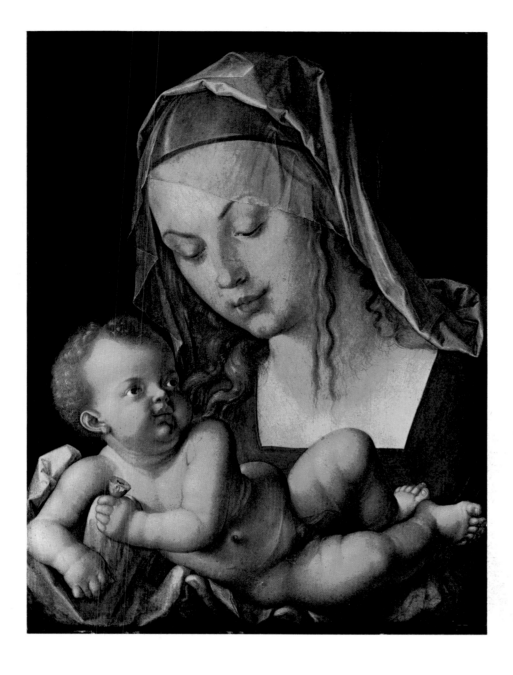

MADONNA AND CHILD
Oil on panel (lime); $19\frac{1}{4} \times 14\frac{1}{2}$ in.
$(49 \times 37$ cm)
Dürer's monogram appears in the top
right-hand corner with the date (1512)
Vienna, Kunsthistorisches Museum,
Gemäldegalerie
Probably acquired by Rudolf II in 1600
from the Cantecroy Collection in
Besançon; it was in the imperial col-
lection in 1758.

beautifully proportioned form makes it seem highly unlikely that the knight
represents a negative figure, perhaps one of those highwaymen who posed a
threat to the merchants of Nuremberg.

If we study the parts of the engraving that are perfectly clear, we gain
some understanding of the whole composition. The knight is in full armor;
he has left the devil behind and is taking no notice of death, who is trying to
frighten him or delay him by showing him an hourglass that has almost run
out. The concept of overcoming death and the devil is prevalent throughout
Christendom, and we may assume that the relevant portions of Scripture
were familiar to those who would buy Dürer's work. However, no image
could be a better illustration of St. Paul's appeal to fight the good fight —
"Put on the whole armor of God, that ye may be able to stand against the
wiles of the devil" (Ephesians 6:11) —since Christ already has conquered the
devil. The apparition with the horned head of a wild boar is cast in the same
mold as the Lord of the Underworld in a woodcut in the cycle called *The
Great Passion*, where he is trying in vain to defend his kingdom with a broken
lance against an assault by the victorious Redeemer. In depicting death
Dürer has taken literally Christ's promise: "Verily, verily, I say unto you, if
a man keep my saying, he shall never see death" (John 8:51).

The statuesque or monumental feeling created by the whole engraving
gives it a symbolic ring, as do many other details that were probably
ambiguous from the start: the dog may be seen as a symbol of vigilance; the

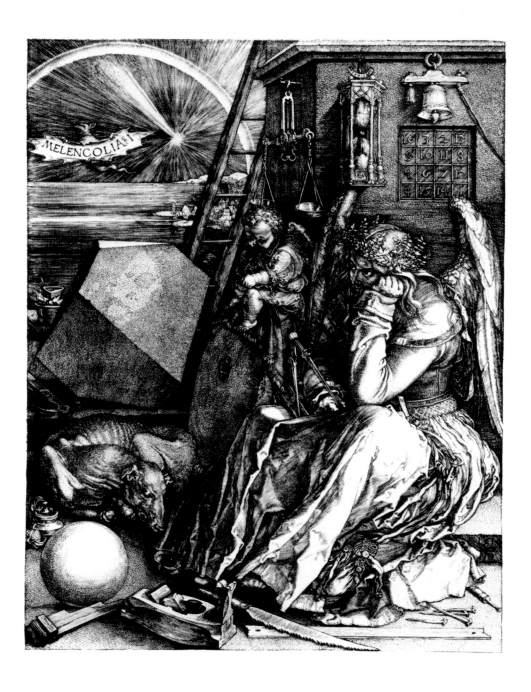

MELENCOLIA I
Engraving; $9\frac{1}{2} \times 7\frac{1}{4}$ in. (24×18.6 cm)
Dürer's monogram and the date (1514)
can be seen on the step on the right
Overleaf: Detail.

salamander is a creature impervious to fire; the castle perched on the mountain top might represent the celestial city of Jerusalem. The difference between the 1498 drawing and this engraving, which has the same basic composition except for the confrontation with other powers and its enrichment with moral values, can be seen clearly in the knight's armor. The armor worn by the Nuremberg horseman has been transformed into armor fit to protect its wearer against the powers of darkness—"the breastplate of righteousness," "the helmet of salvation," and the "sword of the Spirit, which is the word of God." Taken together with the other two *Meisterstiche*, *The Knight, Death and the Devil* signifies the moral path to salvation, distinct from the theological path followed by St. Jerome and the intellectual path of Melancholy.

Dürer's Discovery of Nature
Dürer's compositions are based on the human figure, using it not only as a vehicle for the action but also in that it is three-dimensional, to create the pictorial space. His studies of living models and research into proportion were useful even when he was not specifically basing a work on them. Dürer also used architecture and landscape to extend the pictorial space. Indeed, his discovery of nature and his attempts to reproduce it faithfully, in a thoroughly lifelike manner, were among the crucial innovations that he introduced into art. In this he built on the achievements of fifteenth-century

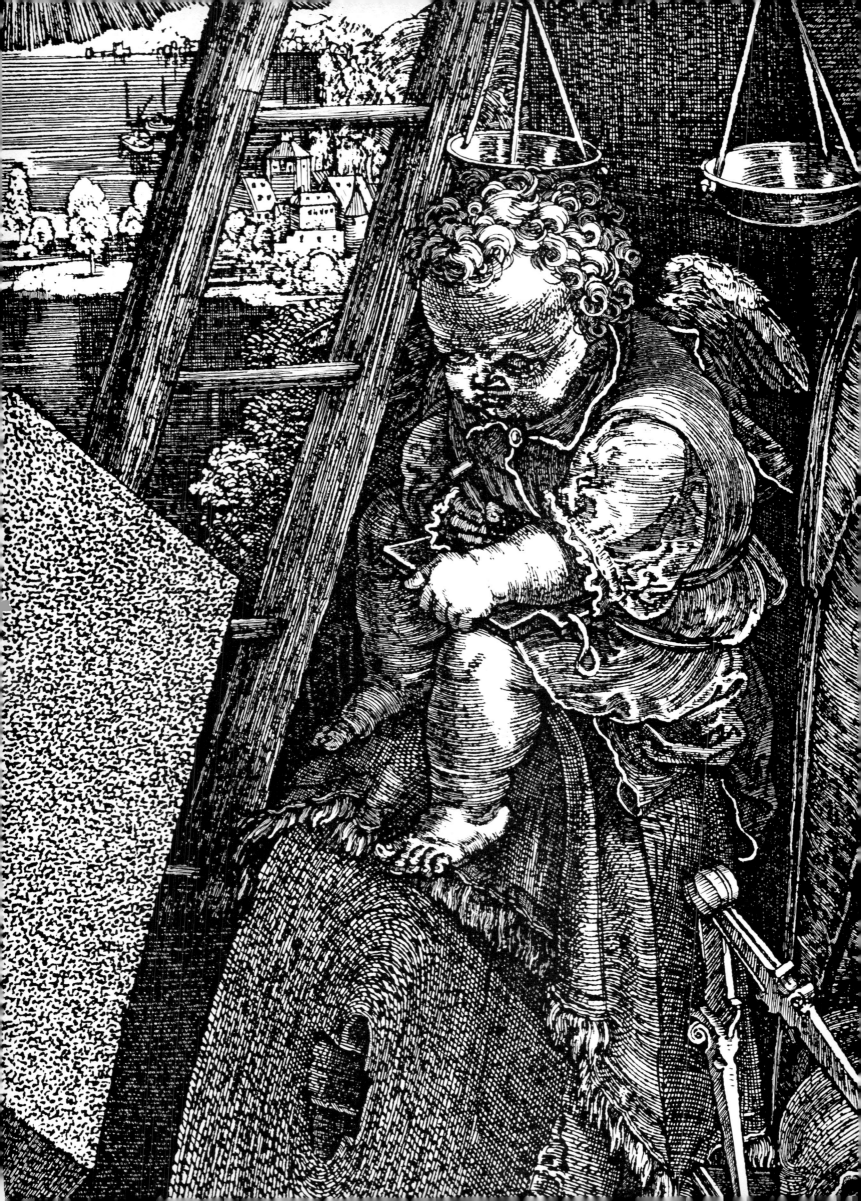

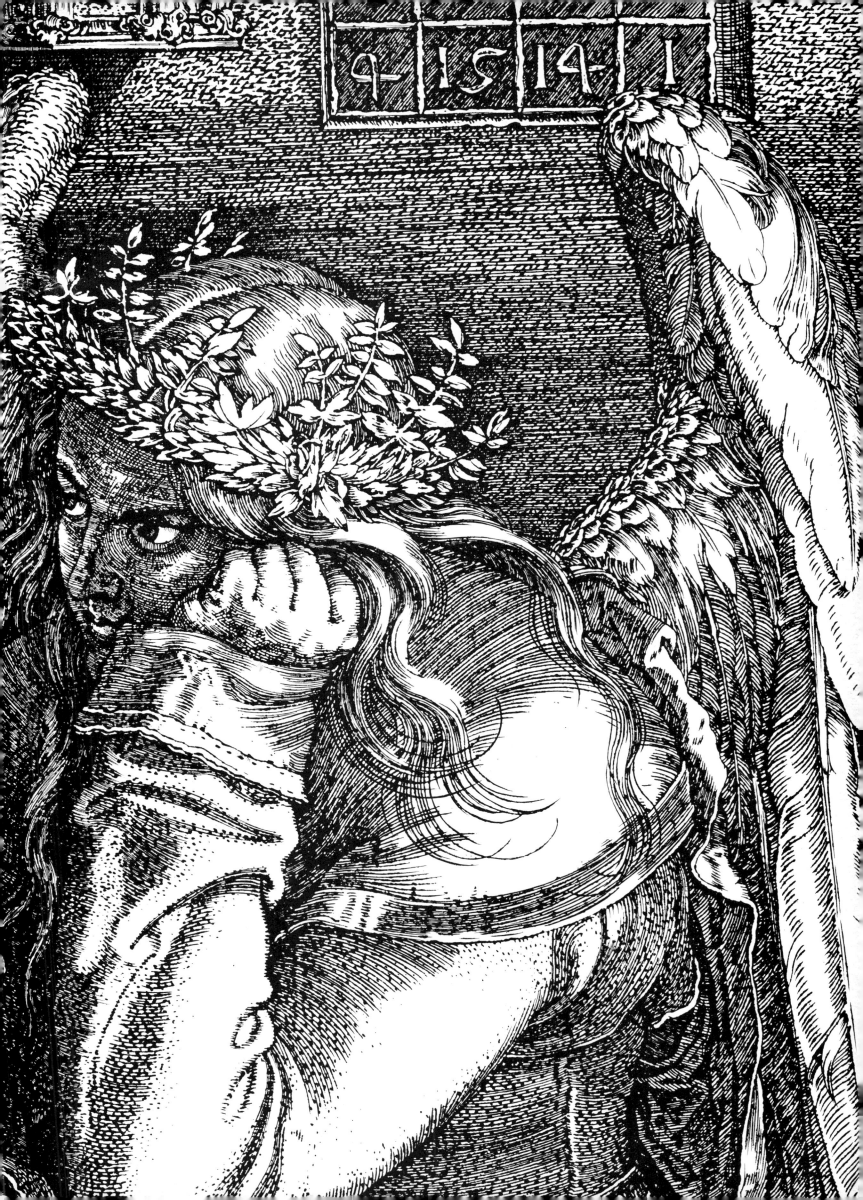

artists, rejecting the old formulas for trees and plants in favor of shapes and forms based on detailed nature studies. Once these accurate drawings of natural organisms had been produced, they could be handed on to others in the workshop. For instance, if we study the work of Nuremberg painters, we see that this occurred with the iris, which first appeared as a symbol for the Virgin Mary in the work of artists associated with Hans Pleydenwurff and later spread to Michael Wolgemut's workshop. A life-size study of an iris, now in Bremen, has been attributed to Dürer. It is a large, painstaking watercolor and gouache drawing that belongs to a whole series of plant studies, now in Vienna, which may or may not be by Dürer. It is difficult to judge since similar botanically accurate reproductions of plants were used to illustrate contemporary herbals. Some of the sketches are painted on vellum, and the date 1526 was later added to all of them.

A watercolor drawing of a columbine (p. 64) also belongs to this group. The interest shown in this plant may have been partly due to its symbolic value since it had been used to refer to Christ's passion even in fifteenth-century altarpieces. In this study it is depicted with meticulous scientific accuracy. The stem, leaves, and flowers seem to grow before our very eyes, shooting up from blackish-brown earth, so that we see it from various angles and in different stages of development. Even the plant's habitat is indicated by a flowering blade of grass, perhaps dug up by mistake. Vellum, which Dürer liked to use in earlier years, is not very absorbent, and it does not allow the usual vaporous effect of watercolors. Therefore it is not easy to compare this study with other better preserved watercolors on paper.

One of Dürer's first plant studies is the eryngium in the 1493 self-portrait. Although it clearly was painted from life, the thistle plant (the common name in Germany for one member of the species means "male fidelity") is depicted here in the Gothic style, and even if it had not been part of a dated picture, it would be fairly easy to guess when it was painted.

Whereas sketches of individual plants are always to some extent preparatory drawings, a pair of studies known as *The Great Piece of Turf* and *The Little Piece of Turf* (pp. 66–67) depict a detail from a living whole. *The Great Piece of Turf* is executed in watercolor and gouache on paper that has become very yellow with age. It reproduces the microcosm of a meadow with a wide variety of plants at different stages of growth seen against a low horizon. The plants are the yarrow, the dandelion, the smooth-stalked meadow grass, and the greater plantain. The date, 1503, has been painted in the bottom right-hand corner but is difficult to find. The apparently random juxtaposition of the plants on a small piece of damp earth turns out on closer inspection to be a carefully thought-out arrangement determined by artistic criteria. A transparent tracery of delicate grasses allows us to look through to the broad leaves of the plantain growing in the center, which catch the light and are framed by an enclosing wall of grasses and dandelions, which becomes lighter on the left. The stems and flowers grow up from a shadowy area at the bottom and are arranged in groups, looking delicate and fragile against the once-white paper. The bright ochre stems and petals of three dandelion plants rise up from the green, seeming to sway as they do so. The overall composition and coloring create an illusion of depth. The structure of the plants and their surface texture are depicted in meticulous detail down to their roots, and we even can tell whether they are sharp-edged or soft.

This little piece of nature illustrates the entire natural process of growth and decay. None of the other plant studies attributed to Dürer attains this high level of invention and execution. Even the well-known painting on vellum of a bunch of violets (p. 65) isn't of such superb quality —only the petals reveal the hand of the master in the subtle variations of violet coloring, depending on the light and shade of the three-dimensional form. The impression of lack of structure in the leaves and stems is thought to be the result of later overpainting and restoration.

Dürer's animal studies, too, have a symbolic significance as they relate to the content of the picture and serve to illustrate attributes. His early woodcuts and engravings of the Virgin and the Holy Family are named after the creatures depicted in them—hares, a long-tailed monkey, a dragonfly. Traditionally, each of these creatures has a symbolic meaning. The large number of creatures in the 1503 drawing called *The Virgin with a Multitude*

PEASANTS DANCING
Engraving; $4\frac{5}{8} \times 3$ in. $(11.8 \times 7.5$ cm)
The date (1514) and Dürer's monogram appear at the top edge in the center.

ST. JEROME IN HIS STUDY
Engraving; $9\frac{3}{4} \times 7\frac{1}{2}$ in. $(24.7 \times 18.8$ cm)
The tablet above the lion's tail bears the monogram and the date (1514).

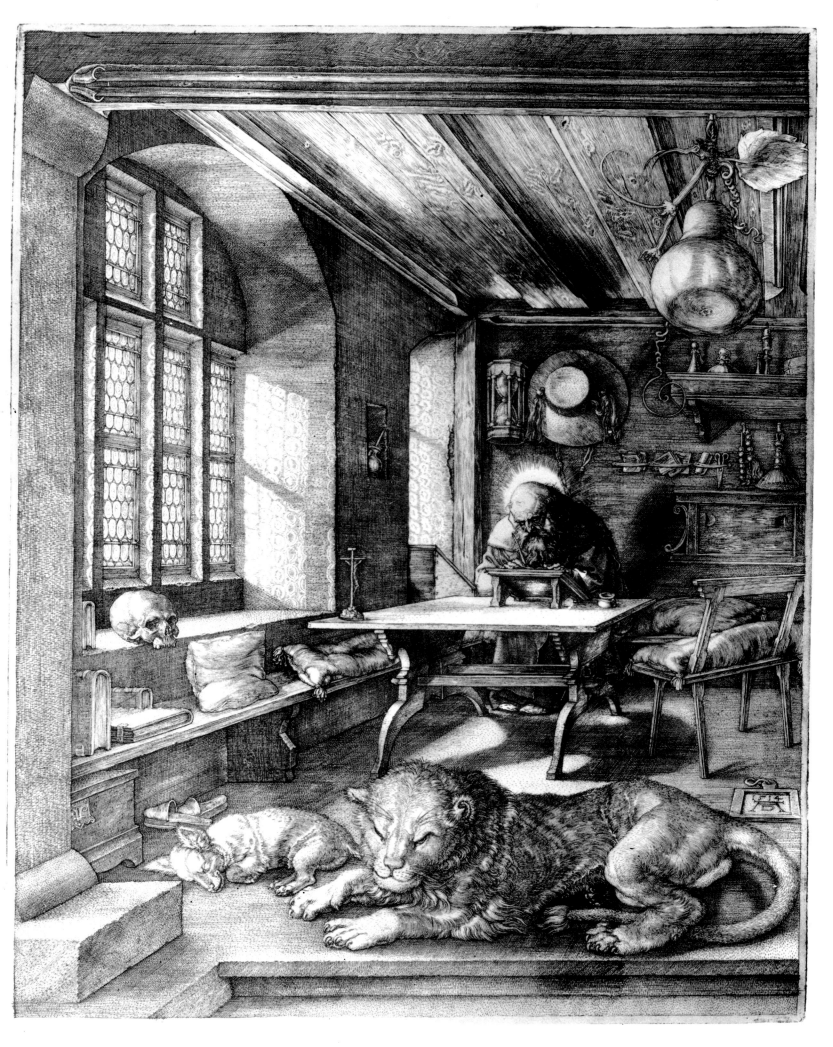

133

DECORATED PAGE FOR
MAXIMILIAN'S PRAYER BOOK
Red, green, and purple ink on vellum;
$10\frac{7}{8} \times 7\frac{3}{4}$ in. (27.5 × 19.5 cm)
Munich, Bayerische Staatsbibliothek
This little volume, which is made up of
a collection of anthems, psalms, and
prayers specially chosen for the em-
peror, was published in Augsburg in
1513 by Johann Schönsperger the
Elder. The marginal illustrations are
by Dürer while the gothic typeface may
be the work of Maximilian's secretary,
Vinzenz Rockner. Only five of the ten
copies printed have come down to us.
Not all the illustrations were by Dürer.
The other artists included Hans
Baldung-Grien, Lucas Cranach the
Elder, and Albrecht Altdorfer.

PORTRAIT OF THE ARTIST'S
MOTHER
Charcoal drawing; $16\frac{5}{8} \times 12$ in.
(42.1 × 30.3 cm)
The inscription and the date (1514) are
in Dürer's hand
Berlin, Staatliche Museen Preussischer
Kulturbesitz, Kupferstichkabinett
Dürer drew this portrait two months
before his mother's death, when she
was already seriously ill.

of Animals (three different versions exist, in varying stages of completion,
and are now in Berlin, Paris, and Vienna) represent a state of paradise in
which the fox, symbolizing evil, is tied up at the end of a long rope (p. 68).
The drawing is full of humorous touches, and the animals have something of
the anthropomorphic features ascribed to them in fables. Aesop's *Fables* had
become popular again in the second half of the fifteenth century, thanks to
illustrated editions printed in Ulm and Augsburg. Dürer made separate
studies for each of the animals that appears in this drawing and for the
flowers as well—note that the iris reappears here. This delightful scene
probably was planned originally as an engraving. When this fell through,
Dürer touched up two of the versions (those now in Vienna and Paris) with
pale watercolors.

The watercolor of a hare (p. 63) bears the date 1502 and Dürer's
monogram, so he clearly thought of it as an independent work of art, thus
raising the animal kingdom to the level of valid subject matter for a work of
art. The effectiveness of this watercolor lies in the fact that it records and
reproduces the hare's appearance and characteristic features in a lifelike
manner. Dürer must have used a stuffed hare as a model, but there is no trace

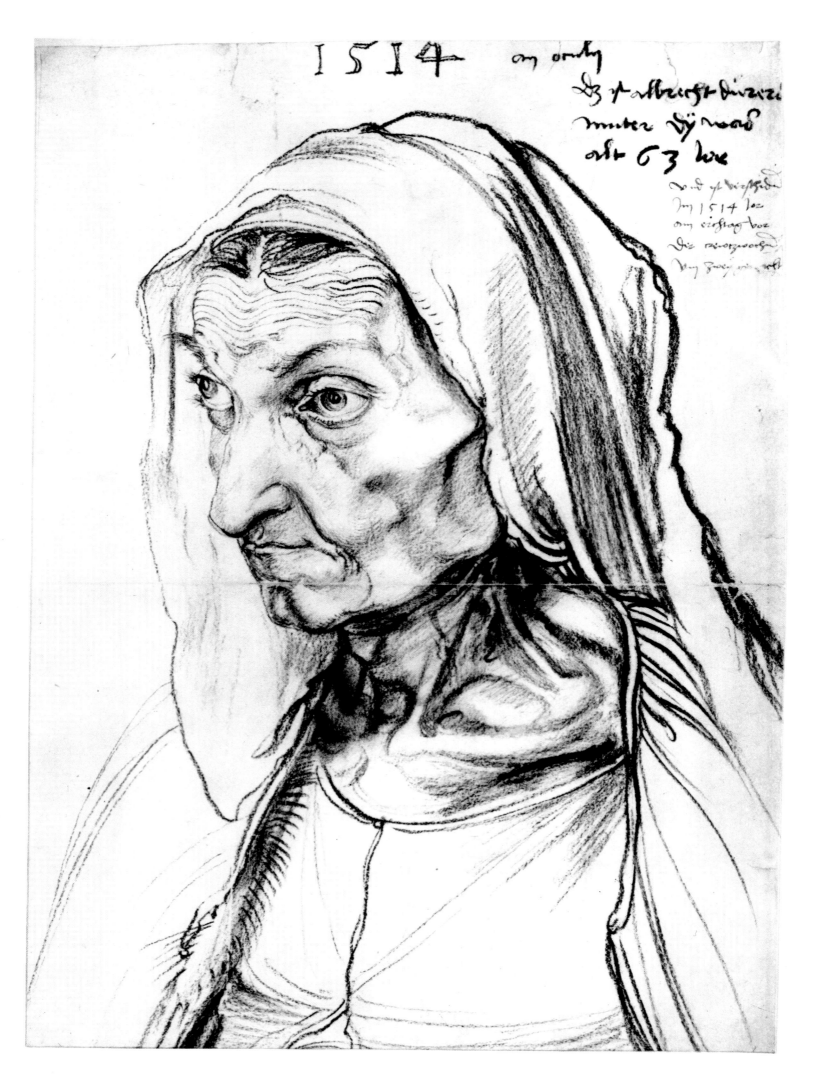

1514

135

of taxidermy in the finished drawing. The hare is cowering timidly, warily on the lookout and ready to leap up and race off. The combination of watercolor, which allows the colors to blend into one another, with the technique of using a pointed brush and opaque colors to draw in details with meticulous accuracy makes the creature's fur look so soft that you feel you could touch it. The reddish and grayish tones stand out from the white of the paper, which is in fact drawn into the composition in places to form the lightest tone of all.

This drawing of the hare has been reproduced so often, usually out of context with the rest of Dürer's work, that many people wrongly believe that Dürer had an idyllic view of nature. Actually, his individual studies reveal something of the painful and reciprocal feeling of menace that exists between man and the animals. Among his meticulously drawn studies of heads of hoofed game and the muzzle of a cow, we find a drawing of a stag's head with the huntsman's arrow still sticking out of it just below the shattered eye (Paris). Even his drawing of the head of a roebuck (p. 62) is something more than an impersonal image of a natural object.

Dürer was particularly preoccupied with discovering and studying nature in the first ten years of his career as an artist in his own right, during which period he acquired the basic features of his style. His conviction that a knowledge and awareness of nature was necessary is set out in an "aesthetic excursus" in his *Treatise on Proportion*:

> But life in nature manifests the truth of these things. Therefore observe it diligently, go by it and do not depart from nature arbitrarily, imagining to find the better by thyself, for thou wouldst be misled. For, verily, art is embedded in nature; he who can extract it has it.

And in an earlier passage he writes: "For if it is contrary to nature, it is bad." Not only was Dürer the first to formulate the idea of referring to nature as the starting point of art and of encouraging artists to observe and be aware of it, he was also the first artist to put this theory into practice. He did not exclude knowledge gained from workshop experience and its traditions, but he believed that it must be measured against nature.

Dürer in fact looked with new eyes at this world in which men, animals, and plants dwell. The clearest expression of his attitude toward nature may

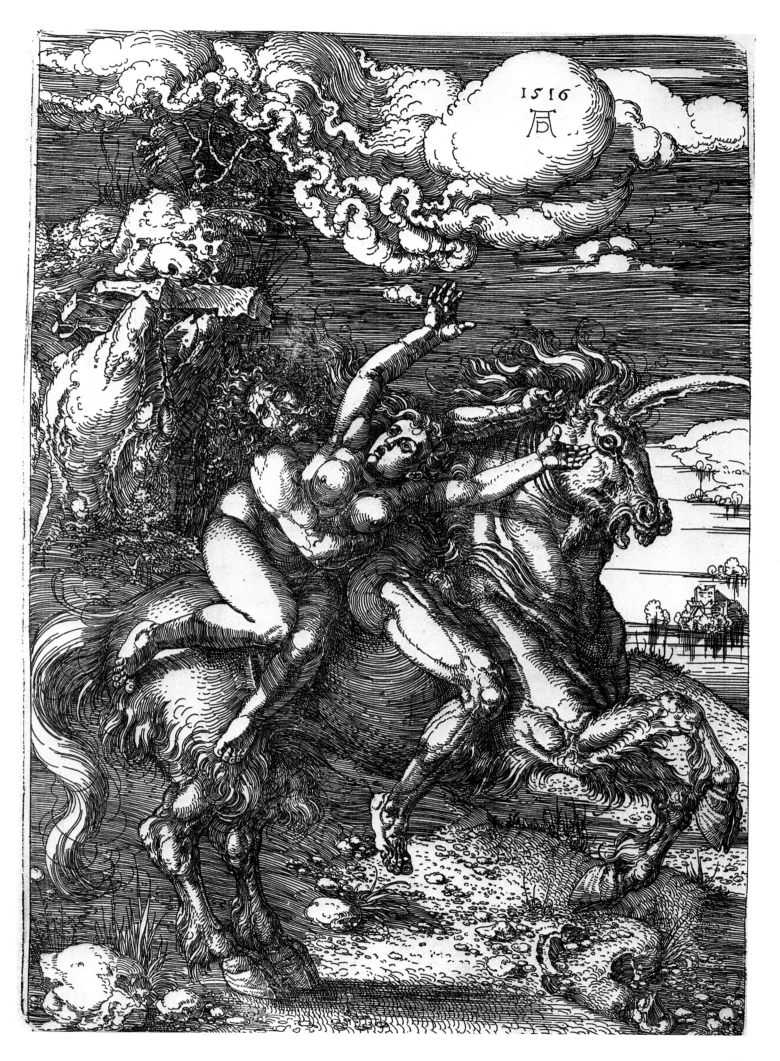

be seen in his landscape studies, for he produced the first landscapes in Western art that can be considered works of art in their own right. Here, too, he worked in a tradition that involved earlier pictures. The first identifiable landscape appears in an altarpiece painted by Konrad Witz in 1444 and dedicated to St. Peter (Geneva). The Lake of Tiberias, on which Christ appeared to the apostles after his Resurrection, has become Lake Geneva, with the surrounding countryside rising up to the Petit Salêve and the wooded massif of the Môle—it is all easily recognizable even today. Witz clearly did a preliminary topographical sketch of this landscape from life. Related studies of architectural motifs that were intended for use in altarpieces have survived from Bamberg (Berlin). One series of six pen-and-ink drawings with watercolor and opaque, painted between 1480 and 1500, depicts groups of buildings on the Domberg. Topographical sketches also were needed for the large number of authentic *vedute* in *The Nuremberg Chronicle*.

Dürer seems to have begun making accurate landscape sketches when he returned home from his journeyman's period in the late spring or summer of 1494—the main evidence for this lies in the summer foliage on the trees. It also has been suggested that the earliest landscapes date from the time when he set off on his travels, at Easter, 1490, but the trees would not have been so

far advanced at that time of year. We cannot now tell whether the topographical sketches of places in the immediate vicinity of Nuremberg were intended from the outset as works of art in their own right—which does not necessarily mean that they weren't later used in other works—or whether they were done for specific purposes. At any rate, it is worth noting that most of the watercolors Dürer painted in Nuremberg and subsequently on his journey to Venice depict objects of significance, such as an industrial works important to the town, castles, or whole villages, and only a few of them are merely typical mountain landscapes and buildings.

The watercolors of places in and around Nuremberg are labeled near the top or in the sky as "trotzich müll" ("wire-drawing mill") or "sant johans

kirchn" ("cemetery of St. John's church," Nuremberg). The inscription forms part of the overall composition, but the monogram has been added later by another hand and throws the composition off balance. The views of the southern Tyrol that followed also are labeled with similar inscriptions, though the lettering is slightly larger. Some rather general titles, such as "wehlsch pirg" ("Italian landscape," Oxford) or "ein wehlsch schlos" ("an Italian castle," Berlin), suggest that he labeled all of his sketches at the same time, when the journey was over and he could not remember the names of all the places he had seen.

The wealth of detail in these early landscapes and their horizontal formats fit with their origin as backgrounds for altarpieces. Indeed, this is particularly obvious in the horizontal stratification of the coloring in the *Wire-Drawing Mill*, which has gray, violet, and brown tones in the foreground, green in the center, and bluish mountains in the distance. If instead of the houses on this side of the river, there were a group of figures and the barn in the right foreground, which bleeds off the edge of the painting, were left as it is, with its high, thatched roof, the composition would be remarkably similar to Konrad Witz's painting *The Miraculous Draught of Fishes*. Dürer perhaps first saw landscapes used as backgrounds in paintings executed in Nuremberg, but most probably his main inspiration

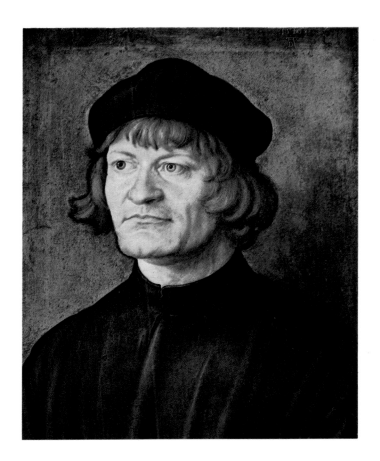

came from his experiences during travels in the Upper Rhine region and perhaps in the Low Countries as well, where important buildings painted into backgrounds enable us to see which town or locality is being depicted. In any event, Dürer was in Basel when Konrad Witz lived and worked there. Witz died relatively young, and nothing has survived of his great series of wall paintings in the St. Peter Kornhaus. All of these points suggest that Dürer probably did not start sketching landscapes until after he had completed his journeyman's period.

The artistic aims behind Dürer's development in watercolors are even more startling than the way in which he raised nature studies to the level of independent landscapes. Critics rightly have pointed to similarities between

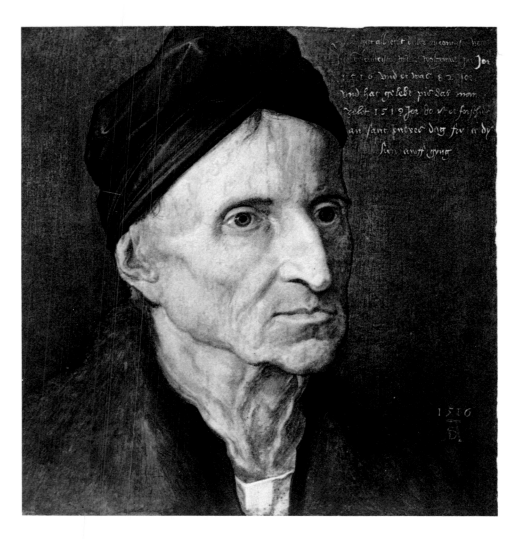

his panoramic view of Innsbruck (pp. 16–17) and earlier *vedute*. Of course,
this refers only to the structure of the drawing, the way in which the
buildings are unraveled to form an overall silhouette so that the most
prominent buildings are completely visible instead of overlapping with yet
other buildings overlapping onto them. But Dürer used completely new
artistic means to achieve this effect, and he also recorded the town at
different seasons, with the sun in different places and under various weather
conditions. In this way he conveys a clear impression of certain phenomena,
such as the way the buildings are reflected in the flowing waters of the River
Inn. Earlier artists had noticed such things and depicted them in their work,
but by observing them in different situations Dürer managed to extend the
potential range of effects that could be created. The sky is covered with
several thick layers of clouds and is completely light only in the south, over
the snowcapped mountains. Together with its reflection in the water, the sky
creates a diffused light in which the town seems to float. In spite of his
meticulous attention to detail in depicting the architectonic details—we can
even recognize the scaffolding on the tower called the Wappenturm, which
Maximilian I had had built in the 1490s—Dürer still manages to fuse all of
the elements together to form a unified pictorial whole, full of light and air
embracing both the town and the landscape.

Two views, both of the inner courtyard of the castle at Innsbruck, are not
inscribed at all. The building depicted on the two drawings (one of which is
reproduced on p. 19) has been identified as the Hofburg at Innsbruck, which
was completely rebuilt in the eighteenth century. The fact that both
drawings contain architectural details seen in close-up sets them apart from
the rest of Dürer's work, and indeed some experts have raised doubts as to
whether they are by Dürer at all, especially since they lack the atmosphere
found in the panoramic view of Innsbruck. Yet the combination of accurate
depiction of detail with unified coloring is of the highest quality, and it seems
unlikely that anyone but Dürer could have painted them. At this early stage

PORTRAIT OF JOHANNES KLEBERGER

Oil on panel (lime); $14\frac{3}{8} \times 14\frac{1}{2}$ in. (36.7 × 36.6 cm)

The date (1526) appears in the top right-hand corner, along with Dürer's monogram; the sitter's sign of the Zodiac (Leo) can be seen on the left. Round the edge of the *tondo* is the following inscription: ".E[ffigies]. IO[h]AN[n]I[s]. KLEBERGERS. NORICI. AN[no]. AETA[tis]. SVAE. XXXX" ("A likeness of Johannes Kleberger of Noricum in his fortieth year"), plus a small cabbalistic symbol

Vienna, Kunsthistorisches Museum, Gemäldegalerie

Wilhelm Imhoff of Nuremberg acquired it from Kleberger's heirs in 1564 and presented it to Rudolf II in 1588. The portrait, which is quite different from the rest of Dürer's work, depicts a highly unusual person. He was the son of a Nuremberg citizen named Schewenpflug and was forced to leave his native city for some reason that is not known today. He returned some years later under another name and with a huge fortune. In 1528 he married Felicitas Pirckheimer, Willibald Pirckheimer's favorite daughter, who was the widow of Hans Imhoff. Pirckheimer was openly hostile to his daughter marrying Kleberger. A few days after the wedding, Kleberger abandoned his wife, who died the following year. In 1530 he moved to Lyons in France, where he became famous for his generosity; he died there in 1546.

he clearly had not yet learned how to depict overlapping buildings in perspective and still create atmosphere, as he did in the general view of the town.

If we study the sketches that Dürer produced during the next few stages of his journeyman's period, plus those that he is thought to have painted on the return journey, we can see how quickly his ability to reproduce architecture in a landscape improved. When he came to Trent (now called Trento) (p. 21), he contrasted a general view of the town in the landscape with a detailed rendering of the castle (p. 18). As the residence in Trent of the prince-bishops has changed very little over the centuries, we can see how accurately he depicted it, though when the River Adige shifted, the topography north of the town changed. Much as in Innsbruck, the town's site is characterized by a combination of river and mountains. What Dürer tried to achieve in the watercolor he painted when he was first in the Alps reached an extraordinary degree of perfection in the watercolor of Trent, where architecture and landscape, town, river, and mountains are all united in a composition of grand scale. It bears no resemblance to earlier *vedute*. The color scheme is based on shades of blue, and it is this that makes the sketch seem all of one piece. Dürer made full use of all the possibilities inherent in the watercolor technique to convey the impression of colored light, which allows the contours to float gently and creates the illusion of spatial depth. We must wait until the nineteenth century for painters to attempt similar effects.

On the return journey Dürer seems to have stopped in the Altmühl Valley once again in order to draw the castle of Prunn in Franconia, which was perched on precipitous cliffs rising sheerly from the river. Parts of the fort, which dominates the whole valley, were destroyed in 1491 and had not yet been restored (p. 18). The sketch was apparently not labeled and has now disappeared. If the sketch really was a depiction of Prunn Castle, we are again faced with the question of when the landscape sketches were made since to visit Prunn, Dürer would have had to make a detour. At any rate,

after crossing the Alps twice, he had developed a keen eye for the geological structure of a landscape as well as for the special features of the light playing on it. He had acquired a feeling for the romantic beauty of a mill in the mountains or a tumbledown hut or, when he was in Franconia, for a small pond ringed by pine trees. Although he never again produced such a large batch of landscape studies as on his first journey to Italy—none has survived from the second journey, incidentally—he continued to record landscape features that attracted his attention right down to the end of his life.

Only a few of Dürer's topographical studies went immediately into work intended for publication. Of all the studies he made in the southern Tyrol, he used only one (a view of Brixen that is now lost) in his engraving of *Nemesis*. The sketch called *House on an Island in a Pond* (London) forms the background to the *Virgin with a Long-tailed Monkey*, and a metalpoint drawing that was once in Rotterdam and depicts a scene from Franconian Switzerland, with the village of Kirchehrenbach set against the saddle-shaped ridge of the Ehrenbürg, was used in the 1518 etching of a cannon (p. 151). This remarkable piece of work is closely linked with Dürer, as one of the oriental-looking figures standing beside the cannon has his features.

Dürer retained all of his watercolors of landscapes, so they could not have had any direct influence on contemporary art. After his death they belonged at first to his widow but were later dispersed and now can be seen in ten different collections. One group, including some of the most famous, was removed from the Albertina in Vienna in the early nineteenth century and came into the possession of the Kunsthalle in Bremen in 1851. Their whereabouts have been unknown since the end of World War II, and they might have been destroyed.

Discovering the Human Personality
The beginning of portraiture in the fifteenth century clearly indicates a changed assessment of a person's value as suitable subject matter for art that was intended to survive after his death. Dürer described this new field of art in various ways in the introduction to his textbook on painting. He writes: "It preserveth also the likeness of men after their death." He uses the word *Gestalt* ("form") to mean first and foremost the individual facial expression, as we can see from the formal inscriptions, giving the sitter's age, that appear on many of his portraits. In explaining his belief in the importance of painting, Dürer followed Leon Battista Alberti, whose *De Pictura* refers to the portrait to prove that learning to paint is worth the effort involved: "Inherent in painting is the fact that the dead seem still to be alive many hundreds of years later, so that we can look at them over and over again, admiring the artist immensely and procuring great enjoyment for ourselves. . . . It is therefore certain that the form of a person who is long since dead can live a long life thanks to painting." The three books of Alberti's *De Pictura* were written in 1435 and 1436 but were not published until 1540, so Dürer must have used one of the manuscript copies, which apparently were available.

The first independent portraits in German art appear in the mid-fifteenth century, though artists in Italy and the Low Countries had started painting portraits at an earlier date. The citizens of Nuremberg were the first to take advantage on any sizable scale of this new opportunity to immortalize themselves. Dürer's skill at capturing the individuality and character of a person gave the portrait an authority it had not possessed before, or had only begun to possess in the late Middle Ages. The new attitude toward man ushered in by Renaissance philosophers led artists to portray the overall personality of their sitters instead of simply producing a likeness of their facial features. Making portraits recognizable became only part of the whole process.

The first identifiable paintings of living people, or of those who recently had died, in German art were portraits of donors and were invariably connected with altarpieces. The sitter would be identified by means of a dedicatory inscription or a coat of arms. With few exceptions, they could not be identified by their facial features until the second half of the fifteenth century. This applies, for instance, to the donor families whom Dürer had to include in the commemorative painting for a goldsmith named Glimm

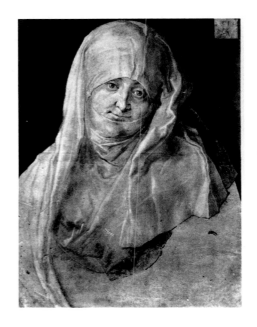

AGNES DÜRER AS ST. ANNE
Drawing; $15\frac{5}{8} \times 11\frac{1}{2}$ in. $(39.5 \times 29.2$ cm)
The date (1519) and Dürer's monogram appear in the top right-hand corner
Vienna, Graphische Sammlung, Albertina
Preparatory drawing for the painting (opposite).

VIRGIN AND CHILD WITH ST. ANNE (ANNA SELBDRITT)
Transferred from panel to canvas; $23\frac{5}{8} \times 19\frac{5}{8}$ in. $(60 \times 49.9$ cm)
The monogram and the date (1519) appear on the right
New York, Metropolitan Museum of Art, Altman Collection
Acquired by Maximilian I of Bavaria from the Gabriel Tucher Collection in Nuremberg. It then passed into the collections of Jos Otto Entres in Munich, Jean de Couris in Odessa, and Benjamin Altman in New York. The museum acquired it in 1913
Overleaf: Detail.

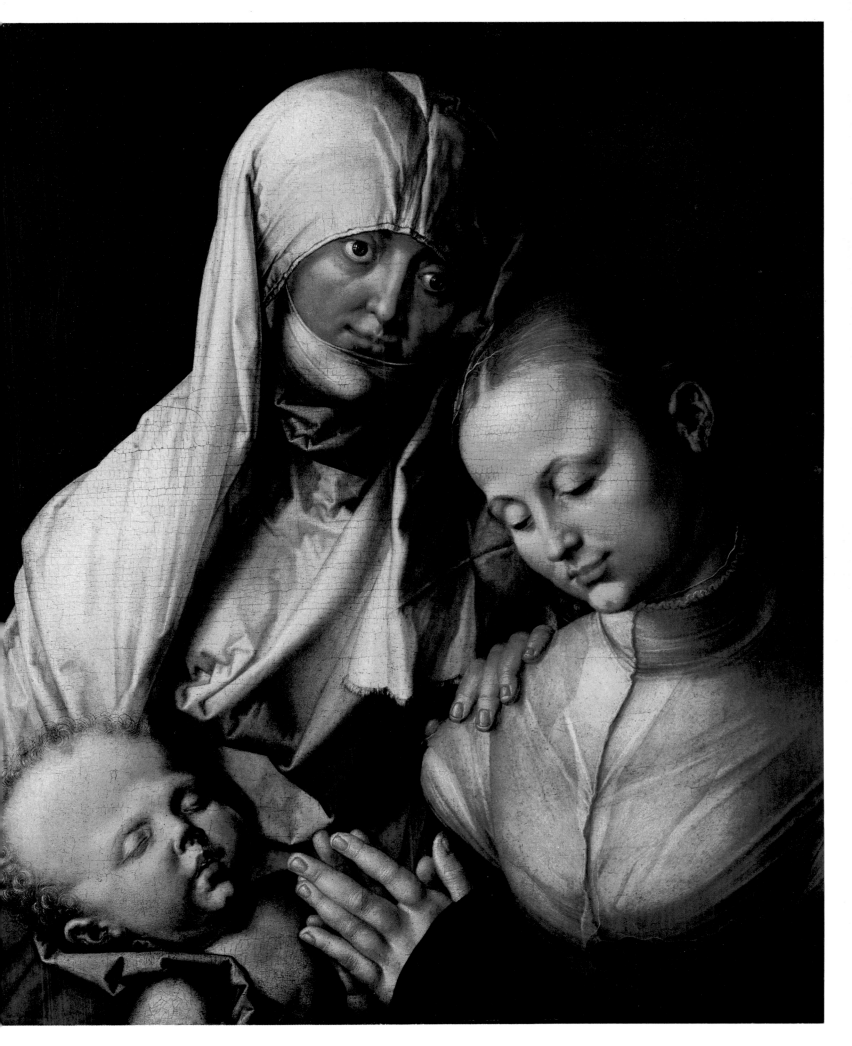

(*Lamentation over Christ*, p. 55) and to the central panel of the altar he painted for the Paumgartner family (p. 75).

The portrait's potential for preserving a person's image after death was connected in votive paintings with the Christian doctrine of redemption. The idea was for people to remember the sitter in their prayers both in his lifetime and after his death and shorten his period of purification in purgatory by their prayers and by donating indulgences. The secular value of portraiture is illustrated by Eobanus Hesse, who taught Latin at the St. Egidius grammar school in Nuremberg. In an epitaph to Dürer he has a man looking at Dürer's portrait say: "Your fame lives on and will never die." The thirst for fame, which outlives our short span of life on earth, was indeed one of the most characteristic qualities of the new "Renaissance man."

Dürer's interest in himself and in others ensures that his portraits play a vital part in his *oeuvre*, and they are of no less significance than his paintings and graphic works on religious themes. Some of his first paintings were indeed portraits—the portrait of his father, for instance, the 1493 self-portrait, and the surviving portraits of the painter with whom he worked in Strasbourg and the painter's wife. As soon as he had returned home from Italy, commissions for portraits started pouring in. His first patron was Frederick the Wise, Elector of Saxony, who probably sat for his portrait during a visit to Nuremberg in October, 1496 (p. 25). This was the first time that Dürer used thin canvas, painted in tempera. Even when they are in a good state of preservation and have not been ruined by later varnishing, as the portrait of Frederick has, Dürer's paintings in this medium haven't the brilliance of those painted in oils. But their special charm lies in the dry matt coloring, and the grain of the canvas is also a factor. As the elector would have been in Nuremberg for only a short visit, tempera also had the advantage of drying quickly.

Dürer chose to portray a large portion of his sitter in this work, setting him slightly farther back than the figure in the 1493 self-portrait, so that Frederick's arms, which are folded and laid on a balustrade, or window sill, are completely visible. His upright posture is emphasized by the vertical shape of the canvas, and the neutral background focuses our attention on the head, topped by a high biretta. The elector's eyes are wide open and looking straight at us. For this portrait Dürer kept to the old formula he had learned from Hans Pleydenwurff and Michael Wolgemut, but the idea of letting the sitter's personality dictate the pose is new, creating as it does a feeling of living tension and self-assured composure at one and the same time.

The local dignitaries followed the elector's example, starting with two couples from the Tucher family, whose portraits are dated 1499 (pp. 50–51). In both cases they were painted as portable diptychs, but one of the male portraits has disappeared. Whoever commissioned the paintings no doubt wanted the same format used for both pairs of portraits, with each sitter seen in half-length and in front of a balustrade, or windowsill. Our eye is drawn to a brocade curtain behind the sitters but then is led inward toward a landscape in the distance. Inscriptions and coats of arms identifying the sitters appear on the back of the paintings. The idea of combining a portrait and a landscape was taken up by painters in the Low Countries and in Italy before Dürer's day and also appears in fifteenth-century German paintings, which use a view through a window. Dürer took up the same theme, using a balustrade and a curtain and changing the formula only slightly.

Whereas there is something remarkably uninspired about the Tucher portraits, Dürer's career reached its first peak with his portrait of Oswolt Krel, the Nuremberg representative of a trading company, the Grosse Ravensburger Handelsgesellschaft (pp. 48–49). Krel was a young man, about the same age as Dürer, and had already, in spite of his important position, seen the inside of Nuremberg prison—he had made fun of a citizen of Nuremberg during a bit of horseplay at carnival time. Perhaps because of his spirited personality, his portrait has a much more authoritative ring to it than the Tucher portraits. The height is greater compared to the width than in the Tucher portraits, and we see more of the sitter. The young merchant's name and the date, 1499, are inscribed in large characters on the plain red

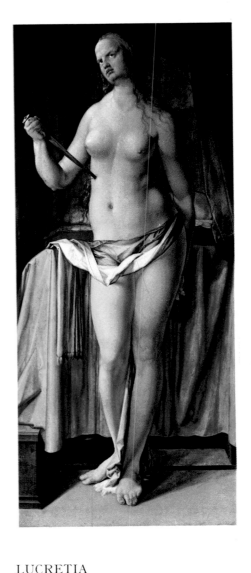

LUCRETIA
Oil on panel (lime); $66\frac{1}{4} \times 68\frac{3}{4}$ in.
(168×74.8 cm)
The monogram and the date (1518) are on the bench at the left
Munich, Alte Pinakothek
The piece of cloth draped around Lucretia was made wider in the seventeenth century. Two preparatory drawings, executed in 1508, are now in the Albertina in Vienna.

background, which leaves only a narrow strip of landscape visible. The trunks and leaves of the slender trees form a sort of optical barrier, which replaces the usual balustrade, or windowsill. Through it we can see a river meandering into the distance. Dürer has used every means at his disposal to focus our attention on the sitter and emphasize his significance. This impression is strengthened by the sculptural contouring of the angular face, whose penetrating gaze is looking sharply past us and to the left. Krel clearly knew what he wanted from life and was determined that people should recognize this quality in his portrait. The insistent and challenging feeling that emanates from the portrait is increased by the aggressively red background while the landscape, which is painted with the utmost delicacy and subtlety, shows the fruits of what Dürer had achieved in his watercolor sketches. The red of the background is echoed in a lighter shade in the sky, which has the reddish glow of early morning or evening, while a yellowish light glitters above the foliage. The painting is displayed today with a pair of side panels depicting wild men bearing coats of arms. They probably once formed the case, which also was painted by Dürer.

A similar impression of energy emanates from a portrait of another young man (p. 53), whose strongly modeled face and chin are set against a dark background. This is a small painting, and only the head, neck, and right shoulder of the sitter are visible. The surprisingly large numerals of the date, 1500, appear in the top left-hand corner. Early descriptions of this painting, which hung in the Paulus Praun collection in Nuremberg from the early seventeenth century onward (it is now in Munich), are not entirely clear, but they describe the sitter as Dürer's brother Hans. He may be the same person as the Hans Dürer whose application to join the Nuremberg tailors' guild was accepted in 1507.

In the early years of the sixteenth century Dürer was commissioned to paint many altarpieces and was also busy with his printing schemes; portraits had to take second priority until his second visit to Italy. He probably resumed portrait painting because he could fulfill his clients' requests fairly quickly and thus be sure of earning a living.

The portraits painted in Venice in 1505 and 1506 no longer follow the traditional Nuremberg formula. Instead, he painted his sitters half-length and turned slightly to one side, with no landscape, curtains, windowsills, or balustrades in the background. This made it easier to attain a unified color scheme. The feeling of intensity in the sitters' gazes gave way to a calmer mood, though this does not lessen the impression of individuality (pp. 91, 101). These portraits make it clear that Dürer approved of the type of coloring used in Venice and had digested it thoroughly. The contours of the faces are molded by means of soft light and transparent shadows, and this makes them seem more emphatic and impressive than the portraits painted by Italian artists. His contemporaries no doubt recognized Dürer's skill and wanted him to bring them to life in this way when he painted their portraits.

Two portraits painted in 1516 have survived, and they show how Dürer had modified his portrait style ten years after he had left Venice (pp. 139–140). As in the rest of his work at this date, the painterly element is no longer so strong. The contours of the faces are outlined with brush strokes in an attempt to fathom the inner depths of the sitters' personalities. The finest portrait along these lines is one of Michael Wolgemut (p. 140). Dürer was not commissioned to paint this portrait of his master and teacher but did it for himself. This is clear from the inscription in the top right-hand corner, which reads: "Albrecht Dürer made this likeness of his master Michel Wolgemut in 1516...." When the elderly Wolgemut died three years later, Dürer took the painting down from the wall and added: "... and he was 82 years old and lived until the year 1519 and then he died on St. Andrew's Day before sunrise." As in most portraits, Wolgemut is depicted wearing fine clothes—a fur-lined cloak. But he still has the piece of cloth wound around his forehead that he wore in the workshop to protect his hair against splashes of paint. Dürer's brush is pitiless in depicting all the signs of age, but this only serves to heighten the impression created by Wolgemut's serene but sharp and powerful gaze. This is, incidentally, the earliest known portrait of a painter that is not a self-portrait.

When he traveled to Augsburg with the Nuremberg delegation sent to

PORTRAIT OF THE EMPEROR MAXIMILIAN I

Tempera on canvas; $32\frac{3}{4} \times 33\frac{1}{2}$ in. (83 × 85 cm)

Dürer's monogram and the date (1519) can be seen on the right, on a level with the emperor's hat. The coat of arms of the Hapsburgs can be seen on the left, encircled by the Order of the Golden Fleece. The long inscription at the top extols the emperor's virtues and gives his dates (March 19, 1459–January 12, 1519)

Nuremberg, Germanisches Nationalmuseum. Formerly in Willibald Imhoff's collection

The Albertina in Vienna has preparatory drawings for this portrait, including one of the emperor's hands holding a pomegranate.

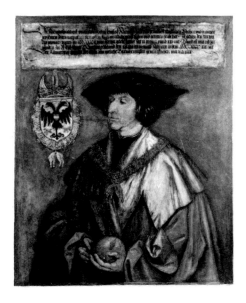

attend the 1518 Diet, Dürer was able, as we have seen, to do a drawing of Maximilian I. But he also had a chance to portray a whole series of important people, including the Augsburg merchant and entrepreneur Jakob Fugger (p. 149), whose wealth had contributed greatly to Maximilian's grandson, Karl, being chosen King of Rome. The portrait was based on a charcoal drawing sketched from life (Berlin) but seems more stately because Fugger is wearing an expensive-looking fur cloak instead of the everyday clothes seen in the drawing. Of all the known portraits of Fugger by Augsburg painters such as Hans Holbein the Elder and Hans Burgkmair, only Dürer's raises the wealthy merchant above the bourgeoisie, seeing him as a "royal merchant." As well as the portrait on canvas that has survived, there probably was a final version in oil on panel since two copies both show a number of differences in the sitter's clothing compared to the tempera on canvas version.

Dürer's stay in the Low Countries in 1520 and 1521 resulted in a number of innovations in his portraits and a change in style. Besides the drawings that he later would work up into painted portraits, he had started in 1503 to produce finished portraits in soft charcoal or crayons, which he signed and dated. These media were exceptionally appropriate for tackling in black and white the sort of light and shade effects that he had been aiming for in color since 1506. He received an amazing number of requests for portraits when he was in the Low Countries, and as he was without the resources of his own workshop these drawings served as a substitute for paintings on panel or canvas and were, therefore, taken to an advanced stage of completion. The entries in his diary, together with the portraits that have survived, show that all sorts of people from the higher strata of society and the artistic establishment sat for him, plus a few, such as the black woman employed by the King of Portugal's ambassador in Antwerp, João Brandão (p. 152), who reflect Dürer's personal interest in his sitters.

Only two painted portraits have survived from his period in the Low Countries though the diary mentions a third one of the exiled King Christian of Denmark. For this portrait he had to call on an unnamed colleague in Brussels for help, and he tells us that the latter's apprentice, a lad called Bartholomäus, ground the colors for him. Dürer expressed his thanks with a tip and the *Life of the Virgin* series of woodcuts.

As for the pictorial effect of the portraits executed in the Low Countries, the fact that he adopted the formula normally used there, which included showing the hands, is less important than the fact that the artistic environment encouraged him to think of himself as a painter once again. His inspiration was further enhanced by studying the works of the old masters in the churches and town halls and by the personal contacts he made among the living painters. The new goals and possibilities he had worked out for himself, incorporating techniques he already had practiced in Italy in 1506 but had neglected since then, can be seen clearly in his portrait of Bernhard von Reesen (or Resten) (Dresden).

In 1519 he began to use graphic techniques for portraits, starting with one of Maximilian I, who had died only recently. Dürer's subjects included various ecclesiastical and secular leaders as well as Erasmus, Philip Melanchthon, and Willibald Pirckheimer, the foremost representatives in their day of theological and secular knowledge. He wished to draw Martin Luther but never did so. In 1520 he wrote to Georg Spalatin: "If God allows me to come to Doctor Martinus Luther, I shall do his likeness with the greatest diligence and turn it into a copperplate engraving as a permanent memorial to that Christian man." This suggests that the engraved portraits were intended to be commemorative images. This admittedly did involve a slight reference to the religious element inherent in donor portraits, which had an intercessory role, but portraits were primarily memorials, intended to convey the sitter's political or intellectual claims to fame. Dürer makes clear this aspect of portrait painting by using ancient Roman tombs as his starting point and by allowing classical ideas to creep into the inscriptions on his paintings and drawings. Beneath the half-length portrait of Willibald Pirckheimer (p. 160) appears a stone slab carved in Roman capitals with the well-known words: "Vivitur ingenio caetera mortis erunt" ("With the spirit we live on; all the rest is doomed to die"). So now it is not the Christian

DÜRER AS A SICK MAN
Pen-and-ink drawing, lightly washed with watercolor; $4\frac{5}{8} \times 4\frac{1}{4}$ in. (11.8 × 10.8 cm)
1512–1513
Bremen, Kunsthalle
The inscription at the top reads: "Do der gelb fleck ist vnd mit dem/finger drawff dewt do ist mir we." ("Where the yellow spot is and I am pointing with my finger, that's where it hurts"). Dürer is pointing to his spleen, and this has led to the theory that he did the drawing for a doctor who was to diagnose him.

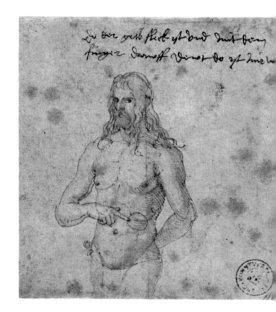

PORTRAIT OF JACOB FUGGER
(Detail)
Tempera on canvas, subsequently mounted on panel (pine); $25\frac{3}{8} \times 20\frac{7}{8}$ in. (64.4 × 53 cm)
1518
Augsburg, Staatsgalerie. Was in Schleissheim Castle in 1760
Jacob Fugger the Rich, as he was known, lived from 1459 to 1525 and was the most famous and shrewdest merchant of his day in Augsburg. There is a preparatory charcoal drawing in Berlin (W571), which Dürer drew from life in 1518, during the Diet of Augsburg.

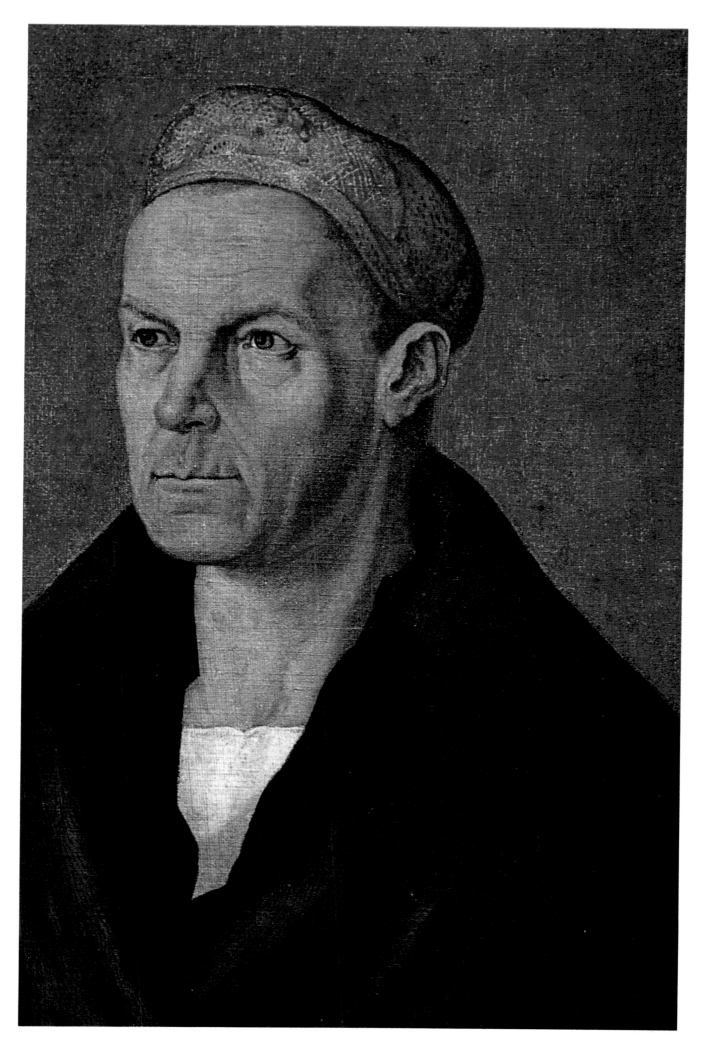

anima that lives on but the creative spirit that emerges from one's knowledge and the fame of one's deeds.

In his engraved portrait of Frederick the Wise, Elector of Saxony (p. 161). Dürer comes so close to the usage of Roman tombstones that one needs some knowledge of the conventional abbreviations to understand the inscription: "B[ene] M[erenti] F[ecit] V[ivus] V[ivo]" ("[Albrecht Dürer] erected [this monument] to this most worthy man as a living man to the living"). He thus follows the Roman custom by setting up a memorial to his oldest benefactor and patron while he is still alive. And in so doing he manages to give artistically satisfying form to humanist endeavors to imbue classical subjects with Christian content.

Toward the end of his life Dürer had mastered a wide range of techniques that enabled him to vary his style to suit the potential symbolic content of a portrait. For instance, in 1526 he painted portraits of the representatives of the highly conservative Nuremberg town council, Hieronymus Holzschuher (p. 171) and Jakob Muffel, which may have been commissioned for some official purpose. But in that same year he also did a likeness of Willibald Pirckheimer's shady son-in-law Johannes Kleberger, a highly gifted and successful merchant (p. 141). Thanks to Dürer's portraits, the names of Holzschuher and Muffel, both members of the upper class in Nuremberg, have continued to live though they did not distinguish themselves in any way during their family-destined political careers. Both men were friends of Dürer, and it seems as though he deliberately contrasted their very different features. He once again had changed his portrait-painting style—which is obvious already in the portrait of an unknown sitter in the Prado, dated

THE TRIUMPHAL CHARIOT OF
MAXIMILIAN I (Detail)
Drawing with watercolor added
The date (1518) can be seen at the top
Vienna, Graphische Sammlung
Albertina.

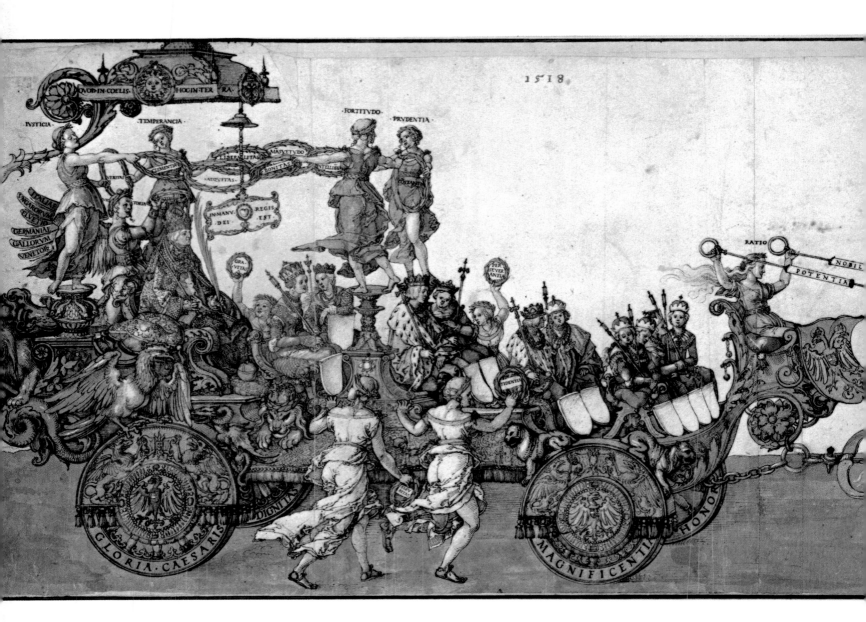

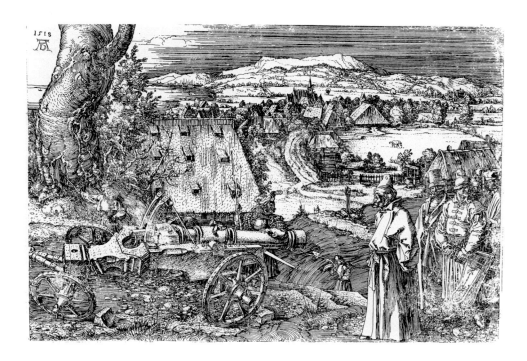

1524 (p. 162). The formula developed in the Low Countries, which included more of the upper half of the body and the hands, has been superseded by a plain head and shoulders image, and in portraying the face he has returned to transcribing the features graphically.

The Holzschuher portrait, which is in an excellent state of preservation, was still in the family's possession down to 1884. The brushwork is very delicate, depicting every hair, but individual details are subordinate to the overall composition, and the portrait gives a definite impression of the sitter's character. In the Kleberger portrait, however, Dürer adopts a completely new formula, combining elements from dissimilar styles to create an alienating effect. The basic image is in the manner of an ancient Greek or Roman nude bust, but the flesh tones are naturalistic, and the bust forms the center of a medallion in greenish marble. Dürer obviously was influenced here by a number of widely differing formulas for sculptural portraits though all of them hark back to classical styles; he might have seen the originals of such portraits or have read descriptions of them. Yet what makes this portrait so innovative is precisely the way in which he has brought together so many heterogeneous elements and the freedom with which he uses contrasting styles to complement one another. It appears that Dürer's knowledge of the historic obligations of portrait painting led him to attempt an illusion of three-dimensionality, feeling that it was better suited to express the new significance of the portrait as a means of preserving a person's fame and individuality. We do not know whether the Kleberger portrait was a unique experiment, inspired at least in part by the sitter's unusual and inconsistent personality, because Dürer's illness and subsequent death prevented him from taking this type of portrait any further.

Christian Subject Matter
The major part of Dürer's *oeuvre* is devoted to the traditional themes of the Christian doctrine of salvation, most of which had been used as pictorial subject matter even in the fourteenth century. As he said himself, painting should be first and foremost concerned with Christian themes: "It also cannot be denied that I was describing something that can be used for art. For Christ's passion can be depicted in painting and it can be brought into the service of the churches." In depicting Christ's passion, with the exception of the memorial painting, *The Lamentation over Christ* for the goldsmith Albrecht Glimm, Dürer chose to use graphic techniques, whereas in his paintings the dominant themes are from the life of Christ as a child and young man, plus individual paintings of the Virgin Mary. He also did a large number of engravings of major saints, whom the ordinary people looked to

for protection and help in times of sickness and need. We safely can assume that even on the eve of the Reformation, which attacked the cult of saint worshipping because it led to abuses and exaggerations, it was precisely these prints that were most widely distributed, appealing to people for whom the artistic quality of the work was of secondary importance.

Dürer referred to one entire group of saints' images of this type as "bad wood work," meaning very simple prints with little claim to technical skill and therefore selling at a lower price. On the other hand, some engravings are clearly very different from devotional images and are aimed more at the educated collector with humanistic leanings. St. Jerome had become the patron saint of the humanists since he was the scholar who translated the Holy Scriptures and was equally proficient in Greek, Latin, and Hebrew. He was also a cardinal and hermit who was counted among the Early Fathers. Dürer depicted this legendary figure on several occasions. In 1492 he simply retold the legend on his title page to an edition of St. Jerome's letters, showing the learned prelate interrupting his translation to treat the paw of the lion who has entered his study-bedroom (p. 13). A different side of the saint is depicted in one of Dürer's early copperplate engravings, an etching of 1512 and a woodcut of 1514. This time the saint is seen as an anchorite in the wilderness, mortifying himself before a crucifix or using a rough-hewn boulder as a table. Then an engraving dated 1514 brings various aspects of the legend together, depicting the saint as a hermit, writing away at the back of a spacious and peaceful study filled with sunlight (p. 133). The only references to the wilderness and the saint's renunciation of all worldly things are a lion blinking peacefully in the foreground, a gourd or pumpkin hanging from the raftered ceiling, and a skull on the windowsill. This engraving, known as *St. Jerome in his Study*, was intended as one of a set of three, which included *Melencolia I*, which was issued in the same year, and *The Knight, Death and the Devil* (1513).

These three *Meisterstiche*, which are much the same size, do not form a sequence as do Dürer's series of illustrations on the New Testament, but they are closely related in their technical brilliance and by their subject matter, which demonstrates the different ways in which man can live and conduct himself. Yet in putting his message across, Dürer uses very different stylistic methods, resulting from completely separate series of experiments. We already have seen that *The Knight, Death and the Devil* was partly the result of his research into the proportions of horses. There, in the encounter with death and the devil, the knight is depicted as a man leading an active life within a Christian framework. St. Jerome represents a different side of this Christian way of life, a quiet existence consisting of prayers and study. The realistic way in which his home is depicted helps to bring him across very strongly as a living personality. The use of spatial perspective, which enables Dürer to depict the whole length of the room, starting from the doorway, is an important factor here. It is based on his researches into central perspective, which already were taking up a great deal of his time at the beginning of the sixteenth century and on his second journey to Italy. However, he did not use the knowledge about perspective that he had acquired from Italian texts until he produced these "master engravings."

In *Melencolia I* (pp. 129–131)—he wrote the title himself—Dürer has woven together Christian and humanistic ideas to devise an image of the creative soul. In this he was influenced particularly by the neo-Platonism that had emerged in Florence. The engraving is dominated by a large, winged female figure seated on a stone step with a pair of compasses, opened out ready for measuring, in her right hand. She is wearing a wreath on her head, which is propped up by her left arm, with the elbow resting on her left knee—an age-old gesture symbolizing a contemplative attitude. Her eyes are gazing into the background, probably staring at the little banner proclaiming her "humour," which is lit up by a comet and borne by a hybrid creature rather like a bat. At her side is a winged *putto* busily writing away and perched on a piece of cloth draped over a millstone, which is propped upright. Both figures are surrounded and indeed almost crowded out by a sleeping dog and various objects, some of which are attached to the lower story of a building towering up behind the figures—indeed it looks like a tower. These objects are the traditional attributes of Melancholy—various

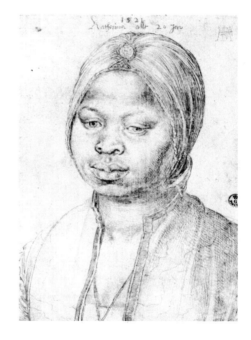

THE NEGRESS KATHERINA (PORTRAIT OF A MOORISH MAID)
Silverpoint; $7\frac{7}{8} \times 5\frac{1}{2}$ in. $(20 \times 14\,\mathrm{cm})$
At the top edge in the center is the inscription, "Katherina allt 20 Jar" ("Katherina at the age of 20"), with the date (1521) above it; the monogram can be seen on the right
Florence, Uffizi, Gabinetto disegni e stampe
The first reference to this drawing being in the Uffizi collection is in an inventory of 1784. The sitter was the Negro slave of the King of Portugal's ambassador to Antwerp, João Brandão.

ST. APOLLONIA
Drawing in black charcoal on green-tinted paper; $16\frac{3}{8} \times 11\frac{3}{8}$ in.
$(41.4 \times 28.8\,\mathrm{cm})$
Berlin, Staatliche Museen Preussischer Kulturbesitz, Kupferstichkabinett
Formerly in the Robinson Collection
This is a preparatory drawing for a *Sacra Conversazione* (Madonna and Child with saints) that was never in fact painted.

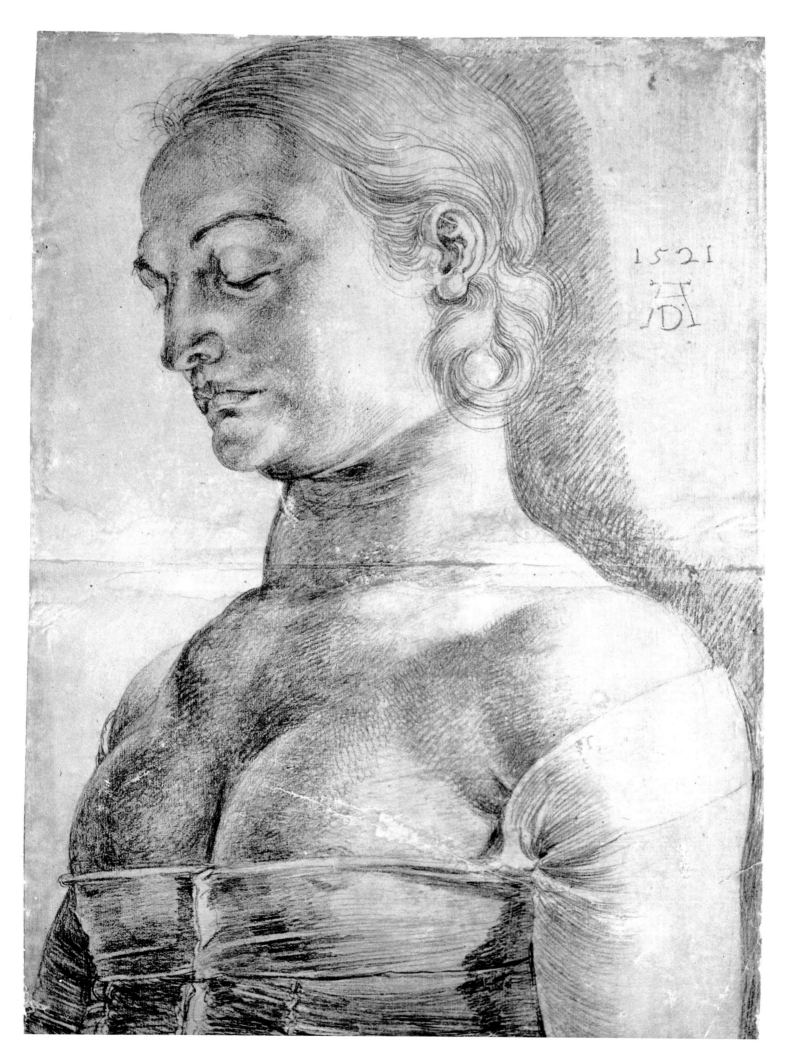

153

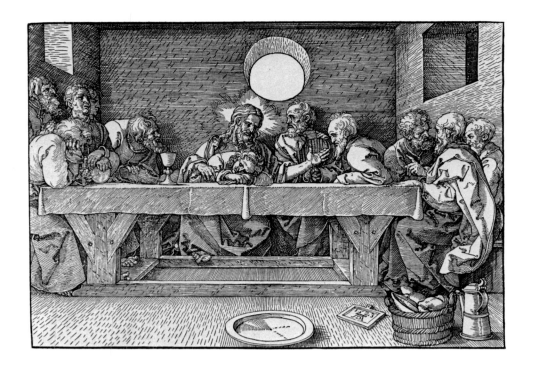

LAST SUPPER
Woodcut; $8\frac{3}{8} \times 11\frac{7}{8}$ in. (21.3 × 30.1 cm)
A tablet bears the monogram and the date (1523).

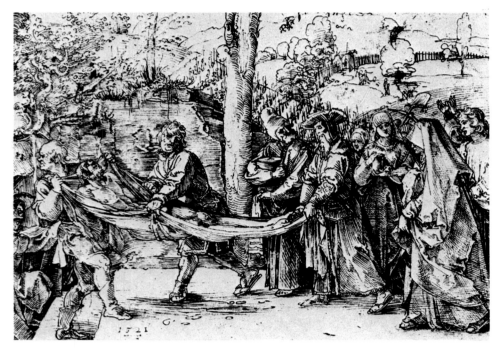

CHRIST BEING BORNE TO THE TOMB
Pen-and-ink drawing; $8\frac{1}{4} \times 11\frac{3}{8}$ in. (21 × 28.9 cm)
The artist's monogram appears in the bottom left-hand corner, with the date (1521) above it
Nuremberg, Germanisches Nationalmuseum (on loan from the city of Nuremberg). From the Andreossy, Schickler, and Mitchell collections
This is one of a group of drawings depicting scenes from Christ's passion that Dürer did in the Low Countries. They were intended to be the basis for a series of engravings that were never executed.

tools, besides articles that should be interpreted as geometric figures (the round millstone, a sphere, and a stone carved to the shape of a polyhedron). A crucible being heated over a fire and a pair of scales are allusions to alchemy, while a "magic square" symbolizes mathematics. All these symbols are ambiguous since they have many different meanings, and the engraving has been interpreted in different ways, though the differing interpretations are not necessarily mutually exclusive. At any rate, the basic theme Dürer wished to express seems to be the melancholy and depression that seizes man when he has doubts about the success of his work. Dürer must have been only too familiar with this mood himself. The humanists and neo-Platonists considered melancholy a positive intellectual force, and Dürer sees it as symbolizing the person who has the ability to create something new with his mind and with his hands.

In depicting themes relating to Christ's message to the world Dürer was not interested in inventing new pictorial imagery. What he tried to do was heighten their impact by using styles that were constantly being modified by the artistic techniques he had acquired from work in different fields. In 1498

he issued fifteen woodcuts illustrating the *Apocalypse* (pp. 36–37), preceded by a title page. For many years master engravers had put individual engravings of the same size together to form a series. Dürer undoubtedly knew Martin Schongauer's series called *Christ's Passion*, though in fact both secular and religious themes were used in this treatment. Dürer's woodcuts were innovations in that apart from the "proofs" (which probably really meant a fairly large number of first-run prints for collectors), they had the relevant Latin text printed on the verso. An edition with the text in German was issued in the same year. Although this meant that pictures and text already were linked, in 1511 it was suggested that a new edition should be put together, in book form this time and with a different title page depicting the Virgin appearing to St. John.

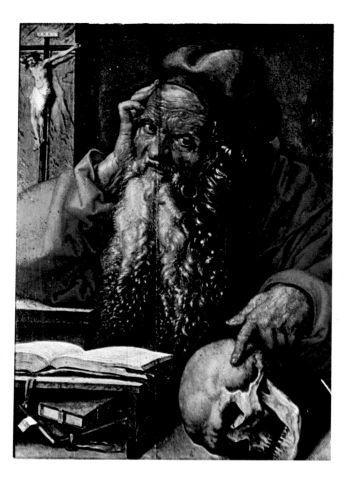

ST. JEROME IN MEDITATION
Oil on panel; 23⅝ × 18⅞ in. (60 × 48 cm)
A small slip of paper in the bottom left-hand corner bears the monogram and the date (1521)
Lisbon, Museu Nacional de Arte Antiga
This painting was taken to Portugal by Rodrigo Fernandez d'Almada, Portuguese ambassador to the Low Countries from 1521 to 1550
Overleaf: Detail.

The apocalypse, using as it does grandiose images to tell of the horrors that will occur when the world comes to an end and the eternal Kingdom of God arrives, always has been among the Biblical writings most often selected for illustration. Both its content and style make it eminently suited to pictorial treatment. Dürer's choice of scenes and his basic schema are modeled on earlier editions, including the Bible published by Anton Koberger in 1483 (the blocks for this Bible actually had been made in 1478 for another Bible printed in Cologne). Yet in Dürer's hands this difficult text, which is based on a long-standing classical tradition, is not simply transposed into a pictorial style that can be understood by ordinary people. Instead, he creates visions worthy of the powerful text and renders them very realistically. The woodcuts must have had an extraordinarily strong influence on Dürer's contemporaries, and they spread his fame far and wide.

From a stylistic point of view, the success of the series lay in Dürer's ability, at this stage of his artistic development, to combine the non-naturalistic late Gothic style with a new method of recording figures and

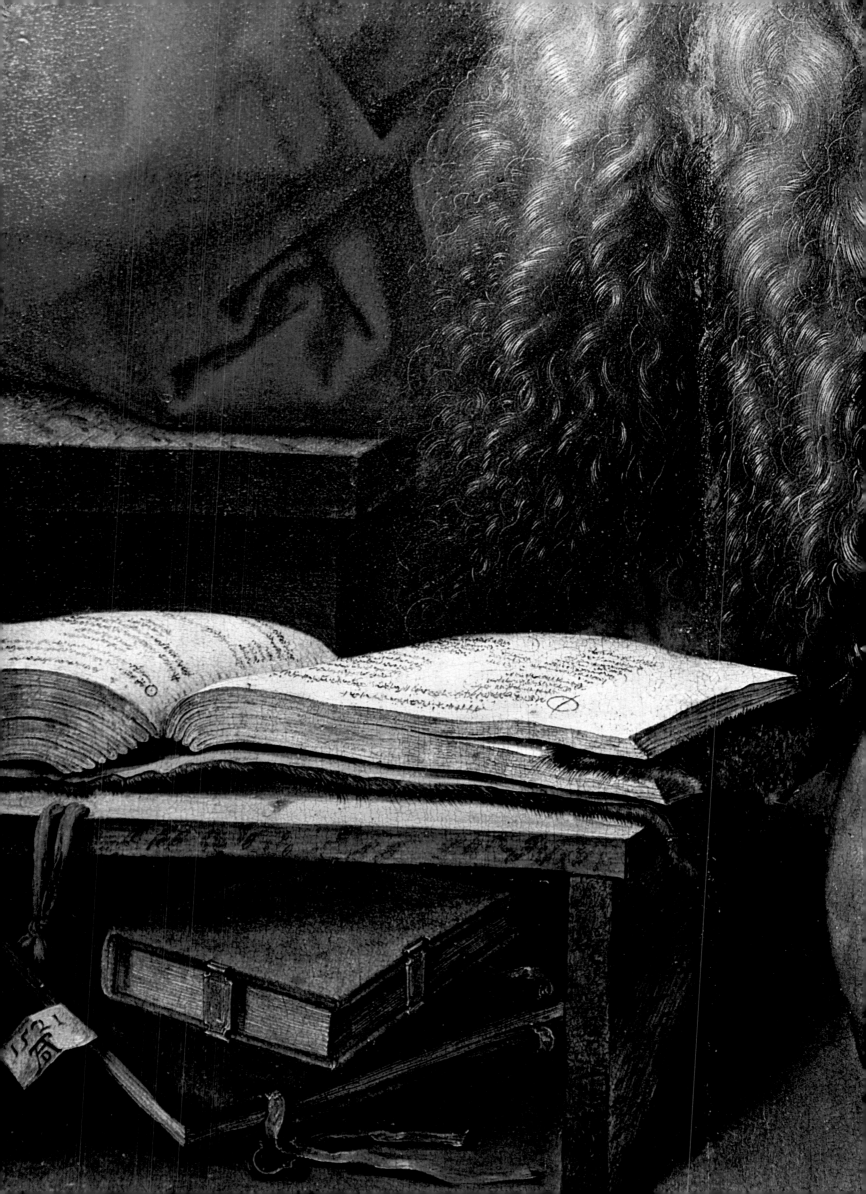

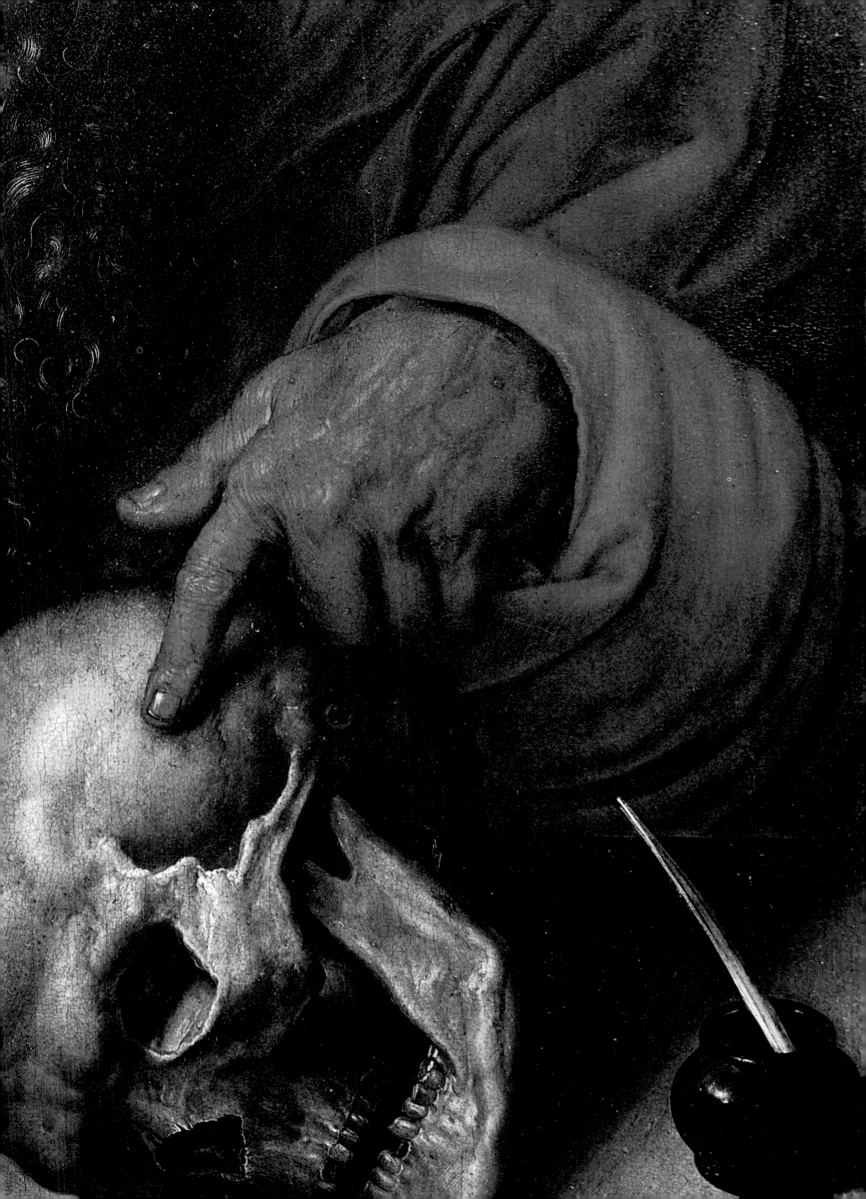

landscapes based on the study of nature. The woodcuts made considerable demands on the wood engravers of Nuremberg—no one before had ever ventured to use such a large format (40 × 30 cm, 15¾ × 11¾ in.), and the initial drawing involved extensive use of hatching and subtle gradations of light and shade. Dürer demanded much greater skill from the artisans than they had shown in the *Schatzbehalter* and *The Nuremberg Chronicle*.

Dürer must have conceived of making the series a cycle of images selected and arranged according to artistic criteria after a lengthy and detailed study of the text and its possible interpretations. The basic theme did in fact fit well with the mood of the times; the first signs of imminent religious and social unrest were beginning to appear, and there was a permanent threat of attack from abroad. The series was bound to awaken a strong response among interested men and women and potential buyers who were sensitive to this mood. Although the symbolic content is fairly inaccessible, images such as the Four Horsemen of the Apocalypse had become widely known, and indeed people still feel they have a valuable message to convey in times of need.

While preparing the *Apocalypse* series, which depicts the battle between darkness and light as the end of the world approaches and includes scenes showing the dragon struggling with the Virgin, the Babylonian whore, and the antichrist leading the people astray, Dürer also was working on another

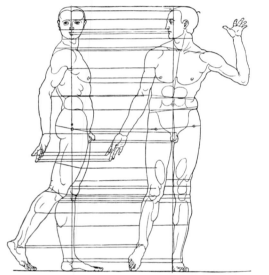 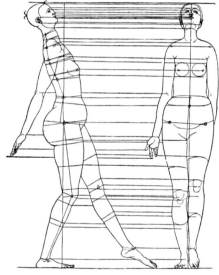

DRAWINGS FROM DÜRER'S *PROPORTIONSLEHRE*
Bamberg, Staatsbibliothek
This treatise, which appeared in four volumes, contains all of Dürer's studies on the proportions of the human body. It appeared a few months after his death (April 6, 1528) under the title *Hierinn sind begriffen vier bücher von menschlicher Proportion...* The publisher was Hieronymus Andrea of Nuremberg.

series of woodcuts, known as *The Great Passion*. They are just as large, but this time they portray the fight between good and evil by illustrating the Way of the Cross (pp. 116–117). This series of plates initially was limited to Christ's passion, but in 1510 Dürer added four more scenes, illustrating the Last Supper, Christ being taken prisoner, His descent into hell, and His resurrection. Then in 1511 Dürer issued the whole series in book form, with a Latin poem by a Benedictine monk at St. Egidius in Nuremberg, Benedictus Chelidonius.

The early woodcuts breathe the spirit of the apocalypse, with thrilling crowd scenes showing the figures all going in the same direction. The main protagonists are portrayed three-dimensionally and stand out as if in relief from the crowd of figures who have been welded together to form a compact mass, whereas the later woodcuts concentrate more on individual figures. Dürer is mainly working here with light, which increases the sculptural quality of the figures, and he brings them out from their surroundings by means of deep areas of shadow. Instead of a sort of relief wall, the figures are free-standing and are contained within a clearly defined pictorial space.

After an interval, during which he produced some of his largest altarpieces, Dürer rounded off his illustrations of the story of the passion and

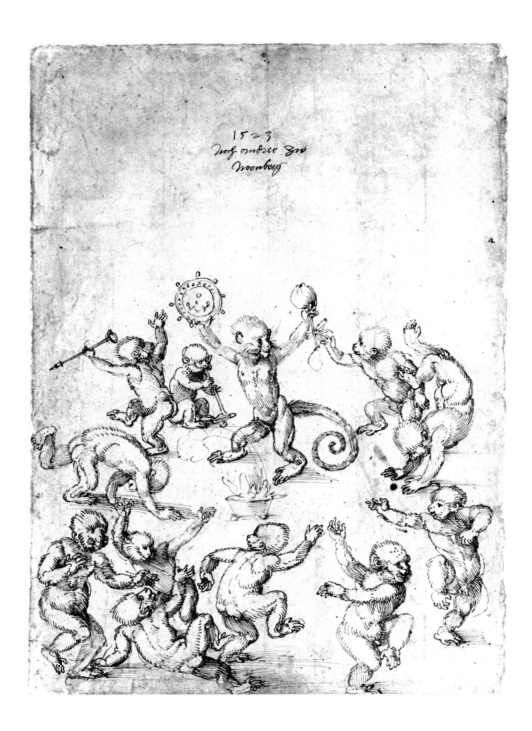

MONKEYS DANCING
Pen-and-ink drawing; $12\frac{1}{4} \times 8\frac{5}{8}$ in.
$(31 \times 22$ cm)
The inscription at the top reads: "1523
noch andree zw nornberg"
Basel, Öffentliche Kunstsammlung,
Kupferstichkabinett
On the verso Dürer wrote a short letter
to Felix Frey, a Zurich canon, dated
December 6, 1523.

salvation of Christ by producing another series of woodcuts, *The Life of the Virgin* (p. 116). This cycle depicts the events surrounding Mary's birth, her life as the Mother of God, her death, and the Assumption, as described in the Gospel according to St. Luke and the well-known stories in the apocrypha. These woodcuts are not dated, but all but two of them, which were completed in 1510, were executed before Dürer's second visit to Italy. The whole series was published in book form in 1511, together with *The Great Passion* and the *Apocalypse* and again with a text by Benedictus Chelidonius. *The Life of the Virgin* prints are smaller than the first two series (approximately 30×21 cm, 12×8 in.), and the atmosphere, as befits the subject matter, is very different. After the tone of high drama in which Dürer portrayed Christ's sufferings and the end of the world, he turned in *The Life of the Virgin* to a popular narrative style that illustrates his material with great affection and without sacrificing anything in quality of execution. Instead of occupying a dominating position in the foreground, the human figure has been thrust back and in the majority of the prints appears inside some sort of architectural structure drawn in perspective. Even in scenes that take place in a landscape setting Dürer has created a similar pictorial space using natural details, within which he places his figures.

Another smaller series of woodcuts depicting Christ's sufferings also was issued at the same time as the publication of the three large books. This is known as *The Small Passion*, as the engravings measure only 12.6 × 9.7 cm (5 × 3.8 in.). The complete series of thirty-seven woodcuts, including the Fall and the Expulsion from Paradise, as well as the Last Judgment, is dated 1509–1511. The four woodcut books next were complemented by a series of engravings that once again depict Christ's passion. Each of the sixteen engravings is dated, indicating that Dürer was working on them between 1507 and 1512. Although the series is often bound together, as it consists of engravings, it is in a different tradition from the woodcut sequences, which were provided with a text and from the outset owed much to the style of illustrated books. Unlike Michael Wolgemut, Dürer was draftsman, engraver, printer, and publisher all rolled into one. His first task was to create a connoisseur's market for his graphic work; he had to reach a far wider circle than those who were prepared to buy individual prints, in

Left
PORTRAIT OF CARDINAL ALBRECHT OF BRANDENBURG (DER KLEINE KARDINAL)
Engraving; $5\frac{3}{4} \times 3\frac{3}{4}$ in. (14.6 × 9.6 cm)
The cardinal's coat of arms appears in the top left-hand corner and his age, 29, is given at the bottom.

Right
PORTRAIT OF WILLIBALD PIRCKHEIMER
Engraving; $7\frac{1}{2} \times 4\frac{3}{4}$ in. (18.8 × 12 cm)
Hamburg, Kunsthalle.

other words, fellow artists. Two contracts that he signed as early as 1497 with itinerant booksellers to hawk his engravings and woodcuts have come down to us, and he also sold direct to the public at markets and fairs—even his mother and his wife did some selling for him. As far as possible proceedings were taken against people issuing pirated editions; the use of special imperial licenses and complaints to appropriate authorities were the usual methods of holding this practice in check.

When it came to large paintings, the financial situation was very different. Although we gather from Dürer's letters and diaries that he sometimes painted pictures on speculation in order to build an inventory of paintings against the possibility of sales, he was dependent on commissions for major works and had to conform to his clients' wishes and views. His earliest extant paintings, the portrait of his father and the 1493 self-portrait, were done on his own initiative, and if he did help to produce an altarpiece for a Dominican church (Darmstadt, Landesmuseum) as is generally supposed, he must have been given this work because of his association with a workshop in Strasbourg. The only commission he fulfilled on his own during his journeyman's period was a small panel depicting Christ as the "Man of Sorrows." He did not start painting in earnest until he had settled in Nuremberg on a permanent basis after his 1494–1495 journey to Italy and had set up his own workshop, taking on assistants and pupils as time went by.

Dürer's first major patron was Frederick, Elector of Saxony, who had received a humanist education. When he decided to have his newly built residence in Wittenberg, plus the castle church, decorated with frescoes and altarpieces, the elector was determined to secure Dürer's genius and the output of his workshop for his own artistic and political schemes. Among the earliest commissions Dürer executed for him was a polyptych, since broken up, consisting of a *Mater Dolorosa* (Munich) and seven *Scenes from the Life of Christ* (Dresden). Although these paintings recently have been restored, it still seems doubtful that Dürer painted them himself. Also dating from this time is a small altarpiece, known as the *Dresden Altarpiece*, painted on canvas and intended for the Schlosskirche (Dresden, pp. 30–31). This painting, too, was particularly badly damaged because of the type of ground used and because it was painted in thin tempera, but it was restored in 1957 to something approaching its original state. The central panel of the triptych depicts the Virgin adoring the infant Jesus, with the child asleep on a

PORTRAIT OF FREDERICK THE WISE
Engraving; $7\frac{5}{8} \times 5$ in. (19.2 × 12.7 cm)
The artist's monogram can be seen on the left, and there are two coats of arms at the top of the engraving.

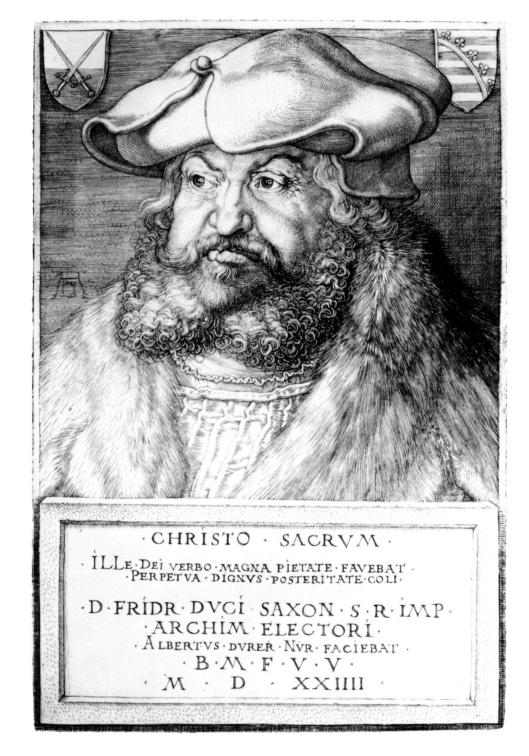

windowsill, while the side panels depict St. Anthony and St. Sebastian, with cherubs holding martyrs' crowns above their heads.

The arrangement of these three paintings does not conform to the usual scheme for reversible altars. Even in their original frame the side panels could not be shut because the painting technique used and the ground were not suitable for an altarpiece painted on both sides. This affected the format chosen for the side panels, which are narrower than usual. The central panel

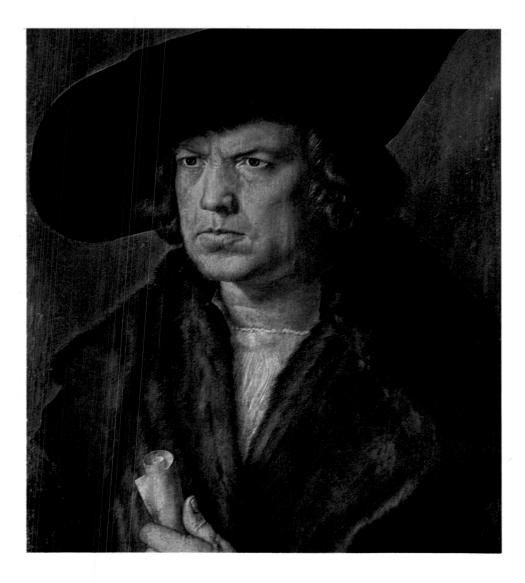

PORTRAIT OF A GENTLEMAN
Oil on panel (oak); $19\frac{3}{4} \times 14\frac{1}{4}$ in.
(50×36 cm)
The date (1524) and Dürer's monogram appear in the bottom right-hand corner (not visible here)
Madrid, Prado
It was in the Alcazar in Madrid in 1686. The sitter's identity is not known, though various theories have been put forward.

is not quite as high, but that is because a strip has been cut off the top. Although there is no doubt that the three paintings belong together—the same stone parapet, or windowsill, runs across all of them—the central panel is on much coarser canvas than the side panels. As a result, the theory that Dürer added the side panels to an earlier work painted by someone else cannot be entirely refuted. This idea arose on technical grounds and recently has been revived; it is supported further by the way the flooring is constructed in vanishing perspective—the only instance of this in Dürer's entire *oeuvre*. At any rate, the overall impression created by the center panel and the side panels is so much of a piece that it is hard to reject the idea that Dürer had at least some influence on the center panel as it now stands.

It seems likely that Frederick the Wise also commissioned another altarpiece from which the center panel is missing. The side panels depict the standing figures of a pair of saints on the inside and on the outside a scene showing Job's wife dousing him with water from a bucket to the sound of music from a shawm (a type of musical instrument with a reed) and a drum (pp. 71–73; Munich, Cologne, Frankfurt). The inclusion of the musicians in

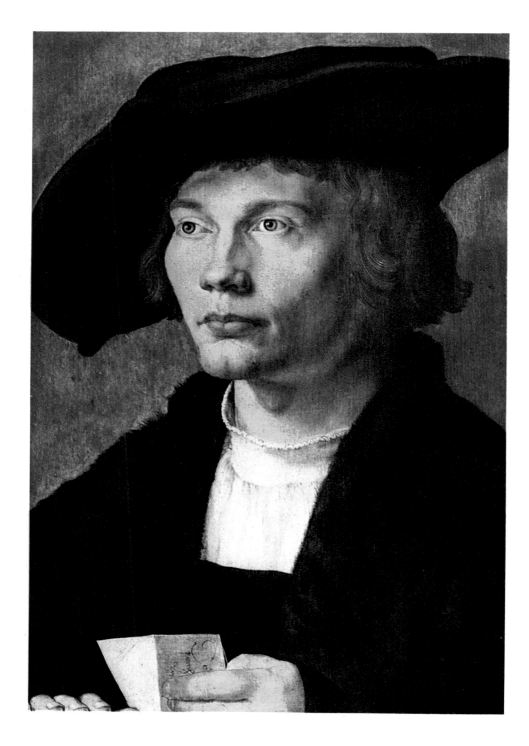

PORTRAIT OF BERNHARD VON
REESEN (?)
Oil on panel (oak) ; $17\frac{7}{8} \times 12\frac{3}{8}$ in.
$(45.5 \times 31.5\,\text{cm})$
Bears Dürer's monogram and the date
(1521)
Dresden, Staatliche
Kunstsammlungen, Gemäldegalerie
This sitter is probably identical with
Bernhard von Resten, whose portrait
Dürer painted in Antwerp in March,
1521.

this Old Testament scene, which is in itself unusual in an altarpiece, can be interpreted in several ways. Some experts believe that they deliberately are mocking a man who is down on his luck and has been abandoned by God while others see them as consoling Job since music was thought to be a cure for melancholy. The resemblance between Dürer himself and the drummer seems to support this second interpretation.

A dated painting of the *Adoration of the Magi* (pp. 87–89), which originally probably was the center panel of an altarpiece, also belonged to the Elector of Saxony. In this painting Dürer has solved various problems posed by the need to link human figures to surrounding pictorial space, which consists of architectural elements. In a related composition—the center panel of the *Paumgartner Altarpiece* (p. 75), which depicts the Nativity—our gaze is forced toward the background through a narrow passageway formed by solid-looking ruins. In the *Adoration of the Magi* this movement is less insistent and has been shifted from the center of the painting to the right-hand side. The compact, self-contained impression produced by the group of figures framed by the architectural elements and

the landscape is strengthened by the subdued coloring. Dürer has avoided the forceful effects created by the presence of areas of color that interact, each strengthening the other—one of the characteristics of the *Paumgartner Altarpiece*.

His next commission was a large altarpiece depicting Christ's passion (Vienna, Diözesanmuseum). He only carried it as far as the preliminary sketches, though these are meticulously drawn (Frankfurt, Städelsches Kunstinstitut). Next followed a smaller panel painting, again for Frederick the Wise. It is clear that the latter is entirely his own work since there are several references to it in his correspondence with Jakob Heller in Frankfurt. The theme chosen by the elector was *The Martyrdom of the Ten Thousand* (pp. 112–115). This refers to the Christian soldiers who were executed on Mount Ararat by various oriental princes on orders of the Roman emperors Hadrian and Antoninus. (The elector's vast collection of relics included relics of these martyrs.) Dürer has made it quite clear that the princes perpetrating the massacre were oriental, and this suggests that the constant threat posed by the Turks had added a topical note to the legend although it in fact originated in the twelfth century and has been traced back to the crusades.

Faced with the need to fit a large number of moving figures into a small area, Dürer demonstrates his skill by creating a pictorial space that is all of a piece and acts as a clearly defined stage, with groups of foreshortened figures moving away from the center in all directions, like spokes on a wheel. In the center stands Dürer himself, accompanied by a thick-set figure who has been identified, probably correctly, as Konrad Celtis, who died in 1508. Dürer is holding a stick to which is attached a placard with a Latin inscription identifying him as the painter and giving the date 1508. The painting was removed from its original panel backing at some later time and transferred to canvas. As a result, the colors have lost something of their original brilliance, but it still is obvious that Dürer expended a great deal of time and trouble on this painting, managing by his artistry to overcome the gruesome quality of the subject, which might otherwise have caused offense, being so much at variance with the tolerant spirit of humanism.

Over the next few years Lucas Cranach the Elder frequently took over from Dürer in fulfilling commissions from the elector—Cranach was now resident in Wittenberg and had been appointed a court painter with a steady salary. In a letter written to the mayor of Nuremberg and the town council in 1524 Dürer complains that he has received very few commissions from the town during his long residence there: "I can also write with truth that, during the thirty years I have stayed at home, I have not received from people in this town work worth 500 florins. ... I have, on the contrary, earned and attained all my poverty (which, God knows, has grown irksome to me) from Princes, Lords, and other foreign persons...." Dürer always was ready to complain loudly when it came to financial matters—yet he died one of the wealthiest men in Nuremberg. It is true, however, that he scarcely benefited from the large number of donations, in the form of magnificent altarpieces, that the citizens of Nuremberg were once again making to the town's various churches on the eve of the Reformation. This may have been mainly his own fault, for his new concept of art and the artist resulted in refusal to follow the usual workshop practice of producing commemorative paintings and triptychs in rapid succession at a price and of a quality that matched traditional ideas of the artist's role. He wrote to Jakob Heller:

> Of ordinary pictures I will in a year paint a pile which no one would believe it possible for one man to do in the time. But very careful nicety does not pay.

As a result, only two altarpieces that he painted personally for merchants in Nuremberg have come down to us. The municipal council, which had little occasion to commission work from painters—apart, that is, from routine jobs requiring a craftsman's hand—did in 1513 order two paintings of emperors for the "Insignia Room." The sum of sixty guilders that was paid for "two pictures" in 1511 clearly did not apply to these paintings, though we cannot say with any certainty to what it did apply. When the town council set about having the interior and exterior of the large main hall in the

THE FOUR APOSTLES, ST. JOHN AND ST. PETER, ST. PAUL AND ST. MARK
Oil on panel (lime); 84⅝ × 30 in. and 84¾ × 30 in. (215.5 × 76 cm and 215.5 × 76 cm)
Both panels bear the artist's monogram and the date (1526)
Munich, Alte Pinakothek
Dürer presented both paintings to the city of Nuremberg in 1526, and the city authorities handed them on to Maximilian I of Bavaria on August 27, 1627
Overleaf: Detail.

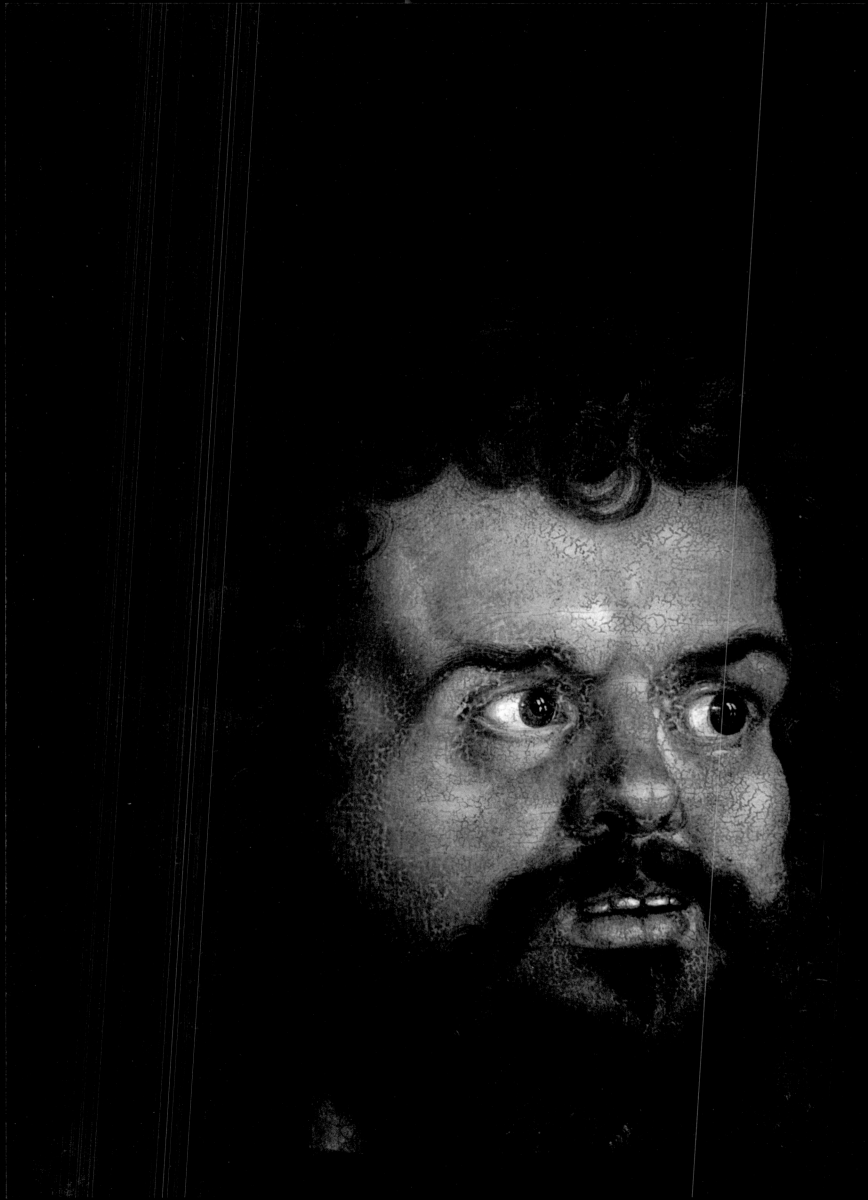

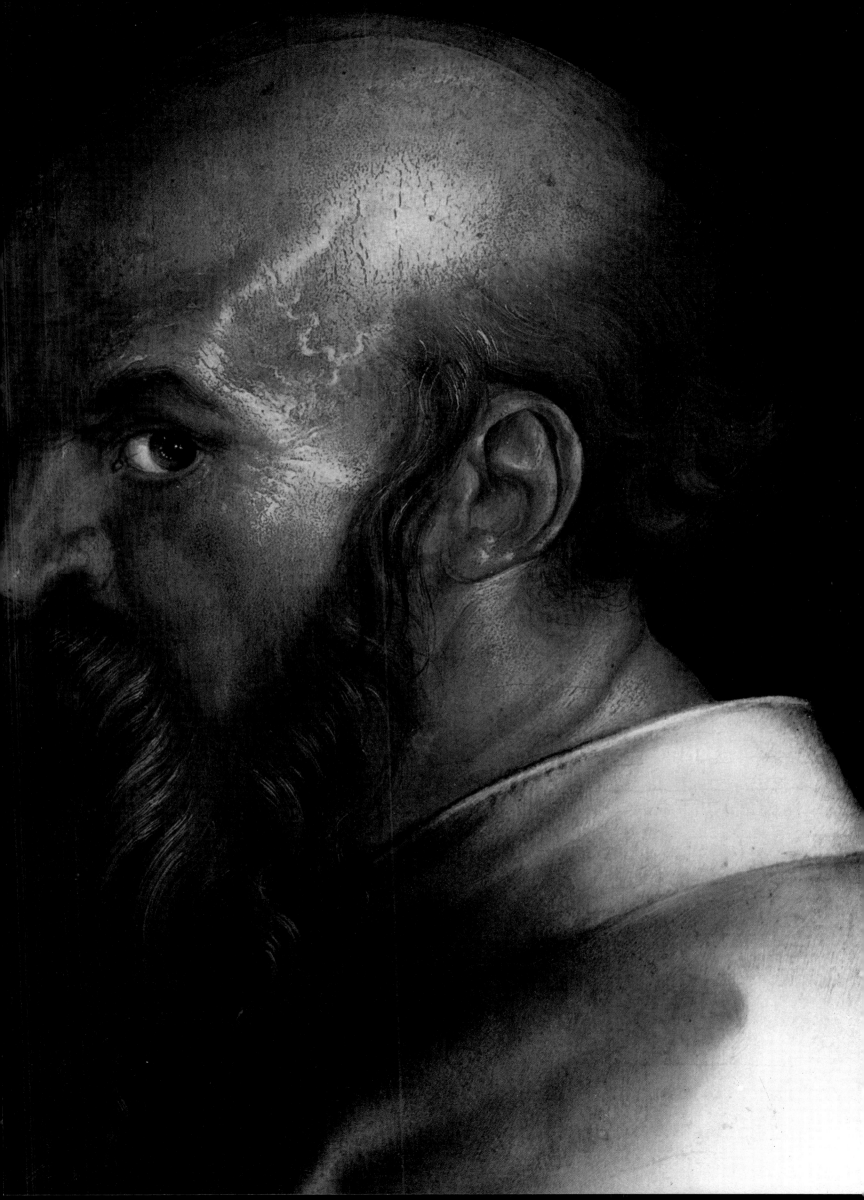

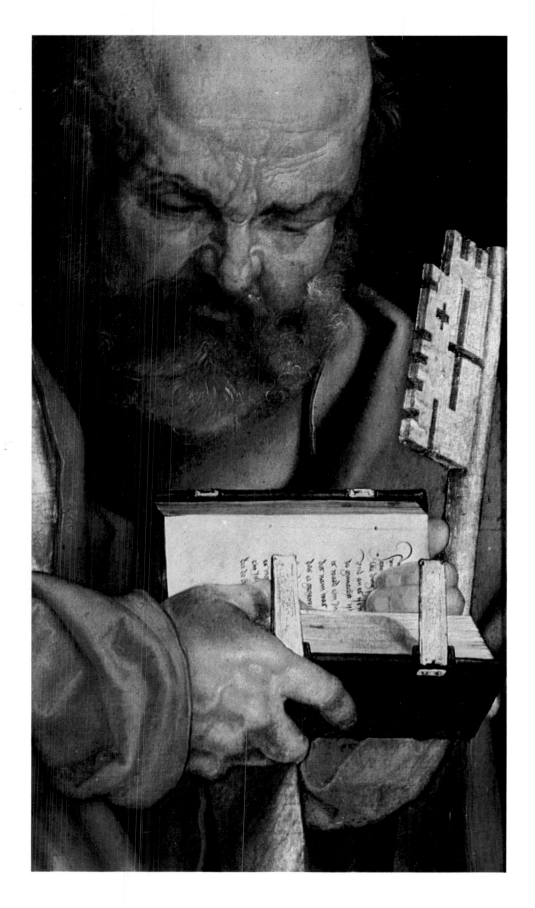

THE FOUR APOSTLES
Detail showing St. Peter.

MADONNA AND CHILD (VIRGIN
WITH THE PEAR)
Oil on panel; $17 \times 12\frac{5}{8}$ in. $(43 \times 32$ cm$)$
Bears the monogram and the date
(1526)
Florence, Uffizi.

town hall decorated with paintings—the year was 1521 and it had just been rebuilt—it was only natural that Dürer should be called upon. He was paid a fee of one hundred guilders, but as all the paintings are now lost, we cannot be sure what this sum represented. All that has survived are two sketches (Vienna; New York, Morgan Library), which appear to relate to paintings on the interior walls.

168

We can tell from the presence of coats of arms belonging to members of the Paumgartner family that they commissioned Dürer to paint an altarpiece for St. Katherine's church, which was attached to a Dominican convent in Nuremberg (pp. 75–80, 82–83). The reredos (Munich) is painted throughout. The center panel depicts the Nativity while the figures of St. George and St. Eustace—with the features of Stephan and Lucas Paumgartner—appear on the side panels. All that has survived of the paintings on the outside of the panels is the figure of the Virgin from an Annunciation scene. We cannot now be sure when the altarpiece was painted. A seventeenth-century account admittedly does refer to Dürer as having painted Stephan Paumgartner and his brother Lukas as St. George and St. Eustace in 1498, but the treatment of space in the center panel suggests that the St. Katherine's work must have been painted after 1500, though before the *Adoration of the Magi* in Florence, which dates from 1504. Whereas the center panel is treated in perspective, the two saints are depicted against a neutral black background and take up the whole width and height of the side panels. Although the figures are full of movement, they are in fact squeezed into a fairly small area. Similarly, although they are not depicted life-size, they have a monumental feeling about them. They are highly realistic figures—this realism is, of course, underlined by the fact that they are portraits —and as such go beyond any standing figures that had as yet been produced in Nuremberg. Dürer's research on the human figure during his stay in Venice clearly contributed to this realism, as did his knowledge of Italian sculpture such as that on the tomb of Roberto Sanseverino, who was killed in battle in 1487. The tomb is in the cathedral in Trent, and Dürer could have seen it on his way to Venice.

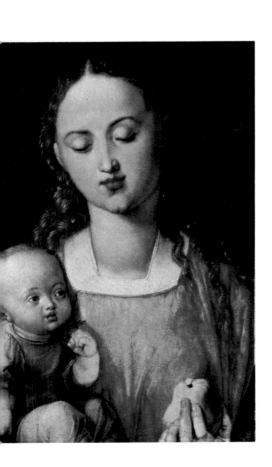

The last painting Dürer executed "in the service of the Church," apart from the group of small paintings of the Virgin, was commissioned by Matthäus Landauer in 1511—this was only the second piece of work ever commissioned from him by a client in Nuremberg. The subject was the *Adoration of the Trinity* (p. 119), and it was to be donated to the chapel of the Zwölfbruderhaus, a type of old people's home. It is an Italian-style altarpiece, consisting of a single panel, and originally was set in a frame designed by Dürer himself. This frame, which still can be seen today in the Germanisches National Museum in Nuremberg, is full of both Gothic and Renaissance stylistic elements (there is a sketch in Chantilly). The painting used to hang in a chapel with stained-glass windows also designed by Dürer. These windows found their way to the Kunstgewerbemuseum in Berlin but were destroyed after World War II.

The basic theme, the adoration of the Trinity, is illustrated in the top half of the painting. God the Father, wearing an emperor's crown, is holding the Cross bearing the living figure of the crucified Christ in His outstretched arms. The dove of the Holy Ghost is coming down from heaven toward God the Father and God the Son, surrounded by a halo made from light and *putti*. The other half of the painting represents the earth, and in the foreground — which consists of a landscape that seems to stretch into infinity —stands the solitary figure of Dürer beside a large memorial tablet inscribed in Latin with the date 1511 and the artist's name in carefully balanced Roman capitals. Between the two zones of heaven and earth hovers the "communion of saints" on banks of clouds. Male and female figures from the Old Testament are grouped on the left-hand side of the Trinity while female martyrs appear on the right-hand side. Beneath them is a wide ring of standing and kneeling humans representing the "Church militant" (*ecclesia militans*). The people stretch across the whole width of the painting and are led by the pope and the emperor. The elderly donor, on the recommendation of a cardinal, can be seen gazing at this celestial vision. The ring is made up mainly of powerful and distinguished living figures, but it also includes a peasant with his flail and a face made ugly by years of hard work. The peasant is turning to an angel who has been assigned to him and will afford him special protection. The idea of giving prominence to the peasants and caring for them had occurred already in a late fifteenth-century altarpiece depicting the Last Judgment, which now hangs in the church of Katzwang in the south of Nuremberg.

In this painting Dürer uses his newly acquired mastery of perspective and

spatial organization to depict the "highest things." He creates an impression of abundant yet finite space, embracing the entire content of the painting and unifying it into a single entity. Dürer achieves this not by means of architectural structures but solely by the way he has arranged the figures and in his treatment of color and light. The top layer of paint is in excellent condition—including the gold on the pope's cloak—and clearly illustrates his belief in the intrinsic value of color for its own sake.

From various remarks Dürer makes in his letters to Willibald Pirckheimer and Jakob Heller we know that he also painted some work on speculation, not seeking a buyer until he had finished. At least one of these uncommissioned paintings was a Madonna, which was bought by Johann V. Thurzo, Bishop of Breslau, for seventy-two guilders. Other patrons, too, no doubt decided to combine the need for a devotional image for private use with their ambition to acquire a painting by a well-known artist. Paintings of the Madonna so often have been bought by private collectors that the subject has become almost more secular than religious. The purely human relationship between a mother and her child became a basic theme—after all, its religious significance was intelligible only in the light of tradition.

Dürer's first Madonna and Child appears on the altar painting that was discovered in the Capuchin convent in Bagnacavallo (p. 24). Another Madonna, painted shortly after this and commissioned by a member of the patrician Haller family, portrays her as a majestic and very upright figure. Her pose so closely resembles one of the variants on the basic formula adopted by Giovanni Bellini that for many years this painting was thought to be the work of Bellini. Yet the overall impression it creates, with the window giving on to a landscape and the remarkably rigid standing posture of the infant Jesus, leaves no room for doubt: it is clearly the product of a German workshop (p. 41).

The painting on the reverse of the *Virgin in Half-Length* (or *The Haller Madonna*, as it is often known) is more puzzling. It depicts Lot and his daughters fleeing from a blazing Sodom (pp. 42–45), and the towering cliffs in the background must have been based on sketches of quarries that Dürer made in the area around Nuremberg in the years immediately following his return from his first trip to Venice. The subject matter does not seem connected in any way with the Madonna and Child on the front of the panel. Yet it is hard to believe that Dürer would have used a panel that was already painted with a fragment of some very large painting, which had been broken up, for a work commissioned by an important family such as the Hallers. The answer seems to be that he originally painted a diptych consisting of a portrait of the donor on one panel and the Madonna and Child on the other. In that case the Lot scene would have been on the outside of the left-hand panel, which revolved. The link between the two paintings becomes a little clearer if we think of the destruction of the cities of the plain by heavenly fire as the real subject of the painting. Lot's flight, which is depicted as a scene from contemporary middle-class life, thus merely clarifies the theme. This indicates that Dürer once again was aiming to portray the theme of a dramatic end to the world, as in the *Apocalypse* series, which indeed dates from the same period. The link between the front and the reverse of the panel would therefore be that Dürer equates the Madonna with the woman in the apocalypse who appears in the sky when the world comes to an end and gives birth to the Messiah.

While at work on the large altarpiece for the German community in Venice, which depicts the Madonna as the "Queen of the Rose Garlands," Dürer also produced a smaller altarpiece on the same theme (p. 99). A piece of paper lying, as if by chance, on a desk at the bottom of the painting bears an inscription in Latin with Dürer's signature and the date 1506. Unfortunately, the top layer of paint is in a poor state of preservation and gives little idea of the brilliant coloring Dürer used to compete with the Venetian painters. The Madonna is seated on a throne against the background of a wide landscape containing a mixture of German and Italian architectural elements. Two *putti* are hovering above her, holding a garland of foliage over her head. Her right hand is supported by a Bible, and she is pointing to it as *sedes sapientiae*, the "seat of eternal wisdom," which is embodied in the Infant seated on a cushion in her lap (the cushion is an age-

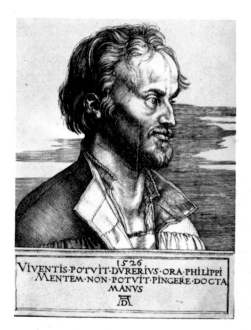

PORTRAIT OF PHILIPP MELANCHTHON
Engraving; 6¾ × 5 in. (17.2 × 12.6 cm)
The lower section bears the inscription: "1526/VIVENTIS POTVIT DVRERIVS ORA PHILIPPI/MENTEM NON POTVIT PINGERE DOCTA/MANVS' ("Dürer could portray a likeness of Philipp Melanchthon from life, but the skilled hand could not portray his spirit"), followed by the monogram.
The humanist and pedagogue Philipp Melanchthon was a supporter and collaborator of Luther. He was invited to Nuremberg twice, in November, 1525, and May, 1526, for consultations about founding a university. This portrait is the earliest to have come down to us of this famous man.

old symbol for a figure throned in majesty). John the Baptist, portrayed as a child no older than the infant Jesus, has drawn near, guided by an angel bearing his symbol, a shepherd's crook. John the Baptist is holding out two lilies of the valley—a traditional symbol of the Virgin—as a gift for both Mother and Child. The siskin perched on Jesus's arm has given its name to the painting, *The Madonna with the Siskin* (or, occasionally, *The Madonna with the Goldfinch*).

In this painting Dürer offers a more profound interpretation of a theme that was common in the late Gothic period, the Coronation of the Virgin, drawing on his knowledge of Italian paintings of the Madonna as a basis for this image of sublime majesty imbued with lovable human features. Such an image, resulting as it does both from the composition and from the type of woman portrayed, had never been seen before in German art.

In later Madonnas Dürer portrays less of the figure and interest is concentrated on her face and on the infant Jesus. Thus the real theme is the very close human relationship between mother and child. In one painting,

PORTRAIT OF HIERONYMUS HOLZSCHUHER (Detail)
Oil on panel (lime); $19 \times 14\frac{1}{4}$ in. $(48 \times 36\,\text{cm})$
Dürer's monogram can be seen on the right, and at the top of the painting (not visible here) is an inscription in Dürer's hand. It reads: "HIERONIM[us]. HOLTZSCHVER. ANNO. DOŇI. 1526. ETATIS. SVE. 57" ("Hieronymus Holzschuher in the year 1526 at the age of 57")
Berlin, Staatliche Museen Preussischer Kulturbesitz, Gemäldegalerie
Holzschuher was a senator and a member of the Nuremberg Council of Seven. The portrait is identical in format and technique to a portrait of another Nuremberg dignitary, Jacob Muffel, which makes it seem likely that both paintings were commissioned from Dürer for some "official" purpose.
Overleaf: Detail.

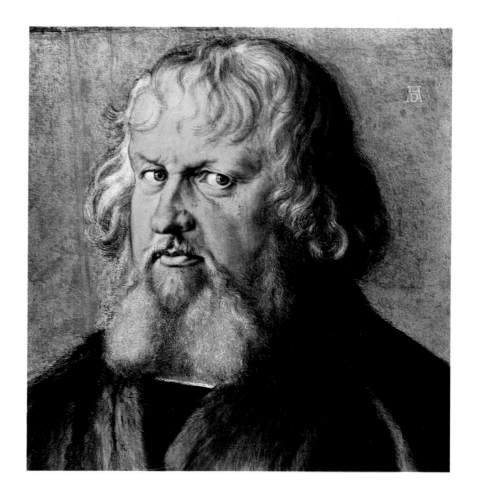

now in Vienna and dating from 1512 (p. 128), the only traditional symbols of the Madonna's special status are a veil and a circlet around her forehead. Her majesty lies in the deeply serious gaze she bestows on the Child as she holds Him up for worshippers and spectators to see. The predominant color is light blue—traditionally the "beautiful" color—and this, together with the nobility and youthfulness of the Madonna's face and the arresting manner in which the vivacious Infant's body is depicted, may well have helped to make it one of Dürer's most popular works. It is an expression of human values that are important even outside of Christian context.

When he returned to Nuremberg from his visit to the Low Countries, Dürer once again became preoccupied with the theme of the Virgin Mary, and he made some preparatory drawings for an imposing painting of the Virgin in Majesty surrounded by saints. The painting itself was never

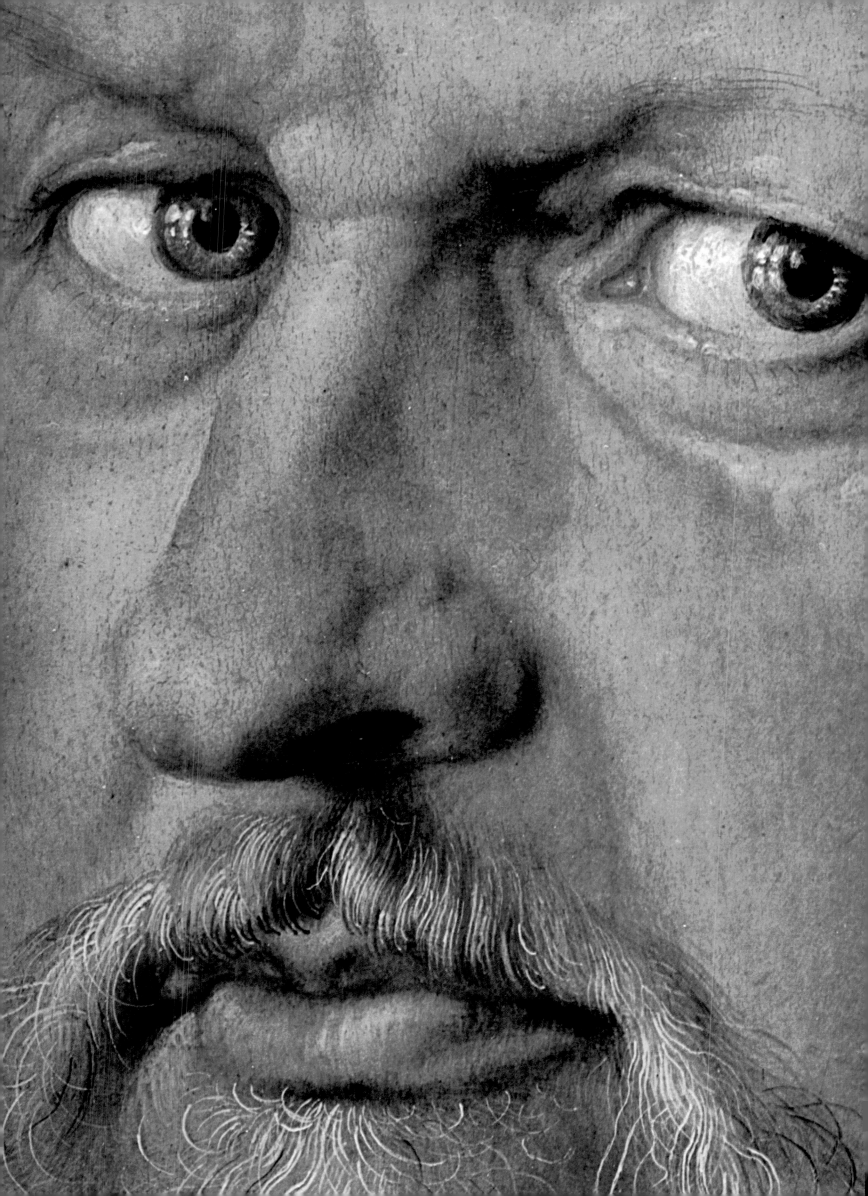

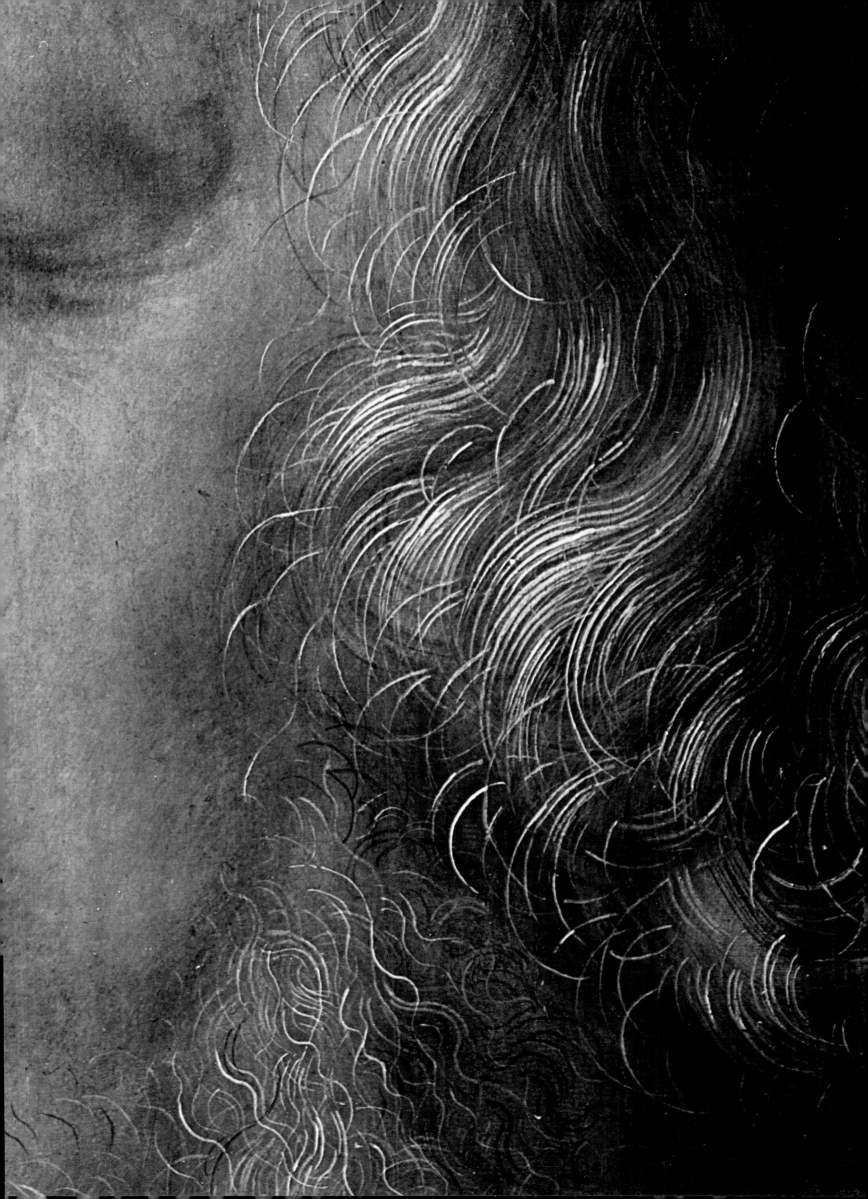

executed though something of the same pose went into his last Madonna, which is dated 1526, a year after the Reformation officially had been introduced in Nuremberg (p. 169). The idea of portraying the Madonna as the embodiment of quiet contemplation is based on a sketch of St. Barbara (Paris) for the larger painting that never progressed beyond the planning stage. This time she is not even wearing a veil, so the last visible mark of her status as the mother of God, as derived from the Byzantine tradition, has disappeared. Instead, the painting's religious significance rests solely on the spiritual relationship between mother and child. This very close relationship between them is expressed not so much in the way they are both turning to look at the pear in the Madonna's hand as in the image that lies at the heart of the composition, the single overlapping silhouette that embraces both the mother and her child. Should we perhaps view this as a first attempt to devise a new method of accommodating a traditional theme to the ideas spread by the Reformation, an attempt to preserve the old image for the new religion?

Dürer was a deeply religious man, and this is constantly reflected in his writings. His was by no means an unthinking faith, for he was genuinely anxious to come to grips with the theological problems that exercised men's minds during the Reformation. Like many members of the upper classes in Nuremberg, he belonged to the "Sodalitas Staupiziana," a group who were followers of Johann Staupitz, an Augustinian monk and professor of theology who attempted after 1512 to teach theology to the upper strata of the middle classes as well as to monks and nuns in the monasteries and convents of southern Germany. Staupitz belonged to the same order as Luther and had been his spiritual adviser in Wittenberg, holding the chair of theology at Wittenberg University before Luther. Carl van Mander tells us that the Dutch painter Jan van Scorel came to Nuremberg, probably in 1519, to work with Dürer. But when Dürer became interested in Luther's writings, van Scorel decided to leave.

In 1525 the Nuremberg council held a discussion on religion in the town hall, which ended with their decision to accept the Reformation. This involved changes in religious services, doing away with anniversaries for the dead, and dissolving the monasteries and convents. These alterations in the age-old rites and forms of devotion inevitably affected art—in spite of Luther's broadminded attitude toward it—though the Nuremberg council took such a firm stand that iconoclastic riots and social revolution were avoided.

Apart from a remark made by Willibald Pirckheimer in a letter to the architect Johann Tscherte in 1530, which seems to suggest something of the sort, we have no evidence that Dürer objected to the decision reached by the city of Nuremberg on the religious question or that he dissociated himself from the Reformation, as Pirckheimer and his biographer Dr. Christoph Scheurl were to do after Dürer's death. His last painting, *The Four Apostles*, shows that after careful consideration, Dürer's attitude toward the religious situation, which was inevitably also a political one, was more one of skepticism than of enthusiasm—he did not greet it with the enthusiasm that bursts from his dirge in the *Diary of a Journey to the Low Countries*.

The Four Apostles consists of two panel paintings depicting the over-life-size figures of St. John and St. Peter, plus St. Paul and St. Mark (pp. 165–168). The title is in fact inaccurate since St. Mark the Evangelist was not one of the twelve apostles, though he already was referred to as such in 1538 when the painter Jörg Pencz was paid fifteen guilders out of public funds for gilding the frame. The figures are standing on pedestals, which are inscribed with texts devised by Dürer and written by the calligrapher Johann Neudörffer. They begin with the words: "Let all worldly rulers in these dangerous times take care not to give heed to human temptation as if it were the word of God. For it is God's will that nothing should be added to His Word, or taken from it. These four men, St. Peter, St. John, St. Paul and St. Mark, give warning against this." Quotations from the writings of the apostles follow, using Luther's 1522 translation. They warn that men may appear who will lead others astray by claiming to be teachers and prophets but will in fact falsify the true doctrine or manage to conceal their monstrous crimes by leading an apparently pious and godly life.

MILLS ON A RIVER BANK
Sketch in watercolor and gouache;
$9\frac{7}{8} \times 14\frac{1}{2}$ in. (25.1 × 36.7 cm)
Dürer's monogram appears near the top of the sketch on the left, but it is not in his own hand. However, the word "weydenmull" is authentic
Paris, Bibliothèque Nationale.

What gives Dürer's warning its momentous significance is the artistic style he adopts and his powerful portrayal of the apostles. The steadfast and monumental figures of St. John and St. Paul, enveloped in their cloaks, stand in the foreground. The folds of their cloaks have a sculptural quality, as if they were carved out of stone, and their coloring—bright red and light, cool blue—is related to the wearers' personalities. The two men embody the quality of spiritual steadfastness. St. Peter, the leading apostle according to Roman Catholic doctrine, has been relegated to the second rank in the left-hand painting while St. Mark occupies the corresponding position in the right-hand painting. Both main protagonists are holding a Bible, the book that contains God's word. St. Peter and St. John are reading it together while St. Paul and St. Mark have closed their Bible and are looking away from it. St. Peter and St. Paul are identified by their traditional attributes, a key

and a sword, as well as by the inscriptions beneath the paintings.

Dürer spent a great deal of time and trouble planning these paintings. A drawing dated 1525 (Bayonne, Musée Bonnat) depicts the complete figure of St. John, and in 1526 he made some large preparatory studies for the heads of the other three saints (Berlin; Bayonne). Although Dürer had not been commissioned to paint this pair of pictures, he did plan them so that they would have the desired effect in the place where he intended them to hang. He offered them to the town council as a gift and memorial to himself, indicating that they should be hung in the town hall (he also addressed the council directly in his inscription). We should consider these paintings in the context of the way town halls were decorated and furnished as centers of municipal power and jurisdiction, although they go beyond the usual appeals for impartial justice made in paintings of the Last Judgment or of historical examples of just or unjust judges. Dürer's work appeals to a new type of responsibility, which accrues to secular rulers when they acquire ecclesiastical authority. By agreeing in 1525 to the introduction of the Protestant religion and setting in motion the means by which this could be achieved, the town council no longer had the sole duty of governing the town in accordance with God's command. The council also became responsible for interpreting God's word and keeping it pure without support from ecclesiastical authorities in Bamberg or Rome.

In *The Four Apostles* Dürer wanted to portray the entire gamut of human behavior. Johann Neudörffer, his first biographer, tells us in his *Nachrichten von Künstlern und Werkleuten* ("News of Artists and Craftsmen"), published in 1546, that the four life-size apostles represent the four humours—the sanguine, the choleric, the phlegmatic, and the melancholic. It seems reasonable to suppose that this reading was Dürer's own since Neudörffer actually wrote the inscriptions beneath the paintings. He also tells us that they used to hang in the Upper Regimental Room in Nuremberg town hall. We do not know what this stately room originally was intended for, but over the years it gradually became a sort of art gallery and offered important evidence of Nuremberg's scientific and artistic activity. At a time when Nuremberg could no longer stand up to political pressure, Maximilian I, Duke of Bavaria and later to become elector, requested the paintings for himself. Even when it was pointed out that it had been Dürer's wish that they should "be preserved in a public place as a memorial to him and should not be allowed to fall into foreign hands," Maximilian still would not be dissuaded. The council, afraid that he might retaliate with economic sanctions, sent the originals to Munich, along with copies made by a court painter named Fischer. They hoped that the Jesuits at court would be incensed by the inscriptions and would urge Maximilian to refuse the originals and accept the copies instead, which did not include the offending inscriptions. The ever-wise Maximilian promptly decided to have the inscriptions sawed off and sent back to Nuremberg with the copies. It was nearly three hundred years before the inscriptions were restored to their rightful place so Dürer's last work could once again convey its complete message.

Dürer died on April 6 or 8, 1528, after a short but severe illness and was buried in the cemetery attached to St. John's church in Nuremberg. His epitaph was written by Willibald Pirckheimer. It was no accident that he adopted the tenor of the inscription beneath the portrait of himself by Dürer, turning the general maxim into a personal statement that is simplicity itself. He proclaims that the dead man's works are immortal: "Whatever was mortal in Albrecht Dürer is covered by this stone."

Catalog of paintings still extant

1. Portrait of Dürer's Father
Oil on panel;
$18\frac{3}{4} \times 15\frac{5}{8}$ in. (47.5×39.5 cm)
The artist's monogram
appears on the left, with the
date (1490) above
The coats of arms of the
Dürer and Holper families
appear on the reverse, with
the date below
Florence, Uffizi

**2. Christ with the
Symbols of His Passion**
(Ecce Homo)
Oil on panel (pine);
$11\frac{3}{4} \times 7\frac{1}{2}$ in. (30×19 cm)
Circa 1493
Karlsruhe, Staatliche
Kunsthalle

**3. Self-Portrait with
Eryngium Flower**
Transferred from vellum to
canvas;
$22\frac{1}{4} \times 17\frac{1}{2}$ in. (56.5×44.5 cm)
At the top appears the
inscription: "My sach die
gat/Als es oben schtat,"
with the date (1493)
Paris, Louvre

**4. Portrait of Frederick
the Wise**
Tempera on canvas;
$30 \times 22\frac{1}{2}$ in. (76×57 cm)
Circa 1493
The artist's monogram
appears in the bottom left-
hand corner but was added
later
Berlin, Staatliche Museen
Preussischer Kulturbesitz,
Gemäldegalerie

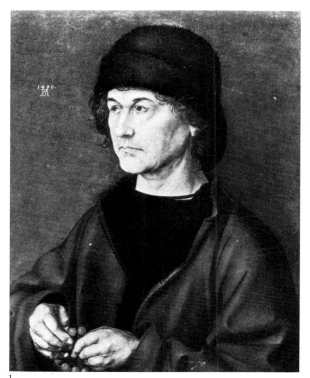

1

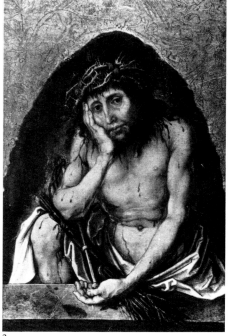

2

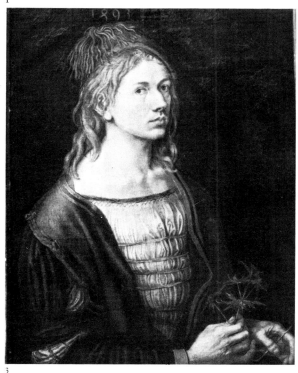

3

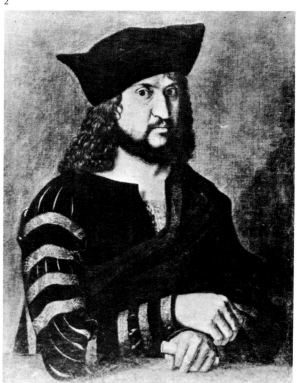

4

5. Polyptych of the Seven Sorrows of Mary
Probably 1496
Eight panels:
a) Mother of Sorrows
Oil on panel (pine);
43×17 in. $(109.2 \times 43.3$ cm)
Munich, Alte Pinakothek
b) The Circumcision of Christ
Oil on panel (pine);
$24\frac{7}{8} \times 17\frac{7}{8}$ in. $(63 \times 45.5$ cm)
c) The Flight into Egypt
Oil on panel (pine);
$24\frac{7}{8} \times 18$ in. $(63 \times 46$ cm)
d) Christ among the Doctors
Oil on panel (pine);
$24\frac{1}{2} \times 17\frac{3}{4}$ in. $(62.5 \times 45$ cm)
e) The Way to Calvary
Oil on panel (pine);
$24\frac{7}{8} \times 17\frac{1}{2}$ in. $(63 \times 44.5$ cm)
f) The Crucifixion
Oil on panel (pine);
$24\frac{3}{8} \times 17\frac{1}{2}$ in. $(62 \times 44.5$ cm)
g) Christ on the Cross
Oil on panel (pine);
$24\frac{3}{4} \times 17\frac{7}{8}$ in. $(63.5 \times 45.5$ cm)
h) The Lamentation of Christ
Oil on panel (pine);
$24\frac{7}{8} \times 18$ in. $(63 \times 46$ cm)
Dresden, Staatliche
Kunstsammlungen,
Gemäldegalerie

6. St. Jerome the Penitent
Oil on panel (pear);
$9\frac{1}{16} \times 6\frac{13}{16}$ in. $(23.1 \times 17.4$ cm)
Probably 1497–98
On the reverse, a red star
among clouds
Cambridge, Fitzwilliam
Museum (Sir Edmund
Bacon Bequest)

7. Virgin and Child
Oil on panel;
$18\frac{7}{8} \times 14\frac{1}{4}$ in. $(47.8 \times 36$ cm)
Circa 1497–98
Mamiano (Parma),
Magnani Collection

5,a

5,b

5,c

5,d

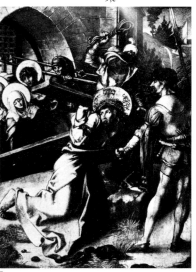

5,e

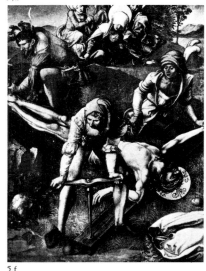

5,f

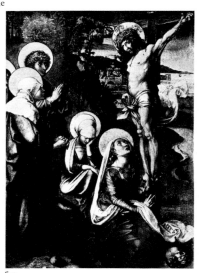

5,g

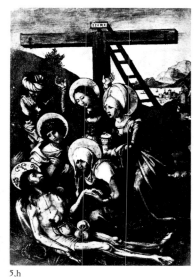

5,h

6

7

8. Dresden Altarpiece
Probably 1497–98
Dresden, Staatliche
Kunstsammlungen,
Gemäldegalerie
Triptych:
**a) Virgin Adoring the
Infant Jesus**
Tempera on canvas;
$41\frac{1}{2} \times 37\frac{1}{2}$ in
$(105.5 \times 96.5$ cm)
Probably not by Dürer
b) St. Anthony
Left-hand panel
c) St. Sebastian
Right-hand panel
Tempera on canvas; both
$45 \times 17\frac{3}{4}$ in. (114 × 45 cm)

9a. St. Onuphrius
Panel; $22\frac{7}{8} \times 7\frac{7}{8}$ in.
$(58 \times 20$ cm)
Probably 1497
Bremen, Kunsthalle

9b. St. John the Baptist
Panel;
$22\frac{7}{8} \times 7\frac{7}{8}$ in. (58 × 20 cm)
This panel was a pendant to
the painting of St.
Onuphrius; it disappeared
in 1945

**10. Portrait of Dürer's
Father**
Oil on panel (lime);
$20\frac{1}{4} \times 15\frac{3}{4}$ in. (51 × 39.7 cm)
The inscription at the top
reads: "1497. ALBRECHT.
THVRER. DER. ELTER. VND.
ALT. 70 IOR"
London, National Gallery

**11. The Virgin in Half-
Length** (Haller Madonna)
Oil on panel;
$20\frac{1}{2} \times 16\frac{1}{4}$ in. (52 × 41 cm)
Circa 1496–97
The coat of arms of the
Haller von Hallerstein
family of Nuremberg
appears in the bottom left-
hand corner
On the reverse:
**12. Lot and his Daughters
Fleeing from Sodom and
Gomorrah**
Washington, National
Gallery of Art, Samuel H.
Kress Collection

13. Self-Portrait (with
landscape)
Oil on panel;
$20\frac{1}{2} \times 16\frac{1}{4}$ in. (52 × 41 cm)
The date (1498) appears on
the right; below, the
inscription: "Das malt ich
nach meiner gestalt/Ich war
sex und zwenzig jor
alt/Albrecht Dürer,"
followed by the artist's
monogram
Madrid, Prado

**14. Portrait of Oswolt
Krel**
Oil on panel (lime);
$19\frac{1}{2} \times 15\frac{1}{2}$ in. (49.6 × 39 cm)
At the top on the right, the
name of the sitter; below,
the date (1499)
On the two side panels:
**a) Wild Man with the
Coat of Arms of Oswolt
Krel**
**b) Wild Man with the
Coat of Arms of Agathe
Krel**
Both
$19\frac{1}{2} \times 6\frac{1}{4}$ in. (49.5 × 15.8 cm)
Munich, Alte Pinakothek
(Wittelsbacher
Ausgleichsfonds)

8,b

8,a

8,c

9,a

9,b

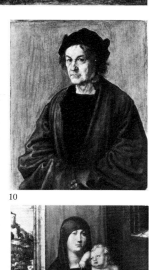

10

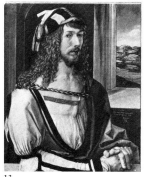

13

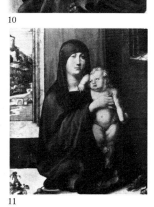

11

12

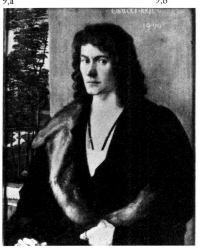

14

14,a

14,b

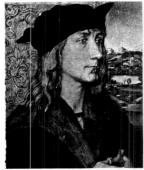

15,a

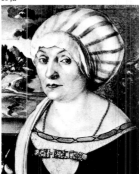

15,b

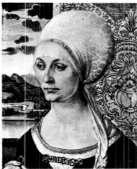

16

15. Diptych of Hans Tucher and His wife, Felicitas
Once in the Schlossmuseum in Weimar, it was stolen in 1945 and is now in New York
a) Hans Tucher
Oil on panel;
$11 \times 9\frac{7}{16}$ in. (28×24 cm)
In the top left-hand corner appears the inscription: "Hans Tucher. 42ierig. 1499."
The coat of arms of the Tucher and Rieter families appear on the reverse
b) Felicitas Tucher
Oil on panel;
$11 \times 9\frac{7}{16}$ in. (28×24 cm)
In the top right-hand corner appears the inscription: "Felitz. hans. tucherin. 33jor. alt. Salus 1499."

16. Portrait of Elsbeth Tucher
Oil on panel (lime);
$11 \times 8\frac{11}{16}$ in. (29×23.3 cm)
In the top right-hand corner appears the inscription: "ELSPET. NICLAS. TVCHERIN 26 ALT."
The date (1499) appears below
Kassel, Staatliche Kunstsammlungen, Gemäldegalerie
The companion portrait of her husband, Nicholas, has disappeared

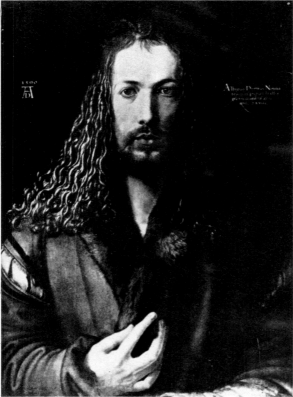

17

18

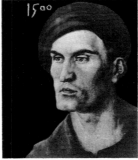

19

17. Self-Portrait in a Fur-Collared Robe
Oil on panel (lime);
$26\frac{3}{8} \times 19\frac{1}{4}$ in. (67×49 cm)
The artist's monogram appears on the left, with the date (1500) above; on the right is the inscription: "Albertus Durerus Noricus/ipsum me propriis sic effin/gebam coloribus aetatis/anno XXVIII" ("I, Albrecht Dürer from Noricum, painted myself with everlasting colors in my twenty-eighth year")
Munich, Alte Pinakothek

18. Hercules Killing the Stymphalian Birds
Oil on canvas;
$34\frac{1}{4} \times 43\frac{5}{16}$ in. (87×110 cm)
The artist's monogram and the date (1500) appear in the bottom left-hand corner
Nuremberg, Germanisches Nationalmuseum (on loan from the Bayerische Staatsgemälde-sammlungen)

19. Portrait of a Young Man (Hans Dürer?)
Oil on panel (lime); original dimensions
$11\frac{1}{2} \times 8\frac{1}{4}$ in. (29.1×20.9 cm)
The date (1500) appears in the top left-hand corner
Munich, Alte Pinakothek

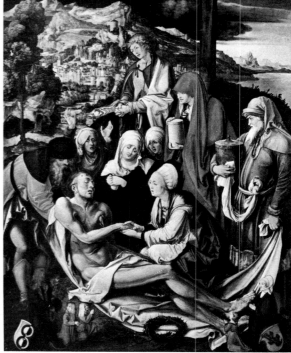

20

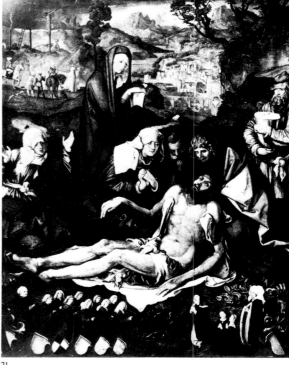

21

20. Lamentation over Christ
(painted for Albrecht Glimm)
Oil on panel (pine);
$59\frac{1}{2} \times 47\frac{5}{8}$ in. (151×121 cm)
1500
Munich, Alte Pinakothek
From the Predigerkirche in Nuremberg

21. Lamentation over Christ
(painted for the Holzschuher family)
Oil on panel;
$59 \times 47\frac{1}{4}$ in. (150×120 cm)
1500
From the chapel of the Holzschuher family in the cemetery of St. John, Nuremberg
Nuremberg, Germanisches Nationalmuseum (on loan from the Wittelsbacher Ausgleichsfonds)

22. Paumgartner Altarpiece
Circa 1502
Munich, Alte Pinakothek
a) Nativity
Oil on panel (lime);
61 × 49⅝ in. (155 × 126 cm)
b) Stephan Paumgartner (?) as St. George
Left-hand panel
On the reverse, an
Annunciation
c) Lucas Paumgartner as St. Eustace
Right-hand panel
Oil on panel (lime); both
61¾ × 24 in. (157 × 61 cm)

23. Madonna and Child
Oil on panel; 9⅓ × 7 in.
(24 × 18 cm)
The artist's monogram and
the date (1503) appear at
the top
Vienna, Kunsthistorisches
Museum, Gemäldegalerie

24. Head of a Young Woman
Tempera on canvas;
10 × 8½ in. (25.5 × 21.5 cm)
The artist's monogram and
the date (1503 or 1505)
appear at the top
Paris, Bibliothèque
Nationale

25. Salvator Mundi
Oil on panel;
22⅓ × 18½ in. (58.1 × 47 cm)
Circa 1503–04
New York, Metropolitan
Museum of Art, Friedsam
Collection

26. Jabach Altarpiece
Circa 1504
Two wings:
a) Job and His Wife
Left-hand outer panel
Oil on panel (lime);
37¾ × 20⅛ in. (96 × 51 cm)
Frankfurt, Städelsches
Kunstinstitut
b) Two Musicians
Right-hand outer panel
Tempera on panel (lime);
37¾ × 20⅛ in. (94 × 51 cm)
Cologne, Wallraf-Richartz-
Museum
c) St. Joseph and St. Joachim
Left-hand inner panel
Oil on panel (lime);
37¾ × 21⅓ in. (96 × 54 cm)
Munich, Alte Pinakothek
(Wittelsbacher
Ausgleichsfonds)
d) St. Simeon and St. Lazarus
Right-hand inner panel
Oil on panel (lime);
38 × 21½ in. (97 × 55 cm)
Munich, Alte Pinakothek
(Wittelsbacher
Ausgleichsfonds)

27. Adoration of the Magi
Oil on panel;
39½ × 43¾ in. (100 × 114 cm)
The artist's monogram can
be seen in the bottom left-
hand corner; above, the
date (1504)
Florence, Uffizi

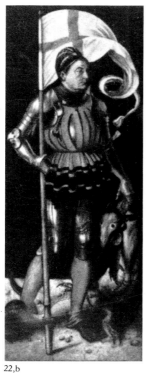

22,b

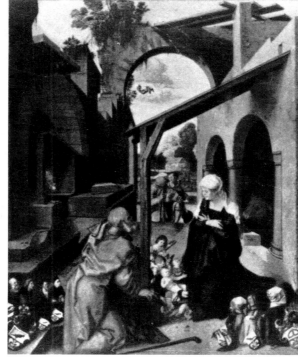

22,a

22,c

23

24

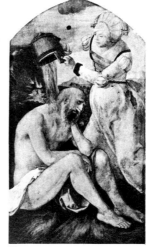

26,a

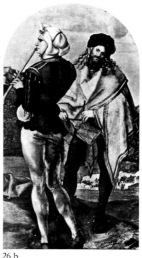

26,b

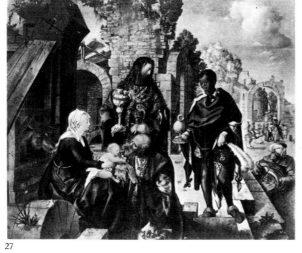

27

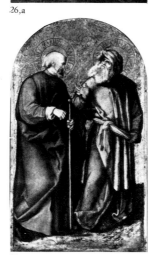

26,c

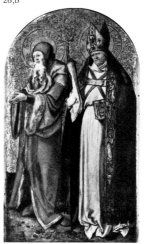

26,d

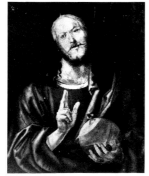

25

28

29

30

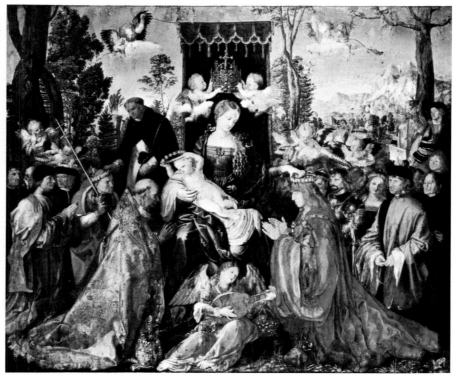

31

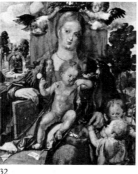

32

34

35

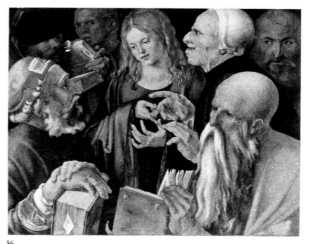

36

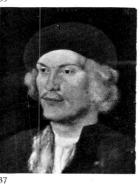

37

38

33

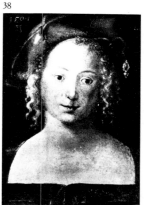

39

28. Boy with His Head Inclined
Tempera on canvas;
$8\frac{1}{4} \times 7$ in. $(21.1 \times 17.9$ cm)
Circa 1505
Paris, Bibliothèque
Nationale

29. Head of a Boy
Tempera on canvas;
$8\frac{3}{4} \times 7\frac{1}{2}$ in. $(22.5 \times 19.2$ cm)
Circa 1505
The artist's monogram can
be seen at the top on the left
Paris, Bibliothèque
Nationale

30. Portrait of a Young Venetian Woman
Oil on panel (elm);
$12\frac{3}{4} \times 9\frac{3}{4}$ in. $(32.5 \times 24.5$ cm)
The artist's monogram can
be seen at the top, with the
date (1505) above

31. The Feast of the Rose Garlands (The Brotherhood of the Rosary)
Oil on panel (poplar);
$63\frac{3}{4} \times 76\frac{1}{2}$ in.
$(162 \times 194.5$ cm)
The artist is depicted in the
background, holding a sheet
of paper bearing the
inscription: "Exegit/
quinque/mestri/spatio/
Albertus/Dürer Germanus/
MDV [I]," with the
monogram below
Prague, Národni Galerie

32. The Madonna with the Siskin
Oil on panel (poplar);
$35\frac{7}{8} \times 30$ in. $(91 \times 76$ cm)
In the foreground, the
following inscription can be
read on a scroll of paper:
"Albertus durer germanus/
faciebat post virginis/
partum 1506." The artist's
monogram appears beside
the inscription
Berlin, Staatliche Museen
Preussischer Kulturbesitz,
Gemäldegalerie

33. Portrait of a Venetian Woman
Oil on panel (poplar);
$11\frac{1}{4} \times 8\frac{1}{2}$ in. $(28.5 \times 21.5$ cm)
1506
The artist's monogram
appears at the top on the
left
Berlin, Staatliche Museen
Preussischer Kulturbesitz,
Gemäldegalerie

34. Portrait of a Young Man
Oil on panel;
$18 \times 13\frac{3}{4}$ in. $(46 \times 35$ cm)
At the top is the inscription:
"Albertus durer/germanus/
faciebat post/virginis/
partu[m]/1506," plus the
artist's monogram
Genoa, Palazzo Rosso

35. Portrait of a Young Man (Burkard von Speyer)
Oil on panel;
$12\frac{1}{2} \times 10\frac{1}{2}$ in. $(32 \times 27$ cm)
The artist's monogram and
the date (1506) can be seen
at the top
Windsor, Royal Collection

36. Christ among the Doctors
Oil on panel (poplar);
$26\frac{5}{8} \times 31\frac{5}{8}$ in. $(67.5 \times 80.4$ cm)
The bookmarker bears the
date (1506); the artist's
monogram and the
inscription: "opus quinque
dierum" appear below
Lugano-Castagnola,
Thyssen-Bornemisza
Collection

37. Portrait of a Young Man
Oil on panel (lime);
$13\frac{3}{4} \times 11\frac{3}{8}$ in. $(35 \times 29$ cm)
Artist's monogram and date
(1507) appear at top
On the reverse:
38. Avarice
Vienna, Kunsthistorisches
Museum, Gemäldegalerie

39. Portrait of a Girl in a Red Cap
Oil on vellum, laid down on
wood;
$12 \times 7\frac{7}{8}$ in. $(30.4 \times 20$ cm)
At the top is the artist's
monogram with the date
(1507) below
Berlin, Staatliche Museen
Preussischer Kulturbesitz,
Gemäldegalerie

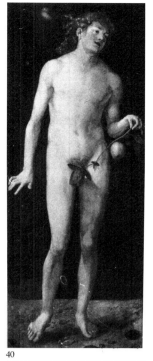

40

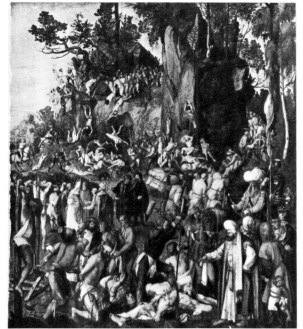

42

44

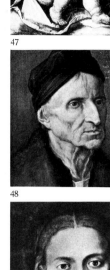

45

47

48

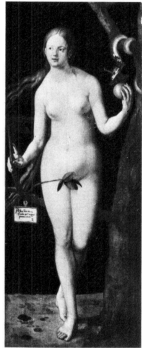

41

43

46

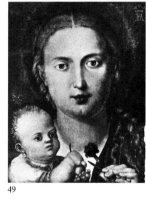

49

40. Adam
Oil on panel (pine);
$82 \times 31\frac{7}{8}$ in. (209×81 cm)
Bears Dürer's monogram
and the date (1507)
Madrid, Prado

41. Eve
Oil on panel (pine);
$82 \times 32\frac{3}{4}$ in. (209×83 cm)
A small panel bears the
inscription: "Albertus
durer alemanus/faciebat
post virginis partum 1507,"
with the artist's monogram
below
Madrid, Prado

42. The Martyrdom of the Ten Thousand
Oil on panel transferred to
canvas;
$39 \times 34\frac{1}{4}$ in. (99×87 cm)
The artist is depicted in the
center, holding a banner

with the inscription: "Iste
faciebat año domini 1508/
albertus Dürer alemanus."
Alongside the inscription is
his monogram
Vienna, Kunsthistorisches
Museum, Gemäldegalerie

43. Adoration of the Trinity
Oil on panel (poplar);
$53\frac{1}{4} \times 44\frac{1}{4}$ in.
(135×123.4 cm)
In the bottom right-hand
corner is a portrait of the
artist standing behind a
panel, which bears the
inscription: "ALBERTUS.
DVRER/NORICVS. FACIE./
BAT. ANNO. A. VIR/GINIS.
PARTV./1511," with the
monogram
Vienna, Kunsthistorisches
Museum. Gemäldegalerie
From Landauer's chapel in
the Zwölfbrüderhaus

44. Madonna and Child
Oil on panel (lime);
$19\frac{1}{4} \times 14\frac{5}{8}$ in. (49×37 cm)
The artist's monogram and
the date (1512) are inscribed
in the top right-hand corner
Vienna, Kunsthistorisches
Museum, Gemäldegalerie

PORTRAITS OF THE
EMPERORS
1513
Nuremberg, Germanisches
Nationalmuseum

45. The Emperor Charlemagne
Oil on panel (lime);
$73\frac{5}{8} \times 34\frac{1}{2}$ in.
(187.7×87.5 cm);
with its original frame
$84\frac{1}{2} \times 45\frac{1}{4}$ in.
(214.6×115 cm)
At the top is the inscription:
"Karolus magnus/
imp[er]avit Annis. 14;" the
arms of Germany and
France can be seen at the
top. They reappear on the
reverse, with the following

inscription: "Dis. jst.
keiser. Karlus. gstalt/sein.
kran. vnd. kleidung.
manigfalt/.zu. Nurenberg.
offenlich. zeige[n]. wirt/
mit.anderm.heiltum.
wie. sich. gepirt./kung.
pippinus. sun auss.
franckreich./vnd
Remischer keiser. auch.
geleich."

46. The Emperor Sigismund
Oil on panel (lime);
$73\frac{3}{4} \times 34\frac{1}{2}$ in.
(187.7×87.5 cm);
with its original frame
$84\frac{1}{2} \times 45$ in. (214.6×115 cm)
At the top is the inscription:
"Sigismund[us]
imp[er]avit/Annis. 28." The
arms of the Empire, of
Bohemia, Hungary, and
Luxembourg can be seen

above. The same arms
appear on the reverse, with
a different inscription
below.

47. Madonna with the Child in Her Lap
Oil on panel;
11×8 in. (27.9×20.5 cm)
The artist's monogram is on
the right, with the date
(1516) above
New York, Metropolitan
Museum of Art

48. Portrait of Michael Wolgemut
Oil on panel (lime);
$11\frac{3}{8} \times 10\frac{5}{8}$ in. (29×27 cm)
Again, an inscription
appears in the top right-
hand corner.
The artist's monogram and
the date (1516) are in the
bottom right-hand corner
Nuremberg, Germanisches
Nationalmuseum (on loan
from the Bayerische
Staatsgemäldesammlungen)

49. Madonna with the Carnation
Vellum mounted on pine;
$15\frac{5}{8} \times 11\frac{1}{2}$ in. (39×29 cm)
The artist's monogram
appears in the top right-
hand corner, with the date
(1516) above
Munich, Alte Pinakothek

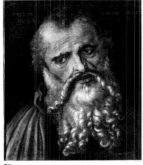

50

51

52

53

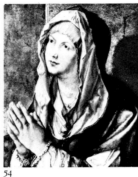

54

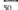

55

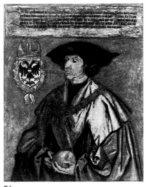

56

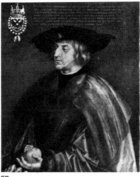

57

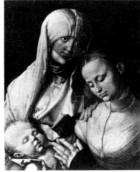

58

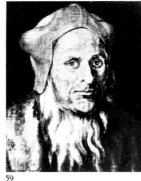

59

60

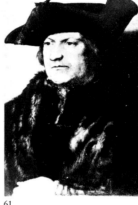

61

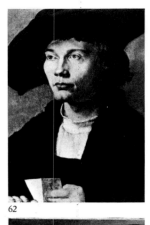

62

63

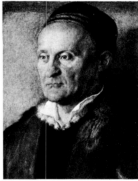

64

TWO PORTRAITS OF
APOSTLES
Florence, Uffizi
50. St. Philip
Tempera on canvas;
18¼ × 15 in. (46 × 38 cm)
The inscription at the top
reads: "SANCTE PHILIPPE
ORATE/PRO NOBIS 1516;"
the artist's monogram
appears beside it
51. St. James
Tempera on canvas;
18⅛ × 15 in. (46 × 38 cm)
The inscription at the top
reads: "SANCTE JACOBE
ORA/PRO NOBIS 1516;" the
artist's monogram appears
beside it

**52. Portrait of a
Clergyman**
Vellum mounted on wood;
16⅜ × 13 in. (41.5 × 33 cm)
The artist's monogram and
the date (1516) appear in
the top right-hand corner
Washington, National
Gallery of Art, Kress
Collection

53. Lucretia
Oil on panel (lime);
66 × 29½ in. (168 × 74.8 cm)
The artist's monogram and
the date (1518) can be seen
in the bottom left-hand
corner
Munich, Alte Pinakothek

54. The Virgin in Prayer
Oil on panel (lime);
20⅞ × 16⅞ in. (53 × 43 cm)
The artist's monogram and
the date (1518) appear in
the top left-hand corner
Berlin, Staatliche Museen
Preussischer Kulturbesitz,
Gemäldegalerie

**55. Portrait of Jacob
Fugger**
Oil on canvas, subsequently
mounted on panel (pine);
25⅜ × 20⅞ in. (64.4 × 53 cm)
1518
Munich, Alte Pinakothek

**56. Portrait of the
Emperor Maximilian I**
Tempera on canvas;
32¾ × 33½ in. (83 × 85 cm)
Bears Dürer's monogram
and the date (1519)
The coat of arms of the
Hapsburgs and the two-
headed eagle appear on the
left, encircled by the Order
of the Golden Fleece; the
imperial crown can be seen
above. Attached to the top
of the painting is a strip of
vellum bearing an
inscription
Nuremberg, Germanisches
Nationalmuseum

**57. Portrait of the
Emperor Maximilian I**
Oil on panel (lime);
29⅛ × 24¼ in. (74 × 61.5 cm)
The two-headed eagle with
the coat of arms of the
Hapsburgs appear on the
left, encircled by the Order
of the Golden Fleece; the
imperial crown can be seen
above. A seven-line
inscription appears on the
top, with the artist's
monogram and the date
(1519) on the right
Vienna, Kunsthistorisches
Museum, Gemäldegalerie

**58. Virgin and Child with
St. Anne** ("Anna
Selbdritt")
Transferred from panel on
to canvas; 23⅝ × 19⅝ in.
(60 × 49.9 cm)
The monogram and the date
(1519) appear on the right
New York, Metropolitan
Museum of Art, Altman
Collection

**59. Old Man Wearing a
Red Beret**
Tempera on canvas;
15¾ × 11¾ in. (40 × 30 cm)
The artist's monogram and
the date (1520) appear on
the left
Paris, Louvre

**60. St. Jerome in
Meditation**
Oil on panel;
23⅝ × 18⅞ in. (60 × 48 cm)
A bookmarker at the bottom
bears the artist's
monogram, with the date
(1521) above
Lisbon, Museu Nacional de
Arte Antiga

**61. Portrait of a
Gentleman**
Oil on panel;
19¾ × 12⅝ in. (50 × 32 cm)
Artist's monogram and
date (1521) appear at the top

Boston, Isabella Stewart
Gardner Museum

**62. Portrait of Bernhard
von Resten** (?)
Oil on panel (oak);
17⅞ × 12⅜ in. (45.5 × 31.5 cm)
The letter in the sitter's
hand bears the following
inscription: "Dem pernh
.../Zw...." The artist's
monogram and the date
(1521) appear at the top
Dresden, Staatliche
Kunstsammlungen,
Gemäldegalerie

**63. Portrait of a
Gentleman**
Oil on panel (oak);
19¾ × 14¼ in. (50 × 36 cm)
Artist's monogram and the
date (1524) are on the right
Madrid, Prado

**64. Portrait of Jacob
Muffel**
Transferred from panel to
canvas;
19 × 14¼ in. (48 × 36 cm)
The monogram is in the top
left-hand corner with the
inscription:
"EFFGIES. JACOBI. MVFFEL./
AETATIS. SVAE. ANNO. LV./
SALVTIS. VERO. M.D. XXVI."
Berlin, Staatliche Museen
Preussischer Kulturbesitz,
Gemäldegalerie

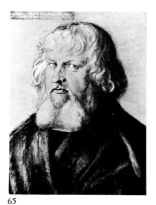

65

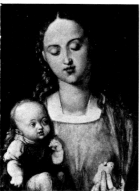

66

67

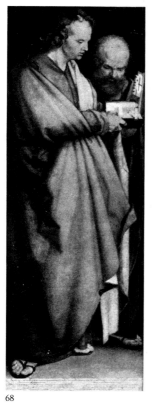

68

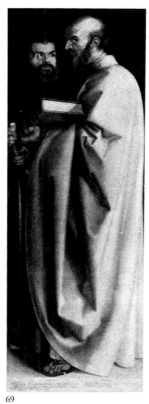

69

1

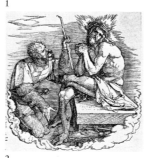

2

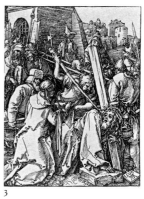

3

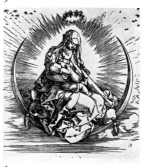

4

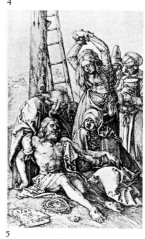

5

65. Portrait of Hieronymus Holzschuher

Oil on panel (lime);
19 × 14¼ in. (48 × 36 cm)
At the top is the inscription:
"HIERONIM[us].
HOLTZSCHVER. ANNO. DOÑI.
1526/ETATIS. SVE. 57." The
artist's monogram is on the
right. The coats of arms of
the Holzschuher and
Müntzer families appear on
the reverse, with the date
(M.D.XXVI.) above
Berlin, Staatliche Museen
Preussischer Kulturbesitz,
Gemäldegalerie

66. Madonna and Child

(Virgin with the Pear)
Oil on panel;
16⅞ × 12⅝ in. (43 × 32 cm)
Bears Dürer's monogram
and the date (1526)
Florence, Uffizi

67. Portrait of Johannes Kleberger

Oil on panel (lime);
14¾ × 14¼ in.
(36.7 × 36.6 cm)
Round the edge of the *tondo*
is the following inscription:
"E[ffigies]. IO[h]AN[n]I[s].
KLEBERGERS. NORICI.
AN[no]. AETA[tis]. SVAE.
XXXX.," plus a cabbalistic
symbol. One of the signs of
the Zodiac (Leo) is in the
top left-hand corner, with
the monogram and the date
(1526) in the top right-hand

corner; the sitter's coat of
arms and crest appear at the
bottom
Vienna, Kunsthistorisches
Museum, Gemäldegalerie

THE FOUR APOSTLES
1526
Munich, Alte Pinakothek

68. St. John the Evangelist and St. Peter

Oil on panel (lime);
84⅝ × 30 in. (215.5 × 76 cm)
The artist's monogram and
the date (1526) are in the
top left-hand corner.
The Bible is open at the
beginning of the Gospel
according to St. John. The
following inscription,
written by Johann
Neudörffer, appears below:
"Alle weltliche regenten jn
disen ferlichen zeitten
Nemen billich acht, das sie
nit fur das götlich wort
menschliche verfuerung
annemen, Dann Gott wil nit
Zu seinem wort gethon,
noch dannen genommen
haben. Darauf horent dise

trefflich vier menner
Petrum Johannem Paulum
vnd Marcum Ire warnung."
Quotations follow from the
saint's epistles in Luther's
1522 translation: Second
Letter of Saint Peter, 2,
1–3; First Letter of Saint
John, 4, 1–3.

69. St. Mark and St. Paul

Oil on panel (lime);
84⅜ × 30 in. (214.5 × 76 cm)
The artist's monogram and
the date (1526) are in the
top right-hand corner;
quotations from the works
of the subjects (II Timothy
3: 1–7 and Mark 12: 38–41)
are inscribed at the bottom

SERIES OF WOODCUTS AND ENGRAVINGS

1. The Revelation of St. John (The Apocalypse with Figures)

1497–98
15 woodcuts with text; each
approx.
15½ × 11 in.
(39.2 × 28.2 cm);
1 woodcut for a frontispiece
with text only
1511
1 woodcut for a frontispiece
with the engraving *The
Virgin Appearing to St.
John*;
7¹⁵⁄₁₆ × 7¼ in. (18.5 × 18.3 cm)
First published in 1498 with
Latin and German texts,
with the title in both
languages on the
frontispiece: *Die heimliche
offenbarung ioh[a]nnis* and
Apocalipsis cum figuris. A
second edition, in Latin,
appeared in 1511

2. The Great Passion

(*Passio domini nostri Jesu*)
7 woodcuts; each approx.
15⅜ × 11 in. (39 × 28 cm)
1510
4 woodcuts; each approx.
15⅜ × 11 in. (39 × 28 cm)
1511
1 woodcut for a frontispiece
with the engraving *The
Man of Sorrows*; 7¹³⁄₁₆ × 7¹¹⁄₁₆
in (19.8 × 19.5 cm) and the
title. The first seven
woodcuts are undated.
Dürer later added another
four, dated 1510. In 1511
they were published in one
volume with a text by
Benedictus Chelidonius
entitled: *Passio domini
nostri Jesu . . . per fratrem
Chelidonium collecta . . .
Nürnberg. [Hieronymus
Hötzel für] Albrecht Dürer,
1511.*

3. The Small Passion

(*Passio Christi*)
1509–10
36 woodcuts; each approx.
5 × 3⅞ in. (12.7 × 9.7 cm);
1 woodcut for a frontispiece
with the engraving *The
Man of Sorrows*;
3⅜ × 3¼ in. (8.6 × 7.8 cm)
and the title
Published in 1511 with a
text by Benedictus
Chelidonius

4. The Life of the Virgin

(*Epitome in divae
parthenices Mariae*)
Circa 1501–05
17 woodcuts with text; each
approx.
11½ × 8¼ in. (29.5 × 21 cm)
1510
2 woodcuts; both approx.
11½ × 8 in. (29 × 20.6 cm);
1 frontispiece with the
engraving *The Virgin
Seated on the Crescent Moon*;
8 × 7¹¹⁄₁₆ in. (20.2 × 19.5 cm)
and the title

5. The Engraved Passion

(*Die Kupferstichpassion*)
Circa 1507–13
16 copperplate engravings;
each approx.
4⅝ × 4½ in. (11.7 × 11.5 cm)

Bibliographical Notes

Texts in this volume relating to most of Dürer's work are to be found in the catalog of the *1491 Albrecht Dürer 1971* exhibition at the Germanisches Nationalmuseum, 1st to 3rd eds., (Munich: 1971). However, in the case of works that do not appear in the above catalog, we have referred to F. Anzelewski, *Albrecht Dürer. Das malerische Werk* (Berlin: 1971).

In addition, the following titles were used:

ALBERTUS DURERUS NORICUS
Life and Personality
Lutz, H. "Albrecht Dürer und die Reformation, Offene Fragen," *Miscellanea Bibliothekae Hertzianae*. Munich: 1961. (Discusses authenticity of Dürer's mourning of Luther in his "Netherlandish Diary.").
Winzinger, F. "Albrecht Dürer in Rom," *Pantheon* 24: 283–287. (On Dürer's possible stay in Rome.)

LIFE IN NUREMBERG
This chapter follows the relevant chapters of *Nürnberg, Geschichte einer Europäischen Stadt*, edited by Gerhard Pfeifer, with the co-operation of numerous experts (Munich: 1971).
Production and Trade
Albrecht Dürer, The Human Figure, The Complete Dresden Sketchbook. Introduction, translation, and notes by W. L. Strauss.
Printing
Rücker, E. *Die Schedelsche Weltchronik*. Munich: 1973.
Wilson, A. "The Early Drawings for the Nuremberg Chronicle." *Master Drawings* 13: 115–130.
Zahn, P. "Neue Funde zur Entstehung der Schedelschen Weltchronik 1493." *Renaissance Vorträge*, Nuremberg; Museum der Stadt Nürnberg, 1973.
The Emperor and the Imperial City
Vetter, E. M., and Brockhaus, Chr. "Das Verhältnis von Text und Bild in Dürer's Randzeichnungen zum Gebetbuch Kaiser Maximilians."

Anzeiger des Germanischen Nationalmuseums 1971–72: 70–121.

INFLUENCES
Martin Schongauer and the Master of the Housebook
Chatelet, A. "Dürer und die Nördlichen Niederlande." *Anzeiger des Germanischen Nationalmuseums* 1975: 52–64.
Evers, H. G. *Dürer bei Memling*. Munich: 1972.
Basel and Strasbourg
Afer, Publius Terentius. *Andria oder Das Mädchen von Andros*. Translation by Felix Mendelssohn Bartholdy; conclusion by Giovanni Mardersteig; with 25 illustrations by Albrecht Dürer. Verona: 1971.
"Hommage à Dürer, Strasbourg et Nuremberg dans la première moitié du XVIème siècle." *Actes du Colloque de Strasbourg*, Nov. 19–20, 1971, Strasbourg: 1972.
Schefold, R. "Gedanken zu den Terenz-Illustrationen Albrecht Dürers." *Illustration 63. Zeitschrift für die Buchillustration* 12: 16–20.
Italy
Pignatti, T. "Die Beziehungen zwischen Dürer and dem jungen Tizian." *Anzeiger des Germanischen Nationalmuseums* 1971–72: 61–69.
Pignatti, T. "The relationship between German and Venetian painting in the late Quattrocento and early Cinquecento." *Renaissance Venice*: Edited by J. R. Hale. London: 1973.
The Low Countries
Brand, E. "Untersuchungen zu Albrecht Dürers 'Bildnis eines jungen Mannes.'" *Jahrbuch. Staatliche Kunstsammlungen Dresden*. Dresden: 1970–71 (1974).

DÜRER'S WORKS
The Influence of Classical Art
Simon, E. "Dürer und Mantegna 1494." *Anzeiger des Germanischen Nationalmuseums* 1971–72: 21–40.
Constructional Figures
Winzinger, F. "Dürer und Leonardo."

Pantheon 29: 3–21.
Dürer's Discovery of Nature
Kauffmann, H. "Albrecht Dürer. Umwelt und Kunst." *1491 Albrecht Dürer 1971*, catalog of the exhibition at Nuremberg in 1971: 20–21. (Discusses the relationship between Dürer's landscapes and the *Germania Illustrata* by Conrad Celtis.)
Koschatzky, W. *Albrecht Dürer. Die Landschafts-Aquarelle, Ortlichkeit, Datierung, Stilkritik*. Vienna and Munich: 1971.
Christian Subject Matter
Harnest, J. *Das Problem der Konstruierten Perspektive in der Altdeutschen Malerei*. Munich: Technische Universität, 1971. (See p. 30 for discussion of the central panel of *The Dresden Altarpiece*.)

Basic Literature

Flechsig, E. *Albrecht Dürer. Sein Leben und seine künstlerische Entwicklung.* Berlin: 1928–31.

Jantzen, H. *Dürer der Maler.* Bern: 1952.

Knappe, K. -A. *Dürer. Das grafische Werk.* Vienna and Munich: 1964.

Koschatzky, W., and Strobl, A. *Die Dürerzeichnungen der Albertina.* Salzburg: 1971.

Meder, J. *Dürer Katalog. Ein Handbuch über Albrecht Dürers Stiche, Radierungen, Holzschnitte, deren Zustände, Ausgaben und Wasserzeichen.* Vienna: 1932.

Mende, M. *Dürer-Bibliographie.* Wiesbaden: 1971.

Panofsky, E. *Albrecht Dürer,* 3rd ed. Princeton: 1948.

Rupprich, H., ed. *Dürer. Schriftlicher Nachlass.* Berlin: 1956–69.

Strauss, W. L. *The Complete Drawings of Albrecht Dürer.* New York: 1974.

Strauss, W. L., ed. *The Complete Engravings, Etchings, and Dry-Points of Albrecht Dürer.* New York: 1972.

Tietze, H., and Tietze-Conrat, E. *Kritisches Verzeichnis der Werke Albrecht Dürers,* vols. 1–2, 2. Augsburg: 1928; Basel and Leipzig: 1937–38.

Waetzoldt, W. *Dürer und seine Zeit.* Vienna: 1933; English ed: 1950, 1955.

Winkler, F. "Dürer. Des Meisters Gemälde, Kupferstiche und Holzschnitte." *Klassiker der Kunst,* 4th ed. Berlin and Leipzig: 1928.

Winkler, F. *Die Zeichnungen Albrecht Dürers.* Berlin: 1936–39.

Winkler, F. *Albrecht Dürer. Leben und Werk.* Berlin: 1957.

Wölfflin, H. *Die Kunst Albrecht Dürers.* Edited by K. Gerstenberg, 6th ed. Munich: 1943.

Zampa, G., and Ottino Della Chiesa, A. *L'opera completa di Dürer.* Classici dell'arte 23. Milan: 1968.

Index

Photographic Sources

a = above; b = below; c = center; r = right; l = left

Anders: pp. 14l, 153. Bibliothèque Nationale, Paris: p. 132. Bildarchiv Preussischer Kulturbesitz, Berlin: pp. 172–173. Blauel: pp. 56–57, 58–59, 71l, 72–73, 76–77, 79, 82–83, 146, 166–167. Brunel: pp. 102, 103, Bulloz: pp. 53, 62, 132. Frequin-Photos: p. 90. Germanisches Nationalmuseum, Nuremberg: pp. 13a, 37, 84, 136, 151, 174–175. Giraudon: pp. 38, 64. Graphische Sammlung, Albertina, Vienna: p. 14r. Hamburger Kunsthalle, Hamburg: pp. 137, 160r. Kleinhempel: p. 137. Kodansha: pp. 11, 33, 41, 52, 55, 75, 80, 91, 109, 112, 119, 120, 128, 138, 139, 141, 165. Kupferstichkabinett, Basel: pp. 13b, 160l. Marques: pp. 155, 156–157. Mella, Arborio: pp. 6, 18, 19r, 20, 20–21, 51, 96, 171. Meyer: pp. 113, 114–115, 121, 122, 123. Mondadori Archives: pp. 16–17, 22, 30. Preiss & Co.: p. 149. Quattrone: p. 152. Reinhold: p. 31. Rijksprentenkabinet, Amsterdam: pp. 116r, 117r. Scala: pp. 48, 49, 78, 86–87, 88l, 89, 169. Staatliche Graphische Sammlung, Munich: pp. 29, 36, 46, 116l. Staatsbibliothek, Munich: p. 13b. Statens Museum for Kunst, Kgl Kobberstiksamling, Copenhagen: pp. 32, 133, 161, 170. Steinkopf: pp. 17, 25, 99, 100, 101, 148. Vaghi: p. 24.
All photographs not specifically mentioned here have been kindly lent by the various museums and collections in which the works are kept. In particular, we wish to thank Mr. Otto Schäfer of Schweinfurt for his kind permission to reproduce and publish several valuable engravings from his collection.